AMERICAN MUSIC DOCUMENTARY

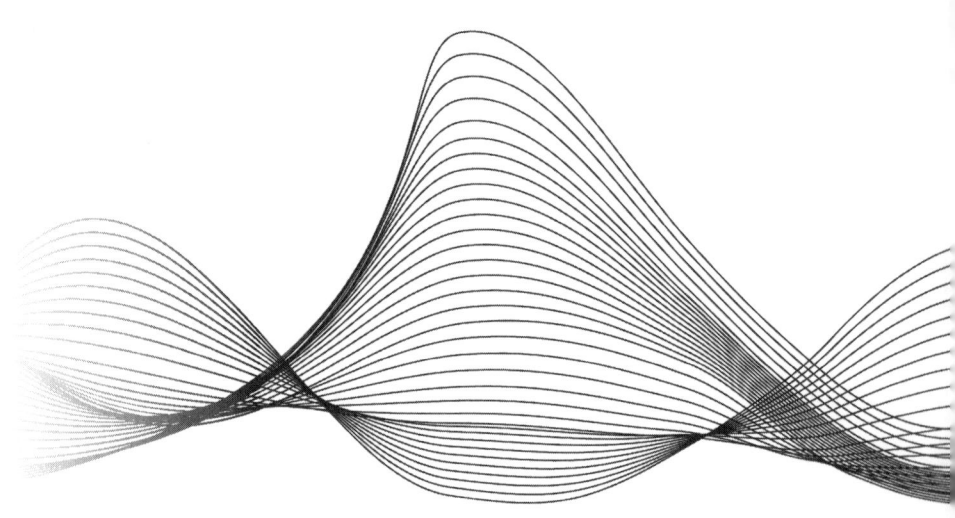

BENJAMIN J. HARBERT

American Music Documentary

FIVE CASE STUDIES OF CINÉ-ETHNOMUSICOLOGY

WESLEYAN UNIVERSITY PRESS Middletown, Connecticut

Wesleyan University Press
Middletown CT 06459
www.wesleyan.edu/wespress
© 2018 Benjamin J. Harbert
All rights reserved
Manufactured in the United States of America
Typeset in Aller and Arnhem types
by Tseng Information Systems, Inc.

Library of Congress Cataloging-in-Publication Data
 Names: Harbert, Benjamin J. author.
 Title: American music documentary: five case studies of ciné-ethnomusicology / Benjamin J. Harbert.
 Description: Middletown, Connecticut: Wesleyan University Press, 2018. | Series: Music/Interview | Includes bibliographical references and index. | Includes filmography. | Identifiers: LCCN 2017036468 (print) | LCCN 2017042746 (ebook) | ISBN 9780819578020 (ebook) | ISBN 9780819578006 (cloth: alk. paper) | ISBN 9780819578013 (pbk.: alk. paper)
 Subjects: LCSH: Documentary films—United States—History and criticism. | Motion picture music—United States—History and criticism.
 Classification: LCC PN1995.9.D6 (ebook) | LCC PN1995.9.D6 H295 2018 (print) | DDC 070.1/8—dc23
 LC record available at https://lccn.loc.gov/2017036468

5 4 3 2 1

To Marina Goldovskaya

CONTENTS

List of Illustrations viii

Acknowledgments xi

Introduction 1

1 Where Is the Music? What Is the Music?
 Albert Maysles, *Gimme Shelter* (1970) 24

2 Representing the Margins and Underrepresenting the Real
 Jill Godmilow, *Antonia: A Portrait of the Woman* (1974) 67

3 The Use and Abuse of Musicological Concepts
 Shirley Clarke, *Ornette: Made in America* (1985) 108

4 The Theater of Mass Culture
 D. A. Pennebaker and Chris Hegedus, *Depeche Mode: 101* (1988) 156

5 Cinematic Dub and the Multitude
 Jem Cohen and Fugazi, *Instrument* (1999) 200

 Epilogue: Toward a Ciné-Ethnomusicology 245

 Appendix A: Extended Music Filmography 255

 Appendix B: Cited Interviews and Archival Material 259

 Appendix C: Glossary of Terms: Sounds, Shots, and Editing Techniques 261

 Notes 265

 Works Cited 275

 Index 289

ILLUSTRATIONS

1.1. Structure of "Wild Horses" sequence 37
1.2. Head position matching chord changes and shoulder motion matching plagal cadence 47
1.3. Unknown to Jagger, a hand from the crowd reaches toward him 55
1.4. Dancing man becomes concerned 61
1.5. Man smiles while woman weeps, both moving their heads to the music 63
2.1. Framing Brico's anger 81
2.2. Freeze-frame at end of kitchen sequence 83
2.3. Juxtaposed spaces of stage and home brought together through performance 88
3.1. Geodesic dome on top of Caravan of Dreams (still from the film) 114
3.2. The real Ornette Coleman connects with the "young" Ornette Coleman played by Demon Marshall 122
3.3. A cut that presents Coleman as if he were watching George Russell talk about Coleman 127
3.4. Two poles of interview: John Rockwell interview framed in a cartoon television set and Coleman with Fort Worth friends 128
3.5. The new buildings of downtown Fort Worth loom behind young Ornette Coleman in his neighborhood 139
3.6. Intermittent reharmonization of Coleman and his music across two different spaces and times 140
3.7. Two cutaway shots of places during the opening movement of *Skies of America* 140

4.1. Transcription of "Pimpf," the leitmotif of the film 168
4.2. Harmonic transformations represented on a matrix and transformational network 177
4.3. Basic harmonic transformations represented on a Tonnetz map 178
4.4. Tonnetz map analysis and transformational loop for "The Things You Said" 179
4.5. Scale-degree analysis of "The Things You Said" 179
4.6. Vocal line, keyboard melody, and visual sequence for "The Things You Said" 180
4.7. Longer keyboard melody for "The Things You Said" 180
4.8. Cathartic scream POV sequence 182
4.9. Rhythm of visual cuts to the repetitive climax of "People Are People" 185
4.10. Colotomic rhythmic structure of "Stripped" 187
4.11. Tonnetz map analysis for "Stripped" 187
4.12. Tonnetz map analysis for "Behind the Wheel" 193
4.13. Transformational network loop for "Behind the Wheel" 193
4.14. Gahan silhouetted at the end of "Everything Counts" 195
5.1. Cover of *Instrument* DVD with all collaborators' handwriting 218
5.2. Crowd portraits 241

ACKNOWLEDGMENTS

Ideas become a book when those ideas seed discussions that then feed the work of writing and revising. I am grateful to all the people who sustained years of deep thinking, rigorous discussions, and hard work.

First of all, this book would not be what it is without the willingness of the directors and musicians to discuss the films that they've seen countless times, to shift their own perspectives on their films, and to put up with exploratory conversations and follow up correspondence. For example, Albert Maysles came to Washington, DC, and later invited me to his home in Harlem. His wife, Gillian Walker, made minestrone soup as we continued our discussion into the evening. During our last interview, days before he passed away, Al's family invited me into their home to be with the family and insisted that I stay until he was well enough to speak. His daughter Sarah Maysles graciously waited with me, every bit as engaging as her father. Interviewing him at the end of his life gave me more than information about film — it revealed to me how a commitment to curiosity and love could bridge a career and a family. Jill Godmilow also invited me to her home after her visit to Washington. We sat at her kitchen table discussing a film that is nearly as old as I am. In addition, Godmilow gave me detailed and thoughtful advice on my own film and has made me more critical of film as a political and cultural practice. Jem Cohen came to campus for a residency and later welcomed me into his home in New York. Our conversation drifted from the kitchen table to his studio, examining films frame by frame. I am also grateful to Ian MacKaye and Guy Picciotto of Fugazi, who encouraged discussion about how they collaborated with Cohen and appeared in *Instrument*. D. A. Pennebaker and Chris Hegedus invited me to their office for a long discussion and later came to DC to do a master class at Georgetown University.

The late Shirley Clarke has a voice in this book thanks to all those who have kept her work alive. Kathlin Hoffman Gray and Shirley's daughter, Wendy, entertained long phone conversations and follow up over e-mails to help with their perspectives on Clarke's film. Dennis Doros of Milestone Film & Video helped me locate Shirley Clarke's materials and Mary K.

Huelsbeck of the University of Wisconsin Center for Film and Theater Research was immensely helpful at identifying and making available documents that led to the central ideas for the chapter on Clarke's film. There was more material than I could examine alone. Thanks to Julian Lynch and Steve Laronga's work transcribing Clarke's production audio, I was able to find the perspective that framed my approach to Clarke's inscrutable film and to pull Clarke's voice into the chapter. Conversations with Marc Cooper and Lauren Rabinovitz were pivotal to my understanding of Clarke and her relationship to the production of her final film.

Universities incubate scholarship. Maria Snyder and the Graduate Division at Georgetown University have been generous in providing me writing and research support. Dean Chester Gillis encouraged me to both make films and write as I developed my scholarship. Carole Sargent's writing groups gave me a place to discuss the writing and the process of writing. I am grateful for the unique departmental intersection between Georgetown's Music Department and the Film and Media Studies Department. Dean Bernie Cook, leading the latter department, has been an ally, making a case for film as a form of scholarship during lunch discussions and presentations of films. Interdisciplinary works come out of interdisciplinary communities. My colleagues Anna Celenza, Anthony DelDonna, and David Molk gave me incredibly useful feedback to draft chapters. Their command of currents in musicology and music theory was an important resource, granting me a solid sounding board as I ventured outside of ethnomusicological topics.

My teaching experience has provided insight for developing this book. The many semesters of my seminar/workshop "The Music Documentary" at Georgetown University have given me a forum for developing ideas, testing out films, and taking risks at interpretations. The framework for the class came from my work with Marina Goldovskaya at UCLA. She modeled an approach to teaching documentary film and worked with me on a related doctoral examination. I am indebted to all my music documentary students—too many to name—who challenged themselves to think about music by reading ever-shifting film studies literature and by taking their own risks by making their own smart films. Students have also been invaluable as a forum in which I tested new arguments. That forum branched out to embrace many important filmmakers. Guests to class included those featured here in the book. Albert Maysles, Jill God-

milow, D. A. Pennebaker, Chris Hegedus, and Jem Cohen traveled to campus and took student questions seriously—bringing their deep experience to our forum, as well as demonstrating their own continued practices of inquiry and human connection. The dialogue provided me ways of thinking that I could not have developed on my own. Other guest filmmakers also visited throughout the years to keep up a rigorous and illuminating discussion about merging theory and practice. I am grateful to Brendan Canty, Christoph Green, James June Schneider, Abby Moser, Jim Saah, and Jeff Krulik for taking the time and demonstrating interest, showing their work (finished and unfinished), and engaging us thoughtfully. A second volume could contain these discussions. A body of student films has developed in the wake of these discussions and engagements with daring and intelligent cinema.

There are hundreds of hours of work given to this book that are not mine. My research assistants provided invaluable support throughout the process. Allie Prescott, Rose Hayden, Dominique Rouge, and Viktoriya Kuz transcribed interviews and read through drafts of chapters. Ashwin Wadekar assembled the filmography appendix. Most of all, Sam Wolter worked with me for two years, doing everything from finding out economic data to counting the number of frames in certain sequences. Sam read multiple drafts, insisted that sections be intelligible, and most of all, provided an important weekly check-in as I progressed through the project. He also put together the glossary appendix.

Beyond my university, I am thankful to have a network of scholars to trust with reviewing the chapters. Marina Peterson helped ferret out and interrelate important themes surrounding *Ornette: Made in America*, giving clarity to the most complex of the chapters I developed. David Novak provided excellent direction with the chapter on *Instrument*, reminding me also that ethnomusicologists don't necessarily know hardcore punk. Ethan de Seife brought his obsession with the Rolling Stones and his grounding in film studies to help revise my argument in the chapter on *Gimme Shelter*. The Baltimore-DC Media Writing Group (Daniel Marcus, Jason Loviglio, Sonja Williams, Alex Russo, Lisa Rabin, Kyle Stine, David Weinstein, Darcey West, Josh Shepperd, Danny Kimball, and Kelly Cole) also gave important feedback from a diverse film and media studies perspective. And through the publication process at Wesleyan University Press, my thanks to Parker Smathers for reaching out

ACKNOWLEDGMENTS

to me about writing such a book. Suzanna Tamminen, Daniel Cavicchi, and Marla Zubel helped shepherd the book through the process with important suggestions along the way. The figures throughout the book look clear because Felix Salazar took his time and expertise to convert screen grabs to black-and-white images. And a final thanks to the two anonymous reviewers who helped me define the book as a whole.

Friends and family no doubt contributed, even if they did not know of that support. Collectively, they spent plenty of hours hearing rough ideas, fragments of arguments, or simply watching the films with me as I watched them yet again. I may never outgrow getting help from my mother, Janet Harbert, who often helped review text in a pinch. And most of all, I am indebted to my wife, Alison Brody—who put up with initial ideas even in the most inappropriate times, who read drafts late into the night, and who inevitably points out issues that I could never notice on my own. I am fortunate to have a continuous dialogue about our worlds. And to my children Elias and Beatrice, who magnify my good fortune.

Thanks to all of you.

AMERICAN MUSIC DOCUMENTARY

INTRODUCTION

"You can't do research but you can make a documentary film." This is essentially what I was told by the California Department of Corrections in 2004. I had been trying to gain access to an institution that was notorious for denying access to researchers. And yet, I had a deep curiosity about the contemporary musical practices of prisoners. Prison has an older history as a site of folkloric and ethnomusicological research, and I knew that prisoners were forming bands, securing and maintaining instruments, teaching each other to play, and writing songs. I wondered how their experiences of incarceration and music interrelated, how the experience of creating music behind bars differed from doing so on the outside, and how it fit into the relationships among prisoners and between inmates and the administration. I had been able to address these questions only by entering Soledad Prison (i.e., Soledad Correctional Training Facility) as a visitor. I couldn't even bring a pen.

In 2003, the prison suffered a round of budget cuts. The department that approved research was hit hard, and when I approached the prison later that year I was told that it was unlikely that anyone could even look at a proposal. They told me I could, however, bring in a camera and make a film, for even as the evaluation of research requests ground to a halt, the media department remained well staffed. And, officially, a documentary film did not count as research. While I was glad I was able to find a way into the prison via my camera, I have come to disagree with their claim that film is not research.

Throughout this book, I hope to argue that filmmaking can be a process of understanding music and that a film can be a way of expressing that understanding. In fact, this practice has existed outside the discipline of ethnomusicology for decades. Documentary filmmakers have developed methods to question, problematize, and present arguments about music and its role in

the world. This is the disciplinary territory of ethnomusicologists—those who study music and its relation to the social world. But, as many have pointed out, ethnomusicologists work in print. Film offers different ways of asking questions and thinking critically about music—through framing a shot, making an editing decision on where to cut a shot, placing music in relation to an image, or offering a sense of space and time. Each act of making a film can be part of a filmmaker's discovery of music. With this understanding, in examining film's role in ethnomusicological research, it is not enough to simply ask how film is different from print. It's important to ask how filmmakers have developed their practices of making films about music. I began thinking about these practices when making films myself.

When I was granted permission to bring a camera into the prison, I decided that I should study documentary filmmaking. At UCLA, I found Marina Goldovskaya, a Russian-born cinematographer and director who taught film at the university. Many of her films ask questions about the complexity of life after the dissolution of the Soviet Union. Her films are more than just images of real life; the images pointed to important issues in their own carefully constructed ways. Studying with Goldovskaya opened me up to like-minded filmmakers. I was able to meet people like Les Blank, Ross McElwee, and Joe Berlinger. More importantly, I sat through screenings and discussions of films—discussions that seemed strange for someone coming from the world of ethnomusicology. They seemed technical, focusing on narrative, camera pans, and dissolves, for instance. It seemed the equivalent of reading a text and then discussing punctuation, verb tense, and font types—not part of an intellectual conversation.

Over the course of Goldovskaya's class, I was able to produce a short film on music in a California prison that made it to a few festivals and community screenings. I also worked with her on a qualifying exam on music documentaries for my PhD. Our sustained conversation during this time began to close the gap between ethnomusicology and documentary film. As a result, I became an advocate for making scholarly films about music, further inspired by my UCLA professors Tim Rice and Helen Rees, who later studied with Goldovskaya. Soon ethnomusicology graduate students became fixtures in Goldovskaya's class, and I took jobs with faculty members, helping them to produce their own films. I edited

Ankica Petrovic's *John Filcich: Life in the Circle Dance* (2008) and Tony Seeger's *The Mouse Ceremony* (2015), which gave me practical experience at turning scholarship into film. Shooting Helen Rees's short film on Bell Young and the *guqin* (seven-sting zither) gave me perspective on production. For me—and for some of the ethnomusicologists I knew—film became an increasingly viable scholarly medium, despite its relative absence from conferences and publications.

Once I began teaching at Georgetown University, I turned the work I had done with Goldovskaya into a class that I have taught for the last seven years. During that time, I embarked on a larger project—a feature-length documentary on music in three Louisiana prisons—that has screened dozens of times internationally. My perspective on this book comes from my relationship with filming music and learning how to watch films critically. It also comes from a series of interviews conducted with the filmmakers featured in these pages. Talking to them about their practice has helped me understand film in a more profound way. We discussed how the eye engages with the image, what audiences do during screening, visual metaphors of sound, the temporal disruption of a cut. The analytic discussions led me to think about how film can take on the concerns of ethnomusicology—learning about how to think about and experience music through film and uncover important questions about music.

Not all music documentaries do this. More often, films about music focus on telling a particular story about a musical era or performer. Films like Ken Burns's *Jazz* (2001), James Spooner's *Afropunk* (2003), Morgan Neville and Robert Gordon's *Respect Yourself: The Stax Records Story* (2007), Drew DeNicola and Olivia Mori's *Big Star: Nothing Can Hurt Me* (2012), and Freddy Camalier's *Muscle Shoals* (2013), for instance, offer captivating stories, but they limit film to being an explanatory text: using sound to tug at emotions and still images—gently moving from side to side—to offer historical veracity. These filmmakers conduct exhaustive interviews, often choosing stars who might draw the interest of fans. Editors stitch together their words to tell a particular story about music. But my work in film has revealed other possibilities.

This is not a "how-to" book, though I will introduce cinematic strategies that have value for ethnomusicology, developed in filmmaking circles outside the discipline. I hope it may encourage someone to pick

up a camera and start thinking about music through the lens, through the edit, and through engaging people with film.

Films about Music

As I brought film to my scholarly practice, I looked for the filmography of my discipline. The lack of films surprised me, especially when reading through the methodological history of ethnomusicology. There is a discrepancy between the technological promise of film and the production rate of ethnomusicological films. In 1974 the filmmaker and anthropologist Jean Rouch speculated: "I must mention the importance that sync filming will have in the field of ethnomusicology" (2003: 42). Researchers do use video. But decades after Rouch's prediction, films are still not understood as *doing* cinematic theory. Video is mostly just a part of *method* (collecting and analyzing) and *presentation* (showing a clip at a conference or grabbing a still for print). Anthropologists have created the subdiscipline of visual anthropology, and ethnomusicologists have used film toward analytical ends. Only a few ethnomusicologists have produced films as part of their scholarly work. A good example of ethnomusicological film is Gerhard Kubik's 1962 film of music in Northern Mozambique. Kubik recorded Mangwilo xylophone musicians on silent film and then visually transcribed the timing of upswings and downswings frame by frame. Film helped Kubik's particular research problem, allowing him to correlate motor skills with acoustic patterns. Jean Rouch's *Batteries Dogon: Éléments pour une étude des rythmes* (1966) presents a series of Dogon musicians playing parts of a complex drumming pattern on rocks and logs, bringing them together at the end in a dance supported by polyrhythmic drumming. The film offers a rhythmic analysis of complex rhythmic patterns. Steve Feld's *A Por Por Funeral for Ashirifie* (2009) follows a Ghanaian Por Por funeral procession and then shows the musicians looking at a photographic book about New Orleans jazz funerals. The film reveals not only the similarity of styles but also the diasporic meaning of the pan-African practices for the Por Por musicians. Hugo Zemp (1979; 1986; 1990c) and John Baily (2007; 2011) have also produced ethnomusicological films, identifying questions about musical change, diaspora, and musical meaning.

But most films by ethnomusicologists rely heavily on textual arguments constructed by voice-over narration and interview testimony from

musicians. Tim Rice's *May It Fill Your Soul* (2011), Zoe Sherinian's *This Is a Music: Reclaiming an Untouchable Drum* (2011), and Lee Bidgood's *Banjo Romantika* (2015) offer expert description of musical traditions, accounting for change and reflexively including the filmmaker-ethnomusicologist in the films. All provide excellent visual and aural examples of musical traditions, taking advantage of film's ability to offer text, sound, and image. That said, they all operate mostly in the perspicuous mode, favoring clarity over experience. Sensations are often explained rather than felt. Despite some efforts, ethnomusicology's major use for film is the instructional film or video lecture—perhaps from the JVC *Anthology of World Music and Dance* collection, aimed at an undergraduate classroom.

As I built a filmography, I began to include films slightly outside the disciplinary circle. A few nonethnomusicologist filmmakers have produced important documents on disappearing traditions. Alan Lomax's *The Land Where the Blues Began* (1979) and the majority of Les Blank's and John Cohen's films use the camera to contextualize music. Using varying degrees of narration, these films present less argument than documentation, preserving dying musical practices and showing how music is part of the daily lives of (mostly rural) people. Films made by ethnomusicologists and those just outside the discipline offer examples of translating concerns and methods from text to film—presenting the voices of voiceless musicians, giving visibility and audibility to underrepresented musical practices, and brokering meaning across cultural distances.

Looking over the body of scholarly and folkloric films, I began to wonder why ethnomusicology has never taken on a cinematic way of *theorizing* about music. Cinematography and musical placement offer such rich ways of experiencing music. One answer might be in the early definition of what ethnomusicology was. In his seminal book *The Anthropology of Music*, Alan Merriam hoped to bring disciplinary focus to a study of music that rigorously accounted for culture. His precursors were an eclectic bunch—explorers, composers, folklorists, cultural anthropologists, and song hunters. As a call to order, Merriam proposed that ethnomusicology should be a discipline of "sciencing about music" (1964: 19–25). He clearly advocated for an empirical method (social science) of studying the humanities (performing arts). In so doing, he cut out the option of ethnomusicology using critical art in understanding music. Reconsidering Merriam's disciplinary approach, what might one

branch of the humanities (film) be able to reveal about another branch of the humanities (music)?

Two influential musical ethnographies contain pathways for answering this question. In his book on music in a Papua New Guinea rain forest, *Sound and Sentiment: Birds, Weeping, Poetics, and Song in Kaluli Expression*, Steven Feld concludes with two photos of Kaluli men in full ritual dress. The content of the photos is the same. A man is dressed in a costume of feathers used for a ceremony in which the man becomes a bird. The first photo freezes the man and his outfit, the medium depth of field blurring the forest behind him. The details of the outfit are easy to see—the symmetrical arrangement of feathers, the painted designs on his body, the drum he holds in his hands. The second photo is of the same outfit, yet it suffers from extreme motion blur, perhaps because the lack of light required a long exposure. The details are lost in the blur but the photograph captures the motion and, in fact, the figure resembles a bird as much as it does a man. Of this photograph, Feld states, "In a sense, then, the imaging code typically considered to be the least documentary and the most 'artistic' structures what is the most ethnographic of my photographs" (2012: 236). The image conveys the experience of the ceremony. Feld continues to suggest that images can bring analysis back to a meaningful whole—the multilayered and multimodal meaningful event that ethnomusicologists interrogate. Like the photograph, cinema can present a synthesis. But it can also provide analysis. For example, a close-up of an instrument encourages listening for that instrument. Including two people in a frame encourages a consideration of their relationship.

Feld's blurred man-bird image has another significant contribution for thinking of how film can engage music. He suggests that the image is an expression of "co-aesthetic witnessing" (2012: 233–38). Choosing the blurred shot renders the Kaluli ritual in photography. In other words, the photo does what the ritual does: it softens the distinction between man and bird. To varying degrees, the filmmakers that I engage in this book approach music through coaesthetics—using the image to represent the elements of music. Shirley Clarke attempts to make a film based on Ornette Coleman's musical theory of harmolodics. Chris Hegedus instinctively pairs circular camera motion with circular harmonic sequences in the music of Depeche Mode. Jem Cohen uses visual and narrative disruption to mirror the dub techniques that Fugazi uses. Co-

aesthetic witnessing has the potential to *show* musical elements from a cinematic perspective—an act that is *theoretical* (from the Greek *theōros*, meaning "spectator")[1] and *ethnographic* when anchored to the understandings of the people being filmed. A film can reveal aspects of music shown through musical and cinematic practices.

The second musical ethnography that helps frame how filmmaking might be used to study music is Tim Rice's *May It Fill Your Soul: Experiencing Bulgarian Music*. Rice came to Bulgarian music as an amateur dancer. As part of his phenomenological approach to understanding the music, he suggests that his understanding of the music expanded from the horizon of dancing. Rice suggests that dance is one of many "nodes of musical cognition and understanding," that the body offers a meaningful experience of music in the same way that playing an instrument or speaking with musical terminology engages musical understanding (1994: 98–103). In this sense, understanding can take many forms—from moving the body without regard to tempo (an expressive understanding of the fact that music is playing) to playing virtuosic melodic ornaments on a Bulgarian bagpipe (an expressive understanding of melodic details particular to Bulgarian music). Rice's contribution is that he describes these activities as types of nonverbal *understanding*. Extending Rice's theory to cinema, I argue that filmmakers engage cinema as a way of understanding music. The process of shooting and editing can be *expressive* nodes of understanding. Shown to an audience, a film can present an understanding of music and of musical issues. Bringing back Feld, my central claim here is that the filmmakers I present in this book develop and express coaesthetic understandings of music through shooting, editing, and constructing a narrative—they engage *filmmaking about music*.

I wrote this book to analyze cinematic techniques and offer perspectives brought through interviews with filmmakers who use their practice to understand music. In Merriam's terms, perhaps this is a work of sciencing about filmmaking about music. My goal, however, is not to establish a science about music films but to articulate how making films about musicians can contribute an ethnomusicological understanding about music. Interview, music analysis, and the stories of production build an investigation into how each film operates as a set of practices that understand music and its relation to social issues.

The filmmakers I interviewed for this book are not ethnomusicolo-

gists, so much so that they often felt unqualified to speak authoritatively about music. That, to me, is the great opportunity that these films offer. Films by people who are primarily filmmakers make more cinematic presentations of music—through narrative, montage, realism, symbolic representation, and temporality, for instance. While they may have felt unqualified to "speak" authoritatively, each is entirely qualified to create films about music. These films operate more in the experiential mode using techniques that differ from ethnomusicological texts. Their commonality, however, is in the acknowledgment that musical and social worlds are inseparable and that problems and questions should drive inquiry into music. Having chosen the types of films to address, I needed to sort out how to write about these films.

Existing Scholarship on Music Documentaries

Scholars have written about film in many different ways. Surveying this literature has given me a way of deciding how to write about the films I present in this book. Tactics include writing about the history of documentary film, writing ethnography of the film industry,[2] and outlining how film can achieve research goals. There are strengths and weaknesses in all of these approaches.

Books on the history of documentary film can offer ways of thinking about the development of the subgenre, fleshing out connections (Barnouw 1993; Ellis and McLane 2005; Nichols 1991). Decade by decade, goals change, technologies evolve, and films make an impact on practice. However critical these histories may be, they often lack the kind of in-depth analysis of any particular film. What's more, there is no critical work on the history of music documentaries. There are important works on how sound came to film and how sound recording technologies affect meaning and form, but none are specific to documentary (Lastra 2000; Beck and Grajeda 2008).

Of greatest interest to me as a filmmaker is the scholarship on how film can be employed as a research medium. Anthropology, ethnomusicology's sister discipline, has had a critical mass of scholars devoted to using film as a research tool. The edited volume *Film as Ethnography* by Peter Crawford and David Turton is an important source for situating film as a unique medium for ethnographic research and publication. In his article "The Modernist Sensibility in Recent Ethnographic Writing

and the Cinematic Metaphor of Montage" (1990), anthropologist George Marcus makes a case for film (and the related form of modernist ethnography) to be *better* suited for research topics that involve late twentieth-century social processes. Recent concerns of the social sciences include the relationship between the local and global, translocal interrelatedness, and the problem of describing homogenization and heterogeneity found in the world (1990: 5). Modernist approaches tend to be on the borders or in many places at once. Marcus argues:

> In the late twentieth century world, cultural events/processes anywhere cannot be comprehended as primarily localized phenomena, or are only superficially so. In the full mapping of a cultural identity, its production, and variant representations, one must come to terms with multiple agencies in varying locales the connections among which are sometimes apparent, sometimes not, and a matter for ethnographic discovery and argument. In short, culture is increasingly deterritorialized, and is the product of parallel diverse and simultaneous worlds operating consciously and blindly with regard to each other. . . . The ethnographic grasp of many cultural phenomena and processes can no longer be contained by the conventions that fix place as the most distinctive dimension of culture. . . . I see the attempt to achieve the effect of simultaneity as a revision of the spatial-temporal plane on which ethnography has worked. (1990: 11–12)

Disciplinary questions lead to disciplinary methods. The anthropologist David MacDougall argues that film can provide an ethnographic alternative to writing—questions, field notes, ethnographic writing (1998: 61). He argues "that ethnographic films are a distinctive way of knowing, which favors an experiential, affective, embodied understanding of individuals, whereas text is more effective at explanation and generalizing about culture." He suggests that theory can be created "through the very grain of the filmmaking" (1998: 76). Well situated in anthropology as a discipline, filmmaking has yet to be understood as a way of conducting theory in ethnomusicology, though there have been a number of attempts to bring film into the disciplinary fold—moving from *filming* to *filmmaking*.

By and large, ethnomusicologists use video cameras to "remember" their own observation, using video as a mnemonic prosthesis in service

of the observer who once participated. Some film-savvy ethnomusicologists suggest that it isn't enough to simply record and urge critical application of film (Simon 1989; Baily 1989; Feld 1976; Zemp 1988, 1990a). The ethnomusicologist Artur Simon suggests that film can be a starting point for ethnographic interpretation (1989: 48). John Baily champions film as a mode of inquiry and editing as data-analysis and discovery (1989: 3). Steve Feld and Carroll Williams, a visual anthropologist, argue that *"film is neither a research method nor a technique—but an epistemology*; it is a design for how to think about and hence create the working conditions for exploring the particular problem involved" (1975: 28, emphasis original). Feld and Williams urge researcher-filmmakers to develop deliberate new languages of film that address specific research questions.

One debate over the use of film for ethnomusicologists centers on a supposed scientific information/entertainment binary. German ethnomusicologist A. M. Dauer criticizes what he considers films about music that have been watered down in favor of aesthetic aims: "Our main purpose . . . is to produce informational content, not beautiful pictures" (1969: 227). Hugo Zemp offers a counterargument: "The problem is . . . to avoid the justified reputation of boredom which many didactic films have, to make them interesting and, why not, entertaining" (1990b: 68). Filmmaker-anthropologist Jean Rouch suggests that most films in either camp fail: "Most of the time, then, what results is a hybrid product satisfying neither scientific rigors nor film aesthetics. Of course, some masterpieces or original works escape from this inevitable trap" (1995: 86). Understanding aesthetics and information to be incompatible undervalues the purpose of aesthetic attention in filmmaking. The filmmaker creates a filmic world that the filmgoer experiences. An effective film is not as much pretty as it is engaging.

As of this writing, the most recent call for ethnomusicological filmmaking is Barley Norton's inquiry into ethnomusicology's print-focused theorizing. He argues that the scientific/pretty pictures binary is a false one. In his words: "There is no reason why we should feel constrained to narrative filmmaking that professional filmmakers often do better than academics or to a rigid style of observational cinema" (2015). Tying research questions to medium, he suggests that film "is not well suited to the development of theories that involve generalizations based on thorough intertextual cross-referencing. Rather than forcing films to be-

come more like written theory, an alternative might be to consider new ways of working that engage with the sensorial, haptic, affective, performative and experiential potential of film" (2015).

While I sympathize with these disciplinary concerns, I find it more useful to cast a wider net to consider documentary films unrestricted by disciplinary boundaries. The works most useful for my inquiry are scholarly analyses of single films, ones that employ a variety of scholarship to unpack the ways in which a single music documentary constructs cinematic arguments.

Methodology: Writing about Filmmaking about Music

Ethnomusicologists spend most of their efforts on writing about music. I am complicating things a bit by writing *about filmmaking* about music. These interrelated layers of practice are at the core of my interest and are important to distinguish. If we don't understand how cinema differs from music, then our inquiry collapses back to two modes of analysis: writing about film or about music. One perspective is to look at writing, filmmaking, and musicking as three interrelated expressive forms. Moving from one mode to another involves an act of translation. There are limits and advantages to translation.

The musicologist Charles Seeger suggests that there are differences in literary and musical modalities and that, when addressing music, writing can fall short of expressing what music might be expressing. Seeger warns music scholars of the tendency for "linguo-centrism"—a dominant reliance on language—when studying music (1961). Understood as two different systems of communication, music and speech have an inherent distance between them. That distance, according to Seeger, must be acknowledged when studying music through language. Seeger's point should not be confused with the saying that *writing about music is like dancing about architecture*; rather, his advice is to *mind the gap*.

The distance between expressive modes might be productive. Considering the act of translation, Walter Benjamin suggests that the goal of translation lays bare the important gap between two languages. He argues that "real translation is transparent, it does not cover the original, does not block its light, but allows the pure language, as though reinforced by its own medium, to shine upon the original all the more fully" (2007: 79). In Benjamin's mystical view, language is imperfect.

But through translation we might witness "pure language." Benjamin's task of the translator is to overcome the boundedness of language by becoming aware of gaps of meaning between two different languages. Similarly, Gayatri Spivak suggests that the "task of the translator is to facilitate this love between the original and its shadow, a love that permits fraying" (1993: 181). For both Spivak and Benjamin, the task of the translator is discovery of new things that language cannot yet express. Translation can do more than bridge a gap; it can expose meaningful gaps—losses in translation. Spivak's and Benjamin's understandings of language translation are instructive when considering how each practice—writing, filmmaking, and musicmaking—relates to another in different ways.

Considering film and print, anthropologist Peter Ian Crawford distinguishes authorial goals: "Whereas film predominantly, or at least ideally, exhibits *sensuous* capacities, the written text, especially that of academia, is characterized by its *intelligibility*. Referring to hermeneutics, one would say that film tends to communicate an *understanding*, whereas the written text procures some sort of *explanation*" (1992: 70). Crawford's distinction harkens back to the notion of experiential filmic worlds that began with pioneer documentarian Dziga Vertov's manifesto, "My path leads to the creation of a fresh perception of the world" (Vertov in Barbash and Taylor 1997: 120). Understanding film involves a sensuous yet critical perspective that is not limited by intelligible explanation. Crawford understands these as distinct modes: "the perspicuous mode and the experiential mode respectively, indicating that the former tends to emphasize clarity whereas the latter conveys to the audience an understanding open to interpretation" (1992: 75).

Films that operate more in the experiential mode take advantage of the experience of both image and sound. In contrast, the perspicuous mode often attenuates the effect of provocative images. As Nathaniel Dorsky argues, "the syntax of the television-style documentary film, like that of the evening news, often turns the visual vitality of the world into mere wallpaper in support of spoken information" (2005: 29). Essay films map onto writing modes more clearly. The gaps between film and print become wider when writing about observational, experimental, realist, and reflexive films.

Given these differences between writing and cinema, I've chosen to write about the music alongside analysis of the films. Setting my writ-

ing about ethnomusicological issues—experiences of music, music and gender, entanglements with music and capital, music as a form of labor, and commodification of music, to name a few in this book—reveals how ethnomusicological writing might differ from ethnomusicological cinema. These two modes of understanding music complement each other. Reading a chapter and watching the film should reveal modal gaps and bridges across a terrain of provocative issues in music.

As for the relationship between cinema and music, I use two methods: analysis and interview. To put it simply, I examined the elements of film and music and I spoke to the filmmakers about their process of understanding music through making their films. A challenge in this approach is that the film shifts between the status of being primary (the thing to be studied) and secondary (the thing that studies). In other words, we can examine the films themselves as collections of data (for example, shots, cuts, sounds, text) or examine the films as offering an argument about its data (music and musical practice). Doing both allows for questioning the unique arguments about music that can be approached through film and answering by describing cinematic techniques in granular detail.

One caveat: The filmmakers interviewed should not be understood as the authorities on the meaning of their films, but they can be important informants on the filmmaking process—on the planning, shooting, and editing of the film. What the films accomplish isn't always what the directors aim to accomplish. The directors make films. The films make arguments. In film studies, the turn from auteur theory has generally left the voice of the director out of scholarship—his or her worldview or creative vision was no longer considered to be the primary factor of film. The directors' voices have moved to the trade press in the form of behind-the-scenes peeks into making films or words of wisdom about filmmaking. In a similar vein, all of the filmmakers featured in this book value the openness of their works. When speaking about *Dont Look Back*, Pennebaker has said that his film "belongs as much to anybody watching it as it does to me, and that's its strength I think" (in Kubernik 2006: 14). While these films vary in their degree of openness, they are nonetheless meticulously constructed using what William Rothman terms "revelatory" versus "assertive" modes of argument (1997: 156) or what Bill Nichols calls "perspective" versus "commentary" forms of argument (1991: 118–25). Analysis of these films as ethnomusicological arguments presents my view,

one rigorous reading of the film. This shared sentiment among all those I interviewed for the book helps qualify my interviews. My own exegesis on the films themselves can productively coexist with the testimony of the filmmakers about their process.

I hoped to learn from the filmmakers about their process of understanding music. To do so, I conducted interviews with the directors and, in some cases, the musicians. (See Appendix B, "Cited Interviews and Archival Research.") The existing interviews with these directors—some of which I draw from—don't offer many perspectives on music. Often, they focus on the band and notable stories about making the film or offer a general perspective on filmmaking. In ethnomusicology, the interview is a central research tool. For me, the interviews were an opportunity to discuss the directors' films and how they came to understand the nature and role of music while planning, shooting, and editing their films. My interviews with the directors helped me learn more about their questions, their methods, and their developing understanding of their subjects.

Much of the practice of filmmaking rests on habits and developed reflexes. I could not simply ask about reasons for each shot and each cut. Jem Cohen likened shooting music to going into a trance. When I asked D. A. Pennebaker about certain shooting strategies, he responded, "There are no rules about that. You do what's seems right. You're just like [the musicians]. You're just playing music." So, just like ethnomusicology, much of my job was trying to understand ingrained practices of shooting and editing. Documentary film, more so than narrative film, is a messy practice. While filmmakers do plan, they also have to be responsive to changing situations. The material in the editing room is disorganized and editing becomes a way of thinking through the material. Similar to Pennebaker, Jill Godmilow stressed to me the pragmatic responsiveness that editing requires:

> The secret of editing is that when you see it, you go, "Yeah, keep that!" That's, in some way, the whole process, if it's not scripted. There are documentaries that are made from scripts, and network television, stuff like that. But you *find the film* by throwing it all up in the air and seeing how it falls down. You go, "Oh, something happens there," and "Let's keep that," and you solve other problems around it. It's a lot of problem solving, but a lot of it, I think, has to do with recognition

when you're editing, of "That's where that should be," and "That's how long it should be."

Editing is an important place to investigate the theorizing of film, since it is in the editing room that many documentary filmmakers find their film—where they find their arguments about their subjects. This process should be familiar to ethnomusicologists' own work—production is like fieldwork, and postproduction is like analysis.

Overview: The Films and the Chapters

The book is split up into five chapters. Each of the chapters focuses on one particular film, going in depth and providing some of the backstories for each. These five films are my examples of cinema that can be usefully interpreted as ethnomusicological documents, ones that parallel the concerns found in ethnomusicology but demonstrate their understanding cinematically. Each chapter extrapolates the implicit arguments of the film into the explicit theories of ethnomusicology. In a sense, the chapters are an act of translation from cinema to print. But I leave the method of translation transparent, explaining how the elements of cinema (for instance, shots, cuts, sound, sequence structure, lighting, and narrative) can produce an understanding of music and its relation to social issues. While the arguments in each chapter are independent from one another, they reveal a range of ways that cinema can understand music. Surveys of cinema often cite too many films to be useful to those not steeped in film history. Long lists of important films remain unwatched, while a general argument about film history or method stands. Deep focus on a small number of films accomplishes a couple of things. First, it allows room to discuss the usefulness of specific cinematic techniques, tying the technical aspects to the rhetorical value. Each film develops its own grammar of cinema that produces experiences among audiences. Second, focusing on a single film provides a sustained conversation with the directors—and in some cases, with the musicians—about the particularities of the film.

The five films I have selected share certain qualities. They are all directed by independent filmmakers. Many of these films aim to disturb conventions, aware of how media and ideologies are linked. They all share certain features of modernism: sustaining multiple viewpoints,

ambiguity, dense allusions, fragmentation, and juxtaposition. The films all address the inescapable limitations of our view, revealing a complexity of events instead of reducing them. They emphasize the process of perception and knowing. In this way, these films differ from most scholarly texts. They eschew sequential, developmental, cause-and-effect presentations of reality.

In addition, these films all involve what William Rothman calls "co-conspiracy," aligned goals and arguments between filmmaker and musician subjects. The relationships between the filmed and the filmmaker contribute to a variety of interesting alignments between cinema and music, transpositions of musical phenomena to film. These films, to varying degrees, borrow musical strategies, rhetoric, and political critiques as well as extend musical practices into an audiovisual document of collaboration and inquiry.

Thus, there are three interwoven modes of writing that run through each chapter: the interviews with the directors as testimony of their processes of understanding through filmmaking, the description of the film as a way of focusing on important cinematic strategies, and my analysis of the films as ethnomusicological documents. Shifting between these three modes of inquiry into the films offers a variety of perspectives on these five exemplary films about music's relationship to social and cultural phenomena.

Chapter 1 examines the film *Gimme Shelter* (1970) by Albert and David Maysles. The film documents the Rolling Stones on tour, culminating in the infamous Altamont Speedway Free Festival in which eighteen-year-old Meredith Hunter was stabbed to death on film.

The Maysles brothers are some of the most renowned figures in American documentary cinema and early pioneers of direct cinema, a method of filmmaking with the goal of liberating truth from the manipulative conventions of cinema and journalism. Rather than asserting a narrative to explain a situation, practitioners of direct cinema let the crisis itself direct the cameras and structure the film.[3]

Much has been written on this film, in part because of the centrality of Albert Maysles in American documentary cinema, in part because of the popularity of the Rolling Stones, and in part because of the documentation of the stabbing. Many view the film as representing the death of 1960s counterculture.

I am primarily interested in the ways in which the sound of the film contributes to meaning and the perspectives the film offers on music. I argue that the film reveals music as being many different things—a commodity, a means of congregation, and autonomous art. The film does not explain these different manifestations. Rather, it puts its listening and viewing audience in different relationships to sound.[4]

Chapter 2 situates Jill Godmilow's *Antonia: Portrait of the Woman* (1974) within second-wave feminist filmmaking. Along with her contemporaries, Godmilow questioned the truth claims of direct cinema. Godmilow doesn't hover with a camera until someone speaks. Instead, she draws a story out of pioneer female symphony conductor Antonia Brico. The interview has become such a stock technique of contemporary documentary. But for Godmilow, it was a radical way of presenting untold stories—ones that were so often buried under the noise of patriarchy. The film is structured around an interview with Brico that does more than create a textual narrative. The film offers feelings of Brico's relationship to her story and—in moments—forces audiences to consider their relationship to Brico's story. I bring together Laura Mulvey's influential identification of the "male gaze" and Tim Rice's theory of musical meaning to suggest that music and image can create certain *musical vicarities*, subject positions that emerge from our relationships to how music is meaningful in different situations.

Godmilow's film also provides a powerful feminist critique of the orchestra. The film certainly resonated beyond female conductors. The orchestra represented a complex structure of patriarchy, especially for women who were beginning to articulate ways in which women face challenges entering the workplace. But as a film about gender and orchestras, *Antonia* is a carefully constructed analysis of the social nature of orchestral performance.[5]

Chapter 3 picks up on postrealism as introduced at the end of chapter 2 by examining Shirley Clarke's *Ornette: Made in America* (1985). Clarke uses techniques that reveal meaning-making conventions of documentary that productively obscure a biographical narrative of Ornette Coleman, a jazz musician associated with free jazz. The film centers on the performance of Coleman's orchestral work *Skies of America* during the opening of Caravan of Dreams, an avant-garde arts center in Fort Worth, Texas. Clarke passed away in 1997, so I draw primarily from her archive at

the Wisconsin Center for Film and Theater Research to present the backstory of her work-for-hire. The multiple agendas of producers and filmmaker provide a way of looking at the film as a site of struggle over the symbolic meaning of a musician in a neoliberal age. The film manages to reveal the ways in which Coleman is constructed as a representative of success in a free market economy, while also showing the racial inequity across Fort Worth's neighborhoods. The critical arguments of the film are oblique, but reading the film within the context of its production provides an example of how reflexive film techniques can dismantle representation. *Ornette* is born from the logics of capital, though, in the end, it undermines those logics.

Clarke was one of a few American filmmakers inspired by the European city symphony genre of the 1920s—Walter Ruttmann's *Berlin: Symphony of a City* (1927) being a classic of the genre. The city symphony melds artistic form and social commentary. These films aimed to create "realistic tributes to urban excitement" (Barsam 1992: 290). Francis Thompson's *N.Y., N.Y.* (1957) used jazz to score the city's rhythm but instead created kaleidoscopic images from the city itself. Shirley Clarke's alternative vision is that of a cross artistic perspective, blending visual arts with music, while staying attuned to urban social issues. Clarke was part of a prolific independent group of filmmakers in Greenwich Village along with Maya Deren, Stan Brakhage, and Jonas Mekas. Clarke's *Skyscraper* (1959) was one of the last of the poetic documentary films made as attention to documentary went to direct cinema in the 1960s (Lev 2006: 273).

In *Ornette: Made in America*, Clarke takes the opportunity to cinematically render Coleman's musical theory of harmolodics. The interrelatedness of art forms is a particularly modernist notion that Clarke and Coleman share. Looking at the film as a *cineharmolodic* work offers a new way of understanding Coleman's inscrutable philosophy and provides a model of a film that *demonstrates* musical processes in place of *explaining* them.

Chapter 4 continues the focus on cinematic extension of musical concepts through an investigation of D. A. Pennebaker and Chris Hegedus's *Depeche Mode: 101* (1988). Pennebaker—who, like Albert Maysles, was a pioneer of direct cinema—is well known for his films on Bob Dylan,

Jimi Hendrix, David Bowie, and other "classic rock" acts. *Depeche Mode: 101* strays from the genre with an account of the 1980s British electro-pop band's massive US tour. In addition to the band, Pennebaker and Hegedus include a busload of young fans who follow Depeche Mode from New York to California. I argue that the film dramatizes various types of estrangement in post-Fordist America. Pennebaker and Hegedus have often spoken about creating documentary films that draw from theater. That strategy, brought to the massive stage design of Depeche Mode concerts, makes the film very close to Richard Wagner's *Gesamtkunstwerk*—a union of the arts. The film draws on dramatic narrative, music, dance, poetry (lyrics), and light design in a way that rejects the rockist stance of preceding "classic" rock bands.

While neither Hegedus nor Pennebaker is a musicologist, they make decisions about shooting and editing performance in ways that make sense of the music. The chapter goes into the details of Hegedus's visual analysis, drawing attention to visual alignments with musical elements—for example, tonal space, rhythmic structures, and arrangement—as well as nonmusical elements of the *Gesamtkunstwerk*. I conclude the chapter by looking at how the final concert in the film presents a festival of the commodity in which people use art to find meaningful space within capitalism.

Chapter 5 shows another side of popular music's relation to post-Fordism in its examination of *Instrument* (1999), a collaborative film about the post-hardcore band Fugazi. The Washington, DC, band is perhaps antithetical to Depeche Mode in its relationship to mass culture. And yet, the two films share certain features—both place emphasis on showing the labor of the bands and subvert the image of the charismatic rock star. *Instrument*, however, takes a distinct strategy. The band notoriously opted out of promotionalism, which makes this film particularly interesting, since most music documentaries are promotional in nature. Director Jem Cohen filmed the group for ten years and collaborated with the band while editing. In the chapter, I examine two consequences of the collaboration: the strategies taken to avoid promotional rockumentary style and the cinematic rendering of Fugazi's musical ideas. Like Shirley Clarke's *Ornette*, *Instrument* transposes music to cinema. A bulk of the chapter identifies these musical and cinematic techniques, many of which come

from dub reggae and involve fragmentation, temporal play, and surprise. The effect of the techniques as rendered cinematically offers what I call a wide *chronoscape*—a range of perspectives on temporality.

In addition, *Instrument* obliquely offers a way of thinking about rock audiences that contrasts with Pennebaker and Hegedus's construction of "festival." The diversity of audience members never congeals through fandom. Rather, they remain a crowd. I investigate this representation of audience as a parallel to Paolo Virno's notion of the post-Fordist "multitude," the many who understand themselves to be many. The representation of the crowd and the independent operations of Fugazi offer a way of envisioning a world in flux and consider how music and cinema produce related ways of thinking and feeling.

Each of these five films can be read in different ways. I take the opportunity to show how these can be read as ethnomusicological documents—films about music's relationship to social issues. I also offer ways of analyzing the films as critical cinema. What emerges are many ways of thinking about how film can contribute to ethnomusicological arguments through shots, cuts, composition, musical placement, sound, dramatic narrative, interviews, and other elements. My hope is that my analysis of these films can model analysis of other films. I also hope that this work demonstrates that questions about music can be explored in ways other than text and that there is something unique to cinematic investigations of music. I don't think that cinema could ever replace print media, but I believe that it is a resource for those who are interested in the study of music.

Films about music necessarily encourage listening. Sound plays a great role in music documentaries. And yet, sound has been underrepresented in film studies. Bringing an ethnomusicologist's perspective, I am keenly interested in music's relationship to the rest of the film, how music's meaning is tied to the image and the people represented, and the significance of aural experiences. In many cases, I solve analytical problems by suggesting terminology specific to a sound-heavy film analysis.

Finally, a note to those who hope to make ethnomusicological films: Let's not limit film to what we know how to do in print. Too often, scholarly films resemble read conference papers. They may contain carefully crafted arguments with rich audiovisual examples, but cinema can do

more. These five films are but a few examples of how an ethnomusicologist might take advantage of the medium. My analysis can reveal strategies of creating cinematic arguments.

The three driving questions of the book are as follows.

What does a critical cinema of music look like? To answer this question, I chose films that are examples of how cinema can pry open issues that lie within the entanglement of music and social practice. These films each examine issues in their own way. Taken together, they can point toward cinematic methods of addressing ethnomusicological theory—the nature of music, how musical practice is gendered, media representation of musicians, the commodification of music, and relationships of music to temporality.

What are some of the constraints? No film is the sole work of any director. Rather, they are products of relationships that are guided, protected, and championed by directors who attach their names to them. Independent cinema has operated on the outskirts of the industry. Filmmaking is still expensive, and considering the funding of each film reveals some of the other interests of producers. Relationships between filmmakers and the musicians also present challenges of access.

What are some of the useful cinematic techniques? Analysis and interviews revealed a great number of theoretical strategies that may be useful when examining other films or when producing new music documentaries. I describe a great many of these techniques in order to claim a distinctly cinematic possibility of doing ciné-ethnomusicology. Some techniques are part of the recognized vocabulary of cinematography and a glossary in the back may help when I use technical terms. I propose new terminology for unrecognized techniques and hope that this contributes to cinema studies and to ethnomusicology.

Further Reading

Three additional essays stand out as good models for considering the rhetorical constructions of music documentaries. Film scholar William Rothman's analysis of D. A. Pennebaker's *Dont Look Back* makes a strong case for considering film as theory (1997). Rothman introduces the notion that Pennebaker and his subject, Bob Dylan, co-conspire in

making a claim that truth resides in plain pictures—an argument similar to Susan Sontag's disavowal of any definitive interpretations of an artwork (1966). To support his claim, Rothman considers framing, camera angles, dialogue, cuts, music, and other elements of cinema. Cultural studies scholar Deidre Pribram (1993) writes about Alek Keshishian's *Madonna: Truth or Dare* as a postmodern feminist text. Considering the juxtaposition of space, film grain, and documentary style, the essay makes a thorough consideration of how the film constructs and collapses distinctions in order to refute the promise of the pop star's authentic self. Pribram squares Baudrillard's theories of sexuality with the ways in which the film structures Madonna's appearances. Matt Stahl's chapter (2013) on Ondi Timoner's *Dig*! reveals ways in which the cinematic narrative of musicians can valorize neoliberal ideals. Stahl shows how the film naturalizes The Dandy Warhols's successful alignment with capital, while pathologizing Anton Newcombe of The Brian Jonestown Massacre. The result is a symbolic tale of neoliberal subjectivity. Stahl's writing adds information about the production of the film that helps frame the privileges that the filmmaker and The Dandy Warhols had, contrasting it with the kind of social support that Newcombe lacked. Chronicling the production history adds to his argument that the film is polemic, though the cinematic style appears to simply document "truth" and let audiences make up their minds.

All three of these works would be good companions to this book.

Watching the Films

Watch the films. Many texts on film theory tend to reference many films in one chapter. But watching dozens of films is a lot to ask. I've structured the book so that you can watch five films and think deeply about each one. Repeated viewing is important. Watch them a few times. The first viewing is an orientation. The second allows you to think about how it manipulates you. In the third viewing, you may anticipate cuts and motion. On the fourth, you may notice a general editing strategy. Watch sections of them while reading the book. To echo an earlier sentiment in this introduction: there is an intriguing gap between film and print. In the case of this book, the gap appears only when you have both the film and this book in your mind.

A Note on Writing Style

The book draws heavily on interviews I conducted with the filmmakers. Those voices form a layer of present-tense dialogue that runs through each chapter (except the one on Shirley Clarke). Quotes from those interviews have no in-text citations. You may refer to the back of the book for information on where and when those interviews took place. I add ellipses (. . .) to elisions in the interview. The equivalent of a cut in film, the ellipsis shows that I'm stitching together segments of conversations. A second level of citation comes from preexisting interviews and a third from scholarly references.

The analysis of music and film occasionally necessitates (what I think to be useful) jargon. When discussion of film gets into technical terms from film, it is likely that the term is in the glossary.

1 WHERE IS THE MUSIC? WHAT IS THE MUSIC?
Albert Maysles, *Gimme Shelter*
(1970)

Before I began any formal interviews with Albert Maysles for this book, he visited my university to speak about his films. Despite feeling eager for lunch, I waited as students spoke with him after his lecture. One asked Maysles if they could have their picture taken together. As a friend held up the student's camera phone, Maysles smiled and playfully directed the shot. "Closer! Come closer." He told the photographer how important it is to get the faces. I recounted this story to him a few years later in his living room. Maysles responded, "Robert Capa was asked to give advice to a photographer, and he said, 'Get close. Get close.'"

But there is a more personal reason behind Maysles's interest in faces. It begins with his father. His father had a trumpet that he didn't play, tucked away in the closet. His mother said his father used to play music with his brothers but stopped after one of them died.

"Even though my father couldn't perform, he did put on music—classical music of one sort or another. That's how I learned my love for music. Because as the music was playing, I was looking at my father for a change of expression." Maysles says he absorbed the love of music his father felt, in part by paying close attention to his face.

Throughout Albert Maysles's music films, there are powerful shots of people listening: The Beatles amused at hearing "I

Saw Her Standing There" from a transistor radio, Vladimir Horowitz and his conductor carefully listening to a recording of their performances of Mozart's Concerto No. 23, and two enraptured audience members behind Seiji Ozawa as he conducts Mahler's Resurrection Symphony. Maysles's cinematography brought a new intimacy to documentary film in the 1960s.

This focus on faces is only one small aspect of a larger filmmaking philosophy. Albert and his brother, David, were some of the most notable documentarians of their time, pioneers of what is known as *direct cinema*. So, in 1969 when the Rolling Stones hired Albert and David Maysles, they said they wanted to have "the best" filmmakers document their tour. But "the best" came with a modernist philosophy of cinema, one engaged in an investigation of truth, plural experience, and epistemology that extends back to the early twentieth century. Over my three interviews with Albert Maysles about *Gimme Shelter*, I came to understand how his childhood experiences of watching people listen merged with the musical interests of codirector and editor Charlotte Zwerin. Many commentators on the film focus on the murder of an audience member, Meredith Hunter. I began to question the preoccupation with blame. The difficulty of assigning responsibility for the violence was, in fact, due to a constructed edit that sustains several perspectives on what music is—experienced through the many faces portrayed in the film.

Gimme Shelter is a type of cinema that offers an experience of complexity to the media-entertainment apparatus. The Rolling Stones 1969 US tour culminated in a public outcry over the death at Altamont. News headlines and public discussion followed the event and the later screening of the film. People wondered: Were the Rolling Stones to blame for the violence? Was the idealism of the "Summer of Love" over? Were rock fans turning into angry mobs? Was the music itself dangerous?

If we are to answer any of these pointed questions, I argue, the answer itself might reduce the inherent complexity of the historical event, the social role of music, and the relationships among people. *Gimme Shelter* sustains the complexity. It offers an unpredictable perspective that shifts across the entire apparatus of the tour—onstage, backstage, a planning room, a press conference, a recording studio, hotel rooms, and within the sprawl of an outdoor festival. As the focus shifts, we are pushed to think about the relationships among these places. We are encouraged to con-

template truth and spectacle. We are invited into the struggle over the nature of the medium of film and the nature of music. By the end of the film, we can see music itself to be as complex as the entertainment apparatus. Music is revealed to be an expression; a material commodity bound to mass spectacle; a conventional cinematic device; a formal arrangement of rhythm, harmony, and melody; and an environmental sound within an ecology of sounds. There is no single read of the film, no message to be deciphered. The film is slippery and open to multiple meanings. I primarily approach this film as a music scholar, asking questions about how music relates to a historical moment and to a tradition of critical thought.

Like his film, Albert Maysles often responds elliptically to questions. The more I spoke with him and read his other interviews, the more I found his opacity to be less an evasive tactic than an invitation for thought. Refusing to be definitive, he graciously opened conversations with others and reengaged with his work. Albert Maysles did not simply create pretty pictures of the Rolling Stones. He engaged them with an approach that was rooted in his staunch philosophy of American documentary filmmaking—one that eschewed the manipulation of Hollywood continuity editing. Much has been written about the gap between the truth claims of direct cinema dogma and manipulation inherent in any film (Bordwell and Thompson 1997: 409–15; Hall 1991; Winston 1993: 44–45; Stahl 2013: 67–74). In Maysles's films, continuity editing mixes with direct cinema features, for instance, the lack of a voice-of-God narrator, the shaky camera, and the rough editing. I'm less interested in whether or not the Maysleses were radical or imitative of Hollywood narrative practices. In this chapter, I'd like to investigate how the Maysleses and editor Charlotte Zwerin used a diverse set of cinematic techniques to make a rhetorical claim about music—that music can be a commodity, a social glue, and an artwork at the same time.

Reconfiguring Documentary Makes Room for Music

Before he picked up a camera, Albert Maysles was on an academic path. He had earned a master's degree in psychology from Boston University and, as a graduate student, taught introductory courses there for three years. He began to veer from this path in 1955, speeding through the Russian countryside on a motorcycle with a Keystone 16mm wind-up

camera and a few hundred feet of film. The Cold War was in full swing. Maysles wanted to meet the faceless people who were our supposed enemies.

A few months earlier in New York, *Life Magazine* had denied him a photo assignment on Russian psychiatry. On his way back to Boston, he had chanced a visit to the CBS offices. In a stroke of luck, the head of the news department agreed to loan him equipment. As Maysles explains in an interview elsewhere, he had experience with still photography but had never shot film.

"The guy said, 'I understand that you're going back to Boston, then coming back through on your way to Helsinki and then Russia. So when you stop off in New York on your way out, shoot a little bit on this roll of film, we'll process it and take a look at it and give you a critique.' That was my total filmic training" (in Dixon 2007: 59).

The result of Maysles's trip to the Soviet Union was the fourteen-minute film *Psychiatry in Russia* (1955) that examined mental health care in three Soviet cities. It was televised by *The Dave Garroway Show* on NBC TV and WGBH public television in 1956. The film revealed non-Freudian psychiatric practices. That *was* interesting—for a psychologist during the Cold War. But Maysles also demonstrated another important concept in his first film: Russians are people. The report of differences of psychiatric treatment is accompanied by images of Russians smiling, interacting with each other, staring into the camera, and lovingly treating the mentally ill. Yet his inability to record sound limited the degree to which he could portray people. In our interview Maysles acknowledges this limitation:

"I knew that sound was important. But because I didn't have any, I just sort of put that yearning aside and did whatever I could to familiarize ourselves with Russian people. So that does come across whether it's a still photograph or a silent movie but not as strong as it might if it was made with talking and music."

What Maysles had brought back from Russia for his first film were moving images that he could edit together with added narration, but he also came home a filmmaker. He reminisces about joining the Drew Associates—a collection of filmmakers who would rethink the goals of documentary film: "Things turned around in 1956, where I met up with Bob Drew, [D. A.] Pennebaker, and [Richard] Leacock. It was introduced

to us a new form of documentary filming where you film what was actually happening. . . . It was such an important advance. It also achieved a much greater sense of opportunity for people to connect with one another, people of different cultures."

One of the goals was to let the cameras retreat out of the attention of the people being filmed.

As Maysles puts it, "Spontaneity. Not controlling what's going on. Observing. Letting things happen with the shot. And patience so that when it *does* come along you're right there to get it in all its fullness."

Many of these early direct cinema films had little music. Hollywood films used music to manipulate. Direct cinema was to be a method free from manipulation, a space in which audiences could make up their own minds.

As much as direct cinema filmmakers distinguished themselves in opposition to classical Hollywood cinema for being manipulative, they also drew from narrative cinema. Their films were dramatic; they used music (albeit diegetic) to score mood; they presented close-ups of faces and found objects to offer psychological focus and symbolic representation. While direct cinema offers great latitude for interpretation, elements of the films still work to narrow meaning. For this chapter, I'll propose that both direct cinema and classical Hollywood cinema are ideal practices. The films themselves—for our purposes, *Gimme Shelter*—employ elements of both practices. Consider direct cinema to be a well from which filmmakers draw rather than a corpus of works or a stylistic circumscription of a film.

Gimme Shelter illustrates how a film in the wake of idealized direct cinema drew from narrative techniques and, in so doing, opened up space for music to have a larger role in creating meaning. The space in-between is a space in which music can shift from one role to another, from scoring, to symbolizing, to being an aesthetic experience of sound in motion.

The Independent Brothers

Maysles left Drew Associates in 1962 to form Maysles Films with his brother David, who had been working in Hollywood as an assistant producer (Vogels 2005: 5). Albert shot images and David recorded sound until David's death in 1987. As a pair, they extended the concept of "being

there" to filming the lives of ordinary people, unusual people, artists, musicians, and celebrities. By and large, most attention to their filmmaking is centered on the image. But gathering sound was just as thoughtful. That was where David came in.

During our interview, Maysles recounts, "Well, he was interested in music—jazz and so forth."

Interest alone didn't make David a great sound recordist. He developed a method of recording sound that augmented the goal of being there.

Maysles continues, "Sound for *me* was just a good sound. Can you understand it? And I could tell if the sound of the music was appropriate, if it was as good as it could be. Apparently my brother *really* knew what he was doing. And we had good equipment."

They modified their audio equipment to extend recording time, synced the camera without a wire, and were able to get close with minimal technological presence.

"We changed the size of the reels. Because there was enough space to make the reels double the size, adding just a couple inches to the reels but giving double the amount of sound."

David used a handheld Sennheiser 804 shotgun condenser microphone, which picked up what was directly in front with great detail while attenuating sound from the sides. The result is an intimacy with the subject, the sense that we are just listening to them. It also makes us unable to hear other things. What we can't hear is just as important as what we do hear.

"It was more direct," Maysles says, "If you held it properly, you got the closest you could to the source of sound. So you know, even to this day right now, most soundmen have a good microphone that's maybe not as close to my brother's, but that it's hanging overhead which I think is always a distraction to everybody."

Minimizing the equipment and isolating sound in the environment allowed the Maysleses to connect with the people they filmed. They could both get close and develop close relationships.

"It's like being just another person there. . . . We both had this feeling of empathy and people would trust us," Maysles says.

Their films were not just windows into other people's lives. They made critical investigations into their worlds. In general, the Maysleses' films

thwart definitive reads of the people on-screen, using details to call attention to the uniqueness of the images presented. Characteristics are not symbols to be read but rather proof of uniqueness, proof that our world is a complex and plural experience. Their films pull us into different ways of watching cinema—especially how we view people in cinema. *Psychiatry in Russia* (1955) used the camera to tell us about Freudian alternatives. I claim that his subsequent work with the Drew Associates offered *experiences* of alternative mindsets.

The Rolling Stones were part of the so-called British Invasion. In 1964 they trailed the Beatles across the Atlantic to reinvigorate popular music in the United States. Mick Jagger has said of the 1960s, "Suddenly popular music became bigger than it had ever been before. It became an important, perhaps the most important, art form of the period, after not at all being regarded as an art form before" (The Rolling Stones: n.d.). "Big" meant that you could produce a movie about your band. The Beatles had *Hard Day's Night* (1964). Bob Dylan had *Dont Look Back* (1967). Both of these films were collaborations with notable directors—Richard Lester and D. A. Pennebaker, respectively. By 1969 the Rolling Stones had a large promotion budget and they wanted a film of their own (Booth 2012: 177). The Maysles brothers were getting critical acclaim yet little financial success with *Salesman* (1969), their film about a traveling Bible salesman. A film about the Rolling Stones had an easier target audience.

In our interview, Maysles recounts getting a phone call in 1969: "I got a call from Haskell Wexler. He's a famous cinematographer, moviemaker from Hollywood. He said, 'I've just been talking to the Stones. They're about to go on tour around America. They're going to be at the Plaza Hotel tomorrow. You might want to look them up.' Neither my brother nor I knew anything about these guys, but I took Haskell's word for it. We went to the Plaza Hotel, knocked on the door, got to talking with them. They said, 'Well, tomorrow night, we're performing in Baltimore. You want to come along?' So we went along with them."

"To shoot or just to go?" I ask.

"Just to go. I don't think we shot anything there. Anyway, we thought, 'Yeah. These guys are good.'"

"What impressed you about them?"

"We loved the music. And of course we felt we had good rapport with them. We were eager to get to know them better and to get to know their

music and to record it. So, a couple days later, they're performing at Madison Square Garden and there we are. I think it was two days of performances and then off to Muscle Shoals and then Altamont."

What happened at Altamont completely altered the course of the film, turning it into much more than a simple concert film. To some viewers, it indicted the band in the melee, but in the end, the band allowed the film to screen. Interestingly, the Rolling Stones would not give a pass to Robert Frank's *Cocksucker Blues* (1972), which contains many unseemly shots of backstage parties. The Maysleses' film has less backstage access yet brings out an intimacy with a complex rock and roll tour.

The intimacy found in much of direct cinema comes from filmmaker and fellow Drew Associate Richard Leacock. His philosophy of "being there" is a strategy of being present while shooting and conveying the feeling of presence for a film audience through the edit. Albert Maysles has his own spin on Leacock's concept of "being there." He's also very good at making friends. In our interview, Maysles tells me about his process:

"Immediately upon meeting the person who is to be filmed—*immediately*—the person catches something in the cameraperson's eyes that conveys the possibilities of love. If you have that kind of relationship and have that kind of heart-to-heart feeling yourself as a photographer, then it reaches the subject and you get the same in return."

His cinematography capitalizes on cinema's ability to pass the relationships he develops through shooting on to his audiences with the film.

"I'm interested in the humanization process, how people make friendships, . . . but at the same time, extending that privilege to anyone who sees the film. They see and hear exactly what I'm getting."

From internationally acclaimed actor Marlon Brando to Bible salesman Paul Brennan, Maysles's trust made through friendship is palpable.

Not so with Mick Jagger.

"Mick Jagger was a little difficult," says Maysles. "He doesn't get that close to people."

Jagger's distance from the Maysleses gives *Gimme Shelter* distinction. Instead of developing an intimacy with characters, the film pulls us into the image-making apparatus of large-scale rock and roll. "Being there" is being in the studio, at the concert, in a production meeting, on the stage, at a photo shoot, a hotel room, and so on. As a critical way into the me-

diated apparatus, the film intervenes by creating a sense of spontaneity, an understanding of complexity, and an engagement with struggle. The interplay of these comes through a structure of the film that is unpredictable but encourages us to think about connections.

Alternative Structuring

The structure of *Gimme Shelter* embodies the philosopher William James's interest in making truth through engaging in spontaneity and employing an unconventional structure. Many films—even documentary—follow a standard five-part dramatic arc. An *exposition* establishes time, place, characters, and conflict. *Rising action* introduces complications for the protagonist leading to a climax. The *climax* brings the drama to its highest point of conflict and suspense. *Falling action* leads toward the end, resolving the conflict. During the *dénouement*, the characters return to their normal lives, often changed from the conflict. Maysles has often looked for alternative structural models.

He says, "Too many people making a documentary film figure, 'Well, if it doesn't have a conflict, if it doesn't have a beginning, middle and end, then who's going to watch it for any length of time?'"

For *Gimme Shelter*, they borrowed from literature. Specifically, they borrowed Truman Capote's *In Cold Blood* (1966) in which a true story of a murder is told from multiple perspectives out of chronological order. The book is a nonfiction novel. After making the film *With Love from Truman: A Visit with Truman Capote* (1966), the Maysleses and Zwerin looked to make films the way Capote wrote books. In the film, Capote states his desire to make art from factual material. There is a kinship between direct cinema and the nonfiction novel. *Salesman* was one of the first films for which the editor—in this case Charlotte Zwerin—was recognized as a coauthor of the film, and *Gimme Shelter* makes that acknowledgment of the editor-as-author through the transparency of filming the editing process. Zwerin's editing strategy offers a sense of unpredictability that culminates in a sense of complexity.

Her privileging of spontaneity begins structurally when members of the Rolling Stones begin to review the film in the editing room. Zwerin invited the band to come view the material and told them that they might be filmed then. Dialogic editing has its antecedents in documentary. Robert Flaherty watched his dailies with "Nanook" (Allakariallak) in the

early 1920s, while shooting *Nanook of the North* (1922). Jean Rouch and Edgar Morin famously end their 1961 cinéma vérité opus, *Chronique d'un été* (*Chronicle of a Summer*) watching and discussing the film with their subjects. In general, on-screen discussion of the cinematic experience reveals the limitations of cinematic truth.

Structurally, Zwerin uses the band reviewing the material as an umbrella—a place, time, and activity that connects all the various parts of the film. Documentary scholar Bill Nichols notes that documentaries are historical documents (1991: ix–xi). In this case, there are two layers of historicity: the event of the festival, including the lead-up to and the death of Meredith Hunter, and the moment of reflection or debriefing. This umbrella continually returns us to spontaneity and complexity. As a central place, out of time with the tour, we learn to expect to jump from anywhere to anywhere within the film. In the film, David Maysles is a step away from addressing the audience directly by explaining the edit to drummer Charlie Watts.

Watts says, "It's really hard to see this together, isn't it?"

"It'll take time," responds David.

"What?"

"Eight weeks."

"Eight weeks? You think you can do it that quick?"

And then David speaks simultaneously to Watts and to the audience: "This gives us freedom. All you guys watching it. We may only be on you for a minute, then go to almost anything."

David's statement prepares us for jumping from the ribs of the umbrella to any other part.

Cuts, to either film or audiotape, can have varying degrees of continuity as we pass over the cut. By nature, cuts are violent. They elide time through physical separation and splicing. (Computer video editing still relies on the metaphor of continuous strips ready for blade cuts or trimming.) We then move through levels of the image-making apparatus, from the film editing to the event planning to the stage to wandering through the crowds at Altamont.

The next two sections of this chapter analyze scenes from the film to show how the edit places music in productively slippery relations to the image. As we watch the band listening to their own music, music becomes different things. Witnessing the shift from music being one thing to an-

other gives us the experience of music as an idea and music as its own phenomenon. Editing music in film can transform music into an idea. Music can represent an emotion, establish a sense of continuity through discontinuous images, or referentially tie us to something that we culturally associate with the song. *Gimme Shelter* strategically presents music in many different forms, connecting ideas and material. As distinct from language or visual imagery, music has a temporality that flows in time. It is more efficient at getting us to experience truth as continuous and discontinuous change. The Maysleses' use of music in *Gimme Shelter* shows truth to be something that is in constant motion, conditional, complex, and partial.

The Many Ways of Listening to "Wild Horses"

As Maysles and I discuss the difficulty of getting close to Mick Jagger, we begin to talk about the many close-up shots of another one of the band members—drummer Charlie Watts. Maysles recalls a moment of getting close with his camera.

"It was a wonderful moment when they were listening to the playback of 'Wild Horses,'" he says.

Maysles explains, "Lots of times you get your best material when you're not filming a performance onstage but the subjects are listening to the playback in the sound studio. You can get right up close on their hands and on their faces. You feel the music coming even more from them than when they are actually performing."

Generally, we think of audio as the support for an image. Sound lends realism to the visual, but what if it was the image's role to support the sound? I am aware of how students listen with their eyes when I teach. When playing music, students instinctively watch me for cues. Gestures, facial expressions, tapping a beat, pointing, and looking all help to accent music. A camera can frame this act of visual listening.

Al Maysles's cinematography and Charlotte Zwerin's editing encourage us to view and, more importantly, listen to this sequence in a particular way. In Jonathan Vogels's analysis of these studio sequences, he suggests that they develop the band's character(s) as laconic image-makers.

> Whether in the studio, hotel room, or backstage, the film also reveals the group to be surprisingly distanced from their own music. In pas-

sive roles as listeners and observers, they are generally transfixed by their own performances, listening intently, sometimes mouthing the words, or dancing a little. Only briefly, in a scene at the Muscle Shoals Recording Studio in Alabama does Jagger suggest how to edit a song; grinning foolishly, he punctuates his direction with a swig from a liquor bottle. (2005: 87)

I think that Vogels is looking more than he is listening. The sequence of the band listening to the playback of "Wild Horses" moves music from the background to the foreground through Zwerin's minimal edit and through Albert Maysles's cinematography.

The "Wild Horses" sequence puts us there—not "there" as in Muscle Shoals, Alabama, but "there" as in the social space of listening. The setting introduces a feeling of scrutiny just as seeing a microscope, telescope, or other tool of investigation might. The camera augments attentiveness to the music. The sequence ends with a shot that lasts more than two minutes, starting with a close-up of Jagger and then artfully panning between close shots of band members listening to the playback. I will describe this in detail below and argue that it is one of the most memorable shots of the film *because it encourages us to listen formally*. We leave the sequence having *listened* to the music as sound in motion because of the copresence of the image—itself a combination of continuity editing and attentive cinematography. Before analyzing the sequence for how the film directs our listening, we should consider different modes of listening.

Modes of Listening

Michel Chion suggests that we shuttle between three primary listening modes in cinematic experience (1994: 25–34). *Causal listening* ferrets out the source of the sound. In this mode, sounds are indices for events and objects—the ticking of a clock, an explosion, for example. The sound of rewinding tape in the studio draws attention to the medium. Listening for the cause of the sound identifies the music as diegetic sound. The people in the room are clearly in the presence of the sound and the object producing that sound. *Semantic listening* renders sound into meaning. Listening to speech is a clear example of this. Much work in ethnomusicology attempts to draw connections between music and cul-

tural meanings by positing that music is expressive culture, symbolizing nonmusical things.[1] The details of the music often retreat as the representation of the song comes strongly into mind. As Chion points out, "semantic listening often ignores considerable differences in pronunciation (hence in sound) if they are not *pertinent* differences" (1994: 28). *Reduced listening* is akin to formal analysis—listening to the qualities of the sound itself. Chion borrows the term from the French composer Pierre Schaeffer (1994: 29). Schaeffer was a pioneer of musique concrète, a postwar musical effort of producing musical works from actual sounds collected on tape. Not surprisingly, Schaeffer was inspired by cinema—Jean Epstein's work in particular. Attention to the details of the sound is an empirical endeavor, reducing the listening experience from its cause and its meaning. We may determine a pitch, a timbre, identify a rhythm or a repeated melodic figure. Much classic musicological analysis reduces sound to formal characteristics. Ethnomusicological studies often make use of formal analysis as part of a claim that musical style has a connection to social phenomena. Perhaps the clearest early articulation of this approach is John Blacking's consideration of "humanly organized sound" and "soundly organized humanity" suggesting that there is interplay between aesthetic forms and social structures (1973).

As I will show next, the "Wild Horses" sequence moves between these three modes of listening.

Sign of Travel, Material Presence, Sound in Motion:
The "Wild Horses" Sequence

Editor Charlotte Zwerin directs our ears as much as she does our eyes. It's no surprise that she had a longstanding interest in music. As a child growing up in Detroit, Zwerin frequented "Big Band and a Movie" events downtown, during which a live band preceded a movie screening (Finn 2003). She married notable jazz trombonist and music author Mike Zwerin. Until her death in 2004, she continued to make music documentaries. Her filmography includes documentaries on Thelonious Monk, Ella Fitzgerald, Toru Takemitsu, Vladimir Horowitz, and Tommy Flanagan as well as films on visual artists Willem de Kooning, Christo and Jeanne-Claude, and Isamu Noguchi. The music documentarian Bruce Ricker praises Zwerin for her editing work with early direct cinema as well as for her sensitivity to music:

WHERE IS THE MUSIC? WHAT IS THE MUSIC?

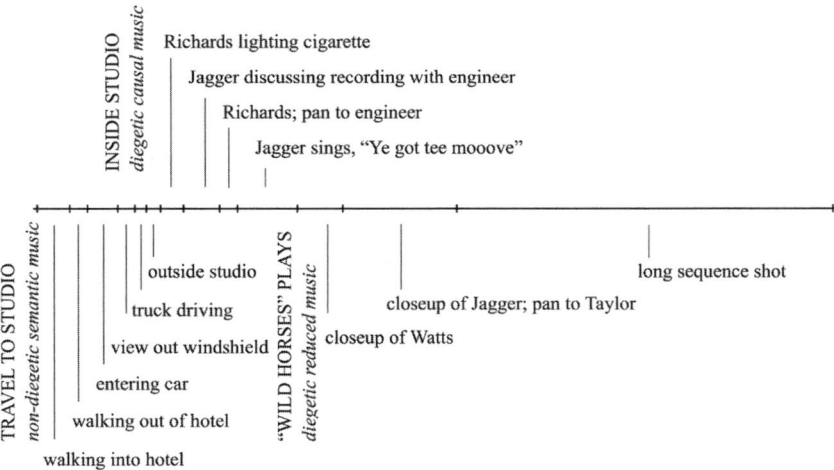

1.1. Structure of "Wild Horses" sequence.

Charlotte's a pioneer of cinema verite . . . She's in the tradition of directors who come out of editing, like Hal Ashby and Robert Parrish. She once said that her major influences are David Maysles and jazz pianist Tommy Flanagan. She gathers all the material and shapes it into a piece of work that's musical in nature. She's got a keen eye and she's a great arranger, like Gil Evans working with Miles Davis. Also, she's a very good listener, the key to making a good documentary. (In Peary 2003)

As will become obvious in my analysis of the scene, Zwerin's edit makes us aware of listening. The sequence I will discuss is in three parts: a travel sequence, banter within the studio, and the playback of the song "Wild Horses." Each of these segments uses visual techniques to encourage us to listen to music (figure 1.1).

Travel to studio: Before we enter the studio, Zwerin uses music as it is typically placed in a transition sequence. Nondiegetically, the song "You Gotta Move" offers flow and a temporality that takes the place of the disrupted temporality of the images. What ends up being an establishing sequence is a series of six shots that brings the band from the Holiday Inn to the Muscle Shoals recording studio.

Zwerin edits with an eye for visual continuity across the cut. (For example, it appears that the band walks through the hotel by keeping their

37

direction the same between the first two shots.) But the musical continuity is perhaps more important. The audio was recorded at the studio during a break from the tour, repurposed as nondiegetic music. "You Gotta Move" is the only audio to be heard—typical of travel sequences in narrative film. The second segment of the sequence positions music in a different relation to the images.

Inside studio: Diegetic music can function as nondiegetic, scoring the scene. Zwerin and the Maysles stumbled upon the richness of finding music in the environment in *Salesman*, a documentary about a Bible salesman that they had made just before *Gimme Shelter*. In our conversation, Maysles describes how the found music was particularly useful: "The opening scene of *Salesman*, the camera is on Paul having a tough time selling the Bible to the point where he must be really feeling pretty low. This child who was sitting on this woman's lap gets up and goes to the piano and plays something that is just sort of dropping off the way . . . it's kind of a musical rendition of Paul's feeling and performance. You could have Leonard Bernstein working his orchestra and using some of his music and it couldn't have been better. It couldn't have been more appropriate. And being played by a child made it all stronger."

Finding the music in the shot was also finding that music could be two things at once. Music was part of the action and it also represented the psychological state of the main subject of the film. It offered two senses of the real: first, an event of real life in which a child (perhaps inappropriately) signals the end of a social interaction and, second, a serendipitous exteriorization of human feeling for film.

Gimme Shelter capitalizes on the ability of music to give different senses of the real. The "Wild Horses" sequence is a key moment in the film, for it presents music as a thing to apprehend, part of the mise-en-scène, and then it brings the music forward. Music shifts from an element of cinema (in this case, conventional support for a travel sequence) to a subject of cinema (we are, in fact, watching a film about a rock band and their music).

"Wild Horses" plays: Once in the studio, the music swiftly becomes diegetic and then ends. Richards is profiled, close up. As he lights his cigarette, the music drops away and someone makes a semiaudible

WHERE IS THE MUSIC? WHAT IS THE MUSIC?

comment about the drums. Music has gone from a conventional overlay to a diegetic sound—from a conventional material of narrative cinema to a material object in the room caused by tape playback. This transdiegetic motion is brief, placing us in the studio with the sound as a part of mise-en-scène, the world seen in front of the camera.

What is more notable in this entire sequence is how the shots and the cuts then direct us from semantic listening (traveling) to causal meaning (music coming through speakers from magnetic tape) to reduced listening (an engagement with the music). Hearing people discuss the recording places the audience in the mindset of listening to details of the recording. Surely the engineer and the band members have been listening to the performance over and over on tape playback. Jagger belts out a comical, "Ye got tee mooove," before swigging from a bottle of whiskey, perhaps reacting to hearing his own stylized voice so many times. As he swigs, the sound of tape rewinding (or fast-forwarding) brings us back to the source. The cause of the noise is the preparation to all to listen. With the high-fidelity recording occluding any diegetic sounds, a G chord comes directly out of the screen. On the sixteenth note before beat three, the film cuts to a frontal shot of Charlie Watts, eyes closed as if to say, "Listen."

Direct address is a distinct and powerful space in cinema, usually reserved for an omniscient narrator. The so-called voice-of-God speaks to the audience, exists outside the time of the narrative, and displaces the images to a more distant place. There are implications to the music's existence within this space. With all diegetic sound attenuated, the music is primary. Pans, zooms, faces, and gestures mostly support our attention to the music as we listen reductively.

At the end of a melody of guitar harmonics, Zwerin cuts to a close-up of Jagger listening. This take is long. In her essay on cinematic timing, Susan Feagin suggests that while rapid cutting can create feelings of excitement, the long take can open up an opportunity for thinking. She quotes the filmmaker Jim Jarmusch explaining why long takes are often rare: Most films, "don't trust the audience, cutting to a new shot every six or seven seconds" (in Feagin 1999: 175). The average shot length in *Gimme Shelter* is 9.8 seconds. This particular shot of Jagger lasts twenty-nine seconds: on Jagger for twenty and then on Mick Taylor for the other nine. Taylor's face is framed like a painting, darkness around his face. This

long take does open up what Feagin calls "cognitive freedom" (1999: 179), but the images presented within the long take do direct our attention. The long take *encourages us to listen* by reducing the cuts and framing people listening. Put differently, the edit doesn't distract from listening to the music itself and the shots of people listening suggest that we too should be listening. During the direct address of "Wild Horses," Zwerin includes only three shots, the last one being a surprisingly long 128 seconds.

Once the last shot of the sequence starts, Zwerin hands off the structuring. Placing no cuts, she allows Maysles's sequence shot to structure our experience. A sequence shot "cuts" within the frame with camera movement. The uncut single shot makes connections through pans, tilts, and zooms.

At this point, we don't rely on sound for sense of real time. Instead, the visuals keep real time. Michel Chion suggests that generally images give us a sense of space and sound gives us the sense of time—temporal continuity or temporal rupture (1994: 13–14). But there are significant moments of *just* listening that include images of listening to the music in real time—again, inverting the traditional editing technique of using music to inform images. The cinematography draws our attention to elements of the music—not unlike how we may point, make a facial expression, or tap in the air when playing a recording of music for someone.

As a whole, the final sequence shot opens up an opportunity to listen to the song. As Maysles's camera moves from Taylor's cherubic face to Richards sitting on the couch, they are very much in the space and time of the room—the historical present. A stack of papers is behind them. They are clearly listening to what we hear in the time of the film. Mouthing the words, Richards is singing along and moving his head to the rhythm of the song. They both face the left of the frame. Generally, that head angle draws our attention to the relationships of people to their surroundings. We ask: "What do they see?" In this case, their glances are to the left but their eyes are closed, yet we still ask, "What are they seeing?" or perhaps, "What are they hearing?" A zoom amplifies Richards's head movements and lip sync. At the same time, it reduces what we are able to see in the room and attenuates the sense of real time in the room. In a well-timed pan, Maysles reduces the sense of the room even more by shifting to Richards's boot. The real time—represented by the images of space—

cedes to the musical time of the song as the close-up of the boot keeps time with the music.

In our interview Maysles recalls the shot. He says that he and David were together in the studio, watching them listen.

"As I was on Keith's face, my brother whispered, 'Take a look at his boots!' Again, with my left eye, I could see this strange piece of boot. At the right moment with the music, I moved to it."

The camera movement and the motion of the boot emphasize the beat of the song. The historical present of being in the room slips away. At this moment in the sequence, primary attention is on the song itself.

"Ricky [Leacock] has described what we do as giving the viewer the feeling of being there. It's quite a gift, especially if the cameraman has a good eye."

The strategy of "being there" may be one of direct cinema's primary truth claims, but few question where "there" is. In this long take, "there" is the musical world of the song. That "strange piece of boot" reduces our vision and makes musical time primary. Perhaps there is some symbolic "meaning" we get out of the boot, but its principal service is to animate the beat of the song. The motion of the boot becomes a tool for listening. A shift of the camera then takes the frame back to Watts, listening as the drums enter. A slight expression of approval and a head nod keeps us listening, perhaps wondering: "What's it like for Watts to listen to himself?"

In general, film rarely encourages reduced listening. Rather, sound assists narrative by posing questions: "Where did that sound come from?" or "What are the implications of that droning cello?" In music documentaries, however, the music is often the subject. The film promises a more intimate understanding of the music—for instance, attaching it to geography or time or associating it with the character of the music-makers. While these approaches to music documentaries draw on the causal and semantic, film can also encourage an audience to listen reductively. Chion argues that reduced listening requires fixing sound to a medium (1994: 30). When we can listen over and over to the details of the sound, we can catalogue layers of formal features.

Maysles is no stranger to reduced listening—perhaps that's another reason he films people listening. I ask him about early experiences with music.

"I always loved Mozart," he says. "My brother—who was five years

younger—I remember when he was a kid, I remember him saying several times, 'Oh, Albie's playing Mozart again!' [Laughs] I would listen to it over and over."

What is more telling than his interest in Mozart is his experience with repetition, playing something again and discovering something new. With no visual reference, focused listening to recorded music can accustom someone to listening reductively.

A film editor with a sensitivity to reduced listening will attach images to sound in ways that encourage listening to sound critically. The image serves a similar function to vocabulary. The medium of film and audiotape offer an opportunity to reduce listening by matching an image, presenting motion, or cutting with a strategic rhythm. In a sense, the visual image underscores or highlights certain sounds. Redundancy of sound and image focuses our ears. In the next section, I'll show how the "Love in Vain" sequence matches image to sound in a more thorough, analytical way.

The "Wild Horses" sequence demonstrates that music can be part of an image in many ways. Asking the patently useless question, "What is music?" is actually useful here. Throughout *Gimme Shelter*, music is a subject of the film. It is also used as a psychological index of both the musicians and of the crowd. It is also, at times, the primary aspect of the film. Cinema frames our experience of music, momentarily framing out a majority of what music might be so that we can understand a sliver of what it is through direct experience. The "Wild Horses" sequence invites us to experience our shifting relationship to music in film.

The Red Light Was My Mind: Psychological and Anempathetic Music in the "Love in Vain" Sequence

Most of those working with Robert Drew considered nondiegetic music to be suspect (Ruoff 1993: 226). Music can do as much to alter a "plain picture" as voice-over narration. And yet, music is found in direct cinema films, of course especially in the many music documentaries made by Drew Associates alumni. I was keenly interested in how Maysles thought of using nondiegetic music, since it seems like a violation of direct cinema principles.

"If music is so manipulative, were you careful in how you used it and what songs you decided to put in?" I ask.

Maysles explains, "The music comes from itself. It's not over the picture, not officially. With so many films, 'Now we'll do the music. We have our material.' I don't like to do that unless somehow there's a piece [of] music that isn't foreign, doesn't have a foreign feel to it, it's sort of a perfect part of what's going on. When would there be music when you weren't there?"

"I'm thinking of *Gimme Shelter*." I specify. "There are two travel sequences. They end up in the studio with them listening to it but it feels like nondiegetic overlay."

He smiles and says, "I think it works."

As I continue to look at the sequence and consider Maysles's response, I think about what it means for the music to "work." The key is in the radically different ways that music is included and the attention we give the segues between those incorporations of music. As a result, music occupies these spaces without being manipulative because we can witness music enter and exit these spaces. Music changes character in the "Love in Vain" sequence but it does so differently than it does in the "Wild Horses" sequence. The position of music shifts within one song. The reduced listening is made through the edit rather than the cinematography; the sequence encourages shifting from reduced listening toward causal listening. As a result, our trajectory as a listener-viewer is one of beginning with attentive listening and ending with detached acknowledgment of music as an object of mediation. For cinema, the implication of this particular shift is an awareness that music works on us. Rather than eliminating manipulative music, the sequence allows us to keep an eye on the music as it moves from a mental apprehension of formal play to an anempathetic sound object. The sequence starts onstage in New York with Jagger addressing the audience. "We're gonna do a slow blues for you now, people." The first note of the song—a low G on the guitar—accompanies a cut to a medium close-up of the audience lit in red. Their motion bobbing up and down is in sync with the music even though they are in slow motion—about a quarter of normal speed.

Slow Motion Separates from Real

The different camera speed puts us in a space for attending to musical detail by slowing action. That experience is cognitive and emotional. In general, the slow motion helps focus on action, separating an action

from the flow of events in time. Slow motion can bring clarity to reading scenes. In narrative cinema, a fight sequence may slow certain motions to heighten our awareness of the drama or physicality of the fight. Sports broadcasts employ slow motion to analyze a critical play. There is an expense to this cognitive effect. Slow motion erodes a type of realism. But rather than apprehending that scene as unreal, we often read slow motion for its psychological realism. In cinema, slow motion makes a moment seem significant by simulating our own significant experiences. We often remember impactful events as if they happened in slow motion. The classic example is a car crash. Our memory of such an unexpected, traumatic event can replay in our minds in slow motion even though the instance of the crash was brief. In what seems like slow motion, we recall a surprising amount of detail. In narrative cinema, slow motion brings us into a significant moment in a character's life by imitating a psychological state—attenuating the objective world and allowing us to study the details of the event. Zwerin's cut of "Love in Vain" repurposes a slowed version of Jagger's performance gestures to draw our attention to the music. Slow motion pushes us out of the real space of the concert. We then enter a psycho-musical space and tend to musical form. As if to say, "watch this," the initial shot pans across the audience and reveals a man looking through the viewfinder of his still camera. As is typical of point-of-view shots, the question of what he sees is answered by the cut. Jagger in slow motion invites audience scrutiny.

Edit Encourages Reductive Listening through Gesture

Why gestures? Gesture draws attention to moments in time unlike language does. As David McNeill argues, a fundamental difference between words and gestures is that the latter "are themselves multidimensional and present meaning complexes without undergoing segmentation or linearization. Gestures are *global* and *synthetic* and *never hierarchical*" (1992: 19). Language requires time to combine words into a whole structure. (It took you real time to assemble these very words into an idea.) McNeill describes: "In language, parts (the words) are combined to create a whole (a sentence); the direction thus is from part to whole. In gestures, in contrast, the direction is from whole to part. The whole determines the meanings of the parts" (1992: 19). Anyone who has tried to talk about music as it is playing knows that the syntax gets in the way of the music.

The phrases that work are short and tend to point: "Here it comes!" "Listen!" "Wait for it . . ." McNeill suggests that, when paired with language, a variety of gestures can combine to create meaningful idea units: "synchronized speech and gestures where the meanings complement one another" (27). Ethnomusicologist Matt Rahaim extends McNeill's concept to music, suggesting that gesture can similarly combine with music, forming interdependent pairs in North Indian Hindustani singing (2012: 7). His examples include a grabbing and pulling gesture accompanying an abrupt increase of loudness as well as a downward series of loops accompanying a terraced descending melody. Rahaim suggests that these gestures are powerful in musical performance because other bodies offer sympathetic ways of knowing (10). We feel the motion as we hear the sound. And corroborating McNeill's suggestion that gesture is less systematized than language or that it is *semi*cultural, Rahaim finds that gesture is both idiosyncratic and inherited through learning and practice (134). There is no one-to-one mapping of gesture to musical idea, though it is possible to make connections between kinesthesis and musical expression.

Zwerin cuts Jagger's motion to create idea units that are both heard and felt. Chion develops the useful term "synchresis" to describe the forging together of an aural and visual event (1994: 63). In his example, the image of a human head being smashed and the sound of a watermelon being smashed form one inseparable syncretic event. Musicological synchresis, then, can be a useful way of understanding how visual elements combine with musical events to create a series of audiovisual experiences of music.

While McNeill argues that gestures are noncombinatoric (1992: 21), film can recombine gesture into parts, visual instances that align with an integral whole of sound. Here, Jagger's motions combine with musical events in a slow twelve-bar blues in twelve-eight time. Zwerin is directing our attention with plenty of musicological synchresis. Figure 1.2 shows connections between the music and the images of Jagger. The first shot of Jagger synchronizes his head movement with an alternation of V and I chords. As illustrated in the figure, a sagittal shot accompanies the V chord and a frontal shot accompanies the I. The direction of Jagger's face mirrors the feeling of leaving and returning to the tonic. There are three occasions in which Zwerin places an image of Jagger raising either

his shoulders or his body on a IV chord and lowering them on the I chord. In these cases, the shoulders iconically match the plagal cadence of a C major chord resolving to a G major chord.

In the twelfth bar, Jagger raises his hands to prepare a stroke for the next beat. Analyzing gesture and speech, McNeill identifies the preparation, stroke, and retraction. "The stroke of the gesture precedes or ends at, but at least does not follow, the phonological peak syllable of speech" (1992: 26). In a similar fashion, Zwerin places Jagger's gestures in a way that the gesture lands on a musical event. On the first beat of the next chorus, Jagger's hands drop along with a superimposition of him in close-up while the sound of the band joins. A prominent electric guitar slide coincides with the abrupt beginning of image superimposition. The sideways motion of the two overlaid images of Jagger also matches the semitone slide of the guitar. (Note the amount of time it took to read this textual description of about two seconds of film. Gesture can keep up with the temporality of music.) The superimpositions often occur with instruments becoming prominent in the mix, drawing attention to the arrangement. Slides of the guitar often accompany Jagger's horizontal motion across the screen. Repetition syncs with Jagger's spinning body. Another plagal cadence accompanies the rising and falling of a slow-motion jump. Claps sync perfectly with the snare backbeat. Watching, you may simply relish Jagger's moves, but Zwerin has offered us an opportunity for a more precise reduced listening to harmony, arrangement, repetition, and musical form.

We watch carefully because of the slowed motion. We feel the musical idea of sympathetic proprioception. We sense the feelings of other bodies, in this case, the musical events through Jagger's body. What's more, Zwerin uses superimposition and crossfades to deemphasize visual cuts that might compete with the musical events she shows us. Chion argues that while visual cuts are generally clear—we can easily count the number of cuts in a film—aural cuts are generally masked. We rely on sound for temporal continuity when viewing a discontinuous series of shots (1994: 40–41). Chion suggests that we have a better understanding of sound in film when looking for sound events, markers of significance within a representation of time: a dog barks, a door slams, thunder claps. Carry that analytic method to music on film and we may see music as a series of musical events that compete with visual cuts. Superimposition

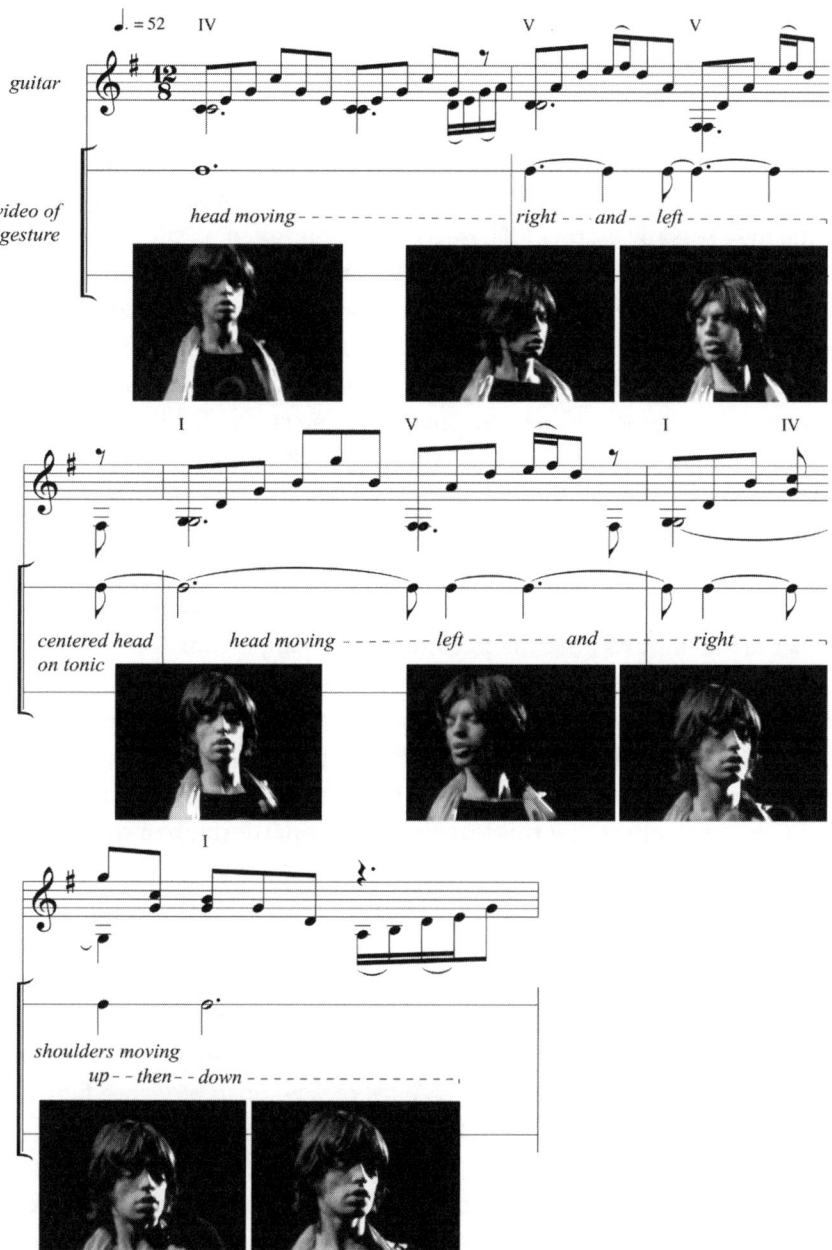

1.2. Head position matching chord changes and shoulder motion matching plagal cadence.

and crossfades draw less attention to visual disturbances and let us watch (and feel) the musical events.

Description of the Significant Transdiegetic Shift

The most radical moment in the "Love in Vain" sequence is a cut to Jagger looking right, motionless. The lyrics sound over the image, "The blue light was my baby . . ." Then, a red filter is taken off the image as the guitar shifts to a vi chord (the E minor substituting for the C major) on beat ten of the twelve-bar blues. It somehow fits the music. The image is the same, but the color is different. The E minor differs from the C major by only one note—the B, which moves to a C for the second half of the bar. The color gesture precedes the harmonic shift. The lyrics continue, "The red light was my mind." At this point, the camera zooms out and pans around what appears to be the control room of a recording studio. We experience the shift of place after it happens. Our attentiveness to the music, heightened by the slow-motion musicological synchresis, holds although we are now in real space, in real time, in real light. Why isn't anyone moving? As the camera continues to pan, Richards is revealed to be lying on the floor. A studio monitor beside him, he taps in time with the music. As you look at Richards and Jagger, you might suddenly think: "They're actually hearing what I hear!" While the transition was smooth, the realization of being in another relation to the music is surprising.

The jarring effect that this transition has is partly due to a shift in temporality. Since the song started and the slow-motion images jettisoned objective realism, our sense of temporality is rooted in the rhythm of the song. Now, objective temporality returns, forcing itself upon us. The experience of music moving from a contemplative form to a sound object in a real space involves what some describe as transdiegetic sound (see Taylor 2007; Jørgensen 2007; Cecchi 2010). Robynn Stilwell calls this space the "fantastical gap," suggesting that there is an unstable space between two ways in which sound relates to an image.

> When we are talking about movement through the gap between diegetic and non-diegetic, that trajectory takes on grand narrative and experiential import. These moments do not take place randomly; they are important moments of revelation, of symbolism, and of emotional engagement within the film and without. The movies have taught us

how to construct our phenomenological geography, and when we are set adrift, we are not only uneasy, we are open to being guided in any number of directions. It is the multiplicity of possibilities that make the gap both observable and fantastical—fantastical because it changes the state, not only of the filmic moment, but also of the observer's relationship to it. (2007: 200)

Perhaps a term that describes the experience of motion rather than the ontological designation of transdiegetic space is "diegetic slide." As the song shifts from the direct address to a sound emanating from a loudspeaker, we can review the footage and mark the cut in which the images shift. We can mark the moment that the red filter is removed. We can mark the moment when Richards nods his head or when the camera pans to the studio monitor. Our experience of temporality and space, however, is in motion throughout; and, as Stilwell observes, this marks a significant moment.

To me, the significance is one of music's ability to be both an object and a mental image. The diegetic slide reveals the point of contact between these two different experiences of music. This is representative of what Vogels identifies as the pragmatic modernism that runs throughout the Maysleses' work (2005: 83)—although Vogels does not consider the ways in which music contributes to that sensibility. Sensing music as two different things (in two different states) as well as *the connection between those states* demonstrates William James's notion of pragmatic truth. James understands truth not to be the rationalist's "idea" or the empiricist's "thing." Rather, truth encompasses the "conjunctive relations" between ideas and things (James 2000: 317–18).

What is true about music is not that it is reducible to pure harmony, illustrated by musicological synchresis, or not that it is a material sound that exists in relation to magnetic tape, loudspeakers, and amplifiers. What is true about music is that our experiences of it shift. Harry Berger investigates this phenomenon with his suggestion that our "stance" on music is inherently part of our apprehension of music. Berger's phenomenological notion takes as inseparable a musical object and the conditions of our apprehension of it. "If intentionality refers to the engagement of the subject with her object, then stance is the affective, stylistic, or valual quality of that engagement. Stance is the manner in which the person

grapples with a text, performance, practice, or item of expressive culture to bring it into experience" (2009: 21). Music has no concrete meaning. It is therefore open to our experiences; and, as Berger argues, our stance on music constitutes our apprehension of music.

Over one hundred years separate James's and Berger's observations, but, as Bruce Elder points out, an interest in experience is a strong current in American thought. This interest is evident in the great many modernist works that pose problems of whether representation is one of perception or of objective reality. "This is a very broad and important current in American arts and letters, and it helps account for the appeal that film had to American arts. For the contents of film equally seem to hover between the status of an object and the status of a mental image" (Elder 2001: 149).

There are levels of this vacillation between music as a thing and music as a mental image throughout *Gimme Shelter*, but they are most apparent in the two studio sequences. Music provides a strong blur between object and mental image. In the "Love in Vain" sequence, sound is a mental image during the slow-motion images of Jagger as the song plays nondiegetically (or perhaps semidiegetically). The vacillation produces what Elder defines as a "neutral monist conception of reality," that is: there is no subject-object division; the material of experience is composed of the same "thing." This reality removes the barrier between human consciousness and nature, a theme that goes back to the American transcendentalists such as Ralph Waldo Emerson, Henry David Thoreau, and Margaret Fuller.

Realism in Rolling Stones' Music Prepares for Diegetic Sliding

Part of the reason that Zwerin's music-placement strategies work is because of a type of musical realism in the Stones' music itself. But what is realism in music? John D. Wells finds realism in the lyrics of Robert Johnson and the Rolling Stones, suggesting that, lyrically, the Stones have a debt to blues portrayals of basic human problems (1989: 161). Carl Dahlhaus notes that realism in music existed on the fringes of romantic music in the nineteenth century, developed from the emergence of expression in the eighteenth century (1985: 12, 23). As he points out, however, the idea that music represents reality is fraught with the problem of "a concept of reality which was itself open to question and undermined by epis-

temological doubt" (25). This more fundamental problem of realism is solved not by a better understanding of what reality is, but rather by what reality *sounds like*. Recorded music, like film, can be produced to sound like a live performance in a real space (what I call realist) or as a collection of disparate sounds in an ill-defined space (formalist). The realism in the music of *Gimme Shelter* that makes it particularly useful for diegetic sliding is a contribution of American record producer Jimmy Miller.

Following a (mostly) failed attempt at psychedelia with their 1967 album *Their Satanic Majesties Request*, the Rolling Stones looked to create a new type of album. Under Miller's direction, their postpsychedelic sound of the next three albums was more akin to hyperrealism. On *Let It Bleed* (1969), street noise blends with an acoustic version of "Country Honk," drum sounds have exceptionally high fidelity, and the sound of Jagger's voice reverberates in a way that puts it in consistent real space. The music seems "real" because it is crafted to sound real. The sound gives a sense of real space and real time, just as music might sound in various real performance settings.

To achieve this, Miller allowed more time for production and insisted on bigger budgets to craft the albums, a developing trend of the era. Instead of intensive use of the studio resulting in psychedelic tapestries of fantastic sound like the Beatles' *Sgt. Pepper's Lonely Hearts Club Band* (1967) or the Beach Boys' *Pet Sounds* (1966), Miller used the studio to craft realistic spaces. The sound of Mick Jagger's voice bouncing off the wall in "Love in Vain" is as important as the melody. Symbolically, the black vocal choirs, Hammond organ, and hand-held percussion bring imagery of black churches from the American South. As a percussionist himself, Miller brought the percussion forward and gave the drums a wide stereo clarity that is now standard in rock—as if the listener is sitting behind the kit. The realism in the music of the Rolling Stones fits well with its association to image. It's for this reason, at any point in *Gimme Shelter*, the music can slide between diegetic and nondiegetic spaces.

The Anempathetic and the Interiorized
Held Together through Song Continuity

In the "Love in Vain" sequence, the relationship between music and image fundamentally changes. The song provides continuity, while space, time, gesture, and the audiovisual relationship change. As described, the

beginning of the sequence uses images to support the structure of the music. The highly edited slow-motion images direct deep listening. With the shift to real space, the same music becomes a sound in the space of the room. After the diegetic slide, the only visual augmentation of the music is tapping of feet and nodding of heads. This tapping, along with a pan to the studio monitor, works strongly to create a realist *aural and visual* space of the studio—we see the space and hear what it sounds like. A long steady pan from Jagger to Richards on the floor and then back to the others in the room establishes both time and space. This is not a sequence shot like the one in "Wild Horses," but a slow reveal of bodies in a room listening to music in real time. Notably, the people in the room do not gesture to reveal the music (as in the "Wild Horses" sequence); rather, they themselves are revealed as simply being people in a room. The way they are framed prevents the viewer from accessing their interiority, which, in effect, creates a separation between the people on-screen and the music itself. Jagger is in profile. Richards is looking up. The other three people have their hands or a still camera blocking their faces. Left without a psychological perspective, a space opens between the subjects and the audience.

Pulled out of reduced listening, we experience something similar to an *anempathetic music*—for example, a typical use in narrative cinema would be the sound of carnival music playing while a character is going through emotional trauma, the music powerfully not matching the experience of the character. Another example is that of a pathological villain committing a horrific act while gentle or happy music plays. Anempathetic scoring symbolizes a character's disconnectedness or alienation to the world. The Rolling Stones and their entourage are motionless. The nature of the music changes to being simply a sound emanating from a studio speaker. It is now associated with the mise-en-scène and no longer supported by the musicological synchresis. A jarring effect of realization in the diegetic slide, we return to our own perspective, since we are now denied any cues from the bodies on-screen. In this case, anempathy occurs when we are diverted from a mental image of musicological attention.

The sequence is an assertion of how music is only partially knowable by forcing a shift of what music is. The greater truth about music that emerges from this sequence is that music has the capacity to change states. That truth is more important than designating music as a par-

ticular idea or object. In other words, the diegetic sliding reminds us that music has the capacity to shift from symbolizing something (ideational) to being something in itself (material).

An Open Defense

Forty-seven minutes into the film we encounter the most startling cut in the film. The break establishes new ideas and perspectives, delivering the audience to the Altamont Speedway. Several cinematic elements establish the second act of the film—one that involves foreboding attention to the crowd and their relationship to music.

In the cut itself, the image forcefully shifts from the band bidding goodbye to the crowd at Madison Square Garden to an aerial shot over the California desert. The hard cut of sound (stage noise to helicopter noise) emphasizes the cut. The transition is an invisible wipe—the camera follows Jagger until the dark behind the amplifiers passes in front of the camera. Used in classical cinema, the wipe across the screen offers the feeling of turning the page of a book. In *Gimme Shelter*, this invisible wipe breaks the film almost perfectly in half. The aerial shot establishes a new place. But it also changes the feeling.

The transition brings us from a stable space (the concert stage) to an unstable one (the view from the helicopter). Zwerin cuts to a point-of-view aerial shot in the moment of plummet. The helicopter is speeding toward the ground and then veers up to reveal an extraordinarily long line of parked cars on the road. A sense of inevitability comes with the single road that leads toward the Altamont Speedway, with the rapid motion felt in the aerial shot and with the initial foreshadowing that death will happen here.

The only continuity between shots is the Rolling Stones audience. They were in front of the stage in New York. They now walk from their cars toward what will be an infamous concert in California. This string of people seen from above is walking into history. The crowd is a prominent feature of this film. Its roaring sound begins the film. The band is constantly engaged with the audience. A great many of the shots of musical performances are of the audience. At Altamont, the crowd was notably large—roughly half the population of San Francisco at the time.

Rendering a crowd in film is challenging. Cinema is better suited for presenting individuals and small groups of people. How do you make a

film about three hundred thousand people? There are a few strategies. In one, you can make the crowd a character. I discuss this with Maysles.

I tell him that one of the ways I read *Gimme Shelter* is that there was a dysfunctional relationship between the fans and the artists. You see that in a few moments when they start jumping up onstage and swiping at Mick Jagger.

Maysles starts to smile. "Oh yeah!"

"The audience is almost a character in that film," I say.

"Yes. Yes!" Maysles replies.

Cinema can draw attention to almost anything to make it a character—or at least a significant force. In early documentary film, Robert Flaherty's *Nanook of the North* (1922) pits protagonist Nanook against his antagonist, the Canadian landscape. In *Gimme Shelter* the crowd is an entity itself, perhaps hydra-headed. There is a sense of lack of control developed in the film. The portrayal of the audience connects to the comment heard earlier in the planning room sequence when one person says of hippie crowds and music festivals, "It's like lemmings to the sea." Following the actual event of the festival, the press presented the crowds this way, as if the unthinking mass was the antagonist to the idealism of the 1960s, an ideal represented by the music itself.

In fact, the concert at Altamont *was* a disaster. Media reports honed in on this; but they did so primarily by describing the audience. The day after the festival, a headline in the *Berkeley Tribe* proclaimed, "Stones Concert Ends It—America Now Up for Grabs" (Vogels 2005). Reviewers described drug use and violence in great detail, while neglecting the music. The *Chicago Tribune* recounts the apocalyptic lead-up to the concert: "The hordes of youths swarmed onto the barren hills beside a motorcycle racetrack for the concert" ("300,000 Jam" 1969). Represented in the film, the crowd is a hydra-headed beast roaring in the beginning of the film, breaking onto the stage toward the end of the Madison Square Garden concert and then moved to violence at Altamont, culminating in the murder. The order of songs has a deliberate narrative function. Rearranged from the order in which it was actually performed (see Galbraith 2014), the music dramatically scores the sentiment from the playful "Jumpin' Jack Flash" to the menacing "Sympathy for the Devil."

Jagger addresses the crowd throughout the film. This is not uncom-

WHERE IS THE MUSIC? WHAT IS THE MUSIC?

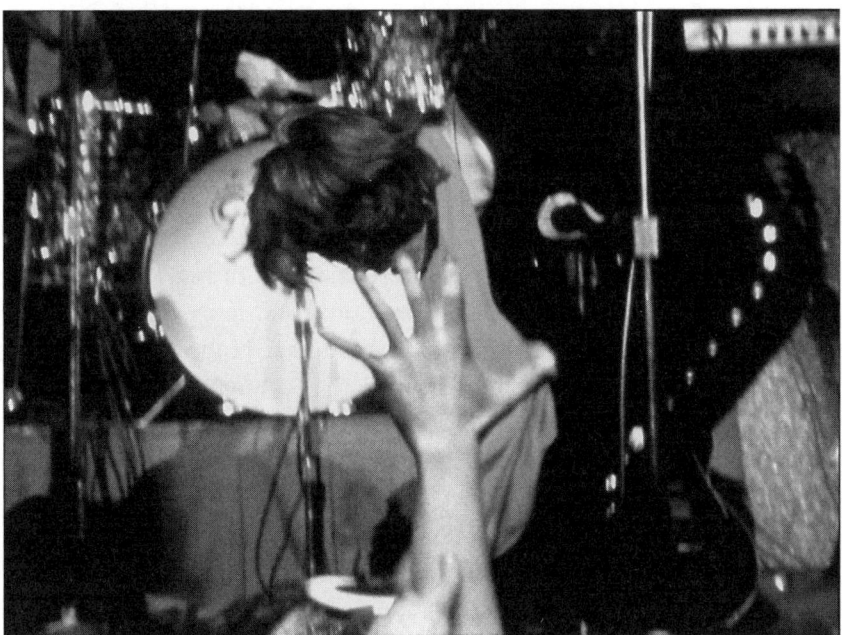

1.3. Unbeknownst to Jagger, a hand from the crowd reaches toward him.

mon for a stage performer, but we sense a dangerous eroticism. "Ah think I've busted a button on my trousers," he teases from the stage at Madison Square Garden. "I hope they don't fall down. . . . You don't want my trousers to fall down, now do ya?" We previously watched an extended close-up of Tina Turner nearly performing fellatio on her microphone. (Interestingly, we never see the audience during her nearly two-minute performance.)

This eroticism seems to create in the audience a frenzied desire to get physically close to the performers. Narratively, the audience begins to reach for Jagger toward the end of the Madison Square Gardens concert during the song "Honky Tonk Women" (see figure 1.3 for an example of the imagery that foreshadows the breach of the stage). At this point in the film, the crowd as a character seems to be moving toward violence because we, the viewers, are already aware of the death of Meredith Hunter, thus we feel the vulnerability through the sexualized performances. Several songs into the New York show, bouncers grab the fans who rush the stage. Shots over Jagger's shoulder offer his point of view. When he turns

toward the back of the stage, facing the camera, Maysles lingers as his face becomes expressionless. In that moment, Jagger's relationship to his audience is revealed to be part of the performance.

When the band arrives at Altamont, they wade through the crowd, no longer separated by a stage and guards. Unexpectedly, someone punches Jagger in the face. "Somebody punched Mick!" says a disembodied voice. It stands in for our own voice of disbelief.

Yet, part of this story about how a rock crowd turned murderous is based less on what the filmmakers are doing and more on the attitude that viewers bring to the film, an attitude that hinges on pied-piper notions of rock's subversive influence.

In fact, I'll argue that far from reinforcing ideas about the subversive influence of rock and its intoxicating effect on its audience, the filmmakers complicate the media's oversimplified story. I'll explore their perspective grounded in the shots and cuts of audience that reveals a plural audience, without a message, without a unified goal, attitude, or style. Entertaining this aspect of the late 1960s rock audience requires that we abandon the standard narrative of Altamont representing the death of 1960s idealism, so aptly contained in the headline from above: "Stones Concert Ends It—America Now Up for Grabs." Let us first consider what this audience was.

Who Was Listening?

The audience was big. In the Rolling Stones 1969 tour, the size of rock concerts grew to the size of major sporting events. Christgau called the tour "history's first mythic rock & roll tour" (1992: 247). The Beatles had played the first stadium in 1965. Fifty-five thousand screaming fans—mostly young girls—filled Shea Stadium in Queens, but fans were not allowed on the field. The band played in the outfield. Madison Square Garden and the Altamont Speedway were not just larger venues, they were spaces in which audiences could come to the threshold of the stage.

The audience was listening. The crowds that Maysles shot were, as Barry Faulk argues, a new rock audience made up of counterculture listeners (2010: 100). Whereas the audiences that met the Beatles five years earlier sat, stood, and screamed, the 1969 rock audiences were more interactive. At this point in rock history, the genre had folded in folk music audiences and progressive jazz audiences, both rife with listeners. What's

more, rock had displaced jazz as the soundtrack to college. College degrees floated through these new crowds.

The audience was plural. In his essay contextualizing Jefferson Airplane, ethnomusicologist Patrick Burke untangles the complexity of 1968 San Francisco counterculture by separating the cultural radicals from the political radicals. He then shows the ways in which white counterculture borrowed heavily from black Civil Rights–era political groups (2010: 66). He argues that "we should view the 1960s not as a romantic epoch during which a unified counterculture fought an unfeeling power structure, but rather as a complex moment in which various cultural and political factions came together and pulled apart in ever-changing ways. Moreover, we need to examine music as an expressive form with the potential to evoke multiple, sometimes conflicting meanings, rather than regarding it merely as a vessel for unambiguous political messages" (65). Burke's call to examination parallels the way that music and mass audience manifest in *Gimme Shelter*. Diverse shots of the audience foil any ability to idealize the crowd. As a strategy, the montages reveal the plural nature of the crowd. Now, let us examine how the film presents them as a plural mass.

Showing the Plural Mass

The confounding sense of so many of these shots is palpable. This emerges as Maysles and I discuss shooting the crowd. As we talk, we move from the crowd representing fanaticism to reveling in the details of the crowd.

I first ask, "Was that something you were curious about—that type of fanaticism?"

He answers, "Yeah. In as much as that was the thing that was going on. You see [it] in the faces of the audience. I was so lucky. One depends on being able to be at the right place in filming a concert. . . . Thank God I was able to get the audiences close up, near the stage. I remember that young woman had tears coming down."

The rest of the conversation went like this:

HARBERT: "That's an unbelievable shot."
MAYSLES: "Ah!"
HARBERT: "Did you shoot that?"

MAYSLES: "Yeah."

HARBERT: "She's still moving along and bobbing her head as she cries. The people outside of her also smiling and bobbing their heads. They're oblivious. But it's not . . ."

Maysles interrupts excitedly: "The guy who's looking up like this. And then, way off in the distance, this woman with a very attractive body nude coming down the aisle. Then that very much overweight woman, fighting her way . . .

I finish his sentence: ". . . with stuff in her hair!"

MAYSLES: "Yeah!"

It's perhaps unusual for scholarship to operate through a series of "ahs" and "yeahs," but for me, this is a good way of valuing these shots. Bafflement and inscrutability contribute to an acknowledged pluralism. Essentializing this crowd does violence to its members. The Maysleses and Zwerin provide a Jamesian flow between details, often striking, revealing the complexity. (After all, William James did coin the phrase "stream of consciousness.") Even though we started on an idea—fanaticism—the images are productively irreducible.

Pennebaker's *Monterey Pop* (1967), Michael Wadleigh's *Woodstock* (1970), and Mel Stuart's *Wattstax* (1973) all show greater degrees of unity among the crowds, erasures of difference supposedly brought about by the unifying nature of musical performance. Conversely, *Gimme Shelter* bears all the disorder of a mass event. The crowd shots offer plenty to confound any sense of unity. Consider this series of shots:

Young family with toddler
Close-up of a young man chugging a large, unlabeled brown bottle, cigarette in hand
Man, possibly on drugs, spinning
Sober couple spreading out a picnic blanket

Some shots themselves reveal an incongruity: A couple lies kissing on the lawn; zoom out to reveal that the man is holding a Doberman Pinscher on a choke chain.

A woman collects money for the Black Panther defense fund amid a less-than-enthusiastic crowd, cutting with her saying, "After all, they're

just negroes you know," as a young black man drops change into her bucket.

The most confounding shot occurs after conflict begins to threaten the show. Cut to a sagittal close-up of a woman looking screen left, supposedly at the aftermath of violence. "They're not going to play music until we get a doctor," she says. She tries again, this time in a soft voice that we can hear but certainly is too soft to be audible to anyone nearby, "Somebody help." Cinematically, however, it calls us to empathize with her concern. A bit louder: "Somebody's hurt." Then she leans back as a zoom-out reveals the crowd looking at her. Most editors would cut here before her concern shifts; but Zwerin keeps the shift, following her through a smile and an offhand frivolous melody on a flute. As a playful punctuation, Zwerin cuts to a clown face looking directly at the camera. The flute trill/melody continues through a cut to a bubble floating across the crowd. Over those two shots, deep concern for human life shifts to haphazard play.

Maysles delivers faces, and Zwerin ensures that we don't linger in one person's experience of the event. As noted in the beginning of the chapter, Maysles gets close to faces when he shoots. Not only does he get close, but he also favors frontal shots that encourage empathetic responses. He explains how he has done that through so many of his shots: "I'm intent on conveying the experience of the subjects to the audience, doing it so closely that the audience feels that they are right there.... In a way, you're that person and that's quite a gift. The audience feels that they're experiencing what the Stones are experiencing, what the Beatles are experiencing, what's the experience of Vladimir Horowitz, Rostropovich, or an ordinary person."

The film confounds our desire to read the situation. Surely things have gone wrong and we look to the faces to communicate some kind of answer, reassurance, or—cinematically—emotion.

Sounding the Plural Mass

As we have seen, music can move underneath, in front or back, and become part of the scene. In the Altamont section of the film it is mostly part of the environment, within a set of relations. There is no nondiegetic music until the very end. The music occasionally seems to move to ex-

pressing a sentiment of celebration, but its interruption and the layering of crowd sounds keep it part of a sound ecology. To achieve this, Zwerin lets us listen to the sound of the crowd at the beginning of the Altamont section.

For ten minutes, there is no music. The visual collage is accompanied by location sound. It is the longest stretch without music in the film. As an experiment, I watched the footage while playing other music separately to see if the images can congeal to the mood of the music. When listening to "San Francisco (Be Sure To Wear Some Flowers In Your Hair)," which plays over the crowd images in *Monterey Pop*, many of the shots support a feeling of celebration and togetherness. Other shots don't fit. The empathetic clashes with the anempathetic.

Without music, the realism of the event is more prominent than if a soundtrack were to ground our feelings or thoughts. Jeff Smith has a term for music's use in organizing our reading of images. What he calls "polarization" is "an audiovisual interaction in which the affective meaning of the music moves the content of the image toward the specific character of that music" (1999: 160). This is not the same as being emotionally moved as if we were the character, music heightening our empathetic response (Smith calls this "affective congruence"). Rather, polarization uses music to shift our view. Using another metaphor, music acts like a visual filter that lets through the parts of image that relate to the sentiment of the music. Smith suggests that this is a cognitive experience. We watch to read the scene, to connect the ideas of how emotion relates to the scene. So for the first ten minutes of being at Altamont, we have no pole, no filter. By forgoing any scoring during this section, the location sound pulls us into a realist yet disorganized space. There are no emotional poles to organize the images. The images retain a fullness and a complexity. In addition, the sound of Altamont is established. It's noisy there. Voices rise over the din of the mass.

The music becomes part of an environmental sound, played by bands on a relatively small riser at Altamont. But understanding music as being part of an ecology is more useful—not an ecology as in a system but as a sound we hear in relation to others. The sounds of music, motorcycle engines, and crowd noise intermingle. We must struggle to hear music as an emotional pole, synthesizing the plurality of the mass. At first, it's tempting to let the music become a direct address.

WHERE IS THE MUSIC? WHAT IS THE MUSIC?

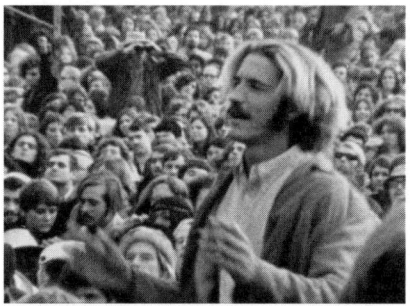

1.4. Dancing man becomes concerned.

As music begins to play, there is a moment when it overwhelms the image. As with the "Wild Horses" and "Love in Vain" sequences, the image supports the musical play, enticing us into reduced listening. Narratively, we might think: "Finally, the concert has begun. Music has won!" A shot of colored balloons drifting in the sky matches the sound of music starting. But it is an ironic move. We know that death looms ahead. We cannot transcend the dysfunctional environment with music. Flying Burrito Brothers begin to play "Six Days on the Road." The crowd throws Frisbees and blows bubbles into the air as they dance. Overwhelmingly, they dance. A frontal close-up of a blond man smiling encourages us to smile as well. An older couple kisses as they sing, "Well it seems like a month since I kissed my baby goodbye." Cut to puppies kissing. The cinematic mood is playful. A moment of foreshadowing presents in a wide shot of a shirtless man crowd surfing the seated audience. Wait. Did he kick someone? The camera zooms out. There are *so many* people here. The zoom is a reveal. Our moment of good-natured festivity begins to draws to a close. A glimpse of the back of a Hells Angels jacket precedes the end of the song. The music cross-fades with the alarmed crowd sounds as the Hells Angels beat audience members with pool cues. A voice over the microphone begs, "Please stop hurting each other," after which a menacing voice from the crowd growls, "Take him off to the other side." The signal that the mood has changed is most evident in the frontal shots of an audience member (figure 1.4). The dancer is now alarmed. A camera behind him augments attention to what he is seeing. We sense his reaction.

As Jefferson Airplane plays "The Other Side of This Life," the crowd sound moves behind the music. In competition, the music never achieves the place of direct address. The long buildup fails musically. As the

images show us the escalating violence, the crowd sound comes back to the front, diffusing the musical effect. As we move from reductive listening to causal listening, music is again part of an ecology of sound. A zoom to a man dancing on high scaffolding accompanies an attenuation of the crowd sound. His relationship to others (and to the thought of his potential plummet) is framed out. The music regains its lone forward position and Zwerin offers us several cuts to people dancing and taking in the music. Two shots disrupt: One is of Hells Angel Sonny Barger lighting a cigarette in indifference. The other is of concert organizer Michael Lang looking out of the frame to his right. His noticeable lack of movement reminds us not to dive into the song with abandon. And then, "Easy," says Grace Slick over the continued rhythm of the band. "Easy . . . Easy . . . Easy . . ." Song turns to plea. As a scuffle ensues, the song falls apart. Some members continue playing. Microphones collapse on the drum set. Listening returns to its causal mode.

A nearly four-minute stretch separates the beginning of the violent end of Jefferson Airplane's music and the Rolling Stones' "Sympathy for the Devil." The crowd sound is on equal status with the attempt at music, each struggling for our attention. The noise of the crowd wins. The instruments offer guitar feedback and a few disconnected beats of the drum. Sounds of pool cues hitting people punctuate the cacophony of the crowd. Grace Slick's microphone address is futile: "You gotta keep your bodies off each other unless you intend love." Cut to the Grateful Dead discussing the unfortunate events followed by the noise of the crowd waiting. And then the motorcycles overwhelm the crowd—both visually and aurally. Finally, the Rolling Stones arrive onstage.

The crowd sound changes character at this point (so much so that I wonder if it is sound brought from the Madison Square Gardens show). Whistles and applause organize the mass into audience. Jagger addresses them: "There's so many of you . . ." That's all we really need to hear from him. The close-up sagittal shot encourages us to think about Jagger in relation to the mass. Just as with the Jefferson Airplane performance, the crowd disturbs the music to the point that it stops. But before that, the attenuation and enhancement of crowd sound pulls us between reduced and causal listening. The polarity of the music weakens. This festival is not festive (but it *should* be). We feel the struggle within an antagonis-

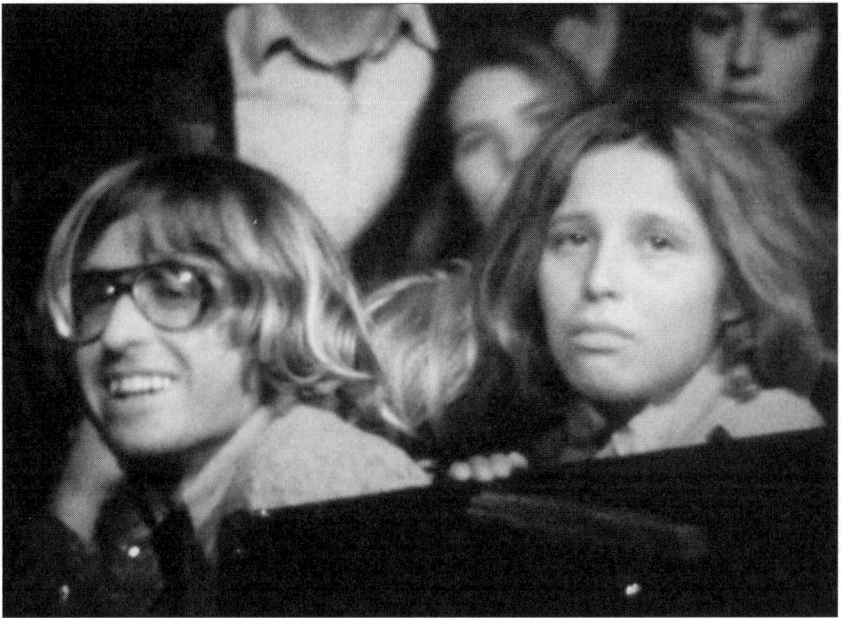

1.5. Man smiles while woman weeps, both moving their heads to the music.

tic sound ecology as we watch images of Jagger's dancing clash with the images of violence. A masterful shot resonates with the juxtaposition of sound and action. In figure 1.5, note the two frontal shots of fans, each reacting to their world. They both move their heads to the music, but one smiles and one weeps. The musical arrangement becomes spare but not for musical purposes. Listening causally, we wonder why the whole band isn't playing. Jagger addresses the crowd halfway in song: "Everybody gotta cool out." Framing the two audience faces together plays with our urge to make this an idealist moment. We may wish to enter into one of these perspectives, but which one? Instead, we are left thinking of their relation and their differences. We also want to experience the music but wonder about the tumult of the crowd.

Music at Altamont is clearly part of the scene. It tempts us to listen in different ways and thwarts our attempts at letting it. The band plays two more songs after struggling with the unruly crowd. During "Under My Thumb," Meredith Hunter is stabbed. After forty-eight minutes since the last time we were in the editing room, we return to the umbrella to re-

watch the stabbing with Jagger and David Maysles. Being brought back is both surprising and marks an end to the film. Not having the umbrella for the Altamont half of the film keeps us in the festival. Also, the editing room was where we learned of the stabbing. Now, catching up to the stabbing ourselves collapses the gap of time between the tour and the review of the footage. Inevitable questions rush in after watching this sequence and then being back in the editing room with the filmmakers and band. You might think, "Does music cause violence?" And again, you might wonder, "Who is to blame?" A consequence of respecting a pluralist film is that it makes room for unsavory arguments. The film met some controversy. Maysles has long defended those who cite the film as an instance of rock music's dangerous potential, connecting the song "Sympathy for the Devil" with the violence.

The final image of Jagger, frozen with a slow zoom, passes the sense of scrutiny to the audience. The cartoonish invitation to look with simulated scrutiny at Jagger conflates our concern for blame with those of the band and the filmmakers. The complexity of the event stands firm. The real details of the media-entertainment apparatus are stronger than the ambiguity of a concert pseudoevent.

The film resists converting the tour into a pseudoevent by preserving the details of the people, the music, and the historical particulars. The images may connote the lemmings returning to their homes, walking through the desert after disaster. In her edit, Zwerin seems to use the lyrics in direct address: "Ooh, see the fire is sweepin' our very street today. Burns like a red coal carpet. Mad bull lost its way. . . . Rape, murder! It's just a shot away." The lyrics resonate with the feeling of precariousness, the loss of idealism (ignoring the optimistic, "love, sister, it's just a kiss away"), to sustain this historic read of the film. It feels like an end to the film, a typical dénouement in tragic dramatic structure following the climactic moment of death. But hold off on that one reading . . .

Conclusion

What makes *Gimme Shelter* such a strong music film is that it allows the viewer/*listener* to experience and think about music in a variety of ways. Zwerin's sensitivity to music contributes to the attention that we can give to the music itself. (The only other rival in Maysles's work is *Horowitz Plays Mozart*, also edited by Zwerin.) My first-ever question

to Albert Maysles in a formal interview was, "Making the films you did about music, did you learn something about music?"

He responded, "I have no education in music, no training, just as I had no training in filmmaking. But I've always had a love for music."

I first took the statement as one of humility. Later, I realized that I had asked the wrong question. He made films about music that allow us to learn about music, not films that hold a particular frame on music. I think about this when remembering that Maysles says he learned to love music by watching his father listen to it. Maysles passes on that type of musical experience to his audience.

When *Gimme Shelter* draws to a close, I accept the suspension of complexity. What strikes me the most, however, is not the image or the threads of narrative. I hear the music differently. In the course of the ninety-minute film, music has been so many things: an instrument of entertainment, a symbol of youth culture, a sound that comes from magnetic tape, a formal arrangement of musical devices, an environmental sound in a melee, the center of a spectacle, a cinematic device, an indication of the band's psychological state and an audience member's psychological state. The film presents to us music in so many different states, often allowing it to change state as we watch and listen. As a film about music, *Gimme Shelter* reveals music to be multifarious. The song "Gimme Shelter," now in direct address, detaches from the image and shows us that there is no such thing as plain music—it is always connected to our ideas of music and how we listen to it. Having been throughout the apparatus of a rock tour, we have leapt through space and time with an eye for what music is and where music is.

When speaking to Maysles about his work, it felt as if we were both discovering new things, that we were on common ground. Even as he sat with me during our final interview, jaundiced from pancreatic cancer, he lit up at discovery, never asserting authorial intent or mastery. He certainly had the right to. His last visit to Washington, DC, had been to accept the National Medal of Arts from President Barack Obama. His cinema—structured by elements of both direct cinema and classical Hollywood cinema—provides a unique and profound view.

I'll leave Maysles to explain in his own words: "So actually—and I like to say this—if the camera is really good, it's better than being there. Because most people don't see it quite as profoundly."

In *Gimme Shelter*, the profundity is the plurality. Music is a great many things and it is our experiences of music that make it those things. What Maysles did is save music from being defined as one thing. The film lets us witness his love for music, a love that allows music to be a great number of things and to retain its fundamental complexity.

2 REPRESENTING THE MARGINS AND UNDERREPRESENTING THE REAL
Jill Godmilow, *Antonia: A Portrait of the Woman* (1974)

Jill Godmilow has explored cinema's usefulness since she became an independent filmmaker, first by participating in feminist dialogue and then by critiquing film's relationship to what she calls the compassionate liberal audience of documentary cinema. Like many who wished to ignite debate over gender issues, Godmilow began working on consciousness-raising films—ones with the specific intent of providing fodder for emerging feminist discussion. Both film and music became tools to bring detail and urgency to issues. Godmilow's work framed, amplified, and disseminated voices that had been silenced.

Godmilow began as a commercial editor, first syncing dailies in New York for television ads, then advancing from assistant editor to editor, cutting documentaries and after-school television specials. She relocated to San Francisco to edit for KQED and then on to Hollywood, where she worked on *The Godfather* (1972) and *The Candidate* (1972). Eventually, she grew tired of commercial editing and returned to New York. That's when she got a call from Judy Collins about filming the conductor Antonia Brico: "Jill, I'm on my way to Denver in two days, to give a concert, and *Ms.* magazine has asked me to write an article about a major female role model of mine, this woman who was my piano teacher. The drummer in my band has a Bolex [camera]" (Godmilow in MacDonald 2005: 129).

The result was *Antonia: Portrait of the Woman*. The film does more than tell a story. It brings women's subject position to the symphony orchestra—a practice of music with an asymmetrical power structure. Strategic use of interview and music in *Antonia* introduces different and often conflicting ways of being. Godmilow's later films were radical challenges to the truth claims of documentary. Her call for postrealist agitprop is an extension of what (at the time) was a radical turn in documentary. The final part of the chapter offers a proposal for a postrealist cinema of music. There are seeds of Godmilow's postrealist turn in *Antonia*. Examining these seeds in relation to her later work is the focus of the final section. The title of the chapter reflects the dual focus on *representing the margins* with *Antonia* and *underrepresenting the real* with her later focus on postrealist cinema. But we should start at the beginning, because even the most radical ideas come from somewhere, and this somewhere was a significant historical moment of documentary film and popular music in general.

1973

Antonia did not just express the sentiment of the times; it was part of the action of the times. The idea for the film came out of a feminist magazine and ended up screening nationally for feminist groups. Second-wave feminist efforts had followed the protests of the 1960s (civil rights and Vietnam). New task force groups began to develop around various core social issues. The "consciousness-raising" of the feminist groups involved holding meetings with women to discuss and critique real issues that had been publicly ignored; for example, domestic violence, rape, workplace equality, reproductive rights, and sexuality. The year that *Antonia* was in production was another year of critical efforts by and for women. The term "sexual harassment" became used to describe a tacit, everyday reality in women's lives. The *Roe v. Wade* ruling was a victory for reproductive rights and a loosening of paternalistic control over women's bodies.

Some discussions of women's competitive abilities were enlivened by public acts. In 1973, tennis player Billie Jean King defeated Bobby Riggs in an exhibition match entitled "The Battle of the Sexes." Riggs had wagered $100,000 that he could beat King, since he felt the men's game of tennis to be categorically superior to that of the women's. King's victory not only

inspired young women to play tennis but, more fundamentally, it challenged gender roles. King gave fodder to the claim that it was acceptable for American women to exert themselves in pursuits other than motherhood. In a parallel move, Godmilow's film included a series of newspaper clippings from the 1930s that questioned whether women could conduct or play in symphony orchestras. In our interview Godmilow doesn't recall having referenced Billie Jean King's challenge in her film. She does, however, see them both as examples of speaking to power. As she explains, "It was a moment where the feminist movement was rebutting idiotic gender statements like that. So it's not surprising that these things happened at the same time."

Godmilow mentions a number of similar projects of the time that were sympathetic to her own interest in historical revision. In 1974, the year that *Antonia* was released, artist Judy Chicago began working on *Dinner Party*. The installation presents place settings on a triangular table for thirty-nine historically or mythically important women. Each plate incorporates the shape of a vagina. The early 1970s were not only years of pointing to the contributions of women but also of documenting influential women—borrowing from Chicago's metaphor, of bringing them to the table. Godmilow reflects on the significance of Chicago's project: "There are those thirty[-nine] plates of women you've never heard of, who were important, so it was a recovery time. 'Let's get us back into the archive, back into the public.' I think that in general." Though *Dinner Party* wasn't finished until 1979, it's easy to envision a place setting at that table for Antonia Brico.

Speaking of Brico's personal archive and professional activity, Godmilow says, "She had the goods! She was someone who kept every clipping. This is rare. She was still doing it, taught for real. She's like a real, very whole, real person about her craft with every student and still had this orchestra which she conducts four times a year." Brico was more than an inspiration. The fact that she is not in *the* archives—that her archive is at her home—speaks volumes. Newspaper clippings, correspondence, and audio recordings themselves have yet to make it from the privacy of her home to the public institution of an archive. She was the first woman to conduct the New York Philharmonic. She conducted the Federal Orchestra at the 1939 New York World's Fair. She had the visual evidence—documentation to show her story—and she could still conduct

major symphony orchestras. Brico had verified talent as a conductor that was not only evident from her performance but by the record of evidence. She made her debut with the Berlin Philharmonic Orchestra in 1930 to great media attention. Brico's story could become rhetorically powerful as a forgotten story of heroism. Film could help make her archive and her performance abilities more public.

(Underrepresented) Voices in Film

Feminist cinema emerged from a particular practice of consciousness-raising that had begun in print. Publications such as *Redstockings Manifesto* (1969), *A Program for Feminist "Consciousness-raising"* (1968), and *The Politics of Housework* (1970) began speaking to power in consort. Consciousness-raising began with group meetings in which women made links between personal experience and larger power structures. This was decidedly not group therapy. In Pamela Allen's influential pamphlet, *Free Space: A Perspective on the Small Group in Women's Liberation*, she qualifies that the "total group process is not therapy because we try to find the social causes for our experiences and the possible programs for changing these" (1970: 30). Consciousness-raising had to move beyond therapeutic experiences. Therapy, in fact, had been a patriarchal tool. In *Women and Madness* ([1972] 2005), Phyllis Chesler criticized the patriarchal male therapist-female client relationship in which the female client submits to the male expert—and if not, is deemed mentally ill. (See Hare-Mustin 1978 and Brown 2004 for more on feminist therapy.) Rather, women's experiences were moved from the personal realm to the political realm, bypassing the male therapist. The move became a memorable slogan: *the personal is the political*.

A new political cinema was rooted in analytic and instrumental practices that stretched before 1960s publications. Cinema disseminated women's kitchen-table discussions beyond the home and into public screenings and discussion. It was a way of transforming old tools through a mass medium. Julia Lesage connects political voice and art:

> Women have traditionally constantly consulted with each other about domestic matters. One of the functions of the consciousness-raising group of the contemporary women's movement is to use an older form of subcultural resistance, women's conversation, in a new way.

There is a knowledge that is already there about domestic life, but it has not necessarily been spoken in uncolonized, women-identified terms. Women's art, especially the Feminist documentary films, like consciousness-raising groups, strive to find a new way of speaking about what we have collectively known as really there in the domestic sphere and to wrest back our identity there in women's terms. (1978: 517)

Notable early films include Jim Klein and Julia Reichert's *Growing Up Female* (1971) and Catherine Allen, Judy Irola, Allie Light, and Joan Musante's *Self-Health* (1974).

In 1973 Judy Collins published an article about her development as a woman musician for a new feminist publication. Godmilow remembers: "*Ms.* had just been born—*Ms.* magazine. They interviewed Judy. She was top of her form. They asked her if there had been any women in her life, and she remembered Antonia, her piano teacher." Brico had been her piano teacher in Denver from about age ten to sixteen.

Brico was preparing for a concerto with her young piano student and the Denver Businessman's Orchestra. Godmilow describes how she was enlisted by Collins:

The piano player in her band (who I happened to know, actually) said, "Why don't you shoot it? Get the very beginning of the moment,"—and it was still 16mm; there was no [U-matic] three-quarter-inch video or anything like that. [He] said, "Why don't you film it?" We had met. She had seen this very first film of mine because of a mutual friend. She didn't know any filmmakers so she called me up and she said would I shoot it? She was going out there, would I shoot the interview? "I don't shoot, but I can put a crew together, [a] small, basic crew together in three days." She was going out there in three days. I said, "If you can pay for it." I roughed up some numbers. And she said, "Okay." The very beginning part of the interviews, when she's in her white and black, more formal, sitting in her living room, not at the kitchen table, we got that and we shot her rehearsing the Brico Symphony Orchestra in the Pillar of Fire Church.

Godmilow had an eye for bringing out critical issues in Brico's story. The turn to a complex feminist issue came when she heard Brico com-

plain that it was women, not men, who blocked her career. In our interview, Godmilow recalls making that discovery when working with Brico.

> Maybe the most important thing [is] when she says—which surprised me at the time—when she said it was women who had been her biggest enemy in terms of the ladies of the Cactus Club who said, "Well, how can we have a woman symphony conductor when we can't invite her to the Cactus Club?" (an all-male club). In some way, there you see patriarchy bigger than Antonia and how important the conductor of the symphony orchestra would be to be able to have him in the private men's club. And the whole thing is transparent from there on. So that, I thought, was worth everything.

Godmilow explains how she pitched the project to Collins: "We [had] shot those two things. Then I said to Judy, I said, 'Actually, there's an interesting film here.' I didn't have to work too hard, but she eventually agreed to fund it. Then we went back and learned more. But it all came from Antonia's life. I had never thought about why there were no woman conductors and here's why. Here's what it took to just get that far." Stories were important tools for consciousness-raising and advocating for women. Stories can develop awareness, reveal power structures, encourage empathy, and personal stories can seem to lay truth bare.

I ask Godmilow about her strategies for bringing out voices in film. "I'd say it's not about running around all the time," she says, "filming them in their daily life. [The Maysleses'] *Salesmen* is a perfect model of that, a beautiful film." Then, Godmilow makes a distinction between what can be observed and what can be extracted from a person and presented. Speaking of the way that she approached filming people during the early feminist movement, she says,

> This feminist film moment had slightly different terms. It wasn't about strict cinéma vérité and all the lies that were told about it and all the games that were played underneath it. . . . *What they know* is worth filming and fashioning into a document somehow. *What they know*—these women who have been written out, who never got to do it in the first place, and whose stories about that have been written out. Sit down, put the camera on the tripod, and get it out of them and record it. . . . This kind of interview thing started [to find] a big place

in women's cinema. I don't know if that's true about men's cinema at the time. I've never thought about it. . . . We were really *just* beginning to make films . . . and suddenly, there was special funding for women filmmakers and women's films. We were just finding our voice, and somehow interviewing women who had had lives was the first impulse.

Godmilow was part of a group of filmmakers who learned how to bring out testimony. They changed how people thought about documentary by making personal stories political. On the heels of direct cinema, feminist filmmakers understood the fallacy of observational cinema's truth claims. The Maysleses may have used cinema to advocate for a pluralistic nature of truth, but feminists knew that the camera is part of gendered power dynamics that exist in public life. Observing alone will capture only women's silences, their inability to speak in public. A participatory mode is therefore necessary to get *their* truths—when women are "witness-participants" in the film. Bill Nichols writes about this moment in which documentary film "incorporates direct address (characters or narrator speaking directly to the viewer), usually in the form of the interview. In a host of political and feminist films, witness-participants step before the camera to tell their story. Sometimes profoundly revealing, sometimes fragmented and incomplete, such films have provided the central model for contemporary documentary" (1983: 17).[1] The early return of the interview, while resembling a return to direct-address exposition, did more to express subject position—personal voices that spoke to experiences of the marginalized. The visible social actor replaces the invisible authoritative narrator. These films were useful in consciousness-raising.

Distributing *Antonia* on her own, Godmilow reached out nationally to women's groups and proposed screenings. As a result, it did plenty of memorable consciousness-raising work. Godmilow remembers: "The feminist movement was happening, and there was an audience of women, hungry. I mean, I still have people come up to [me], you know, people my age, 'I saw that in the Brattlebury Theater in Massachusetts, and I remember it!' It was a strong experience for people then."

The film received numerous accolades. Among them was the New York Film Critics Circle "Best Documentary" award, a nomination for an Academy Award for best documentary, and making the list for the top

ten movies of 1974 in *Time Magazine*. It broadcast in eleven countries. It was also the first documentary to have such an extensive theatrical run. In 2003, it was added to the Library of Congress National Film Registry. The success of the film made Godmilow a fundable filmmaker. She has received a Guggenheim fellowship and grants from the National Endowments for the Arts, the New York State Institute for the Humanities, and the New York State Council for the Arts. From 1992 to 2013 she taught at the University of Notre Dame, where she enjoyed the productive independence in her critical work that tenure offers.

The initial release of *Antonia* briefly reinvigorated Brico's career. Then the conductor returned to relative obscurity. In 1989 she passed away in a Denver nursing home. The film had given her a final chance to play her instrument—the symphony orchestra.

The following analysis of certain scenes from the film shows how Godmilow's editorial choices gave rise to a film that brings subject position to the symphony orchestra and in so doing reveals institutional disadvantages that women face.

Thinking through Cinematic and Musical Subject Positions

Examining the film requires a keen understanding of the difference between Brico and *Antonia*—between the woman and the portrait. Brico was not a spokeswoman for second-wave feminists. The *representation* of Brico in the film presents issues by constructing Brico's relationship to her craft. Brico began conducting at the tail end of first-wave feminism. As a minor part of that first wave, women sought orchestral positions. Rather than integrating, most formed all-women's symphonies in the 1920s and '30s. The new women's orchestras offered a few opportunities for female conductors. This musical ghetto was generally one of popular novelty acts—a spectacle of women playing "serious" music. But these orchestras had started to decline during Brico's emergence in the 1930s. Brico became the first American to graduate from the famed Berlin State Academy of Music in 1929 and the first woman to lead the Berlin Philharmonic in 1930, but her career timing was unfortunate. Back in the United States, government-sponsored concerts had kept musicians working through the Great Depression (Macleod 2001: 128), but these orchestras began to fade during World War II. Women began to take empty seats in men's orchestras as conscripted symphony players

left to fight in the war (see Hinley 1984b: 43–44; Jagow 1998: 131; and Edwards 2003: 222–27). She successfully led all-women's groups but had less success with mixed groups. Between the waves of feminism, Brico was not a spokesperson for a cause (Edwards 2003: 224). She was a working conductor and would have had less time to speak to women's causes even if there were an organized group.

In Brico, Godmilow found a topic that spoke to larger issues of gender (limited access to professional roles), but she also found a dynamic witness-participant. Brico could tell her story—she was a fantastic storyteller—but also in a way that seemed both genuine and fragmented. Godmilow tells me, "She was the most fabulous subject anyone will ever have in front of a camera. She didn't have a media image of herself, so she's forthcoming in some way." Brico didn't watch movies or television. She had plenty of media attention through her early career but had never learned how to conduct herself on camera. She had no ready-for-television backstory. She had complexity.

The film *Antonia* investigates the patriarchal nature of the symphony orchestra by aligning its audience with the complex and shifting subject positions of Antonia Brico. Image and sound as well as the representation of time and space operate to complicate Brico's subject position. As a result, the film reveals the social nature of musicmaking and questions the gendered role of the conductor. *Antonia* does not offer a series of coherent facts that create a story. But because so many documentaries attempt thorough historical storytelling, *Antonia* can leave its audience wondering about the details of Brico's story. Its factual omissions offer a more productive sense of her complicated relationship to conducting. For a consciousness-raising group, the stories and their incongruities are more useful because they offer problems to dwell upon—gaps to fill with questions and ideas. Elsewhere, Godmilow has been unapologetic in her stance: "I am not interested in establishing the facts and the quote 'objective truth' about a situation. I am not interested in that documentary. I am interested in people and how they relate to their story" (in Rosenthal 1980: 365). Feminist poststructuralists have used the contradictions of female perspectives as opportunities to understand what it means to be gendered (Haug 1987: 68–69). Understanding oneself as contradictory rather than being a whole self offers richer understanding. Coherence is detrimental to expanding knowledge, for it dissolves contradictions.

This is the advantage of portraiture—a composed, focused rendering of a person's features—as opposed to biography. We are allowed the space of Brico's inconsistencies as well as a sense of our own shifting positions as we see and hear a woman conductor, a conductor who happens to be a woman, or any other set of relations between those two identities. Music plays a strong part in helping us think through Brico's story.

I will use the term "vicarity" to refer to the experience of occupying the perspective of another. Vicarity takes two important forms: one that looks outward and one that listens inward. Inner vicarity is a view of the interior life of another. Outer vicarity offers a sense of social positioning, often presented as relations within a system of power. Both are related and often experienced simultaneously, but the frame of the camera and the reach of the microphone can direct our attention to this distinction of how we enter subject positions in film. *Antonia* uses both of these vicarities to push on the patriarchal role of the conductor. The feminist deployment of interview was a strategy to introduce the many positions that women occupy within systems of power.

A problem in understanding subject position and music is that the concept has been mostly theorized with respect to the eye. In addition, little has been offered to detail on the cinematic construction of "musical vicarity"—how we are drawn into various subject positions through musical means. I'd like to bring together two lines of thought before examining details of *Antonia* below. One theoretical perspective lies at the center of 1970s feminist cinema, another springs from ethnomusicology following a critique of the "culture concept" that began in the 1990s.[2] My intention is to bring together views on how cinema and music position people—those we see on-screen and ourselves as we watch and listen. It is beyond the scope of this chapter to summarize all of the ways in which subject position has been theorized, so consider this to be a way of developing a workable theory of cinematic presentations of musical subject positions. Finding a meeting place within film studies and ethnomusicology may offer a first sketch of such a perspective.

Perhaps the most rigorous theorizing of subject position has been in poststructuralist film studies, beginning with Laura Mulvey's critique of classical Hollywood narrative (1975). Mulvey draws from psychoanalyst Jacques Lacan to identify the pleasure of the male gaze—a cinematic per-

spective that offers men a way of securing their own subject position by becoming spectators of images of women. Lacan's notion of scopophilia (the pleasure of looking) presents an opportunity to diagnose the pathological need for male mastery over the female object.[3] The term "subject position" draws from linguistics. In Mulvey's analysis, the camera gives male *subjects* agency, while female *objects* are acted upon. The "male gaze" is produced when lookers see or imagine other lookers and vicariously enter into a relationship of power. The gaze is a system of looks that can be deconstructed. The subject-verb-object structure (e.g., man-does-woman) places the spectator in a position of the male subject. Mulvey's deconstruction of cinematic "grammar" reveals an instrumental means of maintaining the male gaze and denying women subject position in classical cinema.

Mulvey's analysis of the image reveals visual tactics that maintain the male gaze by ensuring that female objects stay objects. Tilt shots and close-ups of women's bodies fragment the character into a collection of body parts. Point-of-view combinations begin with the male protagonist looking offscreen; a cut reveals the woman's body to be the object of his look; another cut returns us to a man's face so we may read his reaction. Narratively, female characters tend to slow the story down, giving an opportunity for the male protagonist to push forward. Analysis of subject position allows us to look not at content but also at the formal operations of the film that constitute our perception of the content. Following Mulvey, film can be deconstructed by explaining how we enter into the gaze of the protagonist.[4] Not all films do this, but the male gaze pervades the spectatorship of classical Hollywood cinema. Succumbing to scopophilia, the viewer takes on his active subject position, assuming a vicarious position of control and power.

Moments of vicarity are less clear when extended beyond feminist critique of patriarchy in classical Hollywood films. In a revision of Mulvey's theory, film scholar Sheila Johnston suggests that a spectrum can offer a general theory of subject position. This spectrum reduces "infinite pluralism" or widens a conscripted singular gaze. She defines subject position as "the way in which a film solicits, demands even, a certain closely circumscribed response from the reader by means of its own formal operations (1985: 245). This broadening of the concept also leads toward an

aural equivalent of the gaze. Johnston's wider understanding of subject position can make room for theories about how music positions a subject.

The ethnomusicologist Tim Rice offers an analytic model that considers musical subject-positioning (2003). Rice suggests that scholars and their subjects share ways of thinking about music. In his three-dimensional scheme, Rice proposes that we can think about interactions between individual musical experiences and larger world systems by correlating time, location, and metaphors—fundamental beliefs about what music is. Considering these three dimensions can explain change in musical meaning.[5] Plotting courses within time, space, and metaphor reveals how our positions affect our understanding of music. "It is the space in which scholars, musicians, and audiences know the passage of time, savor music's differing essences, meanings, and metaphoric connections to other domains of culture, and feel the gradations of power as we move (if at times only conceptually) from locale to locale" (Rice 2003: 174). In a revision of subject position, we might say that music is a malleable practice that has meaning tied to position. Extending Rice's model, consider the role that emotion plays in committing us to certain positions and accounting for an aural equivalent of the gaze. Bronwyn Davies and Rom Harré suggest that subject position involves learned social categories toward which people develop an *emotional commitment* (1990: 47). Thus, emotions can commit us to a certain time-space-metaphor understanding of music to produce certain feelings.[6] Thinking about subject position can help us deconstruct how people enter into that position and how that position may be different.

An addition of *feeling* to Rice's three-dimensional scheme may account for a musical gaze, which I will investigate next in relation to the film. Pulling away from the visual and the psychoanalytic, cultural critic Paul Smith revises the term "subject" to mean "the series or conglomerate of positions, subject-positions, provisional and not necessarily indefeasible, in which a person is momentarily called by the discourses and the world he/she inhabits" (1988: xxxv). Such a revision provides an opening for understanding how this film works on subject position.

Antonia brings us to several of those positions, sometimes from Brico's position and sometimes from nearby. As a result, we gain an understanding of Brico's challenges. We also witness many ways in which music is

meaningful to Brico. Watching *Antonia* involves moving within Rice's three dimensions as cinematically constructed vicarities pull us into different subject positions. The film asks us what orchestral music is, pushing us through time and space, to engage with orchestral music being a great number of things. As we follow the film, we are able to witness music as different metaphors: as art, as the sound of collaboration, as a patriarchal structure, as a competition, as a badge of prestige, and as family. Examining vicarity shifts our analysis away from describing inscribed subject positions toward the nature of positioning—the degrees to which an audience empathizes with the subject and the shifting nature of those positions.

Vicarity is constructed in cinema. Shots, cuts, framing, music, and sound design all contribute to an audience's relation to the person represented on-screen. In *Antonia*, vicarity is an important part of feeling the fractured ways of being a woman conductor, of sensing a relation to Brico and Brico's relation to her world and her history, including Brico's often-contradictory relationships to music. I will map out a few of these as subject positions shift within this portrait of Antonia Brico.

Cornering a Pioneer in the Kitchen

Antonia Brico certainly faced a career struggle with patriarchy, but she was reluctant to speak publicly about it. She did not identify as a feminist and, furthermore, she didn't want to threaten future opportunities to perform. Godmilow made Brico's reluctance an asset to the film. The kitchen-sequence edit uses shifting subject positionality and music to reveal the tension between being a pioneer and being an active musician. First, Godmilow needed Brico to speak about gender exclusion.

As a former student, Judy Collins was somewhat of a confidante. But Brico was not ready to publicly express emotion about her story. She wanted her story told in a composed manner—as you would expect of a dignified conductor who had led some of the most prestigious symphony orchestras in the world. But Godmilow needed an emotional expression for the film. Godmilow recounts how they got an emotional response: "We did provoke her that one time. She didn't want to show her anger. She wanted to tell her stories . . . We got her riled up. . . . We worked it out. We actually had a little meeting, Judy and I. 'How are we going to get her interview?' We decided on this one line: 'But Antonia, you were a *pio-*

neer.' And so we just sank that line at her in the middle of that interview, hoping that it's not enough to be called a pioneer in a book somewhere."

After a few attempts in the kitchen, it did work. Godmilow signaled for the cinematographer Coulter Watt to start shooting. The kitchen was small and that, for Godmilow, was fortuitous. The wide-angle lens and handheld camera shooting from a low position all give a feeling of being present. It feels like a spontaneous moment. Brico is a force to be reckoned with. "It seemed important," Godmilow recalls, "that the film hear the pain and hear that 'pioneer' is not enough for anybody. You want to conduct an orchestra."

Historically, pioneer status has been a common grievance among women who moved into male-dominated orchestras. That grievance was particularly felt as second-wave feminists began to realize that entry into male-dominated fields wasn't a simple victory; it brought new problems. Pioneers occupy minority positions that have high visibility, tend to polarize the organization, and offer the limited opportunities of assimilating to dominant characteristics of the group (Katner in Allmendinger and Hackman 1995: 426).

In the film, Brico doesn't speak about the problems of being a female conductor until provoked in the kitchen. The scene does two things: It presents Brico's direct challenge to patriarchy and it attenuates vicarity. With this latter effect, Brico is angry with us in both senses of the word "with." Together, we direct our anger toward patriarchy of the orchestra; but the editing also directs Brico's anger toward the spectator who may realize that seeing Brico as a pioneer reduces her potential as a working conductor.

In the opening shot of the sequence, Brico is shot from below, made to tower above us in her kitchen. "How would it feel to you if you had, in the whole year, four performances?" Brico asks. "Would you like that? I have four, I have five performances a year. I'm strong enough to have five performances a month."

Her words are sharp and pointed.

"I'm essentially a creative artist. . . . I'm squeezed. I'm frustrated," she adds.

A subtle but important edit influences how we understand the anger. The camera pushes in to a close-up of Brico and then cuts to more of a side view, also close-up. The shift of head position away from a frontal

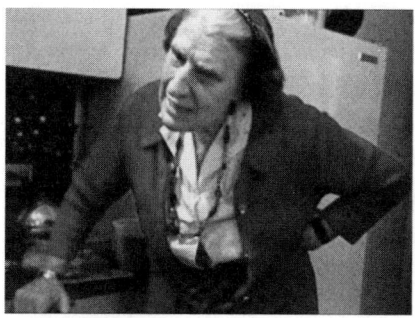

2.1. Framing Brico's anger.

view changes how we register the anger, empathizing less and wondering more (figure 2.1). As we see less of her face, we sense the anger as a thing itself—a sentiment directed offscreen.

Brico then continues: "I cannot play my instrument, which is the orchestra. I get an opportunity like last Sunday. I was extraordinarily happy. And that's one. That's like giving a starving person a piece of bread after days of hunger."

Brico issues that last statement somewhere out of the frame, likely toward the film crew. Her anger has direction and we apprehend the film more reflexively, aware of the constructed nature of the film.

Recall that this palpable frustration follows the successful debut of Brico's student Helen Palacas, during which Brico seems to be a trailblazing female conductor who encourages a young woman to command the concert stage. The abrupt cut to the kitchen is a forceful interruption of whatever sense of pioneer-nurturing surrounds watching Palacas backstage. With the strong cut, Brico (or perhaps we should say Godmilow) tells us that it is not enough to be a nurturer. The construction of this sequence offers a strong sense of conflicting musical metaphors—music as vital and music as patriarchal. The unstable vicarity of this sequence is the most powerful aspect, pulling across Brico's conflicting relationships to music and the film audience's relationship to Brico: feeling warmth toward a nurturer, anger with patriarchy, or reflexively questioning our complicity in reducing her to a mere pioneer.

Brico's discomfort with being a pioneer reveals the fault lines of being a woman conductor who operates both within and against a patriarchal structure. This fault line aligns with two temporalities that we experi-

ence in the film. Godmilow's edit puts Brico the pioneer in the cinematic equivalent of past tense and Brico the practitioner in present tense. Sound plays a major role in establishing these temporalities. The sound of the past tense is generally that of Brico's isolated voice as she tells her stories. The sound of the present is of an ecology of sound: spatial relation, music, dialogue, and ambient noise. Events unfolding on camera have a realism brought from the immediacy of the observational mode (see Sesonske 1980 for a discussion of the role of sound in cinematic tense).

The film continually moves to the present tense. To stay in past tense would be to relegate her to being a pioneer. Diegetic sound (as opposed to nondiegetic or cross diegetic isolated voice) establishes these two tenses, which reinforce the difference between pioneer and active conductor. The two temporal spaces push against each other. If taking the present tense of the film as primary, the stories that Brico tells function as analepses, flashbacks that shift the way we see the performance and rehearsals in Denver. If taking the past tense as primary, the shots of the concert and rehearsals are prolepses pulling us forward across the temporal gap between the young Brico forcefully conducting the Berlin Philharmonic in 1930 and the old yet still highly skilled conductor of an amateur group in 1973 Denver, asking along the way, "How did she wind up here?"

In the kitchen scene, Brico speaks forcefully in the present tense and in second person. As we awaken to our historical gaze at a pioneer, she confronts our gaze. The kitchen scene presents a temporal discontinuity as if to ask a different question: "Why do you want me in the past tense?" Brico forcefully speaks to our (and her) account of her career.

It is not just the words that deliver; it is Godmilow's cinematic delivery. The shaky camera gives a sense of immediacy. The unexpected placement in the film catches us off guard. (We were just with her piano student after her debut.) But Godmilow's cinematic delivery is also a musical delivery with an intercut piano lesson that shows Palacas playing Chopin's Ballade in F major—interestingly, a piece that Chopin dedicated to Schumann, whose concerto is the one that Palacas performs with the orchestra. The carefully edited music of the lesson scores the end of the kitchen sequence and happens to modulate from F major to A minor (the same key as the Schumann concerto). The ballade's strong contrast between stormy and calm thematic sections underscores Brico's unleashed anger

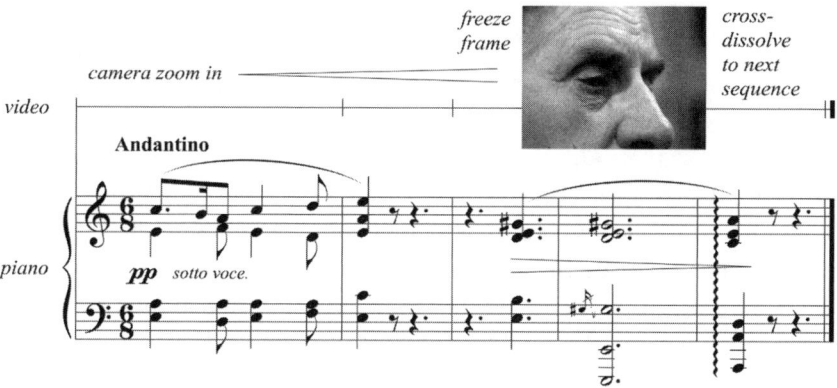

2.2. Freeze-frame at end of kitchen sequence.

and return to composure. Gradually, the music's intensity decreases, offering an emotional ramp that connects initial anger to a more composed Brico.

As Palacas plays, Brico is noticeably detached, as if not participating in her own film out of protest or perhaps because she is lost in thought. It resembles the moment in argument when the other person takes space before returning to conversation. At the very end of the sequence, the camera pushes into an extreme close-up of Brico looking to the right. Her returned composure mirrors the Chopin ballade; the return to rhythmic, dynamic, and textural peace is inflected with the presence of the theme now cast in the key of A minor. A brief freeze-frame does what freeze-frames usually do: It brings open-ended conclusion to the scene, a narrative irresolution that coincides with the musical irresolution of a sustained dominant chord (figure 2.2). The piano resolves to the A minor chord only after the transition to the next sequence, returning us to Brico's public world—rehearsing the Denver Businessman's Orchestra.

Godmilow says that the kitchen scene helped with the success of the film: "People loved [Brico] for it. The response to the film—which was extraordinary—had a lot to do with that. People feeling that she had been real." But that is not the full power of the scene. Brico in the kitchen is not the "real" Brico. It is one of her contradictory ways of being, the one who, surprisingly, is insulted at being called a pioneer.

Brico had no idea that her frustration would be broadcast so wide. Right after the shoot, she was angry, saying to Godmilow and Collins,

"It's all very fine for you to bring these feelings out and then leave with it on your film, but I have to live with them" (in Rosenthal 1980: 366–67). In a later interview, Brico acknowledges that having been caught off guard was productive: "If I'd had any idea about the distribution, the reviews, the Oscar nomination, . . . I would have been unable to express myself as well" (in Macleod 2001: 138).

For an audience looking for role models, Brico fits the bill of being a pioneer. The archives welcome pioneers, but Brico was not ready to be shoved away. Throughout her career, she wanted to conduct. In a 1933 interview she says, "It is my lot to be a woman. I want to conduct orchestras" (in Macleod 2001: 130). In a 1975 lecture, Brico sustains her sentiment: "And don't anybody ever say Brico [is] a 'woman conductor' . . . I am a conductor, period" (in Christensen 2000: 99). She probably would have preferred the subtitle of the film to be "A Portrait of the Conductor." In fact, she wasn't just the first American woman to graduate from the Berlin Academy; she was the first *American* to do so. This problem of musical practice was more useful for the film—that being a "woman conductor" can occlude one from being an active conductor.

Framing the Conductor

The most obvious question that arises throughout and after seeing the film is, "Why not Brico?" We wonder about lack of recognition not because experts tell us about her greatness and discuss these hardships of the woman conductor but because Godmilow allows us perspective into her conducting. The perspective offered in *Antonia* is twofold because to lead an orchestra a conductor must deal with both social and musical complexities.[7] Traditionally done by men, conducting is a gendered, elite musical practice that involves an asymmetrical power structure between conductor and orchestra members (Allmendinger and Hackman 1995: 424). A woman in charge of an elite organization upsets notions of natural male leadership. Orchestral members are often prone to conflict with conductors; adding misogyny is a variation on the theme (Cheng 1998: 83). And yet, Brico's conducting is compelling because of its musicality.

Conducting transmits music through the eye, evident in the gaze of the conductor. That visual pathway into the music is cluttered with complications of gender. For a female conductor, the visual aspects of gesture,

clothing, and direction present a conflict of gendered traits. When they do ascend, women are often in a double bind of choosing masculinity or femininity in their conducting styles. Conducting is tacitly male. In her examination of pedagogical literature, Brydie-Leigh Bartleet finds that "the conductor's body is always discussed as though it is an 'unmarked' male entity. Such discourses examine a conductor's arms, hands, neck, face, posture, and legs and so on, without any consideration of how these corporeal regions are inscribed with societal, cultural, political and gendered significance" (2008b: 42). Some studies of women conductors stress the differences between the authoritarian approach of male leadership and the team approach of female leadership, suggesting that when women adopt the former, they risk being accused of being "bossy" (Hinley 1984a: 33–34; Cheng 1998: 83; Bartleet 2003: 232; Edwards 2003: 226). Others, however, suggest that the male and female characteristics are generally employed by all conductors, regardless of their sex (Bartleet 2003: 231; Bartleet 2008b: 9–10).

Brico has a range of conducting styles that both conform to and differ from dominant masculine traits. Godmilow's editing presents Brico's conducting in a way that presents a wider view of conductor traits, shaking the gendered stereotypes of the role. The frame influences how we apprehend the music—as the complex management of sounding bodies and as the formal interplay of sound listened to with aid of an interpreter. Put another way, we *watch* social dynamics through the collaboration of making music and we *listen* to music differently when gesture accompanies sound. At a basic level, wide shots encourage us to watch and long takes encourage us to listen. Watching the orchestra has long been part of the experience of its music, and that has implications for what the music is. Before analyzing the different subject positions presented in Brico's conducting, consider how cinema brings the orchestra to the eye and to the ear.

In his psychoanalysis of orchestral performance, David Schwarz examines how the visual arrangement of the modern orchestra impacts audience experiences of orchestral music. Tracing the development of the conductor from the dually led eighteenth-century Kapellmeister and concertmaster (the composer's proxy and the timekeeper, respectively), Schwarz describes early anxieties over the new role of a single director

holding only a baton to direct complex masterworks. Of note is why some rejected what now seems natural when a conductor leads an orchestra. His example of an 1836 letter from Moritz Hauptmann is a good example:

> The accursed white-wooden baton irritated me, and when I have to see that thing dominate, all music vanishes. It is as if the entire opera is only there so that a baton can beat time to it, to mark all of its most delicate nuances with this little stick. Perhaps it is necessary, but if I think of the maestro sitting so peacefully at the keyboard and accompanying the recitative precisely, as if everything was happening on its own, I am in another sphere entirely, heavens away from our crude and barbaric present, in which all dignity seems naked and exposed. (In Schwarz 2006: 21)

Hauptmann's objection with the visual addition of the singular conductor is that the music is oriented around the conductor instead of being diffused through the ensemble. Schwarz suggests that the conductor offers us a singular subject position in the figure of the authoritative conductor whose duty is to interpret complex and technically challenging music. He describes a conductor walking onto the stage, facing the audience in recognition, and then turning to address the orchestra. As the musicians meet the look of the conductor, his look is reflected in their eyes. The gaze structures the performance. The modern conductor calls the masterwork into existence through the power of his gaze and his gesture. The orchestral gaze is one of directing the orchestra, a technical mastery of a group of musicians voiced in sound. You can close your eyes, but as Schwarz argues, "What happens when you open your eyes in an orchestral concert is not that you feast your eyes as if looking at a painting; you see instead the brute instrumentality at the heart of the modern musical masterwork" (2006: 25). In cinema, a wide shot from well behind the conductor includes the sense of gazes—power over both music and musicians.

Wide shots in *Antonia* back up the reviews she often got in the press, ones that happened to stress masculine traits: "strongly talented," "authoritative," and, "her beat is firm, her rhythmic sense is certain, and she has genuine authority over her players" (in Macleod 2001: 128, 132). What we watch confirms these reviews. She is unapologetic. She leads with force. There is no time to make people feel okay about errors. In a

shot of her conducting, seventeen minutes into the film, she is filmed from below. The low angle makes her appear powerful—or, we might say, confirms her power and importance.

In *Antonia*, the shots of Brico are from the perspective of the orchestra. Zooming in frames out the other players so that we can see only the conducting—rich with details of motion and expression. Brico studied with Karl Muck, known for working out every nuance of phrase and passing them on to the orchestra with small reserved gestures. When the human objects (musicians) are out of sight, the sound object (music) remains alongside gesture. Her gestures are not framed as leadership but as a means of showing us how to listen. Musical interpretation, in fact, is one of a conductor's primary tasks. Through Brico's gestures we enter into play with sound, momentarily unaware of the submissive position of the orchestral members. It is better than closing your eyes at a concert. Brico's skill and training come to the front, obscuring questions about femininity and authoritative conducting. Framing removes her from the social relations that dominate Schwarz's description of the symphonic gaze.

The sequence that most clearly brings us between these two ways of experiencing the orchestra (visually and aurally) is during the rehearsal of Alexander Borodin's *Polovtsian Dances*, thirty-eight minutes into the film. The intense rehearsal follows the story of how Brico got a recommendation from Arthur Rubinstein. Again, the camera situates us in the orchestra rather than in the audience, with few shots of orchestral players. The handheld camera gives us a sense of being present within the space. The conductor's gaze is flipped on its head. Shot close up with a wide-angle lens, Brico is lit well and occupies the full left of the frame, while her musicians seem small and are backlit. We watch Brico and imagine the spectator's position. Brico's voice is not close miked. Instead, we hear her voice reverberate in the space of the stage. Her speaking power is in her projection and use of the acoustic space. She is forceful in her direction, speaking authoritatively and tapping her baton forcefully. We *watch* the social dynamics of organized sound. A zoom-out and pan reveal the great number of people—orchestra and double choir. A pan back to her establishes the relation between her and this large group of people. Brico is in command. Cut to her stopping the music to call attention to musicians missing the rhythm. "You can count. Do it!" she commands. Brico

AMERICAN MUSIC DOCUMENTARY

2.3. Juxtaposed spaces of stage and home brought together through performance.

stands alone, framed in black. While she occasionally looks to the left—a reminder that she is directing people—her gesture brings us closer to the complex music. We listen through *her*. When later in the film she speaks of conducting, it makes sense because we've experienced it: "I don't think it's the power. I don't think that's it. I think it's the feeling of a painter with a palette and you take one color and do this to it and another color into that. It's a fluid proposition. It doesn't stay stagnant." Through cinema, Godmilow has widened our understanding of the conductor's role in a way that a live performance couldn't. As we go wide and long, we see and hear the orchestra in a fuller way, hopefully shaking away notions of gendered claims to the podium.

From Kitchen Table to Stage:
Musical Continuity between Private and Public

The sequence eleven minutes into the film, of Schumann's Piano Concerto in A minor, Op. 54, reveals two major problems that Brico faced in her career. The first problem is that a conductor needs an orchestra to play. The sequence illustrates a more comprehensive view of the conductor by intercutting performance and rehearsal—expression and labor. The second is that musical performance is gendered. Godmilow stitches together a traditionally male space (the orchestra onstage) and a traditionally female space (the home), establishing a sense of continuity between them with the Schumann concerto. The idea started as a technical challenge for Godmilow: how to create a surprising reveal of new spaces (figure 2.3).

"I don't think I could rationalize it at the time," Godmilow tells me, then, imitating the reaction of the audience, "'Spectacle! How fabulous!'

is the response I get. 'Wow,' and 'Antonia's [singing]!' and 'Ooh! Schumann! Eighty people!' I wanted to try that. I asked Antonia, I said, 'Could you rehearse this piano piece?'—because we knew that was [Helen Palacas's] debut." Godmilow asked Brico if the performance and the rehearsal would be consistent enough to intercut them. "She said, 'Absolutely.' And on the basis of that, I brought Jerry Bruck, who had just invented his sort of strange stereo system. I wanted it well recorded and it was our last trip out there to shoot that concert."

The fact that the intercut worked is clear evidence that Brico has incredible control and consistency.

"So we got the dailies back," Godmilow says. "I synced it up, cut from one to the other, and she was right. She had delivered. That was the big question, because it would be horrible if it was just a little off. I don't know why, I don't know where the idea came from to do that, other than 'Wouldn't it be nice?'"

Within the film, the scene shows the work of music. It also shows the connection between private and public spaces—longtime gendered divisions of musical activity. The orchestra is not only musical; it is social. As Brico says in the film, "It is a public affair."

But how do you *play* the orchestra? This seems like an odd question. No conductor says, "I play the orchestra." But Godmilow presents the useful question: How *do* you play the orchestra? Contemplating this reveals the social nature of Brico's task, one that is impeded through patriarchy. Jumping ahead to the kitchen scene, Brico says in anger, "I cannot play my instrument, which is the orchestra." Later, Brico explains the social reality of her instrument when recalling the let down following performing Verdi's Requiem in Carnegie Hall: "Just like giving birth to a baby and then they take it away from you. If you're a violinist and you play a concert, you can play it and play it and play it for yourself. But an orchestra requires such an enormous amount of money and people. And that's why it's such a fascinating affair, probably, because it slips through your fingers. There isn't anything that you can hold. You can't see it. You can't touch it. You can't do anything but that one split second. And as I said, piano you can play and play in the privacy of your domain, but conducting is a public affair." Being a conductor means occupying a role of managing the players and the community, which means dealing with conservative boards who consider a conductor's ability to fund-raise,

manage budgets, and appeal to the public (Cheng 1998: 84). The Schumann sequence moves us to that understanding by bringing us to three different moments over the course of Brico playing the Schumann concerto—the present tense performance, the near–present tense rehearsal, and the past tense planning. We begin with Brico and her student backstage in the present.

Sixteen-year-old Helen Palacas awaits her debut. Backstage, we are privy to Brico's professional encouragement of her student. Three shots bring Brico and Palacas from backstage to the stage. Cut to an ultrawide shot of the whole orchestra, and the piece begins. Thirty seconds later is a cut to an ultra-close-up of Palacas's hands on the piano. The audio quality is subtly different, and for a moment it seems that perhaps the closeness simply comes with the close-up shot. But then Brico's voice sounds over the piano playing, counting time: "One and two and . . ." The reveal is a surprise, pulling us not only to a slightly earlier time, the rehearsal, but also to another space, Brico's home. The pan left reveals Brico and the setting until Palacas finishes the phrase and Brico says, "That's all," as if to direct us back to the orchestra. The cut back to the ultrawide shot of the orchestra brings us back to the stage and the more proximate present. A slow zoom draws our attention to Brico and Palacas until the forceful end of the musical section. Cut back to the house, though this time it is to a belated establishing shot of the exterior of Brico's home. The hard cuts add to surprise. (If Godmilow had used cross dissolves, we would have known that she was eliding space and time.)

The musical continuity stitches together two differently gendered spaces of musicmaking presented in the film: the public male concert stage and the private female home. Throughout the film, oscillation between the home and the stage (both in actuality and in accounts and archival images of earlier performances) helps blur the gendered contextualization of the female musician. Like most professional musicians, Brico's musical practice occupies a range of activity, from private teaching to conducting. Godmilow's editing presents this range to de-essentialize the female musician.

Returning to Brico's home the second time shows details of her space: flowers, busts, photos of stern men. None of the men speak, but a cross dissolve returns us to the female space of the dining room table. Here, we have access to a third temporality, the historical past tense of Brico's

story. Brico smiles and passes a plate. In a long digression from the Schumann piece, Brico remembers her own debut and then tells the story of arranging for her own performance after returning to the United States. The story exposes the work it takes to play the orchestra, work of convincing venues, donors, and musicians to play.

The digression, as if a cadenza of the concerto, shows Brico's incredible determination to play her instrument before the film returns to the sounds of orchestra and piano. We move from stage to home to stage to home and finally to stage right after Palacas plays her final chord in Brico's home. Godmilow's careful continuity editing stitches the two times and places together. At one point, Brico sings a clarinet part we heard playing in the orchestra several measures earlier. During the final passage, Brico plays a short phrase on the piano with the same musicality that the orchestra has been offering onstage.

Palacas returns backstage and a long take follows her. With only environmental sound, we linger in a moment that follows such a performative achievement. Palacas speaks, but the microphone is too far to hear her. The buzz of the backstage is louder.

Taking Brico from the kitchen table to the stage connects all of the spaces and times. Playing her instrument is revealed in three spaces (the stage, the home studio, and the archive via the kitchen table) and in three times (the present of the performance, the recent present of the rehearsal, and the distant past as a memory of producing the large apparatus of the orchestra).

As Brico says above, "Conducting is a public affair." Godmilow's rendering of the Schumann concerto shows it to be just that. The orchestra is a complex set of relationships organized across time and space until that final public moment. The film drags us through the gendered spaces of Brico's world to expose and allow us to break apart the associations of male to public and female to private.

Framing Interiority

In cinema, music can represent nonvisual elements. It often sounds the interior state of a character, scoring an emotional relation that the subject has with her environment or with her own memory. Music brings us in to the feeling of Brico's subject position within her own story. As a music film, *Antonia* offers a more organic connection between music

and affect. In our conversation, Godmilow tells me that she is grateful for having Brico's music in her palette: "I was lucky. I had music to play with all the way through. I think that's one of the secrets of the success of that film.... I could always cut to another piano lesson or get Antonia in the evening to sit and talk about the musicians who were important to her and somebody playing Schubert, or whatever the fuck it is. So, in some way, it's an easier film to make than a film about an old ballet dancer."

A small but clear example of Godmilow's use of music is when Brico discusses her intense relationship with Albert Schweitzer. The two met in 1949 and corresponded until his death in 1965. But those details wane in the face of Brico's feelings toward him as a mentor and as a man. In the shot, Brico says, "Impossible to describe in a few minutes what it meant to be with a man like that..." As she continues to speak, Godmilow crossfades Brico's voice with a recording of Schweitzer playing Bach's Fugue in G Minor BWV 578 on organ. This is a reflexive move. The cross-fade makes us aware of the construction of the film—as much as if Godmilow had walked up to the volume knob in person and twisted it to deny us Brico's voice. The cross-fade *out of* talking about Schweitzer acknowledges the limitations of film. We cannot have full access to Brico. The cross-fade *into* the music offers a sense of Brico's own reflection on Schweitzer. In a similar visual tactic, Brico holds the framed picture of him for us without speaking.

Another example of music offering more of the subject position than information is toward the end of the film. Brico recounts the many people she has worked with and known, while her own music plays. The content of what she says is less important than the sense of her relation to the growing list of people. The five-minute sequence begins with a cut to black from seeing her in the concert hall taking the podium as the orchestra tunes. Next is silence. Then, "I'd rather die trying," Brico says. A hand, probably hers, places the needle on a 78-RPM record from a 1939 Carnegie Hall recording of Rachmaninoff's Concerto No. 2 in C minor, the second movement. The crackle of the record sounds. Godmilow cuts to Brico. She listens at first; but once the music begins, a cross dissolve connects a flyer from 1939 to Brico now, present tense. Fourteen shots connect through cross dissolves, a device that indicates not only an elision of time or space but also a transition into an altered mental state. We think of or feel the relation between the two shots as one dissolves into

the other. The characteristically romantic music offers a sense of subject position. The music draws our ears and our eyes more to how she says it. With the music playing in the background, we are divorced from the litany of great artists (the information) but connected to her sense of reverence for those who have been her community (the subject position). A cut to a scrapbook is a variation on the foregrounding of her subject position. As altered states usually return to normal states, a cross-fade brings us back into real time and space for the end of the film. The sequence is a subtle push out of her story, yet it keeps us near to her feelings.

Importantly, we do not see the orchestra play. A record plays instead. Images of a live orchestra would offer a different subject position, one directed outward.

Leaving *Antonia*

Antonia would have been a lesser film had Godmilow presented only statements about being a female conductor. Instead, Godmilow presents questions about music as a social practice through presenting gesture, music, and interrelated temporalities as Brico talks about music. In a 1980 interview, Godmilow explained why her method worked for her: "If you can get someone talking about something that really interests them, they reveal themselves by their body movements, their gestures, their language. You can read how they feel about themselves. . . . I wanted to allow her to present herself as a person—not only a frustrated woman" (in Rosenthal 1980: 367). The film is a portrait of a conductor and her relation to her instrument, the orchestra—a gendered social instrument. As a conductor, Brico's gestures are tied to her musical practice within a social field. Framing Brico's gestures about music shows her command over the music and over the players.

Beyond gesture, music also opens up several subject positions—to Brico in relation to music, to musicians, to her own past, to her present career, and to her legacy. We listen with Brico because it scores the film, often across discontinuities, and because Brico herself draws us into the music. We experience more of what the performance is in the film. The relationships among these subject positions are felt across the different tenses of the film—the fragmented historical account, Brico's home and stage in 1973, and in the present tense of the film being made—the reflexive moments.

We can enter different subject positions, understand how positions affect what we consider music to be, and connect these meanings to gendered relationships of power. *Antonia* brings out Brico's voice, a voice that is inherently and intricately positioned within the social apparatus of the orchestra. She emerges a practicing pioneer, perhaps tragically so, but at the very least as a useful subject for consciousness-raising.

For the following final section, I'd like to leave this film but stay with Godmilow. *Antonia* and *The Popovich Brothers of South Chicago* (1977) are her music documentaries, but they are films made before Godmilow developed a more challenging critical cinematic practice. Unfortunately for this book, none of these later films are music films. But what if she were to make a music film now? What might that tell us about a critical cinema on music?

Imagine a Postrealist Music Cinema

When I arrive at Godmilow's apartment for one of our interviews, her friend happens to be there using her editing bay. As she introduces us, she says of me, "He's here to talk with me about a film I made forty years ago!" Her laughter concedes how strange it must be to be seventy-one and discussing a film you made when you were thirty-one—your first real film. Godmilow is now known for pushing on the boundaries of documentary film, thoughtfully rejecting its conventions and critically challenging its social use. There is a clear shift to postrealism nonfiction in her filmmaking since she made *Far from Poland* (1984). It nearly breaks her filmography in half.

Far from Poland recentered her thinking on documentary. In 1980, the Gdansk shipyards strike and ensuing Polish Solidarity movement presented a chance for Godmilow to document a moment of history unfolding. She was in Poland then and rushed back to New York to gather funds and assemble a film crew. Upon doing so, however, the Polish government refused to grant her a visa. While stranded in New York with a film crew and a budget, Godmilow soon realized that *not being in Poland* might actually be the least of her problems. She recounts her epiphany: "I couldn't go to Poland, but does that mean I couldn't use cinema to speak? I'm not a Polish historian. I'm not anything, but I can still speak about Poland in cinema and say some things that don't get said well any other way."

In the film, actors reenact published interviews with Anna Walentynowicz and the ex-government censor known as K-62. It also includes a fictitious interview with General Wojciech Jaruzelski. The reenactments include laugh tracks and other devices that remind us that we are watching a film. The "inappropriate" conventions make us aware of our ideological positions while we watch documentary, that we are spectators. Mixed with actual footage smuggled out of Poland, U.S. news clips about the events, and Godmilow's recurring dream phone conversations "with" Fidel Castro, the film is reflexive, interrogating how Americans react to and use news images for their own purposes. By the end of the film, there is no definitive perspective of Polish Solidarity, but there is perspective on the perspectives themselves.

Making a film about Poland without going back to gather images led to questions about the role of realism in documentary film. Why do we *need* actuality to make a documentary film? What *purpose* does actuality serve in documentary film? Godmilow suggests that the use of actuality can work to tacitly validate the filmmaker, granting him or her the right to speak (Godmilow in Miller 1997: 285). Authentication through realist techniques creates what Godmilow has called the "pedigree of the real, . . . that implicit claim that this 'truth,' derived solely from 'the actual' and delivered to us by a well-meaning filmmaker (whose status as a truth teller is itself authenticated by reality footage), legitimizes the representations of the filmmaker's text as objective. . . . This pedigree has no actual validity. A non-fiction text is as constructed as the text of a dramatic film or an animated cartoon" (Godmilow 1999: 96). Documentary is one grounded not in truth but rather in purpose, Godmilow argues. She left realist representation to create a cinema that offered audiences critical tools with which to examine political subjects and the use of cinema itself. Then, she saw an older German film that did just that. She decided to remake it so that American audiences could engage with it.

In 1997, Godmilow remade Harun Farocki's *Inextinguishable Fire* (1969), a film about Dow Chemical's napalm development during the Vietnam War. When she saw Farocki's film, she tells me that she thought, "This is the kind of cinema we should be making. It actually has a thesis and actually shows you something we've never understood and doesn't ask for rage, it asks everyone to think about what their labor produces. A much more important film."

At the beginning of her shot-for-shot remake, *What Farocki Taught* (1997), Farocki makes a case for not showing the horrific actuality of napalm. He says, in Godmilow's translation, "When we show you pictures of napalm damage, you'll close your eyes. First, you'll close your eyes to the pictures. Then, you'll close them to the memory. Then, you'll close your eyes to the facts. Then, you'll close your eyes to the connections between them." As the actor playing Farocki puts out a lit cigarette on his left arm, an off-camera voice explains that a cigarette burns at four hundred degrees and that napalm burns at three thousand degrees. Cut to a dead rat covered in napalm and lit on fire as the voice describes the extraordinarily long burn time, the release of poisonous gasses, and the impossibility of rubbing it off the skin or extinguishing the fire.

The underrepresentation of this demonstration and the underrepresentation of the ensuing reenactments of Dow employees with nonactors puts the audience in a position of thinking instead of reacting. Actuality can contribute to what Godmilow later calls the pornography of the real, which she describes well here:

> The pornography of the real involves the highly suspect, psychic pleasure of viewing *the moving picture real* . . . a powerful pornographic interest in real people and real death, as well as the destruction and suffering of "others," commodified in film. These "pleasures" are not brought to our attention. The pornographic aspect is masked in the documentary by assurances that the film delivers only the real, and thus sincere, truths that we need to know about. (Godmilow 1999: 95–96, emphasis original)

Postrealist film denies us the pleasure of looking, instead offering analysis and provocation.

In the epilogue to *What Farocki Taught*, Godmilow addresses the camera (us). She explains her critique of documentary, particularly its tendency to produce compassionate voyeurism. After giving the backstory to Farocki's film, she says to the camera, "We don't have a name for this kind of film. We should get one." Analysis and provocation are the aims. Godmilow's espousal of "underrepresentation" and "weak models" are strong tools to liberate "the big questions" and also avoid looking for pleasure (Godmilow 1999: 93). Postrealist films can be useful by present-

ing deconstruction tools. "When I use the word 'deconstructing,'" Godmilow qualifies during our interview, "I mean producing a place where you have to think about what you're watching instead of just being appreciated for watching it."

A postrealist film can use Brechtian techniques (those that produce a distancing effect), direct address, inappropriate conventions, underrepresentation, and weak models that can simultaneously offer transformative experiences and keep the pornography of the real at bay.

When interviewing Godmilow, our conversations often drift between discussing *Antonia* and her postrealist works. What follows consolidates the latter discussion and incorporates some of the scholarly publications she has produced. Despite the radical break in filmmaking, I see clear links between problems and solutions in *Antonia* and her push for postrealist film. I'll close the chapter with some thoughts on what a postrealist music cinema might look like and point to a few films that I think are close to this. Central to Godmilow's arguments are a recognition that certain audiences engage in documentaries with tacit and unconscious goals.

What Is the Liberal Documentary Audience Doing?

Forty years after *Antonia* was released, as we sit in Godmilow's kitchen, I ask if she would make a film like that again.

"I wouldn't be making the same film. I wouldn't be selling Antonia and her troubles. I'd be trying to use that differently. I don't know what I'd do, but I'd try and take that patriarchy problem into another consciousness: male power self-serving, denigration of women's capacities. You get that from that film, but I would try and take that out to capitalism or something like that. I don't know how exactly. More cartoons maybe."

A documentary film today might also resonate differently because a new audience sits in front of the screen. Godmilow acknowledges the relationship between documentary and its audience by giving it a qualifier: the "liberal documentary." In the tradition of psychoanalysis, Godmilow confronts the problem of documentary film's usefulness or, in her terms, its uselessness. Films about liberal concerns played for liberal audiences satisfy a desire to feel compassionate. In her article "What's Wrong with the Liberal Documentary," Godmilow explains:

As audiences, we are mesmerized by the tract of pure evidence and its claim to have made of us mental activists. We are consoled by our own willingness to consider other people's problems, as we see and hear them thoughtfully described in the motion picture medium. Though the liberal documentary takes the stance of a sober, non-fiction vehicle for edification about the real world, it is trapped in the same matrix of obligations as the fiction film: to entertain its audience, to produce fascination with its materials, to achieve closure, and to satisfy. Certainly, it is a vehicle for compassion. (1999: 91)

A film that confirms our own social compassion may do little to effect change. The experience is more akin to a ritual event. "We leave the theater filled with our best feelings about ourselves. The next day we go about the same business in the same way. This produces desire for a better and fairer world, but not the useful self-knowledge required to change anything. It offers no structural analysis of the problems described, and rarely proposes solutions" (Godmilow 1999: 92). This critique fuels some of Godmilow's discomfort with *Antonia*.

At the end of the film, the handheld camera reveals the room with Brico, Godmilow, and Collins. The voice of the cinematographer or sound recordist eggs Brico on to play some light ragtime numbers on the piano. "I'm not so sure I want that in public," says Brico to the camera.

The playfulness is contagious and closes the experience of Antonia's career efforts. "I don't like it," says Godmilow forty years later in our interview. "I love the footage, but today I wouldn't close that way because it says, in some way: 'But she's a good ol' gal. She can lighten up. We can love her. She's just like us.'" To her as an editor, it felt right to Godmilow at the time. It worked to cap an emotional experience for filmgoers. As she bluntly states,

> [Documentaries] have the same obligations as any cinema: To send the audience off or out of the theater feeling good about having watched it. So if you give them a good feeling, one more insight into *Antonia*. "Wow, she can play ragtime!" . . . You don't have to do anything except suck it in and feel glad that you spent your hour, your 57 minutes watching that. . . . You get closure. And what [do] you get from closure and pleasant, happy closure? *Satisfaction* is really the key word.

You get, "Hey, I saw this great film!" You get word of mouth. And then the theater goes another week, and it gets nominated for an Academy Award, or whatever's possible.

Godmilow explains how she might begin to change the ragtime sequence to agitprop, knowing why Brico knew those ragtime pieces: "I think the most interesting part is not that she can play the ragtime but *why she knows it*. And that gets passed [up], somehow. She was paying her rent by sitting in a department store, whacking out this popular music on a Steinway so that people would buy the sheet music.... She was just paying her rent, waiting for her break.... That's why she knows that stuff. She's just a starving artist like everyone else." Brico was, in fact, a salesperson, which brought her to Woolworth's. Her manager found her ability to sell so exceptional that he had her push products that did not sell well. But when selling music, she would add her own embellishments to make the sheet music more enticing, and people would buy the music only to return, saying that it didn't sound the same on their pianos (Macleod 2001: 126). Presenting Brico's knowledge of ragtime differently could have opened up thoughts about Brico's relationship to musical markets and commodities.

While there are plenty of things in the film she would take out or rework, there are glimmers of a postrealist turn in *Antonia*. Identifying them is an interesting project of reimagining the film as a model for postrealist music documentary. Keep in mind, many of the decisions that filmmakers make are practical, intuitive, and subconscious. Reflecting on *Antonia* gave Godmilow a chance to see seeds of what would become deliberate cinematic interventions.

Seeds of Postrealism: The Great Kettledrum War of 1937
In the context of Godmilow's other works, *Antonia* begins to wrest itself from the obligations of realism to become a film that contains tools for structural analysis. This move is most clear in the animated sequence. "It was *unheard of* then," Godmilow tells me.

"The Great Kettledrum War of 1937" sequence solved a technical problem: the lack of historical footage. Most of the documents Godmilow had to show besides the Fox Movietone newsreels in the beginning were

photographs, 78 RPM recordings, and newspaper clippings—all motionless. As with *Far from Poland*, Godmilow pulled resources to create a sequence that did not rely on actuality, something that could push the limits of the outrageous newspaper headlines, such as "Are Women Musicians People?"

"The cartoon came out of the editing room," Godmilow says. "I knew animators because I had worked cutting commercials, so I was lucky. I made one call [to animator Irene Treavis], and she said, 'Sure.' . . . We photographed a whole bunch of [Brico's] clippings. When we did it, without thinking 'Oh, what would happen if I animated that?' That came in the editing room. And some gutsy thing that said, 'God, that's so outrageous, let's make fun of it.' . . . Then we found somebody, a timpani player, who produced those two soundtracks."

Animation was a way of showing a losing proposition. The cartoon drama challenges the gendered imagery of the tympani—typically understood to be masculine—by showing an elegant woman flustering the portly and overconfident man.

But this is not the primary use of this cartoon.

Its alternate title is "A Film Maker's Fantasy of a Contest that Never Took Place." The sequence follows a series of newspaper clippings that reveal public discussion on the legitimacy of women musicians. The cartoon sequence underrepresents reality in such a way that it makes us think. The unreality of the animation pushes us out of Brico's realist subject position for a moment because it admits Godmilow's authorship. Godmilow explains to me how the sequence offers more of her voice to come through:

> Just letting it play out is absurd. But the game of a documentary is to reduce and to hide and to pretend that there isn't an author. If I've learned anything from all the films I've made, it's that you *should* be an author, and if you're an author, you respond to things and use those responses to add something to the film a hundred different ways. . . . I have an author's voice in that film from beginning to end because, as I've said a thousand times in a thousand different ways, films are the most written texts in the world, and the most edited and re-edited and tested. But to show your author's voice, not just edit cleverly and make moments but to actually *announce* that, . . . that's what happens with

that animation. . . . There were people who said, "You can't do that in a documentary." My whole work since then has been to find that voice, use it, announce it.

There are other seeds of rejecting realism. Most of those moments are also reflexive. Mentioned earlier, the cross-fade during Brico's reflection on Albert Schweitzer draws attention to our sense of entitlement as we pry into the thoughts of those on camera. In the interview, Godmilow points out the very last shot in the film, an unintentional tilt caused by letting go of the camera. She left it in for some reason. Technically, it is an invisible wipe. Reflexively, it calls attention to the cinematic apparatus. Prophetically, it signals Godmilow's abandonment of actuality.

Toward a Postrealist Music Film

At the beginning of one interview I ask Godmilow, "Post–*Far from Poland*, what sort of music film would you do now?"

She responds with laughter, "You should have sent me that question a week ago! Give me a break. Jesus Christ. I have never thought about such a thing!"

After a long pause, she says, "I can't dream up the answer to your question because I don't have a problem."

Start with a problem. Problems, for a postrealist music cinema, are ones that can engage tools for analysis and provocation.

"To talk about music films in particular," Godmilow says, "you would have to think about what are the expectations of people [audiences] . . . when they are delivered a culture represented in this case by musicians, usually good ones. 'Who are we in the face of that?' I would try to open that up in some way."

Scholars of music deal in problems, writing and lecturing about certain issues that relate to music, musicmaking, and ways in which music is mediated. Issues for ethnomusicologists include interrogating the social basis for which music is created, connecting local and global expressive practices, transcribing and analyzing music (translating sound to image), considering music as a type of labor and commodity, and accessing musical difference, to name a few analytic strategies. Thinking back to other ways of approaching her film *The Popovich Brothers of*

South Chicago (1978)—about music in Serbian American communities—Godmilow unearths a problem that I believe resonates with ethnomusicological issues: understanding culture in the late twentieth century. In our interview she makes a proposal for beginning an ethnomusicological film: "I would start with the subject of small ethnic groups maintaining some kind of coherence in the face of this monstrous culture. I would try and figure out the questions that would be worth taking up that subject in film—for everybody, not just for Serbs."

The problem here is one of understanding Serbian culture in relation to globalization. A film that gets close to a problem-centered music documentary is John Cohen's *Pericles in America* (1988). The film engages issues of how music is part of notions of ethnicity and forces of globalization by cutting between the musicians in both New York City and Greece. The music provides continuity for the film and for the audience, holding together a community and the sense of a traditional culture through major global changes and local experiences. Cohen's film still trades in realism but with a problem as its center; it could be a model for a music film untethered from actuality.

Watch that music. It might authenticate. Despite her deep interest in music, Godmilow is suspicious of music. She knows how manipulative it can be. In her provocative article "Kill the Documentary as We Know It," Godmilow presents a somewhat playful list of eleven "do nots" for filmmakers. One "do not" is about music. She writes, "Watch that music. What's it doing? Who is it conning?" (2002: 5). Her questions warn that music can set a mood or engage us in the story in unnoticed ways. By directing feeling, music might obscure a way of thinking about a problem. In our interview, she states: "I avoided it in later films, in the feature films I made. I never used music that way. There's just a little bit of music, and it's always self-conscious, the use of music. It's never there to move feelings." Godmilow's point reminds us of documentary's borrowing of musical conventions from Hollywood film. *Watching* the music has two meanings: First, we ought to be careful of the ways in which we employ music, how it constitutes audiences and how it encourages taking positions. Second, we can develop a cinema that allows us to watch music, to see what it does and to experience manipulation and to be productively distanced by it. Godmilow explains that music has many established con-

ventional uses in cinema: "Music—starting mostly in fiction film but now documentary—bears every strategy from fiction, from drama. . . . Music had a very large role in classic Hollywood cinema, and, to say the least, it was to provide a rhythm."

Music helps solve a rhythmic problem in realist work, especially those grounded in photographic realism. She gives an example:

"If you just want to move some slow-moving scene along, put some music in it. It's a gift to most filmmakers. It's the same reason there's music in every goddamn restaurant in New York now—you can't even talk to anyone—and in every Gap store. Every commercial institution of every kind has got music. What, we can't live without a music track? It's way bigger than cinema now; it's gotten into everything. I've speculated about why that is. Part of it is the beat. Another part of it is that you have to talk over it in an excited way, and you remember the experience of that restaurant as an exciting time. Music is just the whore of contemporary culture, absolutely."

Perhaps there is a useful postrealist film in Godmilow's assertion, one that posits music as such a "whore" and makes us aware of how we fall for certain musical affects.

"Music, let's face it," she says, "is an elevator. [It's a] mood elevator and an aesthetic elevator, all that stuff. Not only does that work, but it's covered with, 'This is fun. This is pleasure. I really like this, it's got a really great saxophone.' It's dangerous. Music is dangerous in the cinema."

When Godmilow did add music to her postrealist films, she was careful not to authenticate. When she was asked to set music to her documentary of a gender-reversed production of King Lear, *Lear '87 Archive (Condensed): The Mabou Mines Ensemble* (2003), she chose to score with guitarist Jody Sticker and sitarist Krishna Bhatt, which decidedly didn't fit.

"I was trying to solve that very problem," she recounts, "how can I *not* authenticate that process? All of those things music did for Westerns and everything else tells you how to be in relationship with what you're watching, from the banjo pickin' to the windshield shot going down the road—that's probably the most obvious. You can't do a going-down-the-road shot without a banjo pickin', it's impossible. . . . It helps you enter the diegetic space; it authenticates your movie. If you're making a film about herding cattle—a prime user of that was Ken Burns—you need authentic Civil War music. It makes [Burns] seem authentic; it makes you

103

seem like an authentic and interested audience for it. It's authenticating. That's the worst use of music. That should be forbidden. Maybe I've got to add that to my list: 'Never authenticate your filmmaking.'"

Inappropriate music can distance audiences in productive ways. In our interview, Godmilow and I discuss Leslie Thornton's *Another Worldy* (1999). The film pairs East German techno music with talkies from the early twentieth century. The images of smiling, dancing women conflict with the dark industrial music. Rhythms don't align. No sound in the music connects with an instrument in the bands shown. The lack of synchronization encourages audience reflection on the cinematic experience. The constructed nature of the film is up for consideration. Most people wonder what the original music was. A conscious desire for the music, however, illustrates an important takeaway from the film. *Music makes it okay to watch women's bodies like this.* Provocation has led to a critical thought about music. As we discuss various images, Godmilow says that Thorton's film reveals how music can normalize the male gaze: "How does the construction of that set and the idea of entertainment allow us to look at all sorts of things we otherwise wouldn't feel comfortable looking at? All of that is possible to think about in that film. And then she cuts to tiny two or three shots to some Cambodian girls doing classic Cambodian [dance], but one of their eyes meets the camera and looks away right away. One of the games with women's bodies is that they never acknowledge they're being filmed. And all of that is possible to think about." By decidedly not authenticating, music interrupts the male gaze in Thornton's film.

Godmilow then begins to answer my original question by proposing a film that makes clear how music is part of cinematic conventions. "So for me," Godmilow continues, "that would be the subject of any such film you asked me about: cinema and music and how it's constructed. To make a film that would open up how we're constructed in the face of what's being offered us."

Another film that disrupts cinematic conventions is Trinh Minh-ha's *Reassemblage* (1982). Minh-ha takes on the visual and formal grammar of the ethnographic gaze and shows that music is complicit. Drum sounds over a black screen followed by unexpected edits of images with no music reveal how the music and images of ethnographic film can render rural

Senegalese women into cultural objects. As in Thornton's film, music is complicit in producing the Other, this time with the postcolonial gaze.

Other films that offer reflection on the cinematic use of music are the docu-musicals of Brian Hill and Simon Armitage. In *Drinking for England* (1998), *Feltham Sings* (2002), and *Pornography: The Musical* (2003), interviews and actuality mix with musical video productions that resemble MTV videos, using the subjects of the documentary as singers. Armitage writes the songs drawing material from their research and interviews, and the nonactor subjects sing them in natural settings—a pub, a prison, and on a pornographic video shoot, for instance. These moments pull away from realist convention in a productive way. The staging brought through the music video style reminds the audience that the documentary is authored and that there is as much a style to the presentation of actuality and interview as there is to the music video segments.

A postrealist music cinema is about us: helping us examine how and why we listen to music and what the implications of listening might be. Godmilow suggests, "Some kind of practice that says a thinking audience that has to *struggle with* [watching and listening] is as valid an audience as the open-mouth, wide-eyed lover of Serbian American music in South Chicago. In fact, there's a way to be thinking about this and cinema's relationship to it that's very valid and frankly more important right now."

Take on appreciation. The basic act of documentary is to say to the world, *You should know about this.* It is a way for an author to point to something and grant it importance. In music films, that importance is often one of being "great music." A director feels that a previously underrepresented musician, genre, or music label has been brought up from under the radar. In an act of validation, an audience of fans spends ninety minutes feeling that their own taste is indeed great. Conversely, a fan may feel that the subject was treated poorly by the film, further entrenching his or her own stance on the subject. Regardless, the screening is built around an edification of taste.

The tyranny of appreciation is a major limitation in music documentary. Who wants to make a film about bad music? When we *write* about music, no one has to listen to it. Magazine articles such as John Jeremiah Sullivan's "The Final Comeback of Axl Rose" (2006) and Chuck Kloster-

man's "That '70s Cruise" (2006) don't require that you have to listen to contemporary Guns N' Roses or to REO Speedwagon on a cruise ship. But render those articles into a film, and you'd have to consider the music in some way. Do you let the music sound in the acoustic space or draw it from the mixing board? Do you reveal that the singers have lowered the pitch of their early songs by a few steps? We watch, listen and judge according to taste.

During our discussion of postrealist music cinema, Godmilow blurts out:

> I just had this idea! I think it's helpful. When you make any kind of film about music, in some way, the pressure to deliver—on the answer to the question, "You should see this"—is always, "It's great music." More than a film about welfare mothers, you're not obliged right away to have great welfare mothers. But if you say, "Come watch these musicians make music," it's built-in . . . That, I just realized, is a particular problem that ethnomusicology has or anything near presenting musicians in film. . . . I think it's a useful idea, probably the best thing I've said into this microphone, is that music films are hard that way. . . . You want to deliver good music.

Coda: Looking to Chapter 3

As we sit in her kitchen, Godmilow asks me about the other films I'm writing about. I rattle through a few and then pause on the most obscure and most challenging of them. "Have you ever seen Shirley Clarke's film on Ornette Coleman?" I ask.

"I did," she replies. "I saw it with Shirley Clarke, actually, in Rotterdam."

At that early stage of research for this book, I didn't know how I'd approach Clarke's film. I was only lingering in the uncomfortable details of a film that won't go away, like the talking-head interviews that Clarke frames in cartoon television sets. I only knew that I wanted to write about it.

"I'm not sure what *Ornette* does," I answer, clinging to an image from the film, "other than shaking you out of any sort of mastery of the film with the mock television screens."

"Right, it leaves it whole," Godmilow says. "It leaves the selfness, let's say, intact. It doesn't need us at all. She's someone else who was in my camp way before I was in my camp—always problematizing, viewing, always putting something in front of the camera that's not a subject we know how to enjoy in the cinema."

3 THE USE AND ABUSE OF MUSICOLOGICAL CONCEPTS
Shirley Clarke, *Ornette: Made in America* (1985)

In 1967 Shirley Clarke started working on a film about her friend the jazz great Ornette Coleman. It wasn't until 1985 that she completed it. But the final product was a much different work than she had initially intended. *Ornette: Made in America* was a work-for-hire. Clarke, the director, often clashed with the producers of the film, while maintaining a close friendship with Coleman. This complex triangulation of filmmaker, producer, and subject forms the basis of my analysis of one of the more confounding music documentaries. The producers were part of a utopian commune funded by Ed Bass, a young Texas heir to an oil fortune who was beginning to revitalize downtown Fort Worth—also Coleman's hometown. An examination of how the film came into being ties the avant-garde arts to flows of capital and radical ideology. The first part of the chapter tells the story of how Shirley Clarke, Ornette Coleman, and the producer Kathelin Hoffman stood in the confluence of the economic development of urban America and the spread of systems theories. The second half of the chapter examines ways in which Clarke's film resists this confluence, albeit in sometimes very subtle ways. The film takes on the idea of borders by drawing our attention to the literal border that separates the revitalized Fort Worth and the economically depressed section of town where Coleman grew up—literally the other side of the tracks. Thinking across these

spaces is my prime interest here, for this is where the power of the film lies. The film examines, demonstrates, and maintains a critical distance from concepts of individualism, freedom, achievement, and sovereignty.

Of all the films examined in this book, this is perhaps the least explicit in its critical arguments. The film confounds the audience's habits of looking for clear narrative and story. Clarke and Coleman create an experience that brings together film, dance, music, and architecture—all related by principles of motion, rhythm, and reference. In return, it offers a feeling of Coleman's music, a feeling informed by strategically placed images, text, rhythms, and motion. But this does not mean that the film is "art" divorced from critical argument. Coleman's featured piece, *Skies of America*, is about transcending terrestrial divisions in the United States. Film has the possibility of putting us in two places at once. And in this film, Clarke carries the viewer between land and space, between black and white sections of Fort Worth, between Fort Worth and New York, and between historical accounts and contemporary observation. Film can put us in two other spaces simultaneously: of feeling as though we are *in the film* and that we are *in the theater*. We move from the world of the film to the world of our seats, thinking reflexively. Bringing the critical voice out requires a look at both Clarke's artistic and political approaches, within the practicalities of making a high-budget film with someone else's money.

Ornette is Clarke's final film. She died in 1997 after suffering from Alzheimer's disease. In lieu of conducting interviews with her, I have pored over archival documents and published interviews. Thankfully, there are plenty. Clarke was not shy with the press and was an outspoken champion of the avant-garde. The archival materials are as dynamic as the film. Collage, newspaper clippings, correspondence, summaries of production meetings, and unrealized scripts fill her notebooks. In addition, the audio from her research trips allowed me to listen along with her initial conversations about the film. I have also spoken with Shirley Clarke's daughter, Wendy, as well as producer Kathelin Hoffman. There are three major strands that come together in this film project: Buckminster Fuller's concept of "synergy" (that the sum of a system is greater than its parts), the revitalization of Fort Worth around the arts, and Shirley Clarke's technological interests. These three elements converge in the film in complex ways. This chapter examines the ecological theories de-

veloped by the communal group that funded the film and the theories of harmolodics developed by Coleman, correlating them to the ways in which the arts have been employed in urban renewal projects. Strangely, Coleman is brought into the film as a tacit booster of free-enterprise capitalism. Ultimately, however, the film undermines this relationship between the artist and the neoliberal logic—even though this expensive film was possible only because of its support. The interrelated practices of communal living, urban revitalization, and artistic freedom begin decades prior to the film.

Backstory

Ed Bass, one of the members of a communal group living on Synergia Ranch, had decided to move back to Fort Worth from New Mexico. He ended up bringing members of his group with him. They saw the urban revitalization taking place there as a way of studying another system of humanity, nature, and technology. With Bass's capital, they built The Caravan of Dreams, an avant-garde arts center in the historic district downtown. John P. Allen, the leader of the Synergians, had hoped to have Charles Mingus play the inaugural show, but Mingus died in 1979.

The larger goal of the Synergians was to prepare humanity for a new sustainable and evolved era that achieved a new scientific balance between nature and technology, while preserving select elements of great cultural traditions. They were bold enough (and well-funded enough) to have planned a way to colonize Mars. In a series of summits, members began uniting scientists and artists. In their 1982 "Galactic Conference," they brought—among others—Buckminster Fuller and Ornette Coleman together at their French farmhouse retreat in an attempt to holistically examine the future of the planet (Reider 2009: 57). Coleman was not only a legendary avant-garde jazz musician. He was from Fort Worth. When approached to open the Caravan of Dreams, Coleman also saw an opportunity to do a symphony, chamber music, cabaret performance, and record an album.

Caravan of Dreams broke ground in 1982. Kathelin "Honey" Hoffman, the director of Synergia's theater group, moved with Ed Bass to Fort Worth to direct the arts center. Hoffman took charge of the task of bringing Coleman back for the opening. In New York, under Coleman's bed,

she found reels of film that Shirley Clarke had taken of him nearly fifteen years earlier. Hoffman then approached Clarke to make a film. But what set these people in motion toward each other began much earlier.

1959

In jazz history, 1959's significance is associated strongly with Ornette Coleman. It was the year of his breakthrough—a push from bebop to free jazz. But 1959 was also a significant year for the other key players in the film. That year, Shirley Clarke directed the Academy Award–nominated and Venice Film Festival winner *Skyscraper* (1959). On a basic level, *Skyscraper* is a film about the construction of 666 Fifth Avenue, which would become known as the Tishman Building. The twenty-one-minute film follows the destruction of the old building and the construction of the new. Visually, Clarke uses the images to create play with geometry, with light, and with motion. Dubbed voices of the workers reveal the lived space of the construction site—the home for these men throughout the construction. Clarke later called it "a musical comedy about the building of a skyscraper" (in Berg 1967: 54).

Also in 1959, north of New York in Andover, Massachusetts, fourteen-year-old Ed Bass had just started Phillips Academy and become a millionaire. His great-uncle Sid W. Richardson died and passed on an oil fortune worth over $11 million to be divided among the four Fort Worth Bass brothers. Two years earlier, *Fortune* magazine had called Sid Richardson the wealthiest man in America (Sherrod 1995). Bass had a nascent interest in architecture and had begun listening to avant-garde jazz. As he remembers, "We used to play a lot of Ornette Coleman's music because he was the farthest-out thing we could find" (in Patoski and Crawford 1989: 123).

Meanwhile, John P. Allen was in Uravan, Colorado, head of Union Carbide's uranium and vanadium processing facility. While exploring the area and writing poems about Native Americans and frontiersmen, Allen got a call offering him a two-year scholarship to Harvard Business School (Allen 2009: 249). At Harvard, Allen saw Buckminster Fuller speak and was greatly moved by his ideas (Reider 2009: 14–15). Fuller's ideas of solving global problems through constructing synergetic interactive systems had a profound impact on Allen. Allen would later develop the concept

of ecotechnics (a harmonizing of ecology and technology) in a communal group of mostly Ivy League utopians at what they would call Synergia Ranch.

Back to November of 1959 in New York: Ornette Coleman began a two-week residency at the Five Spot, a New York jazz venue that brought a mix of avant-garde artists from all disciplines. Coleman had left Forth Worth ten years before and finally made an impact in the music community in New York. After being laughed off the stage for years, he found an audience during this residency. He turned jazz on its head. The performance was so well received that his two weeks were extended to ten. What was so startling about Coleman's approach was his eschewal of formal structures. For Coleman, premeasured form, harmonic constraints, and "correct" tonality only inhibited a musician's creativity. Pieces like "Lonely Woman" were what Coleman called "emancipatory ballads" and allowed soloists to create their own logics of melodic construction. In part, Coleman's music brought out an African sensibility of group improvisation untethered by Western constraints of harmony. But Coleman was also inspired by the anti-institutional ideas of Buckminster Fuller. His free jazz approach would later become a theory and practice of what he called "harmolodics," in which melody, harmony, and rhythm all have equal importance when apprehending creative sound.

In 1983, these four would come together in Fort Worth at the opening of the Caravan of Dreams, an ecotechnic avant-garde arts center. Allen, funded by Bass, had pushed for the center. Coleman would open with a performance of his harmolodic opus *Skies of America*. And Clarke would make a film about the whole event.

Clarke Films Coleman and Then Stops Project

In Clarke's eyes, anyone who was the least bit intellectual in the 1960s was listening to Ornette Coleman. She met him through their mutual friend Yoko Ono in Paris, after which she began a project on Coleman and his son, Denardo. At age ten, Denardo had become the drummer for Ornette's group, recording *The Empty Foxhole* (1966) with his father and Charlie Haden. "I thought this would be an interesting way to get into jazz on film, as a father-and-son story," Clarke has said. "Those are always interesting" (in Zahos 2012: 27). From 1967 to 1969, Clarke recorded rehearsals and conversations between Ornette and Denardo.[1] In 1969, the

producer, David Oppenheim, saw a cut and disapproved, threatening to hold Clarke accountable for $40,000 in expenses. Clarke engineered getting herself fired from the project. "I made them sit through more than six hours of rushes," she said (in Bebb 1982: 6). Like many independent productions, the project suddenly had no money, and the footage languished. The footage ended up under Coleman's bed the same year that he was inducted into the *DownBeat* Jazz Hall of Fame. The group of utopians led by John Allen would find that footage while setting up their commune in New Mexico.

Synergia Ranch

Synergia Ranch was founded in 1967. John Allen and his wife, Marie, began to gather young people around them in New Mexico. A half dozen turned into about thirty in a few years. While Allen has been uncomfortable with the terms "commune" or "utopia," the group was a countercultural collection of determined individuals who lived together (Allen 2009: 34). Unlike other communes, Synergia cultivated a strong practice of scientific inquiry. Influenced by many thinkers, Buckminster Fuller was perhaps the most influential. They named themselves after Fuller's concept of synergy and placed great value on Fuller's optimistic hope for a future where humankind and technology were in sustainable balance. Individuals, according to Fuller, are nodes within a system. In his Utopian vision, the world would be a deinstitutionalized system, efficient and sustainable. Not only was Fuller's *Operating Manual for Spaceship Earth* (1963) a large influence on 1960s New Mexico communes, but Fuller himself came to speak to many groups. His geodesic domes were a practical architectural resource; but they were also a metaphor for the new age. Their structure was a system of support engineered such that the weight was spread out across all the nodes of connection—a nonhierarchical structure (figure 3.1).

The other major influence on Synergia was G. I. Gurdjieff, an earlier Russian mystic who believed that for humans to become fully awake, the old world must be discarded (Reider 2009: 30). Allen, addressing his group in 1971, stated:

> Western civilization isn't simply dying. It's dead. We are probing into its ruins to take whatever is useful for the building of a new civilization

to replace it. This new civilization will be planetary. The whole earth will be our home. We are no longer Americans, or Westerners, even though as individuals we were once raised in that tradition. We will build a series of centers in various parts of the world to demonstrate the new way of life. This ranch is merely our first training-ground. (In Veysey 1978: 279)

John Allen's charismatic leadership was as mystical as it was businesslike. The synergists hoped to colonize Mars (eventually completing the Biosphere 2 as a stepping-stone project in 1991).[2] As anthropologist Laurence Veysey observed when staying with the group in 1971, their goal was "to be universal men, to be both 'actors and scientists,' to do everything at once" (1978: 316). The Renaissance man attitude was in line with Buckminster Fuller's generalist stance and enabled many Synergia members to take on roles such as farming, architecture, and scientific research as well as the arts. Synergia added play to the intense work and ideas of Gurdjieff and the synergistic practices of Fuller. But their play was pointed, part of a project of self-exploration of the individual and the piecing together of great civilizations. Under the name Theater of All Possibilities, Allen and his group traveled throughout the world presenting classic works as well as their own.[3] Theater was a way of exploring interpersonal dynamics, of living the wisdom of past civilizations, and

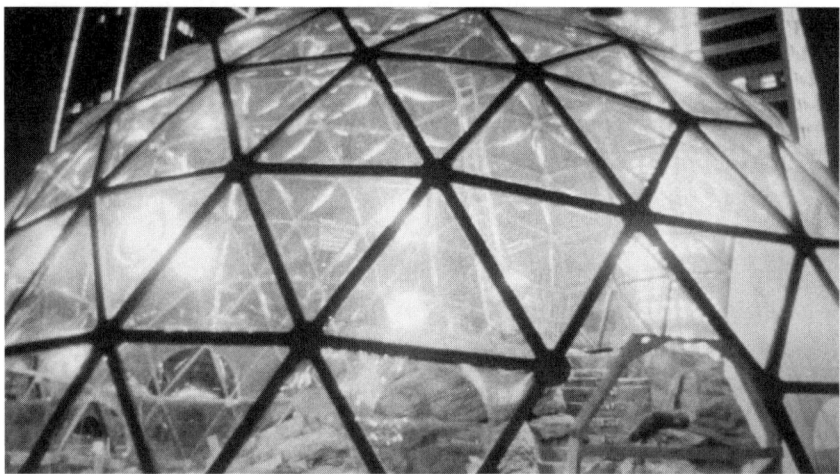

3.1. Geodesic dome on top of Caravan of Dreams (still from the film).

of developing the self. Though the synergists' arts practice was primarily theater, they had many connections to musicians. The avant-garde represented both an intellectual greatness and a rejection of traditional structures.

In 1973, Ed Bass was in New Mexico. He had dropped out of Yale's graduate program in architecture and started a construction company called Badlands Conspiracy. Bass and Allen's Synergia minibusinesses began working on joint venture projects (Allen 2009: 25–26). They built condominiums in Santa Fe and Bass became drawn into Allen's philosophy and the Theater of All Possibilities (Broad 1991). Bass's capital and Synergia's idealistic determination led to a number of grand "ecotechnical" projects, one of which led to the making of *Ornette*. Others included building a sea vessel, an Australian ranch, a French villa, and a Nepali resort. Allen and Bass developed these through a series of Synergia "businesses" with various names. After a few years, the group was interested in interacting with more outsiders, especially artists—to prepare them for work in the social habitat.

Multiple Agendas

In a 1983 meeting between Clarke and Allen, the two discussed the uneasy partnership between capital and the arts. The conversation is on her preproduction audiotapes.

> CLARKE: I went to a school in New York that was funded by the Rockefellers. This was an experimental educational school, very avant-garde. It was hysterical because the kids were either from the very, very rich or the artistic poor. It's always been [that] partnership.
>
> ALLEN: This is what we're trying to bring with Ornette coming here. . . . Bringing together those who made it by staying here and those who made it by splitting.

While they both acknowledge the relationship, the two seem to have very different stances on how money and the arts relate. Allen presents a case of mutual success, whereas Clarke thinks that the relationship is absurd. Both, however, are meeting in Fort Worth because Ed Bass's money is financing a film about Ornette Coleman's return to Fort Worth. During the same meeting, Allen says to Clarke, "One guy in our group

happens to be originally from here but never wanted to come back. But he got to talking about it, and, well, gee, all this energy's coming here. . . . They have all the money in the world. They know how to manipulate power. . . . So, art is the next step." Understanding a film like *Ornette* must especially take into account the relationship between capital and the arts.

In my conversation with producer Kathelin Hoffman, she identified three main agendas when it came to the story of the documentary. She said that Allen suggested a success story: Coleman as the shoeshine boy who became Fort Worth's prodigal son. Hoffman was interested in presenting an impression of the "creative mind" of an iconoclastic artist. As she describes it, "an optic hallucination, a state-change, as can be experienced during a creative act" (in Zahos 2012: 28). Clarke hoped to extend her own interest in the father-son relationship that she had begun shooting in the late 1960s. Hoffman remembers, "The orientation of the movie, as we saw it before Shirley became involved, was the life of a cutting edge avant-garde artist. What does it take to maintain that edge intellectually, creatively? How do you find the stamina to keep going with your vision? That had kind of been the idea of this film, and when I contacted Shirley, we decided to combine the two themes into the film" (in Goodman 2012). None of these stories end up dominating; rather, they intertwine. What emerges strongly from Clarke, however, is her reflexive cinematic critique of documentary truth claims and her interest in race issues. The backstory to the Caravan of Dreams arts center helps situate the film's tensions.

In the early days of Fort Worth, Ed Bass's great-uncle Sid Richardson had been part of the "Seventh Street Gang," a group of men who ran the town through banking, utility companies, law offices, and businesses. By the time Ed Bass moved back to Fort Worth, his family owned a lot of the town. The downtown real estate had become relatively inexpensive, thanks to white families moving to the suburbs in the 1950s.[4]

Like many Texas towns, Fort Worth had separate but unequal black and white populations. Following the Civil War, many African Americans moved to east Texas for jobs. Those who stayed provided domestic services for room and board or worked as tenant farmers. Developing a community in the outlying black neighborhoods was challenging and slow. Schools and businesses gradually developed. Following World

War I, many upwardly mobile black residents moved to the east part of town around Lake Como, annexed by Fort Worth in 1922. The black community was not part of the legal system. Whites were reluctant to visit black businesses. There wasn't even a black hospital in Fort Worth until the 1930s. Most activity remained in large black churches; they provided the space for community in the absence of public parks, meeting halls, and entertainment venues. It was a challenge for most of the black residents to make a mark on the city outside vice or entertainment. An audio recording of Coleman and Clarke from the archive brings out the story of Coleman's first employment at a nightclub. He provided music as a front for a gambling operation. He explains:

> COLEMAN: It was black because of segregation. . . . There used to be some real mean fights up there.
> CLARKE: Over what?
> COLEMAN: You know, girls come in. They'd hired these ladies—of the night, you know—to go in and to be there so whenever they had the law or something, they'd run in, grab a woman, and start dancing so they wouldn't be taken to jail because of illegal gambling. Then it'd turn into a dance hall.
> CLARKE: What was the band supposed to do?
> COLEMAN: We were playing for the front. We was fronting for the gambling.
> CLARKE: So they didn't care what music you played?
> COLEMAN: Well, no. But I was only playing rhythm and blues and pop songs. Whatever was on the radio. That's all I was doing. I was making a lot compared to the money I'm making now.
> CLARKE: That's a comment of some kind!
> COLEMAN: Right.

After Sid Richardson passed what was then the largest private fortune to his family, the Basses along with a new generation of elites eventually set their sights on the neglected downtown. Development started in 1977 with Charles Tandy's Tandy Center. In 1980 Ed Bass's older brother Sid spearheaded his family's foray into development with Sundance Square, a twelve-story apartment complex with an eleven-screen movie theater, a corner deli, carryout pizza, and home-delivered laundry. Public-private partnerships brought tax dollars into private investment with taxpayer

money. Tax abatements, public infrastructure, and bond money expenditures bolstered private development, as millions in charity donations went to museums and music halls (Sherrod 1995).

Ed Bass was portrayed as the eccentric Bass, hiking in Nepal and performing in experimental theater, while his brothers were turning their millions into billions on Wall Street (Patoski and Crawford 1989: 125). His turn from free spirit to mogul is part of his backstory. A 1995 magazine profile on him reflects that: "Ten years ago, if you had asked people to pinpoint one Bass brother who would run Fort Worth for the foreseeable future, almost everyone would have pointed to Sid. Almost everyone would have been wrong. The Bass brother who has emerged as the visionary leader is Ed—Ed, the flaky one; Ed, the hippie one; Ed, the arty one. . . . It turns out that Ed also is an astute businessman with good instincts, an eclectic group of friends, and a sense of humor and generosity" (Sherrod 1995).

Ed moved home from New Mexico in 1979. He wanted to live downtown, but nothing was there. He rented a suite by the month at the Blackstone Hotel. In an interview, he remembers, "It was such a bad address that not only would people not come visit me there, some people wouldn't even phone me there" (in Sherrod 1995). Bass brought members of Synergia Ranch with him to help with a development project—building an arts center on Houston Street. Caravan of Dreams was not the first arts center in Fort Worth. Modern Art Museum of Fort Worth had been established in 1892—the oldest in Texas. The Amon Carter Museum of American Art and Louis I. Kahn's Kimball Art Museum were established in 1961 and 1972, respectively. But this center was created to be somewhat of an outpost for Bass. In fact, he had his apartment in the building itself. To Bass, Caravan of Dreams represented new life in the desolate environment of downtown (Patoski and Crawford 1989: 124).

For Allen, Fort Worth was an opportunity to follow the Bass money, which had already built Hotel Vajra, an eco-retreat in Kathmandu, an estate in Aix-en-Provence, and a grass farm in the Kimberly Region of Australia. In his autobiography, Allen rationalizes the project: "I considered the restoration of a lively cultural life in cities and of farm-based community life to be the two critical needs in American civilization" (2009: 100). While he considered other cities, Fort Worth was where the money was. Allen continues:

Fort Worth was certainly not the first city that came to mind. Encouraged by his brother, Sid, Ed had bought several dilapidated properties in the downtown area, where the Bass Brothers already owned quite a few. Ed told us how he wished to develop a new property his brother suggested Ed buy, using some of the recent profits they had made through Sid's huge deal with Texaco. Ed figured as part of his long-term investment strategy, the Theater of All Possibilities would carry out its Caravan of Dreams project and help rehabilitate Fort Worth's downtown. The lively new venue would also enhance property values, since it would bring a vigorous nightlife to the area, attracted by big-name artists like Ornette Coleman, Wynton Marsalis, Eartha Kitt, William Burroughs, John Lee Hooker, and others. (98)

The joint project of creating an arts center is, on one level, an experiment in urban systems-theory. Allen's "restoration" is stated in the language of ecological systems—bringing a balance of culture and capital to a bleak environment. On another level, thinking of a downtown as an ecosystem is a way of reframing a public good as a system of private interests. As opposed to the public sector urban renewal of the 1950s, the 1980s was a time of privately led urban revitalization. A stated aim of revitalization was to create a sustainable downtown. In so doing, developers increased property value. The arts were conceived as being a part of a balanced system, attracting and occupying residents and workers. The utopian systems experimentation and capital fit well into the goals of revitalization.[5]

Clarke's notebook has an entry about the film in which she writes that the film is about Ornette Coleman, *not* Caravan of Dreams. It could be that the pressure from the funders had the potential to turn the film into a civic promotion video. Or it could be that Clarke was so interested in making a city symphony of 1980s Fort Worth revitalization that she was reminding herself of the subject. In her files, newspaper clippings about Fort Worth development are an indication of her interest in this aspect of the story.

Filming the Concert

On September 29, 1983, Fort Worth's Caravan of Dreams opened, along with a mayoral proclamation that it was Ornette Coleman Day. The

concert was too big to be held in the arts center, so Coleman's *Skies of America* was held at the convention center, three blocks away on Houston Street. According to Hoffman, Caravan of Dreams was the first integrated nightclub in the city. Houston Street was in a primarily white area, though the bus lines brought the black community to work through it. Racial tensions were high enough that the city wanted riot police there for the inaugural show. After discussion, they compromised on having plain-clothes police there, along with the formally dressed Fort Worth elite and the costume-party attired countercultural audience. Hoffman had arranged for the event to be part formal concert and part costume ball.

After the concert and Coleman's string quartet performance, critic John Rockwell gave a thorough review that acknowledged the effort involved and reservations about the aims of the entire project:

> At the end of the quartet performance yesterday, a beaming Mr. Allen raised Mr. Coleman's and Mr. Bass' hands and said the two men helped explain what his "team" had in mind in coming to Fort Worth in the first place—the bringing together of a city's disparate racial, cultural and creative elements. Whether one club can realize such Utopian dreams remains to be seen. . . . A principal group concern, Mr. Allen added, is the ecology of cities, and attempts to ameliorate urban racial and social disunity through artistic experiments. . . . Now Mr. Coleman thinks of the two forces, jazz group and symphony orchestra, as dramatically opposed forces that attempt but fail to merge. (1983)

Even to Rockwell, the mix of propaganda, the avant-garde, and racial inequity seemed perplexing and unrealistic. Clarke and Hoffman spent the next several months in New York editing footage, getting into arguments (according to Clarke's daughter, Wendy), and turning the event into a Shirley Clarke film.

Cinematic Intervention

The editing of *Ornette* presents biography and context for learning more about Ornette Coleman and his music. Certain cinematic strategies, however, blur notions of truth and fantasy. The interviews encourage reflection. The observational footage in the beginning reveals meaning-making around Coleman's presence in Fort Worth. And Clarke's

technique of focusing on a foreground subject, while allowing a background to shift, offers a perspective on the uneven development in Coleman's hometown. This strand of the film is an oblique critique of how artists can be made complicit with urban revitalization projects.

In *Ornette*, Clarke ties together many themes of her career, while presenting the different narratives proposed by all the players involved with the making of *Ornette*. Her cinematic techniques and critical perspectives create a reflexive film that shows how musical biography can serve the interests of capital. While this critical perspective is not overt, research into the development of downtown Fort Worth and an examination of Clarke's production archives reveal her interest in the consequences of urban revitalization. While some filmmakers in Clarke's early peer group played to the romantic notion of the artist, Clarke tended "to question romanticized notions of the artist, however, and also interrogate scientistic notions of the artist as an objective recording presence" (Sterritt 1998: 184). *Ornette* subverts any attempt to co-opt Coleman's biography into becoming what anthropologist Jesse Weaver Shipley calls an "indexical icon" for an economic principle (2013: 21). As Shipley argues, the media image of a musician can signify principles of neoliberal ideology, embodying notions of freedom, entrepreneurship, and autonomy. Throughout *Ornette*, Coleman's story comes in fragments. Reflexive techniques draw attention to the fact that the film is a mediated experience. What's more, the film presents the image-making happening in Fort Worth and provides a critical perspective on how Coleman's presence might aid in representing the free market principles that are driving the revitalization of downtown, while leaving behind the neighborhood where Coleman was born, on the other side of the train tracks. The return of Fort Worth's successful "prodigal son" is also an attempt at image-making.

Shots of Coleman present him in different spaces and times. Reenactment with amateur actors Demon Marshall and Eugene Tatum, as well as the use of historical footage, offers expository biographical perspective, while also productively confusing the viewer. The film breaks the code of reenactment and thus of temporal narrative.

Clarke was struck by how little development had taken place in Coleman's childhood neighborhood, likely since his birth in 1930. She could have leveraged the period look of Coleman's birthplace. Instead she reveals it as an anachronism, flipping between the old neighborhood being

3.2. The real Ornette Coleman connects with the "young" Ornette Coleman played by Demon Marshall.

a set for historical reenactment and revealing its contemporary state as undeveloped. Coleman's return to his hometown illustrates the uneven development of Fort Worth. A musician who has advanced jazz in innumerable ways returns to a neighborhood that has been left to stand still. One moment of conflation happens when Coleman squats down next to the youngest boy playing Coleman (see figure 3.2). The older Coleman appears to be teaching the younger one to play. As producer Kathelin Hoffman describes, "Flashbacks, interviews and oneiric sequences show Coleman is at the same time performing in the Texas of his youth, New York of his present, and throughout his professional and personal life. Clarke worked with temporal and spatial discontinuities, seeking the ability to 'be present' in different places at the same time" (in Zahos 2012: 23).

Much of the film presents dualisms only to overcome or embrace them. Clarke's notebooks are littered with dualisms: for example, day/night, motion/stillness, and old/new. One of the most important dualisms in the film is between the real and the fantastical. E. Deidre Pribram's analysis of the uneasy juxtaposition of reality and unreality in *Madonna: Truth or Dare* draws from Jean Baudrillard's theory of representation (1993: 201–2). Pribram suggests that film can collapse and confuse borders in a way that reveals Baudrillard's notion that excess information can result

in an implosion, an objection to the insistence that referents have meaning. Baudrillard distinguishes between representation, in which a sign refers to an original, and appearance, in which signs are indeterminate. Postmodernism's collapse of binaries disturbs the use of signs and unfixes meaning.

Clarke's work has always blurred categories to subvert notions of film's capacity to represent the real. In an interview she admits, "Everything I've done is based on the duality of fantasy and reality" (in Rabinovitz 1983: 8). Much of her interest came from being around the radical documentary movements of the 1960s: "I was very curious about the whole discussion of documentary and dramatic films and what was truly true. I had a lot of ideas about what was cinéma vérité, what was real, what was documentary, and what was fiction" (10). Clarke understood editing as the means to create *a* reality, whereas the others saw documentary cinema as a way of positioning the camera to unobtrusively record reality (Rabinovitz 2003:125–26). From Clarke's position, the psychological representations—dreams and non sequiturs from Coleman—work less to represent the great mind of a "creative genius" than they do to productively confuse representation.

Reflexive Biography

Throughout Clarke's notebook and transcriptions of discussions of the film with Hoffman, sketches of narrative bylines abound: "This film is a success story" . . . "By sheer force of work and genius, he not only entered into world artistic history, but transformed it. Things will never be the same again. His example can serve as demonstration and inspiration for others to expand their view of their own possibilities" . . . "The story touches upon how he has escaped the limitations of the culture he was born in. He left his hometown and the environment that stifled his artistic fulfillment" . . . "Seen through his imagination—world of Coleman's." The film, however, resists reducing Coleman to a success story. In an interview done shortly after the film's release, Clarke states:

> I wasn't trying to make a "documentary" of Coleman. . . . I hope nobody goes to this film expecting a record of Ornette's musical life because that's not what it is. We wanted people to come away feeling a certain way about somebody and knowing a little bit about his music

and its relation to him. Ornette is not violently well known (outside the jazz world) and that had something to do with my choosing to make a film that could appeal to people who just want to see this kind of film making and don't have to know it's about Ornette. (In Snowden 1986)

But on the one hand, *Ornette: Made in America* does have all the ingredients of a biopic. It presents dramatization of his childhood, source footage of performances, interviews with experts, and testimony from Ornette himself. Within the umbrella structure of the *Skies of America* performance, Coleman's biography is all within the film: his childhood, the beginning of his career, his impact on the 1960s jazz scene, his relationship with his son, his international career, and his life in New York. The stance on this biographical material, however, produces a feeling of representational instability. Through several different cinematic devices, Clarke makes her audience aware of the three registers of biography: the success story, the inner life of the creative individual, and the father-son relationship. By the time she was editing *Ornette*, her suspicion of cinematic truth had developed a reflexive cinematic technique. There are three core biopics at the heart of *Ornette*, and Clarke refuses to hand them over neatly.

Many filmmakers have abandoned the "voice of God" narration and simply string together quotes from interviews. But while this may seem to give credibility to the "raw" nature of a "reality" presented, it substitutes an "edit of God" for a "voice of God." A recent way out of this has been the practice of first-person documentaries in which the filmmaker—or a consistent substitute for the filmmaker—becomes the investigator, meeting people along the course of the film.[6] Clarke takes another tack. She makes us aware of the constructed nature of the interview. In the process, we become aware of its limitations and our own tendencies to want a story.[7] To understand the thwarted biographical conventions in Ornette, it is useful to see how Clarke's 1960s works complicate filmic claims of truth.

Her first feature radically dramatizes a direct cinema director's search for and construction of truth while he is making a documentary about heroin addicts. *The Connection* (1961) plays with audience perspective. Adapted from Jack Gelber's 1959 play about drug-addicted jazz musicians

and featuring notable Blue Note artists Freddie Redd and Jackie McLean, the film is a narrative feature of a documentarian making a direct cinema film. Without a plot other than waiting for "Cowboy," the drug dealer, there is little to propel the film. People wait for heroin. People get heroin. The director tries to capture the life of the heroin addicts but fails, frustrated. Watching the film can induce a type of vertigo because of the desire to move into the nested worlds of the film—the film that the director is making, the "backstage" of the documentary production, and the awareness that the film is not a documentary. It is possible to enter the world of the dramatized documentary subject, the dramatized making of the film, and the actors playing their parts. The cinematography encourages these perspectives. As a result, the viewer is thrust unexpectedly into different ways of watching the images.

Ornette refuses to take the truth of the interview at face value. Clarke's grand opus of revealing the limits of the interview is *Portrait of Jason* (1967). The film reveals that cinema is a discursive practice. It is a 105-minute interview with Jason Holliday (born Aaron Payne), a gay African American man. The film was shot over twelve hours in Clarke's apartment in the Hotel Chelsea. Offscreen direction of the interview combines with Holliday's own manipulation of the interview such that "in a situation where a single character knowingly does an emotional striptease for public consumption, the reality of his confession is hollow" (Rabinovitz 2003: 137). Clarke and her crew continually try to provoke him to reveal more of himself, until he finally breaks down, drunk and weeping. Neither the charismatic storyteller nor the emotional weeper remains authentic—they are both masks—and that is the rhetorical power of the film. As NPR film critic John Powers would later argue, the film "raises profound questions about the nature of the self, about the relationship between fiction and reality, and about the way that film doesn't simply record raw truth but shapes it into something reflecting the filmmaker's vision of life. Clarke was hip to all this, which is why the movie is titled *Portrait of Jason* and not simply *Jason*. There's a world of difference between the two—and she knew it" (Powers 2013). *Portrait of Jason* critiques the cinéma vérité claim for truth by presenting a sustained yet incomplete psychological investigation. While her early career was alongside the social documentary work of Lionel Rogosin (*On the Bowery*) and

James Agee (*The Quiet One*) as well as the direct cinema of the Drew Associates and French cinéma vérité, her cinematic contribution is one of reflection and instigation.

Anthropologist Peter Ian Crawford understands types of cinema in terms of positionality. Whereas direct cinema and cinéma vérité are respectively "fly-on-the-wall" (observational) and "fly-in-the-soup" (interventionist) cinematographic methods, postmodern cinema is an experience of "fly-in-the-I" (reflexive) (1992: 78–79). Accepting the I/eye pun, the genre induces reflection and causes discomfort. Parallel to the crisis of representation in anthropology, Clarke's work in *The Connection*, *Portrait of Jason*, and *Ornette* expose the constructed nature of film by putting her audience on loose footing. The fault lines of cinematic representation are best felt. Crawford's characterization of this cinematic mode includes a rejection of the search for authenticity, truth, and objectivity; evocation over explanation; use of collage; the deconstruction of conventions of representation; exaggeration of reflexivity; the blurring of lines between fiction and nonfiction; and the rejection of contextualization. In *Ornette* we see all of these at play and we are aware that we take part in meaning-making. Coleman may be the lead actor, but we, in effect, are the supporting actors.

Four biographical techniques help develop reflexivity in *Ornette*: formal interviews, psychological portraiture, mediated historical footage, and amateur reenactment.

Formal interviews. One of the hallmarks of contemporary documentary is to string together a series of statements made from formal interviews. In music documentary, this usually means filming interviews of musicians, producers, friends, agents, fans, experts, and other people who lend their perspective on the subject. Sometimes, filmmakers use interviews as a way of collecting statements that support a predetermined narrative. Other times, the narrative will emerge out of a long process of research that happens simultaneously with the production of the film. In either case, the result is the same. A *textual* expository narrative is presented, pieced together from statements of relevant people.

Clarke considers this approach and uses it but adds devices to make us aware of the mediation of the interview. Her preproduction planning notes show that she thought of tapping some notable people to interview for the film, namely Leonard Bernstein, Gunther Schuller, Don Cherry,

THE USE AND ABUSE OF MUSICOLOGICAL CONCEPTS

3.3. A cut that presents Coleman as if he were watching George Russell talk about Coleman.

Billy Higgins, and John Lewis. The interviews that made it into the film are an eclectic mix of family, colleagues, and experts. In one stretch of interviews, Denardo talks with his mother, Jayne Cortez, about managing his business. Then alone, Cortez recounts early impressions of Coleman's music in California. Musician James Clay adds to Cortez's account. His sister Truvenza Leach says, "Ornette has always been different" and then offers a stilted commentary on Coleman's breakout residency at the Five Spot in New York. Martin Williams, jazz critic from the Smithsonian, offers praise for Coleman with a well-rehearsed story about how Coleman once "started to play like Charlie Parker." John Giordano, conductor of Fort Worth Symphony Orchestra, points out differences between classical and jazz worlds. Composer George Russell offers more praise. Cutaways to Coleman watching the statements further disrupt the formal interview (see figure 3.3). Coleman's presence is ambiguous. Is he watching or participating? Then Russell begins to use the second person, further pulling Coleman in to disrupt the formal interview. John Rockwell, author and critic for the *New York Times*, puts Coleman's story in the historic context of jazz. He makes a point about formal aspects of music that resists mainstream music, connecting modernist classical music, free jazz, and punk rock. This sequence is productively messy, presenting biographical information but allowing the audience critical distance.

Clarke had tried to avoid the formal interview altogether. In the notes from a production discussion, Clarke expresses her interest in an alternative model. According to her notes, Clarke wanted "to get people who in some way participated or were strongly affected at the time and to tell the story not in interview form, but some other way such as arranging a 'party,' a meeting or event which would encourage interesting and inspiring images rather than self-serving blah-blah." An element of that

3.4. Two poles of interview: John Rockwell interview framed in a cartoon television set (on left) and Coleman with Fort Worth friends (on right).

conversation remains in two group discussions: one in New York with musician and jazz critic Bob Palmer, George Russell, and Coleman, and another in Fort Worth with Coleman's childhood friends. Both meetings are over food and drink. For whatever reason, the group discussions were not enough. The formal interviews add critical information about Coleman's career. But more importantly, they provide one end of a spectrum with the group discussions at the other end. The edits of discussion play with these extremes, parodying the formal interview by encasing them in cartoon television sets (see figure 3.4).

The edits collapse the binary between formal and casual statement and keep Coleman present throughout, as if he is waiting to speak or, like us, just enjoying listening.

Psychological portraiture. We also hear Coleman, himself, speak throughout the film. Kathelin Hoffman moved to New York during the editing of the film. Her presence, in the editing room with Clarke, had a large effect on the film. Hoffman's interest in the inner mind of the creative individual culminates in the psychological portraiture of an "artistic genius" through dream sequences. She hoped that Coleman's ideas would lodge in the consciousness of the viewer. In our phone conversation, Hoffman explained that the interview sequence with Coleman in which his image alternates rapidly with a shot of a geodesic dome as he talks about the influence of Buckminster Fuller was particularly important. His statement reveals a connection between Fuller's philosophy and his own music, which, in turn, connects to Synergia Ranch and the utopian principles of John P. Allen and his followers. Hoffman hoped that the optical effect of rapidly alternating complementary colors (blue and orange) would lead to a mystical contemplation of Fuller's ideas. During our phone interview, Hoffman expressed disappointment that the coloring was not satu-

rated enough to produce the effect. The irregular cut generally moves between shots of four to six frames as the audio of Coleman's statement plays continuously.[8] As it is, the flicker provides a visual interruption. While the effect generally fails to induce mystical contemplation, it does produce an extreme distancing effect.

Video effects used for portrayals of Coleman's dreams separate Coleman from "ordinary" reality, presenting an alternative psychological space for a "genius artist." The dreams and stories come toward the end of the film and include the sequences of a black and a white woman exchanging babies, a strange woman kissing Coleman and then yelling at him, a story told about considering castration, young Coleman playing in a video arcade, and Coleman placed in outer space and on the moon via special effects. This type of portrayal may stem from Hoffman's interest in presenting a quintessential iconoclast,[9] but the psychological portraiture does more to destabilize the expository mode in the film. As in *The Connection*, reality and fantasy blur. As a result, the truth of film is questionable.

Mediated historical footage. On the other side of realism, historical footage provides information about Coleman's career, examples of his music, and reflexivity. Clarke includes many types of film and video throughout. As with collage, the grain of the different media becomes noticeable. This serves to reinforce the fact that they are mediated. The most striking example is from Milan in 1980. What the audience sees is a shot of a television screen playing the televised concert. The subtitle, "Italian Television 1980," reinforces attention to the medium and again shifts the film from expository to reflexive.

Amateur reenactment. Perhaps the most striking technique Clarke utilizes is the use of two child actors throughout the film. The amateur reenactment provides biographical information, while also revealing the film to be a construction. Reenactment was a prevalent mode of American documentary in the 1930s, most notably in Richard de Rochemont's *March of Time* series (1935–51). The monthly series mixed newsreel and documentary, often using reenactment to explain and comment on current events (Ellis and McLane 2005: 97). Clarke, however, was more in line with Italian neorealism. In an interview, she admits: "I consider myself part of European filmmaking—people like Rossellini and DeSica and Fellini. I was pals with Godard and that whole bunch. That's who I iden-

tified with" (in Halleck n.d.). Her use of amateur actors provides a reflexive moment during the scene in which the landlord demands money and young Ornette Coleman reacts unfavorably while up in a tree. The acting reveals itself as acting when the white man in the 1930s outfit shouts up the tree, "Hey boy. You make your mother answer that door or I'll lock you up!" and Eugene Tatum, playing Coleman, reacts with an out-of-character smile and an attempt at acting caught. In the following shot, the real Ornette Coleman sits on the porch in the background, as if watching the scene play out, remembering the event. Other times throughout the film, the characters look into the camera, breaking a code of classic narrative cinema.

Clarke's treatment of interviews allows the viewer to experience a modernist suspicion: preserving multiple points of view, stream of consciousness, and ambiguity. At times, the devices produce feelings of irritation, as her techniques interrupt our desire to create a clear narrative. Clarke's editing strategy pushes on our tendency to see documentary as a "real" form of cinema—a product of film's verisimilitude. An effect of the film is the denial of a tidy narrative of Coleman's career. Rather, one leaves the film with biographic shards that are useful in learning about Coleman. Leaving them as shards of biography and producing distancing effects requires the audience to put the pieces together. At the very end of the film, Coleman stares into the camera from the center of the frame. The credits roll. The *seen* looks back at the *seer* with an amused smile on his face.

Unmasking Fort Worth

Coleman was skeptical of the way his music had been used during his career as a recording artist. Following his initial success, he stopped recording after noting how the idea of "free jazz" had been taken to mean something beyond its musical origin. "It seems," he says, "that production and publicity are so closely related that they turn into the same thing. What I mean is, in jazz the Negro is the product" (in Spellman 2004: 130).

Coleman's recognition by the Fort Worth establishment is complex. *Ornette* mitigates the problem of having to choose between using cinema to promote through edification or to distrust through reflexivity. Clarke leaves the problem in knots. Coleman's recognition *is* significant. It is not

only a gesture of artistic support in service of venture capitalism. Clarke leaves these strands intertwined for us to pull on and attempt to sort out.

As jazz was becoming America's "classical" music through institutionalization, many downtowns began to develop into new urban centers. Marshaling the "creative class" often involved the construction of arts centers, which could attract young professionals to new industries and provide exciting nightlife (Bianchini 1990; Florida 2002; Florida 2004; Zimmerman 2008). The arts can provide an instrumental role in development (Peterson 2010). As J. Allen Whitt argues, "the arts should not be conceived as a merely symbolic aspect of urban culture, but as 'material' shapers of cities [and] as an emerging arena of instrumental politics" (1987: 16). Whitt writes that corporate leaders of the 1980s extended the rhetorical use of the arts during the Cold War to be "a bulwark to the free enterprise system" (19). One of the new ideal relationships among businesses, government, and the arts began to be described as one of synergy. In the case of this film, the arts were at the center of the Bass family's capital goals, the city's support for their projects, and rhetoric of artistic value. The arts were an instrumental part of Fort Worth's material shift from old to new.

The audio from preproduction of *Ornette* reveals a great deal of how Caravan of Dreams was part of a larger effort to revitalize downtown Fort Worth. And in her notes, Clarke mentions the polished old fixtures and increasing job growth in the area. John P. Allen may have seen himself as an outsider to the powerful world of oil-moneyed developers, but Ed Bass was between these worlds of New Mexico commune and Texas real estate developers. In the preproduction audio, I listened in to Clarke and Allen driving around Fort Worth discussing the changes to the city:

> ALLEN: Now this reconstruction is important. This part was going be bulldozed. Now this began the counterforce that gave us the idea to come here. Because instead of just bulldozing everything, the guy that built these 'scrapers rebuilt two whole blocks—fantastic reconstruction. Just brick-by-brick of old Fort Worth, when it was Hell's Hundred Acres. . . . They had this great old architecture in Fort Worth. It was a wealthy cattle town.
> CLARKE: Stunning. Absolutely stunning.

ALLEN: Caravan of Dreams is just across this on the other side. This is the local milieu.

They continue to drive around the neighborhood.

ALLEN: Now, look down this and you'll see it's already started. This is Main Street. This is the old courthouse.
CLARKE: Wonderful.
ALLEN: And this is this great nineteenth-century Texas school of courthouse architecture. Now look down here.
CLARKE: Oh, I see. This is nice.
ALLEN: These guys are used to winning, that's another thing. Their track record in how they succeed. Now, they've done it in oil, they've done it in aerodynamics. And they're going to turn to art.
CLARKE: They're going to win. They are going to win Fort Worth. They're on their way.

Clarke then asks a pointed question:

CLARKE: Are these things that people vote on, or is there a group of people in charge?
ALLEN: This is what makes it very interesting in Fort Worth, why we're getting it really done quick.
CLARKE: You mean a couple of people who are in charge?
ALLEN: There's about fifteen on the bandwagon.
CLARKE: But they're not stopping. I mean, they're all agreeing?
ALLEN: Yeah. That's what's interesting.

Clarke shows little of the historic reconstruction in *Ornette*, instead focusing on the new glass buildings. During the preproduction, she took a clear interest in the look of the new Fort Worth. Clarke's work on *Skyscraper* (1959) attuned her to all of the new glass buildings being built.

CLARKE: Look, what they've done with the glass building is such an amazing thing. Look at the top of that. I really, unfortunately [laughs] know an awful lot about architecture because of making that movie [*Skyscraper*]. Look at that! Look at how stunning that is, isn't that stunning?
ALLEN: Now, this was the old first church in town that was actually built . . .

THE USE AND ABUSE OF MUSICOLOGICAL CONCEPTS

Later, Clarke and Allen go to Caravan of Dreams and have lunch. Allen points out a few wealthy locals and they discuss the role of Caravan of Dreams in the community. Silverware audibly clinks in the recording, forming a counterpoint with the soft piano rendition of "Chariots of Fire" in the background. Sounding like a real estate developer himself, Allen describes the creative class that they hope to attract.

> ALLEN: Another idea that we've really sold across to the Caravan of Dreams is moving population back downtown. . . . The high-tech guys. The professionals. The hired engineers. Swinging secretaries. Computer people, the lab guys.
> CLARKE: Tell me, lunch would cost how much? . . .
> ALLEN: This is four-fifty.
> CLARKE: This town is too cheap. I'm used to New York and LA.
> ALLEN: Oh, yeah.
> CLARKE: There's no way I could eat for five dollars anywhere!
> ALLEN: And the wage is as good or better.
> CLARKE: Really? Well, you're not going to have any problems.
> ALLEN: No, I don't think so.
> CLARKE: How could you have any problems if you keep these kinds of prices, and they're rich?
> ALLEN: The dinners are going to be for the haute bourgeois. There are three classes.
> CLARKE: What makes you think the bourgeois are going to even find this place?
> ALLEN: Because they roll downtown. Because they eat here, down there at the corner. And then there's two or three restaurants over here. So, they'd be coming downtown anyway. So, then, the sets come in where people can either stay on from dinner into the sets, people can come back from lunch to the set, or people can come in from breakfast—see, but they'll all be around there, see, during the day getting up the vibe of what is going to be going that night. So it'll pull in—we hope—all the different classes.

During the early 1980s, the "Silicon Prairie" was attracting professionals in technology-related companies—from aerospace (General Dynamics) to defense (E-Systems) to communications (TOCOM) to medical technology (National Data Communications) to electronic banking

133

(Docutel) — due to tax incentives and its central shipping location (Appelbome 1982). The Tandy Corporation in Fort Worth was one of the early personal computer developers. Apple Computer (then in Carrollton, Texas) and Commodore International were attracting a new set of professionals as well.

Developers like Ed Bass reaped a tremendous amount of money from the tech boom and Caravan of Dreams was part of the "ecosystem" of businesses that helped attract newcomers. From her notebooks, it is clear that Clarke was on guard against making a promotional film for Caravan of Dreams or an advertisement for a distinct and culturally attractive Fort Worth.

In *Ornette*, Clarke begins with a subtle unmasking of Fort Worth's image-making. The gesture doesn't diminish Coleman's honor but reveals the ways in which musicians can be part of a larger process of image-making in service of urban development — creating distinction and standing as an example of free enterprise. Clarke reveals Fort Worth's historic district to be one of construction and reenactment. In her notes, she wrote down her impressions of the town: "empty streets, wealthy whites, black ghettos, new buildings . . . ghost town feeling . . . scrubbed look to Ft. Worth." During the 1980s, urban revitalization was marked by capital-driven (as opposed to earlier state-driven) development of American urban centers. The arts played a role in attracting people to move to the area and use downtown. This process was in full swing when Clarke visited Fort Worth and her film, in many ways, becomes a commentary on the making of place and the notion of façade.

The opening shot of the film is of the young Ornette Coleman walking in and out of Felix Bar,[10] a modest establishment on an empty street, as canned applause sounds. As the young Coleman walks out of the bar, a voice emerges from the sound of the crowd: ". . . get on outta here." The sound is part of the following street reenactment. The next shot is of a staged gunfight. On-screen, the contemporary and historical clash. Construction workers sit having lunch and watch along with a mass of other contemporary people, while actors in Old West attire and swagger stand off.

> SHERIFF: You fellas just better get on out of here. We're having a big celebration.

ADVERSARY: You gonna give us our money back?
SHERIFF: You just get back on over yonder.
CITIZEN: Yonder? Get out of town.
ADVERSARY: Oh no! We're not gonna drop our guns. We're not even . . .

Gunfire erupts, leaving the adversaries on the ground under a cloud of gun smoke. The audience cheers. The sheriff turns and a cameraman is in the background to the left. Now as actor, the sheriff raises his hat and welcomes everyone, "Ladies and gentlemen, Legends of the West welcomes you to Caravan of Dreams." The costume of the actor contrasts with the 1980s clothing—ties with short-sleeved dress shirts, tank tops, and a contemporary police uniform. The 1980s-era cars provide another anachronistic counterpoint to the gun show. Artificiality is established at the outset of the film.

Directly from the gunfight, Clarke cuts to what would typically be a crowning moment. Mayor Bob Bolen ceremonially gives Ornette Coleman a key to the city—a replica of the actual key, which, as Bolen explains, has been to the moon. The event is suspect. Is it part of the gun show? What happened to that young boy who stepped out of Felix Bar? Bolen issues the following proclamation:

> Whereas Ornette Coleman, born and reared in the city of Fort Worth, has enriched the lives of individuals of every race, color, and creed as composer, performer, and renowned jazz musician; and whereas Ornette Coleman, a widely acclaimed figure in the jazz world, has travelled throughout the United States, Europe, Japan, and Africa, and fashioned for himself an unchallenged right to historical prominence; whereas Ornette Coleman has demonstrated that individual initiative and the free enterprise system continue to be the American way of life and that success is possible for all who take advantage of the opportunities in our country; now, therefore, I, Bob Bolen, mayor of the city of Fort Worth, Texas, do hereby proclaim September 29, 1983, as Ornette Coleman Day in the city of Fort Worth. Congratulations.

Clarke's placement of Bolen's proclamation within the opening sequence makes for more critique than mere documentation. Ornette Coleman's key to the city is more complicated than simply being a rec-

ognition of achievement. Bob Bolen's long reign as mayor (1982–91) was fraught with problems from the standpoint of community groups. Whether Clarke knew or not, Bolen oversaw a decline in public participation and the dismantling of the City Planning Department. Neighborhood activists claimed that Bolen and other city leaders were handing all over to developers like the Basses and Ross Perot Jr. (Sherrod 1995).

Symbolically, Bolen's declaration is an attempt to co-opt Coleman for promotion of "individual initiative" and the "free enterprise system" in a similar way as the jazz ambassadors program used jazz as a way to promote individualism and the American image of democracy.[11] In Mayor Bollen's proclamation, he implicitly hitches Coleman's "historical prominence" to Fort Worth. After all, he was "born and reared in the city." Clarke, having participated in state-sponsored arts events, was well aware of the rhetorical co-option of artistic practices. Clarke presents the proclamation of Ornette Coleman Day ironically. The proclamation is as real as the gun show. The sequence then jumps to backstage and band members Jamaaladeen Tacuma and Charles Ellerbe discuss the significance of the event. The confusion helps set the tone for the whole film. Tacuma inspects the key.

> TACUMA: Where's the moon?
> ELLERBE: He said it *went* to the moon.
> TACUMA: The key went to the moon? Why did this key go to the moon?

The confusion turns to playfulness.

> TACUMA: Did you cry?
> ELLERBE: No, I didn't cry, man. It wasn't that sentimental. It was nice receiving the key to the city, man. You know it's not every day that something like that happens.

This debriefing establishes both bafflement and meaningfulness. Tacuma picks up his earlier question:

> TACUMA: Why would they take [the key] to the moon?
> ELLERBE: Just for the experience. It's like somebody gives you a shirt and it's from Paris.

Clarke's strategy of unmasking Fort Worth in the opening of the film may be informed by the ways in which her own work had been appropriated by both the government and later by commercial advertisers. She had become aware of how artists and artwork can be used toward other motives. In the late 1950s, the State Department brought several experimental filmmakers to the 1958 Brussels World's Fair. Clarke worked with D. A. Pennebaker and Richard Leacock to create a series of short modernist film loops. They later collaborated with Al Maysles on *Opening in Moscow* (1959), a documentary on modernist industrial designer George Nelson's trade fair that brought American innovation to the Soviet Union. After seeing her groundbreaking work put in ideological use by the State Department, she saw her loops used by Madison Avenue. She explains her shock at discovering her work on television ads: "One day during a Republican convention, the phone rang and someone said, 'Quick, look at the TV. They're playing your loop'" (in Nilsen 2011: 150). *Brussels Loops* had an impact on television commercials in the 1960s, Clarke's avant-garde style repurposed to capture the attention of the viewer (Nilsen 2011: 150; Rabinovitz 2003: 100). Afterward, Clarke grew skeptical of ideological and commercial reuses of the avant-garde.

Intermittent Reharmonization and the Era of Simultaneity

Having disrupted the transfer of Coleman's success to the symbolic distinction of Fort Worth's free enterprise system, Clarke shows images of the social consequence of urban revitalization by juxtaposing images of wealth and poverty, revitalization and disrepair, and white and black. The film draws together urban spaces that are economically, socially, and geographically distinct through a technique that I will call "intermittent reharmonization," in which a figure continues over an unpredictably changing ground. This technique, applied to the issues of inequity in urban planning, helps guard against appropriation of Coleman's success and musical values. The effect is one of *simultaneity*—the effects of a process happening in the same time in different places. The film makes an aesthetic link between the revitalized downtown and Coleman's dilapidated childhood neighborhood through musical sounding and musical scoring. In so doing, the intermittent reharmonization prompts a political question: How else are these neighborhoods linked? Clarke's tech-

nique is one of her oldest cinematic strategies, though it started as an artistic technique.

For her first film, *Dance in the Sun* (1953), she shot a friend dancing on a beach. Unhappy with the results, she filmed him dancing the same dance in a theater and ended up intercutting the two, disregarding the different locations. Her editing privileged formal principles of editing, motion, and image. She says, "That was the only good idea I ever got and I still have it! All the things I have done grew from that seed . . . the idea that time and space are totally different on film. There are many variations on the theme, but all my work has to do with what film itself is" (in Zahos 2012: 27; also see Rabinovitz 1983). Film can uniquely reveal connections between places.[12] As Clarke continued making films in the 1960s, her work shifted toward a focus on racial inequity. *The Connection* (1961) and *The Cool World* (1964) reveal mostly African American places that were on the margins of usual portrayals of New York. *The Cool World* dramatizes the street gang life without drawing from the tropes of Hollywood. Clarke complicates depictions of crime by setting them within the black Islamic movement and the struggle against white supremacy. As discussed earlier, *The Connection* brought audiences into a heroin den. Both films go beyond just showing these spaces. Using reflexive moves, they encourage audiences to think about their relationship to these spaces. Use of nonactors and direct cinema techniques presents issues of mediation and truthfulness. *Ornette* continues Clarke's critical interest in fringe neighborhoods through the formal device of intermittent reharmonization. At issue was a contemporary inequity between two Fort Worth neighborhoods—one that was claiming him and the other in which he was born.

While driving around Fort Worth researching the shoot, Clarke, Allen, and Hoffman talked about possible shots for the film. "This particular image," Clarke remarks on the archive preproduction tape, cutting off Allen's discussion of Fort Worth development plans. "The complications of form," Clarke interrupts again. She explains to him how the reflection in the glass building is "very stunning." She is probably looking at the City Center Towers, a Paul Rudolph building commissioned by the Bass family. At one point, Clarke imagines a tracking shot from Coleman's neighborhood over the train tracks to downtown. Later in her notes, she

3.5. The new buildings of downtown Fort Worth loom behind young Ornette Coleman in his neighborhood.

cites a need for a helicopter shot to show the relation between the convention center, the railroad tracks, and Caravan of Dreams. Clarke was thinking about how to connect the urban spaces, intent on using shots of the new buildings. While *Ornette* is not explicit about the incongruous development of Fort Worth, Clarke's intermittent reharmonization of the music and the image connects the two disparate places by maintaining Coleman's presence across both places.[13]

The music begins in the Convention Center. Men in tuxedos with hands to their chins sit in poses of contemplation, watching. One minute into the performance, the image cuts to the train tracks, looking into Coleman's neighborhood. This is the neighborhood that Coleman desperately wanted to escape. The actor Demon Marshall steps over the tracks with his saxophone, a seeming non sequitur to the shots of the audience. Cutting back to the convention center, wide shots encourage thinking about the relationships among the people and of the concert space itself. Cutting back to the young Coleman in the grass, the gleaming downtown is in sight over his shoulder (see figure 3.5). The old and the new are in one shot. Coleman's neighborhood remains unchanged as massive change begins to transform Fort Worth—or at least the other side of the tracks from Coleman's neighborhood.

 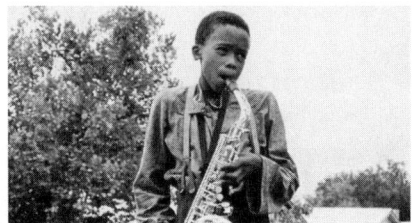

3.6. Intermittent reharmonization of Coleman and his music across two different spaces and times.

3.7. Two cutaway shots of places during the opening movement of *Skies of America*.

Opening titles break up a shot of young Coleman walking back into his neighborhood over the train tracks before returning to the concert space. As Coleman's band, Prime Time, begins to take over from the orchestra, a shot of young Coleman flickers back and forth in rapid reharmonization of the music and of Coleman himself (see figure 3.6). As in *Dance in the Sun*, Clarke establishes a continuous foreground and discontinuous background. In this case, time and space provide the reharmonization. While these spaces and times are separate, they both make sense with the music and the musician.

When the orchestral strings return with their long polytonal chords, the reharmonization returns to juxtapose neighborhoods (see figure 3.7). Eventually, the space of the old neighborhood sounds over the music being played in the convention center. A dog on a chain barks, pulling on the chain in an attempt to get to the camera. After a pan, a man in a hat looks into the camera and then turns to look to the left toward the dog. A cut to the bassoons has them also looking in the direction of the dog, reharmonizing the look. Edits like this reestablish continuities and discontinuities, establishing a sense of simultaneity across spaces divided

by capital development and race as well as time represented by old and new neighborhoods and Coleman's own biographical time.

The train tracks provide a classic and concrete symbol of division but also represent a pathway out of Fort Worth. Clarke was quite excited by the tracks when researching the film. In the recording of her research trip, Clarke notes that Coleman was born and raised *just* on the other side of the tracks. "He was a borderline case," Allen says as he shows Clarke Coleman's childhood house, "He was always a borderline case. He was right on the edge." "Right on the edge of the wrong side of the tracks," Clarke responds. The train tracks divide Fort Worth into two places, while the film connects them.

The sequence that makes the clearest comment on how film can collapse space is the one in which Ornette and Denardo Coleman improvise together through Wendy Clarke's video installation *The Link*.[14] The short segment shows video technology that allows the two to see and hear each other between Manhattan and Harlem. In our post-Internet world, the sequence seems quaint. At the time, however, the technology for Wendy's NEA-funded project was state of the art: a General Electric GEM-LINK microwave system, fiber optic cable, and interface equipment. Two moving cameras covered a twelve-foot-wide blue circle. The images of the people in the circles were superimposed. The sequence provides yet another way of thinking about how media can represent and enable simultaneity.

Whether through explicit demonstration such as *The Link* or through an experience of intermittent reharmonization, *Ornette* follows Clarke's cinematic techniques and political interests. The metaphor of the train as border and vehicle provides for a way of thinking about Coleman's biography as well as the consequences of Fort Worth's transformation. The film pulls the border into the rest of the film. Rather than crossing the border to escape, Coleman, according to the imagery edited by Clarke, has brought the border with him. The tracks, the border, the site of division are interesting places. The imagery of the tracks provokes some thought toward the messiness of the border—be it of a neighborhood or of musical genre. Coleman's notion of harmolodics is also an eschewing of borders. The analytical division of harmony, melody, and motion is suspended.

Cineharmolodics

While the reflexive cinematic interventions draw attention to issues related to Coleman's presence in Fort Worth, Clarke also makes room for Coleman's music itself. The film is as much about Coleman as it is a visual rendering of his music. *Ornette* is interplay between music and Clarke's cinema. Her career-long interest in jazz and her understanding of an interconnectedness of artistic disciplines inform this particular union of film and music.

Clarke's first "jazz" films were her series of loops produced for the American pavilion at the 1958 Brussels World's Fair. The State Department gave one restriction to the loops, perhaps due to concerns of bringing up racial tensions at home. "We had been told," Clarke recalls, "that the one subject we couldn't do was jazz. So I made them all jazzy. It became a game that Penny [D. A. Pennebaker] and I played both in the shooting and in the editing" (in Rabinovitz 1983: 8–9). They found ways of subverting the restriction by creating visual versions of jazz. The loops use formal montage in ways similar to jazz theme and variation. *Bridges Go Round* is one of these loops. Bridges are never simply depicted. They are in motion, doubled, rhythmic, and organized by their formal properties. Clarke also took ideas from dance. In an interview, Clarke remembers that she and Pennebaker "quickly found that our problems on these loops were very similar to those which every dancer must face—to abstract, condense, direct and rhythmatize the movements of life. And I also saw that here we were dealing with elements completely familiar to any dancer—rhythm, movement, symbols or abstractions and what we call in both dance and film 'montage,' the organization of all these elements into a meaningful whole" (in Nilsen 2011: 146).

Many of her later films feature jazz as a soundtrack, but she was interested in investigating the form enough to propose a film on the subject. In a 1967 interview she states, "I was planning a film on jazz and I found myself constantly conceiving it for two screens. My producers asked me not to do it because you can't show it commercially, as theaters are not set up for it. 'Split the screens,' I say" (in Berg 1967: 55). While Clarke's methodology was sound, her financiers rejected her original proposal (Nilsen 2011: 146). *Ornette* perhaps bears elements of the way that she thought film could represent jazz.

Choreography of Film Shooting and Video Editing

Clarke always referred to her roots in dance. By the time Clarke started filmmaking, she had already made a name for herself through dance, choreography, and administrative roles. At that time, dance was one of the few arts open to women. As a dancer, she trained in the Martha Graham method, the Doris Humphrey-Charles Weidman technique, and later was a student of Hanya Holm. This places her in the epicenter of early modern dance—refiguring dance as an idiosyncratic expressive art, as an exploration of the self. Her eventual teacher, Hanya Holm, was herself a student of Emile Jaques-Dalcroze, whose eurhythmics understood musical concepts kinesthetically and visually. The Dalcroze method helped attune her to rhythm and music, itself a corrective method of teaching music to dancers and dance to musicians.

The initial wave of modern dance demanded a new legitimacy of dance as an equal to painting, music, sculpture, and poetry. Legitimization is often achieved through comparison, which can, in turn, suggest a unity of art, especially when modern art systematically reduces art to core principles. Hanya Holm's use of improvisation in choreographing suggests a through line to the inventiveness of jazz. Humphrey's reduction of motion to fall and recovery as well as Graham's contraction and release conceptually connected to Piet Mondrian's nonrepresentational line and color arrangements. Ideas as well as people can pass through a unified art world.

The porous boundaries of modern art were crucial for Clarke to remain active. She saw the limited career that aging female bodies have in dance. Clarke began to study film, bringing with her an interest in dance as a film subject and as way of thinking about film. There were few women in film at that time.

Clarke had grown up in a family that could afford to dabble in home movies during the 1920s. She had also received a 16mm camera as a wedding present in 1944. When she seriously began making her own films in 1953, Clarke thought that the many dance films of the time were needlessly bad. The problem, in her view, was that directors were squandering the possibilities inherent in making moving pictures of moving bodies (Bebb 1982: 3). In her own words: "Most of the dance films I'd seen were awful and I figured I could do better. Essentially, film's a choreographic

medium" (in Zahos 2012: 10). When lightweight cameras came out, Clarke saw her entry. Small cameras had the benefits of portability. While Pennebaker, Maysles, and the Drew Associates exploited small cameras to develop direct cinema's directive of "being there" (see chapter 1), Clarke saw another possibility. She could dance with the camera.

"I started choreographing the camera as well as the dancers in the frame," says Clarke about her first short films. Then she continued to apply the technique. As she explains, "*Bridges-Go-Round* comes out of *In Paris Parks* (1954), which simply establishes the fact that you can make a dance film without using dancers" (in Rabinovitz 1983: 8).

With the advent of video, Clarke found that she could apply principles of dance into her editing as well. After abandoning her late 1960s Ornette Coleman film, the Museum of Modern Art awarded Clarke a grant to develop a video-based editing system for film. The project gave her a chance to break out of filmmaking and film. She set up shop in her penthouse in Hotel Chelsea, a hub of artistic activity. Numerous artists and filmmakers interested in the technology formed the Tee Pee Videospace Troupe and engaged in a myriad of explorations in the form of artworks and workshops—often a blend of the two. Video was a promise of new artistic opportunities. Clarke became committed to exploring the medium. In a 1976 interview, she explains the potential: "Video allows for an emotional response on the part of the person editing. What's going to change is that you're going to have the same kind of freedom that actors have on stage, yet you can record it. It allows the filmmaker to stay in the creative process longer" (in Zahos 2012: 14). Video solved the time lag with developing film. She could see the edit on the monitor in real time. Video also allowed for an editing process that was immediate. A touch of a button in time with sound and image brought a kinetic experience to editing—real-time editing.

Clarke links directing, editing, and shooting but places emphasis on editing. By the time she gave the following interview, she could choreograph a camera and edit in time with the motion of her body: "I became a good director by becoming an excellent film editor to cover up the fact of my really rotten camera work. . . . Film is a director's medium, that's my experience, and I've done them all. No, film is a director's/editor's medium. Most great directors also control the editing. A lot of them do it. I do both, always. I have people helping me, but I would never let any-

body do the editing because that's really when I take all those wonderful pieces I have and create what I'm doing" (in Bebb 1982: 3, 7–8).

Video opened up many other possibilities. The Sony U-matic Portapak boasted hour-long recording. Compared to the ten-minute film reel, one could shoot longer and more cheaply on U-matic videotape. In 1975, Clarke began teaching experimental video and film at UCLA. By the time Kathelin Hoffman approached her to direct *Ornette*, she had begun incorporating video into theater production.

With Caravan of Dreams footing the bill, Clarke could bring together the look of film with her new skills of editing in video. The project included a large budget for a documentary. Transfers from film to video and back to film were expensive and complicated. Many documents of correspondence indicate elaborate solutions to preserving aspect ratios and guarding against generation loss. For Clarke, the mixed media was worth the expense and effort. Video offered a way for Clarke to edit with more flexibility. By the mid-1980s, Clarke was still an advocate for video. Not only did video make her workflow smoother, but it also offered an unknown potential. Video, she predicted, "will be the art form of the 21st century—that's clearly what's going to happen" (in Corry 1985).

Working on *Ornette*, she explains her alignment with the critical techniques of neorealism (discussed earlier) and her interest in new technologies: "There's that neorealist side of me but there's another part of me that loves all the playing with film and video technology. . . . My greatest goal is to combine those two parts of me" (in Halleck n.d.). In Fort Worth, speaking to John Allen in preproduction, Clarke explains the importance of using all the technology they can:

> I truly believe that all this could be shot successfully in 16mm, a concert in 35[mm] where you really want very high-tech quality because this is documentary. If we do it well, it will look great and can be transferred to video and back onto film. We might as well use all the technology that exists, because that's part of what this is all about anyway. . . . Those of us who are alive now are alive in one of the great revolutions in human history so that it's really important to use all of this at the same time in an art way, and you'll be perfectly happy with the results.

Perhaps she was playing to Allen's ecotechnical interests in order to bring together all of her cine-choreographic skills. But regardless of the

multiple agendas behind making *Ornette*, she was equipped with the best set of tools she ever had. With a large budget from the Synergians, she continued linking ideas across many art forms in the service of engaging Coleman's practice.

Theory of Harmolodics and Buckminster Fuller

Coleman's harmolodic theory shares features with Clarke's cross-disciplinary practice, though it is more rooted in musical issues. It has been called "an attempt to draw together his insights about music, language, dance, and theories of time and relativity" (Shipton 2001: 565). Evident in her notes, Clarke studied harmolodics and perhaps discussed the concepts with Coleman. The concept is not systematic and Coleman never published the manuscript he was developing about harmolodics. Most of what is known comes from interviews with Coleman and in some scholarship on jazz. Clarke read Martin Williams's book *The Jazz Tradition* (1970) and also features him as a talking head in the film. In his book, Williams places jazz within a comprehensive framework of the arts, whereas other books on jazz introduce the distinctive vernacular of the genre and of its players. This broader framework is the perspective that Clarke presents—using film to demonstrate principles of harmolodics as they apply to cinema. In Coleman's words, it is "not a style but a philosophy" (in Shipton 2001: 565).

Harmolodic theory is somewhat inscrutable. As Alyn Shipton notes, "some of it flatly contradicts normal understanding" (2001: 565). Its roots are best understood following the roots of free jazz that Coleman presented at the Five Spot and in his album *Shape of Jazz to Come* (1959). This early work deliberately avoids the constraints of bebop harmony and form. He has said, "If I'm going to follow a preset chord sequence, I may as well write out my solo" (in Williams 1993: 237). Rather than improvising in units of eight, sixteen, or thirty-two bars, the soloist was given freedom to play for however much time the idea needed. The freedom from harmony and song form allowed Coleman a way of reassessing a more fundamental aspect of jazz: theme and variation. Musicians could develop phrases until they turned into another idea. The album *Free Jazz* (1961) further extended his thinking into group improvisation. A double quartet, one on each stereo channel, offers a thirty-minute exploration of disorder and order. In a sense, the freedom from form opens up a

space of egalitarian interplay among players. Within the political context of the Civil Rights Movement, the abandonment of Western musical forms offered a freedom of African sensibility: collective improvisation, call and response, timbral manipulation, and polyrhythm. In his later work, Coleman aims at reaching equilibrium between melody, harmony, and rhythm—finding correspondences across what appear to be discrete musical criteria. In the liner notes to the album *Skies of America*, musicologist Robert Palmer (also featured in the film) explains harmolodic theory in these terms:

> Each musician is relating to and drawing from a theme Coleman has written out in advance, but each individual hears it, and plays it, somewhat differently. And from Ornette's point of view, each contribution is equally essential to the whole. One tends to hear the horn player as a soloist, backed by a rhythm section, but this is not Coleman's perspective. "In the music we play, ... no one player has the lead. Anyone can come out with it at any time." This is a typical utopian ideal, but as a concept—as a goal—it is absolutely fundamental to the music herein. Every time Coleman apparently takes the lead, pulling the bassist and drummer along in his wake, you can be sure that a moment of synergy, an unequivocal dialogue of equals, is right around the corner. Even when Coleman and [trumpet player Don] Cherry are playing a written theme together, the same notes and phrases in the same register, they play it as individuals. The fine points of each player's phrasing and inflection are deliberately invoked to render each one's voice distinct. (In Coleman 1972)

Buckminster Fuller's term "synergy" had a definite influence on Coleman. Ornette Coleman admired him. "I listened to his lecture and was just inspired," he says in the film. "When he demonstrated the way his domes are put together and how geometric they were done, it just blew me away because I said: 'This is how I write music.' ... He's probably my best hero." He continued to attend Fuller's lectures through the 1960s and '70s. The discussion about traveling to Morocco and playing with local musicians recapitulates the idea that the experience was more about getting beyond culture with harmolodic theory, creating "synergy" rather than offering an exploration of pan-African roots.

Fuller's vision of a sustainable planet was a deinstitutionalized yet

systematic network. Likewise, Coleman's harmolodics deconstruct institutional ways of thinking with the goal of offering freedom within non-hierarchical structure. Michael Hrebeniak notes a similarity of thought: "Coleman's idiosyncratic 'harmolodic' system can be seen as a musical translation of the global ordering of utilities, a realization of techno-anarchistic society that maximizes individual freedom, with patterns of private ownership adjusted to specialization discarded" (2006: 200–1).[15] Fuller's own writing on music is not very strong, but he did believe that musicians had a sensorial relationship with their own theory and that musicians needed integrative thinking—a "spontaneous awareness of general systems theory" (1966: 126, 143).

The connections were important for Clarke to acknowledge in the film. In her archived papers, a transcript of a conversation with Hoffman summarizes, "Shirley suggested using the Bucky footage towards the beginning of the movie to establish an intellectual standard of the ideas and ideals that OC works with."[16] Instead, she put the connection in the middle of the film, following Fuller's talk with Coleman's statement: "As Bucky says, you can't see outside yourself but we do have imagination. The expression of all individual imaginations is what I call 'harmolodics' and each being's imagination is their own unison and there are as many unisons as there are stars in the sky." Hoffman explained to me that she wrote out Coleman's statement. Clarke, by comparison, uses her film to investigate harmolodics through rendering the concept cinematically rather than explaining the system.

Skies of America

Coleman's third orchestral work, *Skies of America*, is his epic "harmolodic manifesto."[17] He premiered the piece in 1972, though both the recording and debut live performance were rife with problems. The Newport Jazz Festival allowed time for only a partial performance. Columbia Records agreed to release an orchestral recording with the London Symphony Orchestra but wanted it cut into twenty-one distinct tracks—in keeping with the practice of promoting albums and singles in jazz and popular music. The label was unhappy with the releases and Coleman was disappointed that the album wasn't marketed as classical music.

In effect, *Skies of America* was given new life with the Caravan of Dreams commission. Coleman had a new opportunity to have the work

performed and recorded with Prime Time, his electric ensemble. Clarke's film was part of that effort. In many ways, Clarke extended her cross-disciplinary practice to produce a film that is very much a cinematic *version* of the piece. The film follows the structure of *Skies of America* and explores harmolodic principles.

Back in 1972, it wasn't only the Columbia Records executives who had a hard time wrapping their heads around the piece. The experience of recording with the London Symphony Orchestra was relatively unsuccessful as well. The orchestra members were resistant. Coleman had written the piece so that the whole orchestra would read a single line, abandoning basic conventions of transposition and clefs. Many orchestral members found the work to be undignified. It seemed to them to be more emblematic of a lack of knowledge in orchestration than a work of musical genius. In fact, in an interview with Gunther Schuller, Coleman freely admits that he had not understood transposition when learning to read. He did not know that an alto saxophone's A sounds as a concert C. But when made aware of transposing instruments (that a note read at one pitch sounds at a different pitch), Coleman thought that perhaps this convention could be abandoned. Much of Coleman's harmolodic concept is liberatory, flowing from the concept of the "unison" and the rejection of the hierarchical notion of "concert pitch." While "unison" usually means instruments playing the same pitch, the harmolodic approach makes the unison relative to each player's natural pitch. Imagine a chorus. Convention would hold that singing in unison means that everyone matches a certain pitch together. The harmolodic approach would allow everyone to sing at his or her own pitch—perhaps the one most comfortable for each singer. Like Buckminster Fuller's geodesic dome, a harmolodic structure abandons hierarchy. Fuller's architecture subverts beam structure as Coleman's composition subverts concert pitch. Each node is equally important in its nonhierarchical interrelations among other nodes. The synergy is the collective interrelation of the parts.

Ideally, Coleman had wanted to have his own orchestra that he could train for *Skies of America* to vary the performance each time (Litweiler 1992: 54). Though financially unfeasible, it would have provided an opportunity for an orchestra member to explore the idea of his or her own unison—the sense of playing in one's own key, while listening to the collective whole. Such practice would require a skill set outside that of most

professional orchestral players; 1983 brought the next best thing. Caravan of Dreams commissioned the Fort Worth Symphony Orchestra led by John Giordano, a friend of Coleman's since the 1950s, to perform the work. Giordano reorchestrated much of *Skies of America* in preparation for the concert. In effect, he translated Coleman's ideas for the musicians. His explanation of the concept takes account of the role of the conductor and the "unison" individuality of each player. Giordano explains:

> If you could take . . . a group of fifteen or twenty people and each of them were in an isolation booth . . . and you could direct them . . . Somehow you could speak to all of those fifteen people but they couldn't hear each other, they could just hear you, and you could say "Okay, now we are going to sing 'Scrapple from the Apple' . . . and I'm going to just start conducting you and everybody started singing it." Now everybody would obviously sing in a different key. [They would sing] in whatever key their natural voice was, [but sing] together. That's a unison. (In Cogswell 1996: 112)

In the end, Giordano's revisions helped reveal that *Skies of America* could liberate the players, allowing each to follow his or her own style, without subverting the authority of the conductor.

The September 29, 1983, Fort Worth event captured in *Ornette* was the first time the piece was performed live and in full. Coleman interjected different improvisations and compositions. Prime Time improved on the original not only by their presence in relation to the orchestra (absent in the 1972 recording due to a conflict with the British musician's union) but also because Coleman had been working out harmolodic theory with Prime Time. He included two of each instrument to free the individual player from having to play the ensemble role (Coleman 1985). One drummer, for instance, could explore a melodic sensibility while the other engaged rhythmic development.

In the end, this performance emphasized that harmolodic theory was more than polytonality—it is an encouragement to explore interconnections, while remaining true to one's own unison. Clarke does just this in *Ornette*. She follows her own cinematic unison, finding correspondences between music and image. Harmolodic theory breaks down divisions between harmony, melody, tempo, dynamics, and rhythm. In that sense,

Ornette is a work of *cineharmolodics* based on the composition *Skies of America*.

Clarke establishes two levels of connection between cinema and music that are structural and conceptual. Clarke studied the music itself and lays the structure of the film on the structure of the multimovement piece. Her notes contain not only the structure of *Skies of America* but also her notes on each section. She explains: "The first thing I laid down was the sound. Then I decided what images were going to go with that particular sound. I shot every single piece we used without knowing what I was going to do with it. Having laid the spine down, which was his music, I edited to the music. That's where the rhythms and energy came from. The film looks like how Ornette sounds and has the same basic thinking" (in Snowden 1986).

To experience this, Clarke begins the music with the orchestra. Or perhaps it is better to say that she allows her audience to begin listening within the space of the orchestra before following connections within her own unison. The shots of the musicians are from close up with wide angles. These give a sense of being onstage. In an archived summary document of one of Clarke and Hoffman's postproduction discussions, the importance of beginning with the performance is clear. It reads: "Shirley felt strongly that the opening of the symphony was needed to keep a strong form to the film; even if images weren't good this would not seriously affect the quality of the overall film since we have other very good things, and that if we threw the opening out, we would a) change the concept of the film, and b) have to come up with a far, far superior concept which would become an equally strong basis for a structure." The beginning of the performances establishes the primacy of the music. The images of the orchestra provide more than an umbrella structure. They root the experience in the sounds themselves.

Like the piece itself, departures and interruptions often return to themes, instrumentation, and textures. But the film allows the departures from themes to move into other art forms, not just different musical forms. Generally, Clarke retains the orchestral music and uses the images of the performance for those sections. Clarke mostly replaces the sections that feature Prime Time with interviews, reenactment, and montage. The strategy is in keeping with Coleman's substitutions and variations. For

example, instead of moving from the orchestral movement "Birthdays and Funerals" to the shimmery "Dreams" movement, Clarke cuts to a sequence of Ornette and Denardo in 1968. The rhythmic disorganization of car horns in the city soundscape resembles the arrhythmic strings in "Dreams." Clarke's sequence stands in for Coleman's movement.

Some of the translation from sound to image comes from Clarke knowing Coleman's compositional intent. Clarke read documents on Coleman's composition process, underlining the following phrase: "I wanted the sound of the orchestra to create a very clear earth and sky image of sound as much as feeling of night stars and daylight." Earth and sky images abound in the film, corresponding to different sections of the film. Much of the string sounds are high—musicians playing high relative to the range of their own instruments. Other correspondences come from her own ear. In the notes, she writes, "editing approximates the color, rhythm, punctuation, phrasing of the music—sound and images become one." Other notes reveal her more specific translations of sound. A page of notes in her notebook connects what she sees and hears in the score to visual imagery. Entries include: "Wildlife; crawly animals such as reptiles . . . City life. Buildings, cars . . . music played like an aria . . . Each player going for himself . . . Each section of instruments is successively brought up, then sound fades into overall, like twinkling stars. Visual imagery: Gets dark. Stars twinkling."

The research into cross-disciplinary connections eventually led to a process. Hoffman describes editing with Clarke: "To connect with filming or editing, she would sense the musical score, or the musicality of the scene/dialogue. To test just-completed rough edits, we would sometimes stand and move to the shape and tempo of the images" (in Zahos 2012: 23). The choreography of cinema and intermittent reharmonization adapt to Coleman's harmolodic practice. The most cineharmolodic moments of the film occur when the editing connects different musical-cinematic elements. A clear example is the connection between the train and the stage. While talking to Denardo, Ornette sits on his childhood front porch. Toward the middle of the discussion, there is a cut to a shot of the train. The sound of the train competes with Coleman's voice. Denardo makes a comment about the train: "The train really comes through your backyard." Coleman laughs: "That train used to wake me up every morning! Yeah. I was living really close to the track there." The clang-

ing sound of the crossing bell cross-fades with Bern Nix's staccato guitar line in the next movement onstage at the convention center. The pitch is a whole step higher and the tempo shifts from about 140 to 158 bpm. But overall, the musical similarity brings the sequences together without privileging one over another.

Camera pans, shapes, sounds, and rhythms connect various elements of the film music in a way that conforms to Coleman's ideas rather than explains them. In doing so, Clarke found an opportunity to engage Coleman's philosophy rather than reduce him to an icon of free market success. This is in keeping with the poetry of the piece itself. While disorienting, the effect of multiple agendas and the collapse of time and space can give a critical distance. It is this spirit that, in fact, animates *Skies of America*—Coleman's assertion that there are no divisions in the air, high above America. In his liner notes to the Columbia Records release, Coleman states:

> The skies of America have had more changes to occur under them in this century than any other country: assassinations, political wars, gangster wars, racial wars, space races, women's rights, sex, drugs and the death of god, all for the betterment of the American people. What then is left to happen under the skies of America but the goodness, a country with so many changes within the nature of its people must have something very special in store for the world to enjoy since it has done so many things to change its own territory and mental relationships to each other. Love, hate and lies live in the nature of all in some manner. America knows all three of these from the world and its people. Why, where and what is the purpose of a country that has the essence of mankind and the blessing of the skies. America is a young country. When it reaches one thousand years will its descendants care about the American Indians whose skies gave so much? All Americans know who, how and why their existence came to be American regardless of the condition. If only then one could be as true as the skies of America.

Through a cineharmolodic rendering of *Skies of America*, Clarke's film adds the realism of film to show what the world looks like from a higher vantage point—the inequity between neighborhoods in developing Fort Worth, the cultural and economic differences between Fort Worth

and New York, and the different moments of time through Coleman's career. With knowledge of the film's backstory, these differences take on a greater significance.

In a for-hire work, Clarke found a way of allowing the "unisons" of different visions for the film to coexist. In the guise of cineharmolodics, Clarke was able to address her interest in jazz, her political stance on racial inequity, her concern over market appropriation of art, and her interest in a particular kind of cinema. At once the film demonstrates a connection between Clarke's and Coleman's philosophies of art and prevents them from feeding into a theory of individualism that might justify John P. Allen's Gurdjieffian prophecies of the next evolution of mankind or Ed Bass's free-enterprise entrepreneurism. Clarke was very careful not to exploit her subjects. In an interview, she explains her stance within the documentary film world: "I admire the films of Pennebaker and Rick [Leacock] so much because they have a line, like I hope I have, beyond which they will not go. I will not allow people to exploit themselves if they don't win in the end" (in Rabinovitz 1983: 11). Participating in *Ornette* gave Coleman a complete performance of *Skies of America*, a string quartet, and recordings of them all.

Coda

Caravan of Dreams managed an active theater, restaurant, karate studio, cactus garden, rock cave, film studio, and library. They also used the space as their main headquarters for developing the Biosphere 2 project in New Mexico, hoping to create a closed ecosystem to test a way of sustaining a chosen few on Mars. But the synergists running the institution failed to integrate well into Fort Worth. Shortly after the opening, a local journalist expressed displeasure with the synergists: "They seem to take this calculatedly aloof posture that 'we are the missionaries of haute culture, and we'll dispense pearls to the swine of Forth Worth on our own terms'" (Appelbome 1984: 127). "Every time they would leave the building, people on the street would turn their heads and stare," remarked a local (Patoski and Crawford 1989: 125). The public relations director Jane Pointer unnerved a dance critic with her lack of knowledge of the dance field. A local commercial filmmaker was not convinced that Allen's wife, Marie, knew much about cinema. Local architects were wary of Caravan of Dreams architect Margaret Augustine, whose only degree

came from John P. Allen's own Institute of Ecotechnics (124–25). Furthermore, they had little business sense among the city's boosters. Allen was known more for chanting Tibetan mantras in the restaurant than for his business acumen.

Members began shifting practices, establishing hierarchies, wearing suits to meetings with local business leaders. In 1984 they again baffled Fort Worth, announcing plans for the Biosphere 2 project. That same year, a local musician and record producer said Caravan was being controlled by a cult, echoing similar concerns about The Theater of All Possibilities in San Francisco (Brooks 1978). Carol Line, assistant to the creative director, decided to try to leave and also tried to pull Ed out. She approached the extended Bass family for support. Sid and Robert stated that they supported their brother and Ed issued the following statement: "I am certain that time will demonstrate the value and validity of . . . combining sound traditional principles with an innovative capitalist approach" (in Patoski and Crawford 1989: 125). Until its closing in 2001, the booking at Caravan became markedly less experimental.

The synergists are still active. But after legal fights with Ed Bass in 1994 and a subsequent splitting of assets, they lost their oil-fortune funding. Bass took Caravan of Dreams and the Biosphere 2, which had been discredited as "unscientific" (Cooper 1991: 24). Synergia Ranch now runs an organic farm and rents space for workshops, retreats, and seminars. On their website they describe the space: "Very reasonably priced and conveniently located, the charming setting, friendly staff, and variety of facilities at Synergia Ranch makes it the perfect location for your next seminar, workshop, gathering, business retreat or conference. Located 30 minutes from the center of historic Santa Fe." In Fort Worth, the Caravan of Dreams building is now home to Reata Restaurant, which specializes in haute Texas cuisine: tenderloin tamales and cowboy cosmopolitans.

4 THE THEATER OF MASS CULTURE
D. A. Pennebaker and Chris Hegedus, *Depeche Mode: 101* (1988)

In the mid-1980s it was not unusual to see a "DRUM MACHINES HAVE NO SOUL" bumper sticker on the back of a car. Rock seemed to be under threat of degradation. It was as if synthesizers and sequencers were weapons of slick pop music commodities deployed through MTV videos while The Buggles's "Video Killed the Radio Star" played in the background. So when D. A. Pennebaker and Chris Hegedus announced that they were making a film about British electropop band Depeche Mode, people were incredulous. Hegedus recalls the moment during our interview at their Upper West Side office: "For so many years at the time, it was like, 'How could you make a film about Bob Dylan and Jimi Hendrix and Janis Joplin and all of that music and then make a film about Depeche Mode?'" "Yeah," laughs Pennebaker. "It bothered people!"

Pennebaker has provided images of some of the most venerable rock stars, helping define what "classic" meant in classic rock acts. He shadowed Bob Dylan on his 1965 concert tour of the UK for the influential *Dont Look Back* (1967). The film mixes Dylan's playful antagonism toward the press and his resistance to being dubbed an earnest political leader. He shot and directed *Monterey Pop* (1968), capturing notable performances by Otis Redding, Janis Joplin, Ravi Shankar, and Alla Rakha, among others. In 1973 he released a concert film of David Bowie's sur-

prise last performance as Ziggy Stardust with the Spiders from Mars. Depeche Mode is the outlier—a pop band with synthesized sounds and no clear rock attitude, dubbed by *Rolling Stone* magazine as "America's favorite Euroweenies" (Daly 1993). But Pennebaker was never bound by principles of rockist musical taste. Like many of his generation, he was more of a jazz fan. He had been an unlikely rockumentarian—a month shy of forty-two years old when he shot twenty-something-year-old hippies and musicians for *Monterey Pop* in 1967. Decades later, the appeal of Depeche Mode to Pennebaker was their incomprehensibility.

"It's probably our favorite film that we made in many ways," says Pennebaker. "We wouldn't have thought so in the beginning. It seemed like kind of a dumb film to make. *We had no idea who they were.*" When the band approached Pennebaker and Hegedus to document their *Music for the Masses* tour (October 1987 to June 1988), the original pitch seemed like a lucrative yet uninteresting proposition. "When they came to us," recalls Hegedus, "they were really interested in doing more of a music film. . . . But that didn't really interest us as much. Going around on their tour just wasn't that interesting in the beginning. You could just tell right away." Pennebaker knows how rock charisma translates to film. "It wasn't going to be a film that could just hold itself in that way, like David Bowie's performance," he says, "Bowie is spectacular. He's onstage the whole time and you can't take your eyes off of him." Speaking of Depeche Mode, "They're just normal guys," Hegedus continues. "They're not Bob Dylan. They don't have that type of spiritual ascendancy to their personalities." Pennebaker then went to see a show in Oregon and was surprised, noting, "It was really amazing because it was like going to some sort of a large ceremony of early primitive peoples. [The fans] made all the hand signs and stuff. I thought, 'This is a whole new scene that I don't know anything about. That's interesting. I want to know more about it.' So we hung out with them for a while. We went on tour with them, I guess, just to find out what this was about."

For many filmmakers, accepting the proposal to do just a concert film could have been a strategic professional move, an opportunity to make a commercial film, bank the profits, and offset the cost of projects with less commercial potential. But Hegedus was optimistic and ambitious: "I was really interested to see what we could do with it to make it actually more interesting than it was getting for me just as a thing to do."

In hindsight, Depeche Mode is a significant band. Thirteen studio albums, fifty-three singles, six live albums, and eight box sets have sold beyond the one-hundred-million mark. They have been nominated for five Grammy awards and remain one of the most influential electronic music acts. But at the time, they were the antithesis of the rock musicians with whom Pennebaker was associated. The filmmakers started with the question: Was it even rock? The band's three synthesizers and tape loops were categorically different from traditional rock groups. Virtuosic guitar solos were nowhere to be found.

The film Pennebaker and Hegedus ended up with explores the nature of Depeche Mode's music and the relationships that the fans have with the band. *Depeche Mode: 101* is a documentary born of both curiosity and the desire to make theater. Cinematically, the film reveals aspects of the music and its performance, while also dramatizing a massive popular music phenomenon. By doing so, Pennebaker and Hegedus offer opportunities for perspective on a significant moment in popular music and a chance to look at 1980s America through a fresh lens.

A Theatrical View of Post-Fordist America

"I felt like I was discovering America!" says Pennebaker. "It was really a heavy thing in my head. I was finding something that I had no idea about and I thought I knew everything. I thought nothing would surprise me in America.... I was a college graduate. I lived in New York. I knew a lot of musicians and a lot of people fairly well known. I had no idea of *this* world." This wasn't the first time that an American filmmaker used touring British musicians to reimagine America as foreign. The Maysles brothers presented the country through the eyes of the Beatles in *What's Happening! The Beatles in the U.S.A.* (1964) and, to a lesser degree, the eyes of the Stones in *Gimme Shelter* (1970) (see McElhaney 2009: 63–64). Pennebaker presented his own strange perspective on America; but in the case of *Depeche Mode: 101*, the strangeness comes most strongly through the eyes of the fans, not the eyes of the band.

According to Pennebaker the life of the band was fairly uneventful and routine: "They are going from town to town, from hotel to hotel, drinking at night after the show, sleeping, waking up, rehearsing." Given the challenge of making a film about a largely uncharismatic band, Pennebaker and Hegedus added a group of fans following the tour on their own bus.[1]

"We manufactured," says Pennebaker, "which is something that we don't normally do. [Depeche Mode's manager] said, 'Let's have a contest at this radio station right outside of New York that's very into Depeche Mode. We'll pick some kids. We'll send them in a bus across the country.' They thought of that idea to do and we said, 'Great,' and just followed it all."

Depeche Mode: 101 was released well before the days of reality television. Seen now, getting a group of young charismatic people together and rolling the camera is a regular part of the entertainment world. But shooting on expensive ten-minute reels of film, the filmmakers had to be more pointed in their approach. This footage is carefully placed to present the worlds of these fans. The story of the fans on the bus could almost be a separate film. Jeff Kreines and Joel Demott filmed the young charismatic fans. The two had recently filmed, edited, and produced the later-era direct cinema film *Seventeen* (1983), a gritty and bleak look into the lives of teenagers with low economic prospects in Muncie, Indiana. Kreines and Demott had a perspective on and rapport with contemporary teenagers. The material they captured for *Depeche Mode: 101* brings an uncompromising portrayal of 1980s teenage mass culture to the engaged audiences that Pennebaker and his crew shot at the concerts.

Celebration and alienation intertwine throughout the film. Pennebaker's music documentaries are distinctive in how they defeat the division between the stage and audience floor, creating a synchronicity of performers and audience members. In some cases, the audiences are as memorable as the musicians. *Depeche Mode: 101* is no exception. Pennebaker had not, however, ever followed fans outside the concert hall. The tacitly separate worlds of the traveling Depeche Mode fans and the band provide a palpable sense of alienation. The fans on the bus seem uninterested in making direct connection with the band. The gulf between the two narratives provides points of interest into a new world of large-scale music commodification.

Pennebaker and Hegedus create theatre, offering an experience of a reality that does not reduce to a certain argument.[2] Hegedus has explained their intent this way: "We want it to be dramatic rather than documentary, a musical with narrative. . . . The story is basically about music and kids in the Eighties" (in Lowenthal-Swift 1988: 47). The film is neither expository nor is it a disengaged photocopy of the world. Instead, the film preserves tensions and ambiguities, while offering an emergent

critical perspective. The film has roots in direct cinema's adherence to crisis structure—an emergent narrative based on an impending critical moment—only there is no hero, no JFK, Eddie Sachs, or Paul Crump. The film unfolds according to its own structure and, to borrow words from another pioneer of direct cinema, Robert Drew, it has "moments of tension, and pressure, and revelation, and decision" among all those who participate in mass culture of the 1980s (in Bachmann et al. 1961: 18).

Three main spaces in the film play against each other: about an hour of concert performances, a half hour of the band backstage, and another half hour of the fans on and off the bus. As a long-form parallel cut, the first ninety minutes of the film establish two modes: (1) an investigation of alienation through the separate dramas of the band and of the fans and (2) a visual investigation of the inscrutable music of Depeche Mode. The final half hour brings the two worlds of the band and the fans together, providing a celebratory finale that suspends the tensions established earlier. The following sections show how the film draws from a Wagnerian ideal of art, how the edit reveals formal aspects of the music to bring the film audience into a complex event, and how final concert material becomes a type of theater that focuses on the search for dignity within mass culture.

Gesamtkunstwerk of Estrangement

The heading "*Gesamtkunstwerk* of Estrangement" refers to older concepts that are at play in *Depeche Mode: 101*. *Gesamtkunstwerk* is Richard Wagner's term for the "total work of art," and estrangement has been of use in understanding many consequences of capitalism. While neither Pennebaker nor Hegedus was thinking of these terms while making the film, the concepts help illustrate how the particular theater of the musical event revolves around critical issues of labor and commodification. In the narrative that follows, I will consider musical similarities to Wagnerian opera, but this section applies Wagner's concept *Gesamtkunstwerk* to the film—a bringing together of the arts in an intellectual and dramatic form. These are working terms to gauge how cinema can draw from a distant dramatic tradition to engage persistent issues with music and capitalism. If there were any musical ideas brought to the film during production, they were from jazz.

When he was young in 1930s Chicago, Pennebaker began collecting

78 rpm records of musicians he had never seen. By the time he began making films in New York in the 1950s, jazz musicians played everywhere. Seeing long performances of live jazz and knowing three-minute recordings from his collection had an influence on how he thought of making film. The recordings weren't the same thing as the live event. They were distillations of the original, completely different yet related attempts to fit ideas into a smaller container. Film offered a larger container size for music.

Filming Depeche Mode in the 1980s, Pennebaker continued to think in jazz terms: "I was always amazed at how much they could accomplish with the musical program and how much they were able to leave out and still accomplish it." In place of virtuosic musicianship, Pennebaker suggests that the band innovates by stripping away instruments and simplifying melodies. He continues, "I thought that was kind of a test of some kind of musical genius that they were able to do that. Because I think that is what good jazz does. . . . Good piano is so simple but just gets to the bone. They kind of could do that just the way they performed. Not just the way they wrote the music but the way they performed it had that quality."

Musical simplicity makes room for a greater complexity of the entire work: the lyrics, the lights, the dancing, the stage design, and the soup of electronic sounds. By the 1980s, commercial heavy metal pushed virtuosity to a limit (see Walser 1993: 58; Berger 1999: 57). Guitar players staked out real estate within pop songs with complex flashy solos. Drummers often claimed time for jaw-dropping drum solos at arena concerts. Contemporary metal was not unlike nineteenth-century opera and its prima donna singers commanding the stage. Writing in 1850, Wagner's criticisms of contemporary opera could be easily applied to the 1980s world dominated by "guitar gods" Eddie Van Halen, Randy Rhoads, and Yngwie Malmsteen:

> Surveying the busy desolation of our musical art world; becoming aware of the absolute impotence of this art substance, for all its eternal ogling of itself; viewing this shapeless mess, of which the dregs are the dried-up impertinence of pedantry, from which, for all its profoundly reflecting, ever-so-musical, self-arrogated mastery, can finally rise to the broad daylight of modern public life, as an artificially distilled stench, only emotionally dissolute Italian opera arias or impu-

dent French cancan dance tunes; appraising, in short, this complete creative incapacity, we look about us fearlessly for the great destructive stroke of destiny which will put an end to all this immoderately inflated musical rubbish to make room for the artwork of the future, in which genuine music will in truth assume no insignificant role, to which in this soil, however, air and room to breathe are peremptorily denied. (1998: 68)

Wagner's call to order may aim to squelch one type of complexity, but doing so also makes room for a more complex interrelation of artistic modes. In his essay "Artwork of the Future," he imagines an egalitarian complex of all the arts as an antidote for the stratified nineteenth-century operatic traditions of his time. "Man as artist can be fully satisfied only in the union of all the art varieties in the *collective* artwork; in every *individualization* of his artistic capacities he is *unfree*, not wholly that which he can be; in the collective artwork he is *free*, wholly that which he can be. The true aim of art is accordingly *all-embracing*; everyone animated by the true artistic impulse seeks to attain, through the full development of his particular capacity, not the glorification of *this particular capacity*, but the glorification *in art of mankind in general*" (1998: 70).

Wagner sought to integrate music with painting, lighting, and sound design. He understood music to be at the center of all the arts, particularly in its role between dance and poetry. He also wanted to deflate the hierarchical diva/divo culture of opera and reassert the primacy of the composer as central creator. (It is likewise interesting to note that Depeche Mode was considered to be a band rather than a collection of superstars.) By the time Wagner died, cinema was in an infant (if not fetal) stage. One can only wonder if he would have seen film as the great unifier of the arts. Like opera, cinema can operate as collective artwork.

Depeche Mode: 101 brings out working-class issues (particularly those of estrangement) within a cinematic mode like that of Wagner's *Gesamtkunstwerk*. Speaking of the demographic of the fans and the band, Pennebaker says, "They were trying to create a whole new kind of class music that would be every bit as up as Wagner, only for their generation." In fact, many Wagnerian characteristics run throughout the film. The editing draws together the light show, the clothing, and the stage design and draws attention to the lyrics as poetry. Depeche Mode's deviation from

typical rock poses of control aligns with Wagner's critique of pompous virtuosity as a mirror of aristocratic power. The film adds dramatic narrative to a direct engagement with the entire rock event. Following Wagner again, "True drama can be conceived only as resulting from the *collective impulse of all the arts* to communicate in the most immediate way with a *collective public*" (1998: 70).

But why theater? Why not explain the music of Depeche Mode and the historical moment of their fans? For his entire career, Pennebaker has been consistent in making films that resist definitive readings. In a panel discussion on the work of the Drew Associates, Pennebaker admits that, while tempting, "film should not lecture. . . . I don't think films should provide information. Film should be in the first place something that you don't doubt. You believe what you see. And then, you can never tell all things. Every film tells only certain things" (in Bachmann et al. 1961: 19–20). Partiality acknowledges the limitation of perspective. Pennebaker's films achieve perspectives that result from what a camera can do—where it can be, the relationships that the camera engenders, and the resulting footage that comes together once cut into a film.

Pennebaker's definition of theatre is illuminating in how he sees the combination of discovery and drama: "Theater is where you go to find out something new that you don't know. It goes through somebody's brain and comes out in a comprehensible way that is beautiful, that's really interesting" (in Jalon 2012). Hegedus's edit offers possibilities of discovery. As she explains, "You're left with something much more cerebral, something more experiential where you have to use other aspects of your mind to figure out where the story is going, what it's about, what they are really like. You have to pick up all sorts of unspecific clues to get through." For Wagner, the cerebral component of art was also important in *Gesamtkunstwerk*. His dedication to an art form was not just sensual but also highly intellectual. Wagner expected the listener to deduce the narrative substance from the music and its coordination to the other elements of representation (not solely the singing).

Depeche Mode: 101 took shape in the edit room, not in the preproduction planning. Much of the material had no predetermined place in a preconceived cut. While Pennebaker tends to cut film in the order that events actually happened (compare *Dont Look Back* to the Maysles's *Gimme Shelter*), Hegedus brought a willingness to play with time. The

edit came together by connecting material of audiovisual interest. One of Pennebaker's principles of editing is to keep asking "What's next?" developing a sense of anticipation. "Usually when you're watching things that interest you," Pennebaker says, "[you are] like a cat. You don't need a person to explain what you're watching." Cats learn through watching. And we learn about the music as we watch the first section of the film. The film is highly organized, bringing us into alienated yet playful worlds of the fans and the band. Rather than laying out the clues that reveal the argument of *Depeche Mode: 101*, it's more useful to see how clues are laid. The first ninety minutes of the film sets up the *Gesamtkunstwerk* of estrangement.

Estrangement within a Post-Fordist Music Industry

From a business perspective, Depeche Mode operated like no pop group Pennebaker had ever seen. "They were sort of adventurers," he says. "They reminded me of the little pirates—the small-time pirates who used to go down along the Panama Canal coast and raid these villages. And that's all that they did. [Depeche Mode] would raid these villages with two forty-foot trucks. They hardly even had to do setups. Somebody would run the tape recorder to make sure it was working and that was it." The film does not, however, present the band as the pirate captains. It presents the band as musicians laboring under capitalism, participating in the commodification of music for a target consumer audience. Narratively, the film presents a complex story of alienation.

Alienation comes in many varieties and these varieties appear throughout the film. Scholars from many different intellectual traditions have used the term to understand the social effects of capitalism. This is not the place to summarize or compare theoretical traditions of the concept, but a few examples show how estrangement offers insight to the arrangements of capital. For Marx, capitalist production creates types of estrangement from oneself, society, species being, products, and labor (Marx and Engels 1988: 76–78). Martin Heidegger was also concerned with estrangement, and his writing centers more on the dehumanizing estrangement of being (2008: 212–13). Walter Benjamin and Theodor Adorno find the term useful in describing how mass culture can alienate people from art (Adorno 2002: 391; Benjamin 2007: 226; also see Taylor 2016: 8).

Depeche Mode's lyrics, though certainly not as systematic as those

cited above, conjure images of estrangement as well: "Let me hear you make decisions without your television" (from "Stripped"); "Sitting waiting. Anticipating. Nothing" (from "Nothing"); "There are times when I feel I'd rather not be the one behind the wheel" (from "Behind the Wheel"). *Depeche Mode: 101* adds dramatic and visual layers to the band and the fans' relationships to capital, to various types of estrangement, as we discover alienated musical practices in a post-Fordist economy. The film collapses the realist evidence of estrangement and the performative address of estrangement into a single, yet complex, theater of estrangement. Dramatically, the backstage and fan bus segments establish three distinct types of tension: consumer estrangement from community, cultural workers estrangement from their own labor, and the loss of an artwork's aura when converted to a reproducible commodity.

Estrangement by a Thousand Cuts

By the mid-1980s, commercial music markets had become highly segmented, deepening into a post-Fordist economic practice. Pennebaker noted this economic shift of music markets in a 1988 interview: "This film may not have as broad an audience as you had in the Sixties" (in Lowenthal-Swift 1988: 44). Audiences became subject to narrowcast more so than broadcast as niche markets multiplied. Put another way, rock had become hydra-headed. As a result, Pennebaker recognized that bands like Depeche Mode could overwhelm particular niches and yet be relatively unknown outside their audience; "The audience they had was amazing to me always because it was huge and it seemed to me that these were people who never went to anybody else's concerts." The narrowcast separation works both ways. Pennebaker continues, "[Kids] would say 'Depeche Mode' and the parents would say, 'Who?' They would never know that they just lifted a quarter of a million dollars out of that town and [went] on their way."

The film shows the effect of narrowcast by presenting encounters with outsiders. An airport worker in Los Angeles thinks that fans Oliver Chester and Sandra Fergus are members of the band. Earlier, Oliver Chester and Christopher Hardwick sing "Route 66" for incredulous local diners. "What do y'all sing, punk?" asks a local patron at the diner. They can't read the clothing and hairstyle and match it to the musical subgenre. Perhaps the middle-American diners are Elvis fans, but the De-

peche Mode fans clearly have no taste for Elvis Presley. In Nashville, Joel Demott films Oliver and Sandra getting dressed and preparing for sightseeing. Sandra asks Demott about the itinerary, and Demott discovers not only that Oliver does not know what Graceland is but also that the two fans consider Elvis Presley to be boring.

In Pennebaker's time, he had witnessed a nation split on the merits of rock artists such as Elvis Presley and the Beatles; but in each of those cases, the entire country knew who the artists were. Rock had unified teen audiences before, but now it was splitting them apart. In Albuquerque, the fans engage in a "cultural encounter" with heavy metal fans. They take photos, examine each other's clothing, and (in a particularly awkward moment) discuss Mia Decaro's appeal. As they watch the locals leave, Jay Serken says to Hardwick, "They're driving a Chevrolet. What do *they* know?" after deriding a heavy metal band. Thirty years earlier, Dick Clark's audiences were coming together through consumption, while the margins were local minority audiences (Delmont 2012). The Albuquerque encounter reveals fragmented national audiences.

For much of the film, the fans seem estranged in their own country. Chris Hardwick even kisses the ground when arriving in California, perhaps feeling he is finally on more stable cultural ground. At one point, Chris Parziale believes that they are driving through the Sahara Desert.

The film reveals that Depeche Mode's musical taste contrasts with that of their fans. The band has a broader interest, evidenced by impromptu jams backstage of music that is, by then, decades old. They make a trip to the Ernest Tubb Record Shop and purchase a few cassettes—Johnny Cash, Roy Orbison, and Willie Nelson. When asked by the clerk if he prefers country or bluegrass, Martin Gore replies, "Don't know enough about it. I'm just getting into it, just starting." He and Andrew Fletcher also visit, presumably, Gruhn Guitars and play acoustic and twangy electric blues rhythms. They look out of place but they sound Nashville appropriate. Their drama of estrangement is one of musical labor.

Estrangement from a Musician's Own Musical Labor

Dave Gahan's alienation from his own labor is perhaps most clear in a backstage scene following the performance of "Stripped." Gahan begins listing the hardships of touring to a member of the production team. He

paces back and forth, occasionally looking at the camera. His tone is ambiguous—nervously flitting between sincerity and playfulness.

"You miss your family . . ."

"You can get drunk," adds Gahan's companion.

"Yeah, you get drunk. Stay away from home, yeah. You lose a lot of friends because you don't see your friends. I've got maybe two friends in the world—real friends. There is a bonus, though. You make a lot of money. A lot more money than when I used to work in the supermarket. Well, that was more fun, though."

"It was more fun at the supermarket?" asks Pennebaker from behind the camera.

"Yeah. A lot less pressure as well."

His companion tries to clarify the comparison. "That's what I think. It doesn't make a big difference. You make more money but the pressure gets big as well. So at the end of the day, it's the same."

Gahan brings the discussion back to himself. "At the end of the day, I was stacking shelves, but I was very happy."

In the lead-up to the concerts, the tape recorder dominates, standing for a capitalist enterprise that appropriates the musical labor of the band members. As a result, the musicians' relationship to the products of their labor becomes another instance of estrangement. Under the arrangement of capitalism, the worker becomes alienated from his or her own labor. In his seminal book, *Labor and Monopoly Capital: The Degradation of Work in the Twentieth Century*, Harry Braverman explains, "Having been forced to sell their labor power to another, the workers also surrender their interest in the labor process, which has now been 'alienated.' *The labor process has become the responsibility of the capitalist*" (1998: 39, emphasis original).

Throughout the first ninety minutes of the film, the band is intensely managed, fairly hapless, and their large stadium shows seem identical from city to city. Early evidence in the film is backstage, in the relationship between tour manager Andy Franks and the band. "Toilet? Any one got to go toilet?" asks Franks, "wee-wees?" The band is in the same outfits they wear for every show, waiting for the tape to start—a signal akin to a factory whistle that starts a day of work. In the drama of *Gesamtkunstwerk*, the tape machine plays the role of the appropriator.

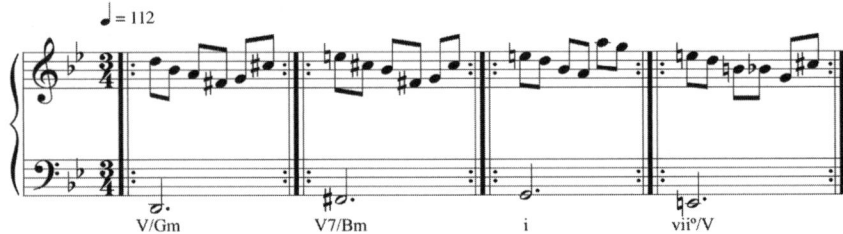

4.1. Transcription of "Pimpf," the leitmotif of the film.

The ominous shifting six-note motif of the track "Pimpf" begins each show. For the film, it serves as a leitmotif of the performance apparatus. Leitmotif, an operatic technique also associated with Wagner, is a recurring theme that becomes associated with a character, object, or feeling, forming the structure of the entire musical work through repetition and development. "Pimpf" begins the film, preceded by band manager Andy Franks saying, "Okay. Start the tape," and Gahan saying, "I think you should say, 'Start the intro tape.'" Albeit playful, the verbal introduction establishes the music as being part of an apparatus. Aurally, we anticipate a concert. But visually, we arrive backstage in a photo shoot—the band draped in loose chains.

The motivic ostinato has vague yet suspenseful harmonic implications (see figure 4.1). The G–C-sharp tritone is in all sections but the third one, a more stable but uneventful hint at G minor. The fourth is the famous Tristan chord (re-spelled) from Wagner's *Tristan and Isolde*. The Tristan chord is Wagner's condensation of dissonance that pushes forward a long series of resolutions, representing unresolved longing and desire in the form of a leitmotif. Only in "Pimpf," the chord seems to function more as a long ostinato than a preparation for resolution. Rhythmically, the figure has features of hemiola, implying a metrical division that vacillates between three quarter notes and two dotted quarters. Repetitive instability marks this musical figure.

The "Pimpf" leitmotif recurs throughout. It scores the exhausted band being shepherded onto stage by manager Andy Franks. It tears the band away from pinball games (and doesn't even lead the film audience to the concert). It waits for technicians to troubleshoot the faltering technology in the intense New Mexico heat. It plays nondiegetically as the fans resolve themselves to being lost on the freeway. In each of these re-

currences, the unyielding and unstable leitmotif is cut short. But it is not until the Rose Bowl concert that the final instance of "Pimpf" develops fully, slightly over a minute, only to stop at its climax and prepare the audience for the songs. The band dramatically snaps into "Behind the Wheel" and the large curtains drop. In this last repetition, the leitmotif cedes to the band.

Estrangement of Art from Other Regimes of Value

The third type of estrangement is that of music losing its value outside exchange—otherwise known as "selling out." Adapting the work of Arjun Appadurai, the ethnomusicologist Timothy Taylor suggests that music does not contain value itself; rather, it exists within many regimes of value (2016: 9). Music might have value, for example, in religious events (Werbner 1996), in family cohesion (Seeger 2004), or in existential contemplation (Harbert 2013b), depending on its circumstance. Popular music has long been a part of a synergistic package of related consumer goods—recordings, T-shirts, posters, lunch boxes, films, books, magazines, video games, and even action figures (Delmont 2012: 458; Altschuler 2003: 121–22). But by the time of the *Music for the Masses* tour, it was even more so. Increasingly, music's use on radio and television was to bring listeners within earshot of advertisements. The popular music marketplace had become global, audiences (consumers) were more segmented, and albums had an even shorter shelf life.

Music has been connected with markets as long as there have been markets, but it has also produced types of value other than commodity. The 1980s music market was not a new moment of musical commodification; rather, it was a moment when commodification became more visible (Taylor 2016: 79). The film augments the visibility of musical commodification. Hegedus explains, "It was so important for me to show the business and that whole part of the money and how much money they were making. . . . It's this huge commercial thing but at the same time, the music is art."

The film offers its most direct commentary on alienation and mass culture in a scene in which the fans debate the nature of art in the hotel room. The scene has deep resonance, putting in perspective the scripted concerts. The show is so elaborate and rehearsed that it is difficult to know where each concert is held, the reproducible event repeatedly ob-

scuring the distinctiveness of local venues. Cutting abruptly from the sequence in which Gahan confesses to being happier in the grocery store, fans are in mid-argument about art and fashion. As Margaret Mouzakitis looks on, Elizabeth Lazlo directs a blunt question to Chris Parziale.

> LAZLO: Then what the hell is art to you?
> PARZIALE: What is art? Art is a feeling, a gut feeling.
> LAZLO: Yeah, well fashion illustration is a gut feeling too. You get it when you draw a woman's body and you add color and shape . . .
> PARZIALE: It's a trend. It's people trying to look like something they're not. They're just not . . .
> LAZLO: It's an art! It's an art form.
> MOUZAKITIS: What you're saying, the way you're talking sounds like [it's] something original. When you design a jacket, you have to make copies of it so you can sell it.
> LAZLO: Fashion design is an art form and it's a business. When you like what you do, it's great. But if you like what you do and you're not making money, then how are you going to pay for everything? How are you going to get things in life?
> PARZIALE: That's whoring yourself. But I'm saying, going it yourself and taking out something that is so beautiful — like a rose, like dew on a rose in the morning. That's something that you gotta capture.

Exasperated, Lazlo and Mouzakitis have stumbled onto an intractable disagreement.

> LAZLO: So what are you going to live on? Love?
> [laughter]
> PARZIALE: You can live on love. There's no doubt about it!
> MOUZAKITIS: You're gonna be a bum!
> PARZIALE: Nah. You're not going to be a bum. You just marry rich!
> [laughter]

The issue is unresolved, dismissed with a joke. Several viewpoints remain.

Warner Brothers pressed to cut this scene from the film. Pennebaker and Hegedus, however, held their ground and the band supported their decision. "It was an important discussion in that it has so much relevance

for that time where commercialism was taking over art," says Hegedus. "Music had a sacredness and then it started getting co-opted in the '70s, and by [the] time you got there to the '80s, it was this huge massive business." The hotel room discussion gets to one of the fundamental issues in rock music—a form of music that resists commodity despite having been conceived as a commodity. Rock as a genre is a critique of mass culture from within mass culture (Keightley 2001: 127). At stake is the musician-author's authenticity as a self-determined artist and music's value outside exchange value.

The debate stands as an important—although messy—question of authenticity for a band led by a tape machine and wearing the same outfits night after night. Perhaps authenticity lingers somewhere within the commodity. The Romantic notion that art is beauty pulled out from the deep sensibilities of the individual artist may be outmoded in the exigencies of living as an artist in the 1980s.

These three forms of alienation (consumer estrangement from community, cultural workers' estrangement from their own labor, and the loss of an artwork's aura when converted to a reproducible commodity) establish the foundation for the drama of the film, portrayed by the alien music of the *Gesamtkunstwerk*.

Film Editing as Visual Analysis

"What was interesting was to gradually get into the music," Pennebaker recalls when talking about shooting the concerts night after night. "In the beginning, I could hardly hear the music. It was like going to listen to Wagner or something and you'd never heard that. It was noise and it went over your head. And then, little by little, we became absolutely involved in the music. . . . The music has a whole different quality to it, but it certainly wasn't jazz—which I had grown up on—but it was just as interesting when you got into it. I felt that I had made some sort of generational leap here into music, which I never expected to do." Not only did they become acquainted during the weeks of shooting, but they created a systematic series of edits that focus on one element of the complex performance event. Each song offers, in fact, a chance to see components of the *Gesamtkunstwerk*. The sequences offer a visual analysis of the synthesized total work.

Images were no stranger to Depeche Mode's music. They were part of

the second British Invasion, during which time MTV became a clearinghouse for new British acts. But MTV wasn't in the business of providing visual analysis of music. Music video edits were guided by the need to keep eyes on a relatively small television screen so that advertisements would be guaranteed to reach young target audiences. Fast cuts dominate because dynamic, flashing images help draw the eye to a screen that is among many things in a room. It is the equivalent of waving one's arms to attract attention in a crowd. Hegedus recalls the standard editing style of early MTV: "Just as long as you are moving, it didn't matter. And you're cutting this and that and it didn't necessarily make any sense to the music or what you were looking at. It just had to be very fast and visual."

Hegedus's ears and her understanding of the entire Depeche Mode performance guided many of her editing decisions. She edited to instruct: "Just so you can see what you're hearing," she explains. "I really wanted you to get a sense of the music by watching it." For example, "watching how it comes in and out and who's coming in and singing where. I tried to bring out that." Far from explicative, Hegedus's edits offer the audience directed opportunities for aesthetic discovery.

The heuristic edits function differently from the long takes. A hallmark of direct cinema, the long take is the anathema to an MTV edit. Lingering on a well-framed shot can have a strong effect of drawing attention to the performer's skills. Pennebaker says, "Performance is when a guy who probably couldn't do anything else in his life, because he was a loser, got drawn into practicing long hours on a guitar or something, and he got good at it—because if you do anything long enough you get good at it—and pretty soon he got some ideas in his head, I don't know where, and then one day he's up there as an icon, y'know, playing music. That's his thing, that's who he is; and when he performs and he's good, and you're filming him, then you really want to see the performance, you don't want to hype something else. . . . I'm not big on cutting to enhance performance. I like to watch the person doing it handle it, kind of move it around and make it grow in front of you" (in Kubernik 2006: 26). The long takes, scattered throughout the Depeche Mode edits, call attention not only to the performance but also to *the performer*. Often, the lingering produces interest in the character developed in the backstage sequences.

Film scholar Nathaniel Dorsky characterizes a useful difference be-

THE THEATER OF MASS CULTURE

tween shots and cuts: "Shots and cuts are the two elemental opposites that enable film to transform itself. Shots are the accommodation, the connection, the empathy, the view of the subject matter we see on screen. The cuts are the clarity that continually reawakens the view" (2005: 45). The extended long takes and well-placed cuts in the concert sequences reawaken the eye and the ear, calling attention to the arrangement and structure of the songs as well as the production of the show and the drama of the musical laborers and narrowcast consumers. Fundamentally, the edits of the performances systematically offer an interest in two things: the musical elements of *Gesamtkunstwerk* and the drama of estrangement.

"Master and Servant": Anticipatory Introduction/
Audience-Performer Relationship

The first performance to appear in the film is an excerpt of the song "Master and Servant." The song occurs twice and for different effects. The first instance offers a brief unsettling summary of the *Gesamtkunstwerk*. Unlike the other performance cuts, the first edit does not draw the viewer into the performance. Rather, it keeps us at a distance, dropping us into the performance midsong to point out a few unusual aspects of the event—offering anticipation of the visual analysis to come with the other songs leading up to the Rose Bowl performance.

Global film structure: Shots of the road anticipate the crosscut technique of the whole film, the concert space and the road space interleaved. These cuts anticipate the juxtaposed three spaces of the film—stage, backstage, and road. At the end of the sequence, an unexpected jump cut from stage to the airplane presents the gap between the vibrant stage and the surprisingly ordinary backstage. The audio cut is particularly effective, creating a jarring difference between Gahan's stage scream and silence, represented by a full twenty seconds of airplane cabin noise.

Light design: The first shots of the sequence are of the lights themselves. The bodies of the performers are in shadows. Lights flicker dynamically, confusing a sense of space but heightening the interlocked rhythm of industrial sounds.

Electronic arrangement: The simple percussive sounds made by striking large rectangles are only part of the tapestry of interlocking sounds.

No melodic hooks or vocal croons pull our ears into the performance. When we see Gahan, he spins with the microphone stand, not singing. The musicians seem to be entangled in a musical machine.

Audience-performer relationship: A young girl screams and smokes. A close-up of the cigarette widens to reveal a woman watching in repose, leaning on the barrier of the stage. She screams and then takes a casual drag on her cigarette. To Pennebaker, it's an important shot, bearing his interest in fans. "Yeah," says Pennebaker as we discuss the shot during our interview. "The sophistication of a twelve-year-old or fifteen-year-old!" It is unsettling. The odd detail allows the fan to stand out; it confounds the tendency to reduce her to a typical audience member. In a way, the scream and puff offer only a possibility for meaning. The shot starts with this inscrutable detail and zooms out to reveal the large crowd. Who is master and who is servant in this relationship between Depeche Mode and their consumer fans?

Performative struggle: The final shot is of Gahan, singing the beginning of the song. The take is long: twenty-seven seconds of the seventy-two-second sequence. A zoom and a change in lighting bring Gahan's face out of the shadows. His performance appears labored. At the end of his vocal line, his head falls out of rhythm and he looks to the ground. Regaining composure, he lets out his long scream into the microphone.

The second sequence of "Master and Servant" occurs a full fifteen minutes into the film. It gives us the entire song to examine the interplay between the band and audience as well as the complexity of the instrumentation. Of all the performance sequences, this one has the quickest cuts and the most consistent lengths, especially during the percussive introduction. The thirty-two shots are short, building anticipation. Many of the cuts occur on dark moments—when a stage light moves or goes off. Cuts defer timing to the formal logic of the light show, heightening the machine-like rhythms. The visual emphasis, however, is on collapsing the space between concert floor and concert stage.

Audience-performer relationship: Nearly every cut alternates a shot of the band or band member with the crowd. Thirty-nine percent of the cut is on the audience. Discontinuity of the stage and audience is made continuous through editing together the faces of the band and audience. The lyrics of the song are made into a dialogue. Captured singing along, the

audience "sings" the first two lines, "Come on, yeah. Master and servant." Edited gestures also bring audience and performer together. A good example of this is when the cuts join gestures of "air drumming" from a woman in the audience to keyboardist Andy Fletcher and then back to Gahan. The result is a single motion that unifies the audience and the stage. Eye-line match augments the continuity of motion: Fletcher is across the screen but directly in the eye-line of the audience member after the cut. In the next shot, Gahan lowers his hands as a downward keyboard melody leads to the chorus. These fans and performers are not as close as they seem to be in the film. The edits construct an intimate mass participatory event in which the audience is seen nearly as much as the band, their motion and "singing" as part of the *Gesamtkunstwerk*.

"The Things You Said": Harmonic Circularity and Orchestration

The slower pace, reduced presence of audience, and longer takes during "The Things You Said" allow the viewer to primarily attend to visual representations of the electronic arrangement and to visual representations of harmonic strategies. The sequence builds on the audience-performer relationship as developed in "Master and Servant."

Electronic arrangement: Early on, Hegedus recognized complex layers of electronic sounds in the arrangements. The sound had emerged from British bands since the late 1970s but synthesizer technology was still fairly new by the 1980s. "There were other bands," says Hegedus. "They weren't the only one. There was New Order . . . but [Depeche Mode was] definitely coming out of that impetus and that movement of 'We're not just going to play drums and guitars and do it this way. We're going to take this new stuff and do something new.'" Visually, electronic music presents a problem: Where are the sounds coming from? An orchestra or a typical rock band has a plethora of visual cues that an audience will associate with a range of different timbres. In other words, an instrumentalist does something to an instrument and it uniquely sounds. On film, a wide shot of a group of musicians is a visual representation of the potential timbral field. Zoom in on a guitar and a film audience will likely listen more to the guitar part. But with three keyboards and a tape machine, it is hard to know the origin of particular sounds.[3] Hegedus and Pennebaker solve for this problem by interviewing Alan Wilder, who breaks down the components of the synthesizer and rectangular MIDI triggers.

Wilder plays individual parts for "Black Celebration" on different parts of the keyboard and explains how the tape machine plays backing tracks. He also demonstrates how the suspended plates trigger sounds like keyboard keys. Following this sequence, seeing a keyboard brings an understanding that there are different timbral spaces on each keyboard and that they change for each song. In the spare and slow arrangement of "The Things You Said" these melodies are clear but made more noticeable with the frequent close-ups of the fingers on the keys. Close-ups of keyboards in the following musical cuts help direct us to melodies, distinct timbres more difficult to isolate within the tapestry of sound of the more complicated song arrangements.

Harmonic circularity: "[The music] had that very layered quality to it," says Hegedus, "and it was a circular thing. I remember editing the film, trying to be able to get that sense—when you watched it—of the music." While rhythmic cycles abound, there is another type of musical circularity present: a harmonic structure in which different chords revolve around common tones. The use of this harmonic movement in Western art music has been to induce a feeling of vertigo.

Much of the harmonic motion in the songs throughout the film is similar to that of late-nineteenth-century tonality developed by Beethoven and extended by Wagner. Breaking from key-based tonality,[4] this approach to harmonic movement connects triads through stepwise motion of chord tones. To develop a theory of this circular tonality, musicologist David Lewin resurrected a system of German music theorist Hugo Riemann to understand the process and effect of Wagner's harmonic constructions (1984). Rather than operating by a cadential tension and release, triads can *transform* into related triads by changing one or two notes of the triad. The harmonic logic of neo-Riemannian operations is one of pivoting around common chord tones rather than the tension and resolution typical of key-based harmony. Relations between notes no longer adhere to a harmonic hierarchy based on the promise of a terminal tonic note.

Wagner and other composers employed both scale-degree space and Riemannian tonal space, often shifting within the same work. Music can involve "essentially different objects and relations, embedded in an essentially different geometry" (Lewin 1984: 345). The geometry has an effect on the listener. Musicologist Richard Cohn suggests that neo-

THE THEATER OF MASS CULTURE

Riemannian tonal space can induce a "mild type of vertigo" through "a suspension of tonal gravity" (1996: 11). Musicologist Guy Capuzzo identifies neo-Riemannian operations in Depeche Mode's "Shake the Disease" (2004: 178–81), but further inspection reveals that neo-Riemannian operations underlie a bulk of the band's material in the film—mostly drawn from the *Music for the Masses* tour.[5] Martin Gore's songwriting had begun to incorporate neo-Riemannian operations at this point.[6] As a whole, the music in *Depeche Mode: 101* moves between these two tonal spaces. Cinematic circularity emphasizes harmonic circularity. First, I'll illustrate the harmonic circularity in "The Things You Said," and then I'll analyze the sequence's cinematic circularity.

Neo-Riemannian operations are best represented on a Tonnetz matrix or by transformational networks (see figure 4.2). I will use these representations to identify harmonic circularity for several songs in the film throughout the rest of the chapter. In a Tonnetz matrix, the horizontal axis is a series of fifths. The diagonal axes are a series of thirds—from the bottom, forward-sloping lines are major and backward-sloping are minor. Major triads can be found in an up-pointing triangle and minor triads in a down-pointing triangle—the three notes of the triads on each of the three points. Motion from one proximate triad to another happens in three basic ways: leading-tone transformation (L), relative transformation (R), and parallel transformation (P). Transformations that preserve only one chord tone can be understood as being combinations of these three types, for instance RL or RP (see figure 4.3).

The alternation between the two chords of "The Things You Said" suggests harmonic circularity felt as a vertiginous harmonic space. The notes C and E-flat sustain throughout the harmonic oscillation. A simple

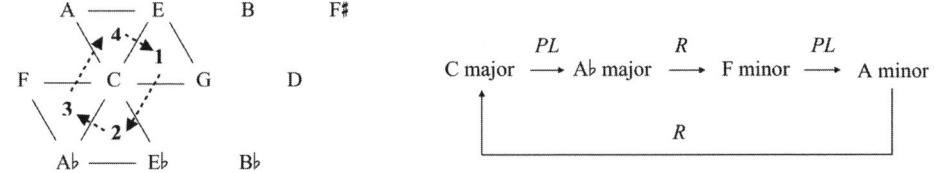

4.2. Harmonic transformations represented on a matrix and transformational network.

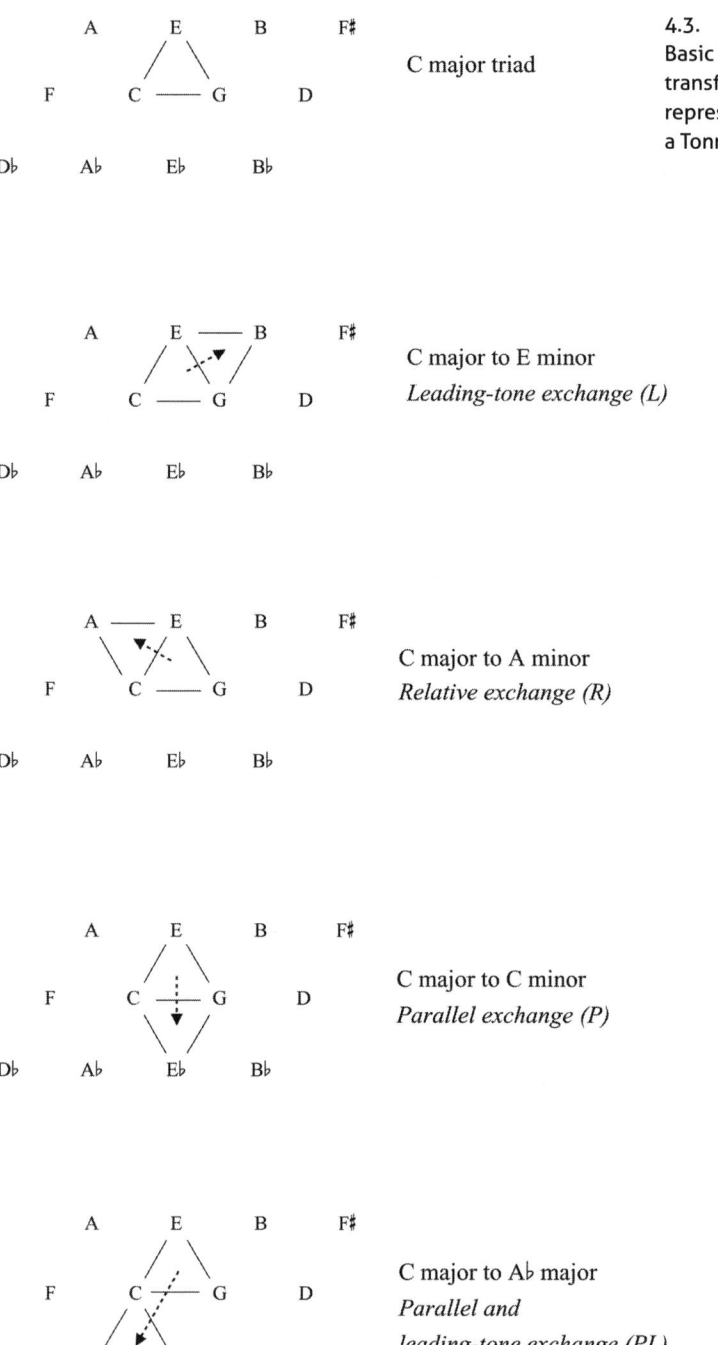

4.3. Basic harmonic transformations represented on a Tonnetz map.

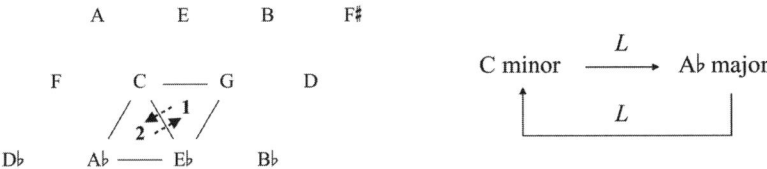

4.4. Tonnetz map analysis and transformational loop for "The Things You Said."

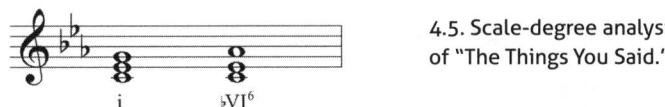

4.5. Scale-degree analysis of "The Things You Said."

shift from the G to an A-flat transforms the C minor triad to an A-flat major triad over and over (see figure 4.4). Theoretically, it is possible to place this harmony within C minor (see figure 4.5), but the two chords aren't functional and the visual circularity in the sequence encourages a vertiginous feeling. Much of the remaining music in the film is in neo-Riemannian tonal space. "The Things You Said" provides a gentle introduction to this alternate tonal space.

Visual circles continue through the film—shapes, spins, feeling in space, departures, and returns. These cinematic presentations are gestural. The ethnomusicologist Matt Rahaim argues that certain gestures can be metagestures, conceptual and proprioceptive complements to a wide variety of sounds (2012: 42–46). A gesture can encourage a certain way of thinking about sound. In the case of this sequence, the cinematic gestures encourage a way of feeling the repetition of C minor and A-flat major.

The song starts when the engineers activate the tape machine during sound check. A wash of synth tones sound with a bass ostinato. The notes C and E-flat sustain through the chord changes. Gore stands onstage as the camera circles around him. On-screen, this fixes our eyes on his, the periphery in motion. A cut to the fans in the bleachers keeps them in motion as if we have momentarily flipped our perspective to look outward. Cut back to circling Gore as he begins to sing. A four-note keyboard line punctuates the first line of the song, "I heard it from my friends about the things you said" (see figure 4.6). The punctuation is a double appog-

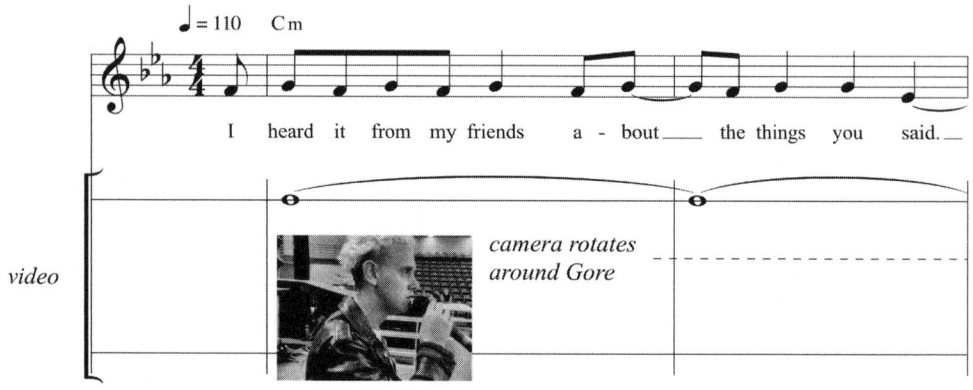

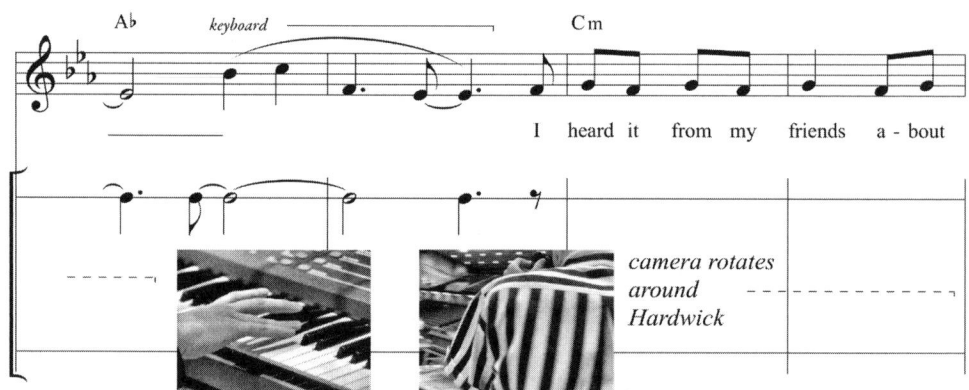

4.6. Vocal line, keyboard melody, and visual sequence for "The Things You Said."

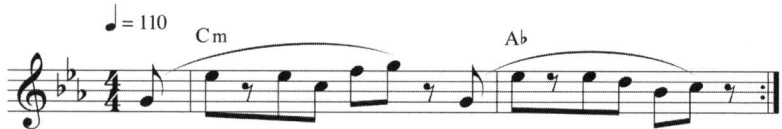

4.7. Longer keyboard melody for "The Things You Said."

giatura in longer rhythmic values with each half coming to rest on the persisting C and E-flat from the tape machine. Another simple keyboard melody frames Gore's singing, again emphasizing the C and E-flat (see figure 4.7). A cut to the keyboard helps draw attention to these melodic stresses within the circular harmonic space. The next cut is to circling the

fan Christopher Hardwick in his black and white referee shirt. (This cut offers visual continuity with the keyboard's black and white keys.) There is a brief break from these two chords in the bridge. The F minor to B-flat major to C minor assert a sense of scale-degree space with a repeated iv–flat-VII–i progression. The cadence is not strong, but it doesn't need to be. It shifts a sense of tonal space.

Within the first few cuts, before the cut that moves us from the sound check to the concert, Hegedus has tied together the three elements of the entire sequence: the arrangement of instruments and tape machine, the neo-Riemannian tonal space, and—continuing from "Master and Servant"—the audience-performer relationship. Half of the shots in the entire sequence are on Gore, the remaining half equally divided between the audience and Wilder's keyboard. Harmonic circularity is one instance of Depeche Mode's distinct sound, represented by the circular meta-gesture of the camera, a feeling of encirclement. As I will later explain in "Stripped," musical circularity also applies to Depeche Mode's rhythms.

"Blasphemous Rumours": Cathartic Fatalism

Separated by one backstage shot that tracks Gahan's return to stage, "Blasphemous Rumours" follows "The Things You Said." The editing presents the intense cathartic effect that the music has on the audience.[7] The lyrics question God's intentions in relation to suicide with the double-time chorus, "I don't want to start any blasphemous rumors, but I think that God's got a sick sense of humor and when I die, I expect to find Him laughing." Cinematically, the sequence centers on emotional affect by drawing attention to two different fans engaged with the song. The "Blasphemous Rumours" sequence extends the band-audience relationship but deepens into an investigation of the psychological impact of the music.

Audience catharsis: In the sequence, audience members "sing" half of the verses. Displacing the voice of the song on them, the edit links their intense engagement to the dark themes of the song. The first shot is of Gahan, silhouetted by the stage lights. The flashing accentuates the downtempo industrial music in the background. A red light illuminates Gahan's face, cueing attention to the direct first words of the song, "Girl of sixteen, whole life ahead of her, slashed her wrists, bored with life. Didn't succeed, thank the Lord for small mercies." The camera remains

on Gahan throughout the line and first part of the slow synth melody. The film cuts to medium shots of the rest of the band, filling the remaining time before the next verse. Hegedus returns to Gahan, framed exactly as before in the upbeat of the first beat before the next verse. Gahan runs his hands through his hair, about to sing the next line. But on the upbeat of the measure, Hegedus cuts to a male fan as he lifts his head back. The fan's hair provides a quick invisible wipe before the first beat, the beginning of the verse, and a shift from blue to red. The sagittal shot puts the fan in relation to the song. (Had it been a frontal shot, we would be more inclined to read his face and apprehend interiority.) A cut back to Gahan facing the same direction links the two "singers." Eye-trace provides yet more continuity between the shots of Gahan and the fan. The intense focus of the fan and, to a lesser degree, of Gahan directs their attention to a space beyond the right side of the frame. In fact, the faces in the entire sequence look to the right of the screen save for a few shots of the band and a final shot of Gahan. This editing doesn't create dialogue between Gahan and the fan; it creates a relationship between both "singers" and something out of sight.

Following the first chorus, Gahan breaks from performance mode and pushes back his hair again. The keyboard line offers a slow melody. Then, a scream sounds from the left and Gahan looks in that direction. Hegedus constructs a point-of-view (POV) sequence here. A cut connects Gahan to the screaming fan through eye-line match, putting her in his perceived gaze (see figure 4.8). In actuality, Gahan would not have heard the fan, but through continuity editing they seem to interact. The fan's scream distracts us (and seemingly Gahan) from the song. The cut back to Gahan has him turned around, seemingly ignoring the fan. The scream continues over the shot, intruding until a cut to the wide stage. This cut

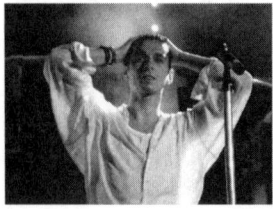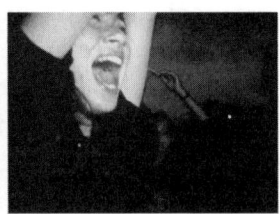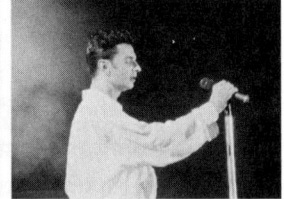

4.8. Cathartic scream POV sequence. Gahan looking during sound of scream; cut to cathartic woman in top left of frame; return to Gahan looking away.

distances us from the preceding interaction and reestablishes the performance stage—but not for long.

During the next verse, the scream returns and we are drawn back to the cathartic fan for the longest and most memorable shot in the sequence. Her performance overtakes Gahan's. The twenty-eight-second take begins during a break from the lyrics. Nothing particularly interesting is happening in the music, so our attention is keenly on her. The shot continues as she sings the verse, out of tune, and runs her hands through her wet hair: "Summer's day as she passed away; Birds were singing in the summer sky. Then came the rain and once again a tear fell from her mother's eye." It is as if the words originate from deep within. Her out-of-tune singing represents emotion overflowing the container of melodic restraint. This is no Beatlemania-esque anachronism. The sequence updates the image of the screaming female from teen adoration to adolescent distress. Popular music scholar Tara Mimnagh argues that inserting the fan's rapture during the song helps to show a "clash of material and spiritual excess through the fans, and not the band. . . . She exceeds the material in terms of her own subjectivity and the tour machine" (2003: 622). But is she in ecstasy, pain, fear, or something else? She is enmeshed affectively in the performance, the imposition of the *Gesamtkunstwerk* allows these two cathartic fans to represent emotion that exceeds mere entertainment.

"People Are People": A Duet of Light and Song
In "People Are People" music gives way to the visual display so that we can see the relation between the two. The first instance of the song occurs when Gore and Fletcher take a radio listener call at a radio station. A fan sings a bit of the chorus over the phone. The sound is thin. Remember, Depeche Mode's canvas is the entire stage production. The thin phone rendering is a foreshadowing of the sequence in which music is seen to be just one component in the *Gesamtkunstwerk*. The stage performance of "People Are People" reveals and stresses the lighting director's contribution.[8] Hegedus remarks, "She worked harder than the whole concert. She played the entire concert."

Light design: The massive venues in which bands like Depeche Mode play often use complex and bright lighting to augment performance—especially for those in the back row. The members of Depeche Mode,

rooted to their place onstage behind their synthesizers, also benefit from the motion that lighting offers. The "People Are People" sequence includes three spaces: the lighting booth *backstage* space, the dynamically lit *stage* space, and the plainly lit *real* space.

In the backstage space, the camera reveals lighting director Jane Spears. In the longest shot of the sequence, Spears audibly directs her lighting crew through her headset and skillfully operates the lights in sync with the music. Over her shoulder, we see the effect it has on the stage. Close-ups reveal that she "plays" the light board with attentive precision. Close-up shots of the lights themselves connect the backstage space with the lit stage space. Hegedus's editing augments the light design by often cutting to the rhythm of light. Cinematography, editing, light design, and the music itself combine into a layered audiovisual experience.

Following the shot of Spears directing and "playing" the light board, we cut to a stage shot from behind Gahan. He is connected to the backstage shot through eye-trace, in line with Spears's direction of sight following the cut. There is a stark visual difference, however, between Spears's rhythmic play and this steady white light that illuminates Gahan. The plain-lit shot is actually from Spears's use of a steady bright white light during the verse. The camera angle helps turn the steady light into a new space. The floors of the stage and the arena are both visible. The audience, though distant, is in this same unadorned light. The camera pans and wide shots reinforce a real sense of space by making physical relationships clear. The constructed "real" space provides relief from the light design. In doing so, the juxtaposed spaces help identify the light design as an aspect of the *Gesamtkunstwerk*.

As the sequence progresses, a series of quick cuts builds to the climax of the song. We leave the real stage space to experience musically timed cuts to band members in the stage space. The editing and light design is synchronized. Cuts occur in every measure on the offbeat of two and the offbeat of four (except for one cut on the beat used to show Gahan's yell to the audience). Together, cuts and light motion emphasize the repetition. The disruption of the visual frame mimics the bass drum at the end of each measure (see figure 4.9). It is as if Spears and Hegedus are performing a visual duet based on the structure of the music. After the climax, Hegedus grants Spears the final gesture. A wide shot shows the

THE THEATER OF MASS CULTURE

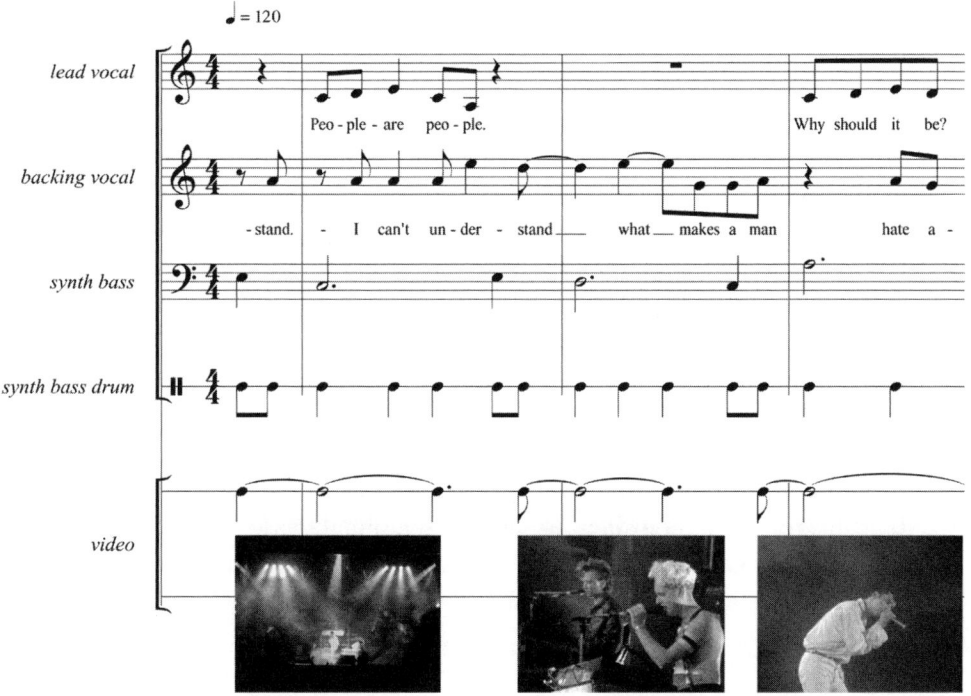

4.9. Rhythm of visual cuts to the repetitive climax of "People Are People."

whole stage. The sound of Spears over a headset reminds us that she is in charge. The cut to black is her doing.

From here on out, we understand the light design to be an integral part of the *Gesamtkunstwerk*. Though absent until she and Gahan embrace at the end of the Rose Bowl show, we know that the wizard is in fact behind the curtain, her power continually transposed through Hegedus's editing.

"Stripped" and "Black Celebration": Drama of Musical Labor

In the performance sequence of "Stripped," the refrain "Let me see you stripped down to the bone" takes new meaning as we watch shots of Gahan ducking out of audience view to rest. Directly before this concert sequence, Gahan admits to taking steroids to pep up his failing vocals. Clearly, the tour is taking its toll. Gahan has had his share of real personal struggles over his career, notably with drug addiction. "It made me feel so good to see him survive," Pennebaker empathizes, "because even

though he only physically danced the music, he was a real part of it in a way that's hard to explain if you didn't see him with the band." The film doesn't explain but rather presents a palpable sense of struggle. Whereas "People Are People" revealed the large apparatus of the show, "Stripped" pits Gahan against the appropriation of his labor. He is featured prominently, taking up 65 percent of the shots. An absence of fans puts him on his own. (They only appear unglamorously as a mass of shadowed arms and heads at the end.) Gahan's relationship to the apparatus forms somewhat of a backstage *Gesamtkunstwerk*.[9]

Dramatic (non)performance: The lights take on a new role. In the beginning of the sequence, they search the stage, rising with the melodic ascent on the synthesizer. A cut to Gahan puts him in silhouette, eventually framing his head and a light over his shoulder. The swirling mist animates the lights, drawing attention to the apparatus of the show. Anthropomorphically, the light resembles an eye or a searchlight associated with the "Pimpf" leitmotif discussed above. We watch Gahan in this long take—a full minute, a fifth of the whole sequence. As the rhythm comes in, Hegedus cuts to a wider shot of Gahan. The lights that had been searching at the beginning quickly and purposefully converge on him. There seems to be nowhere for him to hide and he begins to sing. About halfway through the performance, Gahan breaks his usual song gestures, looking down, and comes to rest during a keyboard solo. The camera pans down to follow Gahan crouching amid a speaker monitor and circular fan. In the real stage space just established in "People Are People," Gahan has found a private space, or, more precisely, we feel as though we have found him in this private space. A slight zoom draws attention to the fact that we are watching him and that there is something to see. He mouths something that may be a complaint. Then he stands, looking up with his arms outstretched. In an instant, he is back in the performance, his expressive facade revealed. This theater of struggle, seen only by the film viewer, casts new interpretation on the lyrics: "Take my hand. Come back to the land where everything's ours for a few hours" and "Let me hear you make decisions without your television." The sense of struggle within alienation runs thick. The song ends with a slow zoom on Gahan somewhat in the shadows. He moves a bit to the music, running his hands through his hair. A final pan of the crowd cuts to a well-lit dressing room—refuge.

Rhythmic and harmonic circularity: The whirling mist around the

THE THEATER OF MASS CULTURE

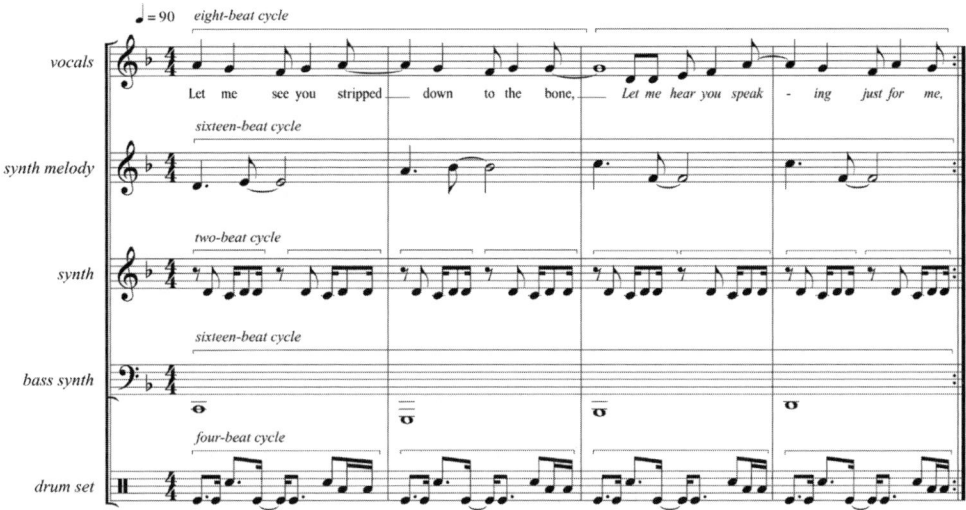

4.10. Colotomic rhythmic structure of "Stripped."

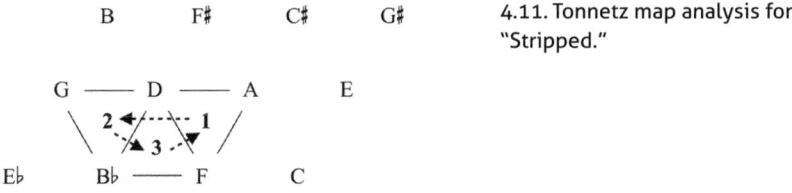

4.11. Tonnetz map analysis for "Stripped."

light visually foreshadows two types of musical circularity: colotomic rhythmic structure and Riemannian tonal space. A cut to Wilder on the keyboards draws attention to the colotomy. Short rhythmic cycles are nested within larger rhythmic cycles (see figure 4.10).[10] With the colotomic rhythm established, regular syncopations weave in and out of the prominent synthesized backbeat. Gahan's gestures strongly accent the larger beats. Harmonically, "Stripped" revolves around a D pedal tone (figure 4.11). Cadential punctuation during the verse breaks up the droning, doing less to establish key than to call attention to the persistent drone. The cadences are more rhythmic than harmonic.

Later in the film, "Black Celebration" continues the theme of struggle through Gahan onstage. The song begins with a long take. Long takes can encourage viewers to contemplate finer details of the story and the char-

acters (Feagin 1999: 174). An insistent ostinato pattern augments the long take, in effect measuring its time. We feel time and think about Gahan in relation to the story.

As with the last two songs, the audience is noticeably absent in "Black Celebration." Hegedus widens the gap between the band and the audience by interrupting the song with a jump cut to the fans bringing a sizable amount of Lone Star beer onto their bus. A fade of sound from the concert spills over this shot, creating a tension between the spaces. The lyrics, "Take me in your arms, forgetting all you couldn't do today," resonate as Christopher Hardwick and "tour guide" Marcello Romero proceed to drink beer and tequila on a bus in the desert, far from the Depeche Mode stage. And for those familiar with the studio recording, the bus scene is a narrative and visual substitution for the alternation of lyrics that closes the song: "I'll drink to that" and "black celebration."

"Nothing" and "Shake the Disease"

The next two songs in the film mostly prepare tension leading to the Pasadena show through harmonic structure and a narrative intensification of estrangement.

Melodic fixation: Iconic image-matches draw our attention to musical phenomena—reducing our listening and luring us into formal contours of the music. While not based on Riemannian tonal space, there is a high degree of melodic fixation in the vocal line and the keyboard melody—primarily on the G-sharp but also other notes of the tonic C-sharp minor triad. Images of buildings iconically represent the drawn out notes. We stare at the buildings while in motion. The shots of buildings are at once views out the window and views of a melodic feature. At one point, a turn around a building coincides with a fixation on a new note, as if we were looking at the sustained triad from another position.

Dramatic tension: As stated earlier, there is little to no contact between the Depeche Mode fans and the band. The parallel stories of the film emphasize this particular social alienation. Hegedus explains the idea behind her cut for the "Nothing" sequence: "The whole film is about the two realities: the band's reality going cross-country and then the [fans'] bus reality going cross-country. So it was a mixing of their worlds because they were going at the same time." The "Nothing" and "Shake the Disease" sequences, however, make this separation more clear. In both,

Hegedus contrasts spaces, intercutting the band in concert with the fans on the bus.

"Nothing" is a synecdoche of the film's social estrangement narrative, one constructed through metaphor and contrasting representations of the characters' bodies in their respective spaces. The metaphor is clear. "There is just a long, nothing road in a certain way," explains Hegedus. "And in some ways, [on] their tour there is a lot of nothing going on for them. There is a kind of boredom of touring for a band."

Music provides a string of continuity between spaces. "It worked," says Hegedus, "because the beat worked and the girl on the bus was just so great—her movement with it." Compared to the intercut shots of the band, the fans move much more dynamically. The band mostly stands, most of Gahan's motions framed out. Musically, the cuts onstage mostly emphasize the simple divisions between the vocal line and the backup line: "Ooh, ooh!" But on the bus, the fans charismatically "sing" the song.

Intensity of experience is felt through fans dancing and also the cinematography. Shooting with a wide-angle lens, the bus shots offer a deeper sense of space. Wide-angle lenses exaggerate depth. Close objects appear larger than distant ones. The mirrors often double the dancers, again at varying sizes due to the lens. The song and the dancing pull together these worlds to such a degree that actual physical proximity is unnecessary for the experience. The band does not miss these fans and the fans seem not to need the live performance.

At risk of getting completely sucked into the dance, Hegedus includes a foil that pulls us out toward the end with a cross dissolve to a fan sleeping on the bus. The cross dissolve is not an elision of time but a reminder that the space of the stage and bus are not the same, lest we forget. The music is anempathetic until we cut back to Decaro.

Closing the sequence, Hegedus brings together the image of the bus driving into the distance (as if we are standing on the side of the road) with a fade-out of the crowd. The combination of disparate audio and visual phenomenon is what Chion calls "synchresis," a cinematic event that produces meaning (1994: 63). Here, synchresis presents the bus and the stage as both united and separate, summarizing the experience of the entire sequence.

"Shake the Disease" widens the gaps between band and fans. It also creates new dramatic tension of estrangement. In the intercut back-

stage shots that precede the musical sequence, the fans and the band get dressed for the show. The fans try out chic clothing and roll a joint. As one fan exclaims, "Hot Momma!" Hegedus makes a startling cut to the band backstage—a full-frame, close-up shot of a baby. Close enough to irony, the cut further divides the band and fans. Outside, the concert production team struggles to start the show as technology problems develop. No "Pimpf" means no production apparatus? The fans then get lost on the bus as the music at the concert finally starts. As it does, the diegetic audio of the bus competes with the song. Other than the slight resemblance of the keyboard sound to a car horn, the sounds of these two intercut spaces differ starkly. In contradistinction to "Nothing," "Shake the Disease" keeps the world of the fans separate from that of the concert. The fans arrive at the concert for just a snippet of "A Question of Time." Christopher Hardwick dances and sings Gahan's line. A cut from Gahan spinning to Chris Parziale spinning (in his daring striped spandex shorts) links them for only just a moment.

For the film's formal narrative, "Nothing" and "Shake the Disease" set up the alienation as we move into the final act: the Pasadena Rose Bowl concert. Drawn into the dynamic space of the bus during "Nothing," we might ask if fan proximity to the band even matters. In the case of "Shake the Disease," we might feel the disconnect poetically: the traffic representing an overly mediated world that prevents connections between artists and fans. For nearly ten minutes following "Shake the Disease" there is no music—only observation and anticipation.

Altogether, these song sequences focus on certain aspects of the *Gesamtkunstwerk*. The "101" in the title *Depeche Mode: 101* is at once a reference to the fact that the Rose Bowl show is their one hundred and first show of the tour as well as an indication that this film is a study of the band—an introductory course so that we may engage in the *Gesamtkunstwerk*. By the time the band plays the Rose Bowl, we are aware of the intense interaction between audience and performer and sense a widening gap—the feeling of estrangement that pervades the film. We also are conditioned to the vertigo of neo-Riemannian tonal space and colotomic rhythmic structure. We can listen through the arrangement of machines and instruments producing sounds timed with the intense light design. The stage is set for the final act.

A Theater of Dignity in Mass Culture

As the band prepares to go onstage for the final show, Gahan is clearly nervous. Outside, the crowd moves their fists in time to "Pimpf." Awkwardly, Gahan jokes, "I'll just go back to the hotel. I mean, I had a good time." His entire body is small in the center of the frame and he addresses the camera with a nervous wiggle. Nothing in his presentation bears rock star confidence. Gahan and the massive crowd outside appear to be in very different emotional spaces. Gahan's redemptive moment will come. This buildup to the concert offers the first opportunity to heal the gap between the fans and the band as well as the gaps between the featured fans. The enormous crowd in the stadium dances in anticipation.

The final act of the film resolves dramatic tensions in the space of festival. By the time the final concert begins, many types of estrangement run deep. There is also familiarity with elements of the *Gesamtkunstwerk* thanks to the visual analysis from the preceding concert edits. The five songs at the Rose Bowl make up the festival—a subject that Pennebaker knows well from his earlier work on festivals of the 1960s. In William Rothman's survey of Pennebaker's music films, he writes, "In *Depeche Mode 101*, as in *Monterey Pop* and *Dont Look Back*, the 'truth of cinema' and the 'truth of song' come together in celebrating a shared dream of a world in which no fence separates the everyday from the festive" (1997: 209). "It's a ceremony of sorts," says Pennebaker, "Once you get into it, you're expected to carry on. You don't just blithely jump out. You kind of become part of it in some funny connection that you understand and a few other people understand . . . I've seen it before. . . . But with Depeche it was the most obvious." The characters seem to enter a state similar to anthropologist Victor Turner's concept of *communitas*, a feeling born from liminality, the suspension of social divisions during ritual process (1979; 1982: 25–27).

In fact, the structure of *Depeche Mode: 101* bears close resemblance to the stages of Turner's ritual process. First *separation*: the fans (as well as the band) are removed from their everyday worlds for a period. Then *liminality*: people temporarily merge their basic humanity without the ordinary divisions—for example, class, race, age, ideology. Sameness matters most. Finally, *reintegration*: the fans reenter their worlds. The third phase, as in all Pennebaker's festival films, is truncated, perhaps leaving us with the question of whether there was any transformation at all. The Rose

Bowl show is squarely within the second stage: the liminal. This phase involves the collapse of boundaries as people start engaging in ritual activity. In the film, they dance and they sing as the divisions set up in the earlier part of the film collapse. Considered within the framework of the *Gesamtkunstwerk*, the film shows how music refigures estrangement. The festive space in *Depeche Mode: 101* is the everyday of 1980s consumerism. Importantly, the final show does not resolve all of the dramatic tensions; it simply passes over some of them. In leaving the tension between art and commodity open, the film acknowledges their interdependence.

Festival/Capital

Anticipation begins the Rose Bowl show with the longest run of "Pimpf" thus far. As the song develops, new parts overlay the disorienting piano motif: voices, rhythms, and new timbres with synth countermelodies. For the first time in the film, "Pimpf" ends. No longer truncated, the leitmotif runs its course, its musical power realized and, perhaps, dissipated. The last hit of "Pimpf" echoes—a studio reverb that we feel in the acoustic space of the Rose Bowl—and "Behind the Wheel" begins.

Listening critically, the four chords to the song's verse not only build, but they insist on a neo-Riemannian tonal space. Only two of the chords are in the key of B minor: a tonic (B minor) and its submediant (G minor). The addition of D minor and B-flat major chords force us into the vertiginous space of neo-Riemannian tonality (see figure 4.12, the numbers representing the sequence of chords). The triads spin around the pitch of D, the same note that Gahan stresses with his voice. The transformational network loop for the chords is represented in figure 4.13.

Short keyboard parts build the colotomic rhythmic tapestry. Musically, this is the strongest cyclical harmony and rhythm. The combination of neo-Riemannian tonal space and colotomy is particularly powerful in popular music. Simple repetition can establish a clear sense of resolution on the first chord of the cycle. Nested repetitions, however, subvert the feeling of resolution by creating a complex set of related cyclic resolutions. Musically, the more complex and disorienting cyclicality of "Behind the Wheel" prepares us for transcendence. Narratively, gaps established between people in the film begin to close.

Visually, the road space and the stage space have converged in festival. Shots of Gahan are quite different from the struggling performance

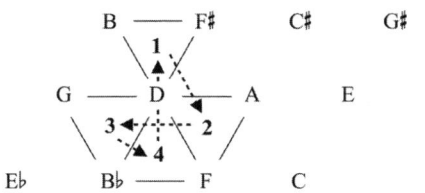

4.12. Tonnetz map analysis for "Behind the Wheel."

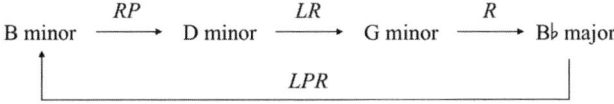

4.13. Transformational network loop for "Behind the Wheel."

we witnessed in "Stripped" and "Black Celebration." Before the second curtain of the stage drops, a profile shot of Gahan and Gore shows them smiling and turning toward each other. Gahan is no longer isolated on the stage. In the crowd, Elizabeth Lazlo and Chris Parziale dance together, as if they have suspended their Benjaminian debate on art and mass media. Mia Decaro dances *with* the band instead of dancing separately on the bus. She even jumps up and down out of rhythm when the second curtain drops, evincing her unbridled enthusiasm of being there.

During "Strangelove" we finally see all the bus fans together in concert. The refrain repeats as the camera passes over all the traveling companions we have come to know as unique individuals. Pennebaker did find there to be a genuine love within that group, as strange as it was. In our interview, he explains: "All of the kind of platitudes that we grew up on, that I grew up on came out of a kind of concept of politeness—of what a polite person would do—and manners. All seemed to have been thrown away. And yet, they still made the same kind of decisions that seemed very rigorous and very right within whatever they were. . . . They seemed very reasonable. I really liked them all. . . . They were masters of what they're doing *in that moment*." As represented in the film, however, their contemporary consumer competency did not totally hinder them from citizenry. They had, in fact, scoured Albuquerque for Christopher Hardwick when they feared that his drunken state might put him in danger. The idea of strange love also develops through the spiky-haired young couple, Oliver Chester and Sandra Fergus. Throughout, they seem simultaneously young and on-trend and like an old, bickering couple. The pans

across the dancing fans encourage us to consider the strange love that runs through the group.

But not all divisions heal. The edit of the Rose Bowl act introduces a new space of capital. Shots of the concert producers and accountants tallying the large profits separate the performances. Cinematically, the visual flow of capital intertwines with the aural and visual flow of music. With our privileged view of the intercut, we see inside the festival to *communitas* and outside the festival to the trailer where Baron Jonathan Kessler and the other producers tally the money made. Registering a tension between spaces, this new tension engages the paradox of authenticity in popular music—what Keir Keightley identifies as the untenability of commercially successful mass society critique (2001: 109). Pennebaker and Hegedus use the film to place us on the brink of paradoxical discord. It was of its time.

The film was made in the post–Bill Backer world of "I'd Like to Buy the World a Coke" (1971) and during Benetton's multiracial "United Colors of Benetton" campaign. Advertising had already brought a celebration of a postnationalism that revolves around a product. The message is that we can be one people as consumers, bucking the narrowcast global markets and rendering nonconsumer differences irrelevant (but symbolically visible). The film pushes us uncomfortably into this logic—the relation between capital and *communitas*. While the edit of the festival suspends all the other binaries and shades of alienation developed in the narrative, the contrast of the festival space and the concert producer's trailer is stark. Vacillating between, we see the fans as citizens reaffirming their oneness and as consumers separated from their money by this collection of strangers in the production trailer.

The producers reveal that they made a killing off of the show. Kessler tallies the numbers after a final adjustment. He looks to someone in the trailer and says, "$1,360,192.50 and paid attendance was 60,452 people." Then, he summarizes with a smile, "Tonight, at the Rose Bowl in Pasadena, June 18, 1988 . . . We're getting a *load* of money, a *lot* of money, a *load* of money. *Tons* of money!"

Cutting back to the concert, the song "Everything Counts" begins on the heels of the producers smiling. The lyrics of the song begin, "The handshake seals the contract. From the contract, there's no turning

back." Power and money, corporate boardrooms; this song seems to celebrate the arrangement of capital as breathtaking power. With lines such as, "The grabbing hands grab all they can, all for themselves, after all. It's a competitive world," it is hard not to let the song score the profiteering.

It is at the end of the song that perhaps the most profound moment of the film takes place. The music fades after Gore plays a few lines on a melodica—perhaps the "soulful" version of the synthesizer? Gahan encourages the crowd to sing the refrain: "Grabbing hands grab all they can, all for themselves, after all." The music drops out. The show seems slightly unscripted for the first time. Audience noise competes with the chorus. Dave Gahan's unmediated connection to the crowd is ephemeral, like his silhouette in the fog (see figure 4.14). The image suggests his double—the performer within the Depeche Mode apparatus and the ordinary man that we have seen backstage. Is the silhouette a suggestion that Gahan is at once a cultural worker and a human being alienated from his craft? Ambiguity sustains multiple interpretations defeating a definitive read. What stands is detailed picture—not a moral determination, but a detailed picture—of a complex economic apparatus mediating relationships among all participants.

For a while, Gahan smiles out to the crowd as they sing. The semantic meaning of the song drops and then simply the act of singing becomes meaningful. They all sing together. They are, in fact, consumer-citizens. The dignity granted to the band and to the fans is not in their overcoming consumerism but that they have found each other within the commodity. Despite the profiteering, people can connect in spontaneous ways. In the DVD commentary, Gahan states at this moment of watching himself,

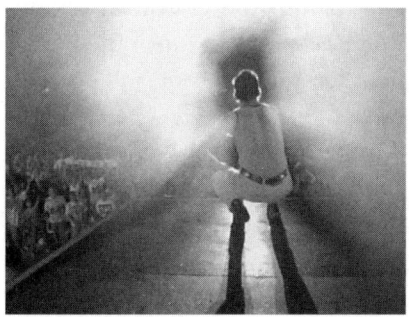

4.14. Gahan silhouetted at the end of "Everything Counts."

"You know, we really *can* come together in a way that is really moving and powerful and cuts through the crap . . . Euphoria, great to be alive."

The art-commodity of popular music is unique in the arts. While Wagner's *Gesamtkunstwerk* was an attempt to move outside the consumer mentality of nineteenth-century opera, Pennebaker and Hegedus's *Gesamtkunstwerk* identifies a space within the commodity market. This space is less about the liberation of art than it is about the liberation of the self. Elsewhere, Pennebaker has made the distinction between fine arts and popular music: "The audience for paintings is thinking more of investment. People who are buying records aren't looking for investment, they're looking for the news" (in Lowenthal-Swift 1988: 45). It should be clear that by "news" Pennebaker does not mean direct message. Rather, they are looking for truth and a sense of the real. In this moment, truth is the acknowledgment that we have the capacity of recognizing humanity. Therein lies our dignity within post-Fordist capitalism.

The Rose Bowl act closes with the song "Never Let Me Down Again." Audience participation is high and we return to the disorienting neo-Riemannian tonal space. A startling shot reveals the sea of audience, synchronized body movement to the extreme. When the shot starts, Gahan's body is in the center of a black background as the song transitions from the chorus to the instrumental conclusion. He waves his hands over his head and shouts at the audience to join in. Then, lights cast on the audience reveal a mass of people waving their hands in unison. The camera pans as synthesized "choir ahhs" punctuate the third beats of the cycle, rising and falling in pitch as if responding in lockstep to the block chords from the synthesizers. The camera continues to pan across the thousands of waving arms for more than a minute.

Pennebaker's camera has always looked into the crowd, extending Richard Leacock's cinematography in *Jazz Dance* (1954) into the crowd response to Ravi Shankar and Alla Rakha in *Monterey Pop* (1967) to the synchronized motion of David Bowie fans in *Ziggy Stardust and the Spiders from Mars* (1973). But the mass participation at a Depeche Mode concert was like nothing he had seen before. Pennebaker first saw this in his initial trip to see the band in Oregon. Interviewed shortly before the film came out, Hegedus acknowledged the discomfort of the image: "The group gets to wave their arms in unison—it's almost frightening when

THE THEATER OF MASS CULTURE

somebody controls an enormous group like that" (in Lowenthal-Swift 1988: 44).

There are filmmakers who would have adopted an ironic or cynical attitude toward the spectacle of a hundred thousand rock 'n' roll fans in a football stadium waving their hands in unison, filmmakers who may have assumed that these young Americans must be as conformist, as mindless, and as sheeplike as their German counterparts during Nazism. They might present this shot as an exemplar of inhumanity, not humanity. But that is not the attitude of Pennebaker and Hegedus. After all, these young people have not gathered to listen to Hitler rant about a master race building a Third Reich; they are fans who have gathered to celebrate the music of an electropop band, to celebrate being human, to celebrate living on Earth, where everything changes. But in the end, we find dignity not by bucking the commodity. The *Gesamtkunstwerk* is at the basis of an intense organization around the commodity and found moments of citizenry within it.

Coda: An Unlikely Collaboration

I have neglected to mention the penultimate song, "Just Can't Get Enough" in the above treatment of festival. The sequence warrants its own concluding section that acknowledges another collapse of boundary during festival: the boundary between filmmakers and subjects. During "Just Can't Get Enough," Gahan looks into the camera, breaking from performance. I register this look differently having interviewed Pennebaker and Hegedus. It is a hint at the co-conspiratorial relationship — another relief of estrangement felt during the oftentimes-disquieting portrayal of four noncharismatic musical laborers.

Repurposed for the *Gesamtkunstwerk*, "Just Can't Get Enough" scores a momentary connection between Pennebaker and Gahan. The song is a light love song, mostly revolving around a I–IV chord change. The harmony seems innocuous compared to the disorienting neo-Riemannian space that bookends the Pasadena concert. The lyrics seem innocent compared to the darker themes of alienation (though trite love songs can stand for complicated expressions of estrangement). Gahan intones: "When I'm with you baby, I go out of my head. And I just can't get enough. And I just can't get enough." In the beginning of the sequence, a long take

with noticeable camera shake tracks Gahan. The shake indicates that someone is holding that camera. The next shot is of Wilder, who looks into the camera and then turns again with a smile into the camera. The music breaks, and Gahan gets the crowd to sing (not nearly as dramatically as with "Everything Counts"). Many of the shots are from Pennebaker's camera, roaming onstage and often behind Gahan. Then, from another camera, Pennebaker himself lifting his camera behind Gahan. The next cut returns to Pennebaker's shot. We register it as being from the filmmaker's perspective. Gahan then turns and smiles directly into the camera. The next series alternates between these two perspectives. Gore smiles after we see Pennebaker and Gahan run to the edge of the stage to get shots of the crowd, nearly arm in arm save for the camera.

The sequence reflexively acknowledges the presence of the camera. But it also suggests collaboration between the band and the filmmakers. Despite the alienating portrait of life that has led up to the festival, despite the hapless portrayal of a band not in control, despite the evidence of consumer excess, this is a film done together. *Depeche Mode: 101* may be a later entry to the classic rockumentary filmography, but it still comes out of the observational tradition. And as we have seen in the other films discussed in this book, most observation is successful when the relationship between filmmaker and subject is sympathetic or, as Rothman says, "co-conspiratorial" (1997: 147). Depeche Mode invested time during the postproduction process and advocated for Pennebaker and Hegedus's vision. "They came to the mix for ten days," recalls Hegedus. "We did it at night to do it cheaply and they came. We started at eleven and went until six in the morning. They came and did the whole thing with us to make it exactly how they wanted." The members of the band were some of the first to see the cut and approve the gritty focus on the fans in the bus. "We were worried when they first watched the film," says Hegedus, "when they came in our studio and we watched it with them. They saw right away—and they always called them the stars of the show—the kids on the bus. [The band] went for it. They stood up for it. The record company wanted to take out the money part . . . and the whole music business part. They said, 'No.'" The record company wanted a concert film and, as Hegedus puts it, Depeche Mode "wanted to make a different kind of film."

As the film came together, Pennebaker articulated his emerging goal: "to see music juxtaposed to the architecture and scenery of everyday life

and to do that without being obvious. That's the motive of music filmmaking" (in Lowenthal-Swift 1988: 46). I have attempted to reveal Pennebaker and Hegedus's methods of juxtaposing music and life: the use of drama and visual analysis in the cinematic engagement of critical issues in music, a *Gesamtkunstwerk* of estrangement.

5 CINEMATIC DUB AND THE MULTITUDE
Jem Cohen and Fugazi, *Instrument* (1999)

Jem Cohen never played an instrument, but his childhood friends did. They were all part of the early 1980s Washington, DC, hardcore punk scene. As his friends opted out of college to develop the scene, Cohen went to Wesleyan University, a small liberal arts school known for placing graduates in Hollywood. "I didn't go to film school," Cohen says, clarifying that he did not take classes in the department. "A lot of the stuff I stumbled into was a combination of logistical necessity, ignorance, and discovery all mixed together." He studied art and photography while still participating in the punk scene, now networked nationally. Upon graduation, he continued making short films and collaborated with bands. His friends in Washington, now all in their twenties, were reorganizing around the self-produced music scene they had started in their teens.

The post-hardcore band Fugazi formed in 1987, in the wake of early 1980s hardcore punk. Hardcore musicians had taken the recently classic sounds of the Ramones, Sex Pistols, and Buzzcocks and intensified them. A live set of short, fast, and aggressive hardcore songs might last less than twenty minutes. It was somewhat of a classicist move in response to a sense that punk had gone astray. (Post-punk experimentation of the late 1970s — such as Wire's design-method of songwriting or Scritti Politti's

incorporation of Antonio Gramsci's writing—veered too far from kids playing guitars and drums loudly.) But as the members of DC hardcore groups such as Minor Threat, Void, and Government Issue grew slightly older, their musical interests and abilities widened. "Post-hardcore" acknowledges an awareness by the musicians of *having participated* in the hardcore scene yet wanting to push into other ways of thinking about music, performance, and organization. Beginning in the second half of the 1980s, bands like Fugazi, Rites of Spring, and Nation of Ulysses engaged a greater degree of musical styles and continued to develop their local community and national network of bands, record labels, independent media, and audiences.

Fugazi remains as well known for their political-economic stance as they are for their music. Many contemporaries, such as R.E.M., Nirvana, The Replacements, and Sonic Youth, moved from the independent circuit to major labels (see Azerrad 2001). Still, after the wide commercial appeal of Seattle's "grunge" music had turned independent music into gold once again, Fugazi chose to remain independent. They even declined a personal invitation from Ahmet Ertegun of Atlantic Records to work together in 1993. Their career was, for the most part, on their own terms. They insisted on affordable ticket prices and all-age admittance. They played unconventional venues such as pizzerias, Elks lodges, and youth centers to avoid the alcohol market of bars and draw a more diverse audience. Not all hardcore practices were worth keeping. Aware of the violence that had invaded punk shows, they would stop playing and personally escort any disruptive audience members out of the venue. Prepared cash refunds in envelopes were always ready. They did things themselves. Throughout their career, Fugazi notoriously opted out of media self-promotion. DIY punk simple living placed little value on self-promotion. Fugazi refrained from engaging with much press, forgoing the image-making industry that seemed crucial for 1980s rock bands. Simplicity and self-production restricted the number of people who could control their image, themselves remaining the basic contributors to their art worlds. Despite their relative media silence, they became a band with international reach, and as they did their image began circulating in strange ways.

Meanwhile, Cohen became an award-winning independent filmmaker. Cohen's films have garnered acclaim for "gazing out at worlds and people

on the long, winding road that leads every artist back home" (*New York Times*, qtd. in Dargis 2015). His work "glows with bruised lyricism. . . . temporary shelter in the face of an imminent storm" (*Guardian*, qtd. in Sandhu 2015). But you have to dig for the accolades, as he engages in self-promotion at a bare minimum. His filmography is eclectic, but music remains a core interest. He has worked with many musicians, including R.E.M., Patti Smith, Miracle Legion, Vic Chesnutt, Elliott Smith, and Godspeed You! Black Emperor. *Instrument* stands out within his body of work as an intensively collaborative film. In the film, Fugazi and Cohen's shared principles of art, audience, and market emerge obliquely, through a provocative aesthetic experience. Unpredictable shards of images and sound appear and disappear as the film plods through ten years of Fugazi's (and Cohen's) career.

While *Instrument* can seem like a rockumentary, it subverts important elements of the promotional genre. Audiences have habits of watching films about bands with a rockist gaze, expecting the music to be great, the band members to be compelling offstage, and a drama of celebrity and artistic struggle to unfold. Denying the rockist gaze opens new ways of thinking about what a film about a rock band can do. To a large degree, Jem Cohen and the members of Fugazi worked together to explore the nature of music and image, crafting a work of temporal art that stands up to the rockist gaze, itself a political act in a commodity-laden 1980s and '90s. From this perspective, *Instrument* presents a stance taken by an independent art world working to define and preserve its principles within its contemporary political-economic mediascape.

Instrument shares many traits and goals of the postwar Italian neorealist school. Directors sought to look at working-class themes by bringing cameras into the streets, using long takes of amateur actors. The reality of the images was thought to have the power to inspire change. Many of these filmmakers who had been state sponsored during wartime now operated on shoestring budgets. Roberto Rossellini and Vittorio De Sica's approach spread across Europe, setting fiction works in the ruins of a fresh world war. Termed "rubble films," the documentary-style camera work brought to light the devastation of war and at the same time mythologized it (Barnouw 1993: 185). Though his rubble comes from another ruin, Cohen has stated his interest in rubble clearly:

The rubble is often the most beautiful place—a glimpse of a caryatid here, a bit of grass growing up through a supermarket façade, the old Ozymandias of Egypt bit about the distance to which the mighty fall, revealed in the wreckage. We now know that the details of the seemingly most mundane, the slag heaps in which anthropologists follow the evolution of pottery through shards, the seeds in the mummy's stomach that reveal what people lived off of, those things become much more telling than just following big stories of the "important" people. (In Evans 2009: 26)

The devastation of Cohen's world is late capitalism—a moment in which the economy is marked by finance and heightened commodity consumption. Just as neorealist film framed children in bombed-out streets, Cohen's camera brings us to the margins of capitalism, the place where independent bands like Fugazi operated. Occasionally, we arrive through the simple power of Cohen's images: a long take of the venue floor littered with bottles after a show, unfinished buildings, freeway overpasses, a McDonald's sign under shroud, or a broken showerhead in a cheap hotel room. The band members often serve as cultural commentators. For example, at a grocery store Guy Picciotto punches shelved boxes of granola bars after drummer Brendan Canty laments, "They don't just make normal granola bars anymore."

Instrument centers on experiences of independent music over a ten-year period starting in 1988. The film documents experiences of live performance, the work of independent musicians, and the battle with promotionalism—all within the backdrop of post-Fordist America. This chapter examines the ways in which Jem Cohen and the band members collaborated to make *Instrument*, simultaneously a political act and an artistic work. I will offer a perspective on Fugazi's stance within the music industry and show how that stance influenced the making of the film. I will conclude the chapter by drawing on Paolo Virno's work on class in post-Fordism with an argument that the film proposes a rock audience to be a multitude: the *many* who see themselves as being *many*. The following section will examine how *Instrument* rejects promotionalism by focusing on aesthetic experiences and the work values of the band.

"Never Mind What's Been Selling, It's What You're Buying": The Challenge of Representing Neosyndicalist Post-Hardcore

Perhaps the most interesting thing about *Instrument* is that it attempts to reject its use for self-promotion. The band inveterately refused to participate in what had become conventional music documentary—dramatic performances both onstage and offstage interleaved with adulating fans and congratulating industry peers. This refusal is not simply an irreverent rock star rebelling against a system—that type of rejection had already been appropriated by capital. As historian Thomas Frank and others have pointed out, the unbridled individualism that underpinned the anti-institutional stance of the 1960s became, by the 1990s, a model of entrepreneurship under neoliberalism (Frank 1997; Shipley 2013; Taylor 2016). The issue for Fugazi and Cohen was that the free space of post-hardcore performance was being colonized. Outsiders began speaking, filling Fugazi's media silence with their own words. The neoliberal language of the music industry increasingly informed those words. In the film, the issue of misrepresentation is clear when Cohen asks an audience member what "punk" means. The answer is as wrong as it is confident, mispronouncing Fugazi member Ian MacKaye's name and mistakenly identifying his membership in the band Black Flag.

"Tell me, what does 'punk' mean?" asks Cohen from behind the camera.

"'Punk' means just fuckin' going out, don't give a shit about nothing, and just having fun. Playing good music, man. That's all there is to it."

"Is that a good description of what Fugazi's lyrics are all about?" baits Cohen.

"Fugazi's all about . . ." he stumbles before gaining confidence with a semi-earnest reply, "I mean Ian MacKaye, you know: Black Flag, Minor Threat, Fugazi. You can't fuck with a motherfucker like that."

The bald and bearded young man provokes with misapplied rock and roll nihilism, while offering little substance. He speaks as the colonizing (mis)interpreter. His statement is one of neoliberal individualism, a voice that makes natural an everything-goes philosophy of entrepreneurship. If the band opts out of speaking, do they risk being part of a contrary ideology? Is it even possible to opt out, even partially?

The problem of inevitable self-representation in a post-Fordist mediascape is the heart of the film. Arguably, the film *is* promotional. It still operates to sell a band through image, but that is not its primary function. The driving force of the film is the promotion of a political-economic philosophy of art. Unpacking the reasons why Fugazi rejected promotionalism will help inform an analysis of the techniques of rejecting rockumentary and lead to an understanding of what the film offers instead.

"Tell Me, What Does 'Punk' Mean?"

Many musical practices can rely on drawing a distinction between a *style* of music and a *strategy* of musicmaking (Hatten 1985: 70; Shank 2001: 262–63). For punk as well as rock in general, resistance to a mainstream is typically understood as one of style. From the roots of distorted guitar in Jackie Brenston's "Rocket 88" (1951) to the New York Dolls's sloppy anthem "Trash" (1973), style has been a way of drawing a line in the sand between audiences. Alternatively, sociologist Dick Hebdige describes punk as a *strategy* that operates through bricolage. Hebdige's argument is that British punks in the mid-1970s juxtaposed commodity styles to resist the logic of the marketplace (1979: 102). For instance, a 1950s leather biker jacket, a Scottish kilt, and a necktie violate the cosmology and social meaning of styles of dress. Hardcore doesn't bear the kind of musical eclecticism described in Hebdige's scheme of strategy. Instead of adopting a *symbolic strategy*, post-hardcore musicians resisted the logic of the market through *economic strategy*. Many of the British bands that Hebdige wrote about had taken a political stance by dropping out of the economy, protesting the terms of labor by squatting, stealing, begging, and communal living. Hardcore punk, the second wave of punk activity in the 1980s United States, redefined subversive practice by taking over the channels of production.[1]

Hardcore resisted commercial practices by redefining the marketplace (O'Connor 2008: 60; Tatro 2014: 433). Musicians and fans took over as many aspects of music production as they could. At one point in the film, MacKaye seems to be antimarket: "We don't want to play to a bunch of heads and bodies because heads and bodies represent consumers, and I don't want anything to do with that." But he did want something to do with that. MacKaye's records *were* consumed. Audiences *did* pay for

concert tickets. Hardcore was less antimarket than revisionist. Fugazi attempted to change the terms of musical consumption—in effect, to put their system where their mouth was.

Popular music has often been part of an economic process in which small labels or artists become acquired by larger ones. The popular music industry works largely as a form of contract labor and record label acquisition. Musicians take on the burden of developing marketable skills and assume a large degree of financial risk in an unpredictable market (Frith 2001: 49; Stahl 2013: 228). Aspiring popular music laborers might receive a contract from a recording company, with little support besides an advance, and be beholden to producing records and helping promote them through performance tours. While this is changing somewhat today with the Internet and desktop publishing, this was one of the few paths to popular music success when Fugazi was active. But they chose to stay within their own production channels.

Easier said than done.

As the mediascape changed, capital found a way of absorbing not only music but also artists' political stances. By the mid-1980s, very little music spoke for itself. Much popular music was brokered through the tastemakers of MTV. The cable network began as a $15 million effort by Warner Brothers and American Express. The twenty-four-hour series of music videos accentuated a quirky youth culture not only with the videos but also through the "video jockeys" in dress and style. The advertising was directed at youthful consumers, mostly male. After the 1982 "I Want My MTV" campaign, the station was in 80 percent of homes. MTV had more influence on musical tastes than radio. Video budgets increased to help ensure artist attention. By the late 1980s, the music industry spent $50 million on video production per year (Goldberg 1990: 62). Gradually, video directors gained prestige and large budgets. At the same time, record contracts began requiring videos (with half the cost often covered by the artist).

An antimainstream veneer seemed to align early MTV with experimental and subversive free-form radio of the 1960s despite its being a calculated commercial project that aimed at a narrow youth market. MTV producer John Payson publicly defined the network as "a commercial sales medium that masquerades as an entertainment and information

medium" (in Goldberg 1990: 62). For those operating in the underground music world, the sham was clear. For many filmmakers and musicians, the big business of a music video-dominated field meant that it was harder to enter.

In spite of MTV, hardcore musicians established a national network through independent record labels of venues, audiences, and floors to sleep on. The network developed through long-distance phone calls, letter writing, word of mouth, photocopied zines, and (notwithstanding the oil crisis of 1976–83) driving cross-country from venue to venue. For audiences, turning off MTV and picking up an independent zine was a first move into a more diverse and unkempt musical world. Eventually, independent labels like SST and Dischord began filling their rosters with a more diverse list of musicians, moving hardcore into a post-hardcore independent music scene. New small labels like Two Tone, Touch and Go, Taang!, and Sub Pop offered a broad alternative to the increasingly large-scale music industry.

The Omnivorous Mediascape of the 1990s: Grunge and Reality TV

Cohen found out how pervasive capital was in the music industry when he made a subversive music video for R.E.M.'s "Talk about the Passion" (1988). The song was released in 1983 but rereleased as a single in 1988, the same year that the band moved from their independent label I.R.S. to Warner Brothers. The deal that R.E.M. struck was lucrative and also granted them a great deal of artistic control (Buckley 2002: 177). They began their major-label career determined to make political statements from the more visible position of having major-label support. In their original independent release of "Talk About the Passion," the muddled lyrics obscured the fact that they had written it as a song about hunger. Cohen's music video revealed the buried political sentiment of the song by editing together video of the homeless in New York and then ending with the caption, "in 1987 the cost of one destroyer-class warship was 910 million dollars." Surprisingly, MTV was able to appropriate the sentiment—a protest of the network's own apolitical nature—into its own brand. MTV's appropriation of "cool" was a turning point, a forewarning for the youth of the 1980s that countercultural survival within the mediasphere was under threat. Can rock still be political if mediated? Two de-

velopments in the 1990s made it even harder for Cohen and Fugazi to think about how to make a film: the national "discovery" of Seattle's independent music and reality television.

Originally, the space in which the members of Fugazi participated was one relatively free from capital. In a musical world of REO Speedwagon, Diana Ross, and Lionel Richie, there was little commercial promise for fifteen-year-olds who had just learned to play a few chords loudly on guitars. Performance venues in desolate downtown Washington, DC, were spaces of political action free from an ordinary world of commodity. MacKaye's Dischord Records evolved from a way of documenting local hardcore bands to a strong independent record label with international distribution. For members on Dischord's roster, a do-it-yourself approach could protect the labor of the musicians from post-Fordist capital. That protection became even more important as grunge music moved punk into national tastes in 1991—when Nirvana's *Nevermind* album bumped Michael Jackson and Guns N' Roses off the national charts. Fugazi bassist Joe Lally directly acknowledges this moment in the film. "Something happened around the early 1990s. The industry saw a market in agitated guitar music—punk rock or whatever you want to call it—and an enormous amount of money and attention descended on the scene. It's a lot harder, I think, now for people to be able to avoid that kind of cultural carpeting or whatever. It's hard to see things without having seen them through the eyes of that industry and that really affects people's response to it." Despite the low ticket prices, the lack of mass media promotion, and the use of unconventional venues, audiences were coming to shows informed not by experience in the independent scene but by the way the image of that scene had been co-opted by a mediascape that included underground music in its suite of stylistic offerings.

Fugazi also operated under the shadow of an MTV-era that began developing reality programs. New reality television programs *The Real World* (1992–present) and *Road Rules* (1995–2007) were starting to shift MTV from the audiovisual spectacle of popular music videos toward the dramatic spectacle of pseudo-observational portrayals of contemporary young adulthood—all with advertising revenues in mind, of course. Direct cinema style was gaining visibility through the reality shows. The techniques—handheld cameras, lack of narration, focus on everyday activities—were no longer as useful in disrupting conventional cinematic

gazes the way they did in the 1960s.² It was as if the cultural industry had co-opted the two primary components of classic rockumentary: edited musical performance and direct cinema. The postfeminist interview (discussed in chapter 2) was yet another technique redeployed and neutered in reality television. Interviews were at once spectacle and narrative. Cinematic techniques that were once countercultural were becoming part of the visual attraction to commodity. Fugazi and Cohen both operated within a subtext of anti-industry ambivalence toward self-promotion and interbranded cultural commodities.

As a like-minded DC hardcore insider, Cohen was best positioned to visually navigate the post-hardcore representational politics to make a film about Fugazi. He was a friend of and the art director for the band, having created several album covers. But how to address appropriation cinematically? On the one hand, if you don't speak, someone may speak for you. Allowing misinterpretation aids capital's infringement on the free space of the post-hardcore scene. On the other hand, speaking authoritatively asserts a power over audience that risks the free space of interaction among a plural public within a space free from the concerns of capital. MacKaye's expression of this dilemma occurs twice in the film—at the beginning and then in an echo with the video from the discussion thirty minutes later. "The problem is," MacKaye awkwardly explains in the film, "if you don't say anything, people place their thing on you. They say who you are. Then, if you try to steer it at all, then you start to feel like you're being . . . well, it leads to propaganda . . . It's an issue of creating a false . . . premeditated. You're trying to steer people. You're manipulating it." In the second instance, the recording is surreptitious. MacKaye's hand blocks his face, betraying his knowledge that the camera is on.

In our interview, MacKaye remembers this moment well:

> I realized [Jem] had the camera on the table. He had at that point put a little piece of black tape over the red indicator light. We were having this argument. . . . He wanted us to talk. He wanted to ask us questions and interview us on camera and we said we don't want to talk on the camera. . . . While we were discussing it, I started noticing that he was subtly, ever so subtly moving the camera in the direction of the speaker. And that's when I realized, "Oh, he's fucking filming this

thing!" I got nervous about it. I got angry too, because I didn't want to say, "Are you filming this?!" because it just seemed like it would just blow up. . . . People in the band would've been furious. So I didn't want to call him out, it was complicated, cause he's my friend and I love him. But also I was like, "Is he really doing it?" I kept thinking, but I put my hand over my face as sort of like an indicator that I know he's filming me.

MacKaye was wise to be wary. Documentary has roots in propaganda film and those roots had found new use in advertising.[3] Speech had become the performative fodder for capital. Within media, speech could be used to affect the exchange value of related products, and it could also be used to promote ideology.

Ideological Frame: Neosyndicalism Resisting Post-Fordism

The story thus far pits an independent art world against mass culture—a David and Goliath story acted out between the Fugazi-Cohen alliance and MTV. The labor of staunchly independent musicians is constantly at risk of appropriation by a disorganized and flexible capitalist system. Musical labor can be myriad—music, attitude, charisma, antics, political statements, and any form of mediated representation. A broader theoretical framework reveals a war of economic systems: neosyndicalism versus post-Fordism.

The stance that Fugazi took is akin to the syndicalist movement of the early twentieth century. Syndicalists, or trade unionists, hoped to provide an alternative to capitalism and communism by advocating for industry run by the workers. Mostly a French movement, adherents sought to change society through economic reform rather than political rebellion. Worker-owned democratic cooperatives could potentially protect the autonomy of skilled workers from capitalist appropriation. Labor polemicist Fred Schepartz suggests that a practice of neosyndicalism can create "liberated zones through organisms like worker cooperatives, collectives, and other forms of worker-owned businesses, along with economic alternatives such as fair trade, community-supported agriculture, and, in general, sustainability" (2009). Neosyndicalism carves out a space within global neoliberalism for worker-owned industry. Informal economic systems usually exist on the fringes of organized markets. Neosyndicalism

is useful in defining intentionally created sovereign networks. But what exactly is musical labor?

Defining musical labor is challenging in a neoliberal post-Fordist market for two reasons: first, everything is potentially in the service of capital (neoliberalism) and, second, the music industry tends to be organized through flexible networks of related industries (post-Fordism). In the commercial market, musical labor occurs across a spectrum from contractual to informal activity. Record contracts often require that musicians promote their albums through performances, interviews, and press conferences. Rockumentaries are usually promotional. One of the signature devices in the genre is the backstage. As film critic Jonathan Romney argues, the backstage appears as a seemingly private space that contains the "real being" of the performer. Romney reveals a complicity of image and music that revolves around an enigmatic artist: "In pop more than in most arts, what artists produce—records, shows, videos—is generally insufficient to satisfy their public. Rather, their off-stage existence is expected to be their defining 'authentic' achievement, for a pop star is assumed to be not so much a performer as an elemental force manifesting itself" (1995: 86). In our interview, MacKaye describes the formulaic approach to these backstage narratives: "There's the drama that bands have, like a drug problem, or the band got ripped off by their management or whatever, and it's like the *same* fucking thing." Cohen agrees: "So many music documentaries—even ones that I love," he admits, "are just people talking about how great something is. You have some subject and you just line up a bunch of people with slightly different variations about how great it was or even how crazy it was or how reckless certain experiences were. But it's still just a reiteration of the 'God-like being' of the musician. We just weren't going to do that." In the film, Guy Picciotto states his rejection of rockumentary promotion: "It's not important that everyone in the country fucking hears what we do. It's more important that what we do exists in a context we control and that people are invited to participate in but not forced to participate in and not forced to hear people mouthing off every goddamn ten minutes about what trauma it is to be a star or how incredibly great our new record is or what the lyrics exactly mean."

Branding through speech and social performance fixes meaning within the flux of products and cultural meanings (Hearn 2008: 195).

Documentary audiences often seek out films that give us mastery over the subject. As the documentary scholar Bill Nichols argues, documentary feeds epistephilia, the "desire to know," conveying an "informing logic, a persuasive rhetoric, or a moving poetics that promises information and knowledge, insight and awareness" (2001: 40). Epistephilia, when used for career biography, points us to what the philosopher Axel Honneth identifies as biographical individualism, which, together with autonomy and intimacy, form frictions of modern notions of individualism (2004). Honneth points out that, today, institutional arrangements that expect "the creation of biographical originality [have] become something required of individuals themselves: more and more the presentation of an 'authentic self' is one of the demands placed upon individuals, above all in the sphere of skilled labour, so that it is frequently no longer possible at all to distinguish between a real and a fictitious self-discovery, even for the individuals concerned" (2004: 467). In musical labor, biography is the branding and the mode of satisfying the biographical epistephiliac in a predictable way in the expository mode. We can access the type of information that led to an understanding of the biography—what musicians symbolize, for example, struggle, redemption, entrepreneurship, loyalty, authority, talent, or the everyman.

The backstage space is an instrumental part of developing biography. In the neoliberal market, consider the backstage to be *anything* that a musician does offstage. A photo, quote, or rumor about a star can constitute the backstage through an article, television show, or film. When mediated, anything that a star has done can be redeployed as promotional labor. For example, when Oasis front man Liam Gallagher smoked and swore at his fellow passengers on a Cathay Pacific flight, that behavior likely added to album sales.

Within the MTV-dominated mediascape, the spectacular backstage activity of the star can also attract eyes as successfully as a music video. The activity of a star is always potentially part of products advertised on the network or in any other ad-based publications. The value placed on star charisma and its use in commodification is so strong that it can distract from what a musician might have to say outside a star-system marketplace.

To defend against audiences looking for Fugazi's charisma, MacKaye tells me of his initial idea of getting school children to play the band:

> I had this idea of taking interviews, . . . converting them into scripts and getting school children to do plays playing us. . . . When you strip the words out and you put them in the mouths of other people, you get a different view of them [the words]. . . . Seeing people being interviewed, it's hard to get the words away from them because you're so caught up in *who they are*. So the idea of having children play us—and they would do it so naively, because they have no idea, they wouldn't be trying to play me, wouldn't fucking know who I am! They're just reading a script. . . . Words get obscured by the charisma of the speaker.

Had they done this, it would have been an excellent example of a postrealist music film that Jill Godmilow proposes at the end of chapter 2. Framing out charisma meant occluding representations of themselves. Charisma can be the glue that binds commodities in a musically related marketplace.

In post-Fordism, single-product organizations have given way to virtual networks that create flexible multiproduct organizations.[4] Rockumentaries are most often part of a diversified portfolio of music commodities and media, confirming stardom and musical status quo (Shuker 2005: 85). The doings of popular musicians are part of the flow of capital. When a guitarist of a band endorses a brand of amplifier, publicly dates an actor, writes a memoir of career ups and downs, and records a radio spot, for instance, he is providing the interstitial labor that binds the electronics industry, the print media industry, and the record industry. This wider sense of public performance or free political action helps maintain brand recognition (Bruce Springsteen is as much a brand as he is a person). Brand maintenance helps buffer the risk that record companies have in selling product in an overwhelmingly unpredictable market. The labor that generates charisma is often rooted in speech.

In Fordist factories, where labor produced things, a sign might say, "Silence, men at work!" (though people have always spoken while working). But speech no longer interferes with labor. It may, in fact, be the more fundamental aspect of cultural labor. Some bands are known more for their provocative idle talk than for their music. As philosopher and political theorist Paolo Virno argues, "The principle breakthrough in post-Fordism is that it has placed language into the workplace. Today, in certain workshops, one could well put up signs mirroring those of the past,

but declaring: 'Men at work here. Talk!'" (2003: 91). The post-Fordist emphasis on speech not only threatens the value of musical craft but also degrades speech and performance, converting political action and daily life into instruments of capital.

To envision a neoliberal post-Fordist music industry as a factory, imagine a building with many interconnected factory floors. One floor would be busy with laborers recording music. Through a door, workers would wander to another floor to speak into microphones about their political views. Through another door, workers would stumble into situations of well-documented bacchanalia. In the offices upstairs, another set of workers would be combining images and sounds for triple use—to sell (commodity), to promote other goods (spectacle), and to maintain the integrity of the factory itself (ideology). The musical laborers spend all day wandering from room to room, always potentially at work. Of course, they get paid only when something sells upstairs. As post-Fordist, the bays of the factory themselves attach and detach depending on their use for capital accumulation. Flexible networks are more adaptable to risky global markets.

With the changes brought by the discovery of grunge and reality TV, the configurable factory grew around the practices that had formerly been free. Doors opened that were previously shut. The neosyndicalist laborers would start effecting change by closing and locking doors, restricting their labor to a few floors, and disassociating from the offices upstairs. They would also identify the exits—not to leave, but to be able to come to work at will. In the film, MacKaye answers an interview question with: "You ask me, 'What is Fugazi about?' Fugazi is about being a band. . . . Our concern is to be a band—to play." In a sense, MacKaye's answer directs us back to the factory floor that they continue to occupy. In the film, a cut to the stage makes his point cinematically, forcing us into the performance. From a neosyndicalist perspective, *Instrument* was intended to be a product that could not be folded back into neoliberal capitalism. At stake is the ability of music scenes to maintain spaces in which their activity is free from appropriation.

But There Are No Shots of the Labor!

Throughout the film, Fugazi's DIY approach is apparent. They declare that they will fund an Alaska tour themselves. They pack their tour van.

CINEMATIC DUB AND THE MULTITUDE

MacKaye discusses operations on the phone and does the accounting with the venues after shows. But during our interview, MacKaye wishes that they could have shown more of the work involved:

> Jem was traveling with us, and he [alone] was the video crew. So when we would arrive at a venue, we would load the gear in, he would load his gear in. While we were setting up, he was cleaning his cameras and getting stuff ready. Then we'd do the show and he'd go out and film people and film the band. End of the night, people were packing up, he's packing up his stuff; I'm doing business. At the end of the 1996 tour—where he had gone on with us—we're looking at the footage and realizing that [there was] almost zero footage of us lifting an amp or of me booking a show, nothing in this in terms of me working.... He had lopped off a really significant part of who Fugazi was.... You got to have something of us working.

In fact, the scene of packing the van was shot after the fact to address this problem. Not only was the labor of the tour absent, but so was the work at home. MacKaye is still bothered by the invisibility of work: "Nothing of me in the office is *crazy* because that office is like Fugazi Brain Center. There's good ... shots of us in the practice space, which is nice, but the whole work ethic is not really captured.... We did *all* the work." The film might not be as compelling showing the work, but MacKaye's critique addresses a larger issue of how musical labor is generally invisible.

Marina Peterson argues that the public reframing of music performance during the 1940s American Federation of Musicians recording bans developed a lingering metaphor for musical labor and that, as a consequence, "*voice* as a model for musical expression hides the labor of playing an instrument" (2013: 800; emphasis added). Despite the underrepresentation of Fugazi's musical labor, *Instrument* makes visible and problematic another kind of work—the work of musicians speaking about their music. Only a neosyndicalist approach to labor attempts to wrestle back speech from synergistic entrepreneurial self-promotion.

Dub Techniques: Fragmentation and Incompletion

"From the beginning," says Cohen, "we were like, 'We're not going to do this, this, and this; but then, it was kind of wide open—what will we do?'" Surrounded by restrictions of avoiding the rockumentary

gaze and the necessity of cutting the project to size, they eventually stumbled upon a guiding question. "In some ways," Cohen continues, "I was troubled because there were certain restrictions. But in others it was freeing because I had to make other things happen. I think the primary obsession became, how do you make a music film that *embodies music* rather than discusses music?" They began looking at time *strategically*. Ian MacKaye explains, "We also approached the whole thing like a visual record." Here, it is important to distinguish the difference between a "visual record" and a "music video."

"One of the things we were going to be reacting against was music video," says Cohen, "which had just become the dominant mode of [how] people thought about music and the moving image. [When watching], most people's minds and attention would unfortunately go toward music video, which was really in its ascendancy at that point." As discussed in the previous chapter, MTV videos use fast cuts to draw the eye to the television or stop channel surfing. Despite the timing of cuts, the songs generally have a predictable pop format structure, ideally one that keeps a listener listening. The editing in *Instrument* moves outside MTV conventions by taking two extreme strategies: synced long takes and highly unsynced sequences. "That became a touchstone for me, those two poles," says Cohen, "either let it go really free and don't even think about trying to lock in to a realistic documentary veracity, or really let the actuality hold." The first ten minutes of the film introduce the strategy of two poles—the highly cut sequence and the uncut sequence.

The film starts with an anthemic build of music over unsynced slow-motion performance video. It then moves to the long take of a performance. The two sequences are separated by a twenty-five-second visual mix of film leader, misaligned film of Picciotto in performance, and shots of people in the ticket line over two different fragments of guitar. These three segments offer a summary of three modes of the film, foreshadowing components that are to follow—manipulated media, long take, and crowd portraiture. In avoiding rockumentary, *Instrument* opens other modes of musical cinema—demonstrating music and ideas.

When he began shooting the band, Cohen used silent Super 8 film. Without the ability to capture audio, he attempted to capture fragments that represented the group visually, that, as he puts it, "got to some core of what the band was like in performance." The editing process built on

this music-to-film transposition when the band started editing the material to their own demo recordings. MacKaye recalls how they initially found a way of using the silent film that Cohen had shot: I remember looking at videotapes of the black and white footage, silent, Super 8 stuff: incredible looking. . . . We discussed what we could do with this footage, like what do you do with silent footage of a band playing? So we had this idea of recording dub kind of stuff. . . . We took the song and we actually edited the slow-motion stuff, or the Super 8 footage; we edited it to the song. . . . I remember being really deliberate, using double shots so that it shows clearly that this has been edited to the [music]." Members of the band often helped edit, bringing with them the skills and mindset that they used when recording music. When discussing the film, Picciotto drew my attention to the cover of the DVD (see figure 5.1). What appears to be a working script of the film acknowledges that it is an assembly of clips. Furthermore, it contains everyone's handwriting—itself an acknowledgment of collaboration and of plural authorship.

The exchange between Cohen's images and Fugazi's soundtrack centered on showing time as an elastic medium. The musical reference point for Cohen's temporal approach was dub reggae, a subgenre of reggae in which songs are stripped down and rearranged live by studio producers. It was the technique of dub that offered useful tools for the film. Cohen explains:

> The band listened to a lot of Jamaican dub music. They were interested in it; they loved it. . . . I'm sure everybody was into Lee Perry or Augustus Pablo, different things, [but] it was more just *the notion* of how some of that studio work happened, where somebody might take a song and take it to a producer, who would totally transform it, basically breaking down the components of it and then reconfiguring them. Thinking about that before the known sampling revolutions and before all remixes were kind of common language. For a lot of us, dub reggae was where we first encountered that approach to music.

Central dub techniques, according to ethnomusicologist Michael Veal, are those of "fragmentation and incompletion" (2007: 57). Dub reggae is the root of bringing the engineer to what Veal calls a macrocomposer's role (86). Its influence is most obvious in DJ practices of hip-hop and electronic dance music (EDM). Less obvious is the influence of dub on

5.1. Cover of *Instrument* DVD with all collaborators' handwriting.

punk music following its initial wave of development and commercialization (Reynolds 2006: 17–20). British post-punk bands such as Wire, This Heat, and PiL, introduced to dub through the large number of West Indian immigrants, found the shock effects of dub useful. In his prescient 1976 essay in *Melody Maker*, "Dub and the Sound of Surprise," rock critic Richard Williams notes the possibilities that dub had to offer rock musicians. "Its evanescence and randomness make it perhaps the most existential of musics, and its most stunning implication comes with the realization that no dub track is ever 'correct' or 'finished': it can always be done again in a thousand different ways, each one as 'correct' as any other" (2007: 21). Veal argues that dub's appeal to British punk musicians was in part the identification with cultural marginalization (another variation on exotic black otherness) and the aesthetic qualities of heavy textures, foregrounded electronics, and minimalism, which could provide a structure of feeling to alienation in an increasingly technological world.

There are two levels of dub techniques in the film: the documentation of musical process (evidence) and what I will call "cinematic dub" (demonstration). On the first level, there are shots of Ian MacKaye producing a sweep of feedback frequencies by placing the guitar headstock on the amplifier and detuning the guitar, as well as Picciotto describing a fluttering sound that he is trying to bring out of the interaction between his and MacKaye's guitar track. Veal describes these techniques in dub as abuse and misuse of equipment (2007: 75–76, 115). Expository sequences also reveal the use of widely varied instrumental timbres, especially with the guitars. Such techniques have a strong connection to a dub DJ's use of equalization as tone sculpting (Veal 2007: 73–74).

On the second level, the film edit uses similar techniques of fragmentation and incompletion with the aim of cinematic surprise. Visually, the film shows strips of film as they run out, exposing the seams of the shots. Cohen demonstrates dub in his unexpected play with music and space in "I'm So Tired," cutting from the playback of the recording of MacKaye singing to piano chords directly to band members whistling the same melody in the kitchen. The elision of time and space is jarring. Unexpected shots, sometimes accompanied by sound, drop into a place, disrupting flow. Like dropping a spring reverb, a snippet of dia-

logue, or an extraneous instrumental sound, the unexpected shots offer moments of both spatial and temporal disorientation. Abrupt entry and exit from spaces and temporal experience riddle the film. A particularly jarring sequence cuts between alternating spaces of the stage and gas stations, representing more the fragmentary experience of travel and performance. Varied film speed mimics the tape speed manipulation in dub mixing. The film transfers to videotape vary in playback speed and the repetitive music suspends expectations that come with song form. The scraps of images and sounds developed around this exchange process.

Reconfiguration became a structural idea for the film.[5] Songs, backstage images, career narrative, and interviews could all be broken into component parts and reconfigured. As a result, time feels elastic. Long stretches of performances and transitional sequences blur together as the audience plows through ten years of the band's career, never knowing where the next turn will take them. The strong cuts, unsynced montages, repetition, and variable speed have the effect of bringing the viewer's attention to the moment—to the image and sound—rather than the process of putting together a narrative.

After composing/editing the Super 8 sequences, they realized that they had even more material to subject to dub techniques: their entire archive. MacKaye remembers "looking at all the silent footage and thinking, 'Shit, we have all this [archived material].' We have so many Fugazi recordings that we loved that will never be released because we couldn't figure out what to do with them." Dischord Records itself started as a way of documenting high school bands, as much an archival project as a commercial one. They were mediators of underground cultural history. "I think we probably had four to five, probably four hundred live videos at that point," admits MacKaye. The videos were shot by different people on a variety of formats. The stylistic mess could, in fact, help confound the rockumentary entanglement of charisma and offer opportunities to speak through more formal cinematic means. Cohen continued to shoot and then began looking at ways of using the material. They found that avoiding convention could also refresh listening and looking as well as awaken people from the slumber of consumption.

Senses of time come from different aspects of the film experience, primarily through the experience of music and sound, the visual content, and the shots and cuts of the film. There exist several different ways of

distinguishing time in aesthetic theory across artistic disciplines. Musicologist Carl Dahlhaus and film scholar Nathaniel Dorsky offer similar ways of thinking of experiences of time-bound art, analytic perspectives useful in understanding the myriad ways in which *Instrument* presents temporality.

In his phenomenology of music, Dahlhaus distinguishes between two experiences of musical time (1982: 74–75). His aim is to account for two relations that music has with time. A musical score *contains time*, while a performance is *contained in time*. When attentive to the structure of the piece, we engage a spatially represented framework: *temps espace*. This is because we expect that it is a whole—a total sound-object in time. In this experience, we have a sense of when it began, how many repetitions occur, and how long the piece will be, for instance. But when attentive to the rhythmic play of sound, we experience motion: *temps durée*. When engaging music, we move between these relations of time. For Cohen, music reconfigures time. He asks, "What is the visceral experience of seeing these musicians play? . . . When I'm sitting onstage watching a band that I love, a song might be over way too quickly or go on forever. It doesn't really have anything to do with how long the song actually lasts; it has to do with my experience of that music." Rhythmic motion gives way to anticipation of the whole and we remember and predict (retention and protension). Continuity and discontinuity interpenetrate our experience of music.

Instrument stresses *temps durée*, though Fugazi's music pulls on both. Popular music songs, especially those well known, engage *temps espace* as we anticipate returns to a chorus, the build of a section, or the familiar melody of a verse. Despite the high degree of improvisation, a Fugazi concert included plenty of songs well known by the audience. The film shows that mode of song engagement: bodies moving in protension as they mouth the lyrics to the songs. The film, however, denies *temps espace*, for example, unexpectedly cutting short a well-known song in the middle. The most extended live musical sequences tend to be improvisations, not songs. By stressing *temps durée* in the film, *Instrument* hones our capacity to experience types of motion without relying on a represented framework. Dahlhaus goes on to determine that music is, in fact, multileveled—rhythmic, sonorous, melodic (1982: 83). Film, I'll add, offers more levels with which to create rhythmic motion.

Like Dahlhaus, Nathaniel Dorsky argues that film can produce different senses of time. *Absolute time* is an experience of nowness, images respecting their own unfolding through cinematic motion (2005: 34). This is distinct from *relative time*, when images illustrate ideas other than themselves; for instance, when rain symbolizes sadness or a leitmotif variation suggests the transformation of a character in the plot. Relative time is the experience of the narrative framework. Another way of looking at this difference is that absolute time, like *temps durée*, stresses verticality, whereas relative time, like *temps espace*, stresses horizontality—the relation of now to other moments experienced and anticipated. Dorsky argues that the fear of direct contact with the uncontrollable present pushes us toward "concept," toward the safety of an idea. In absolute time, however, the image becomes something in itself when not providing an illustrative function, unfolding of its own accord. As a result, the sense of absolute time is "a narrative of nowness" that reveals a hidden world: things being what they are (2005: 37). In both Dahlhaus and Dorsky, the experience of time as immediate is constantly under threat of being overwhelmed by narrative.

These two theories of temporal experience reveal an overlapping bifurcation of temporality across music and film. Each medium has a set of formal techniques that can pull the audience into a direct relationship to the present. At the intersection of music and film, time is a central concern for Cohen. As he explains,

> It's a given, but it's also kind of forgotten: the nature of film is *time expressed* [emphasis added]. Basically, this potential of compression or stretching—not only transforming time but also embodying the different experiences of time—that's the heart of cinema, at least as much as anything else is. In a way, there's something central in music in terms of what music does to time. In a way, you have a little frame, which is like the length of a piece of music. But it doesn't really have anything to do with the way you experience it because there are ways in which mood and memory and all of those things can be triggered that alter entirely the actuality of the time that the music lasts. So in both of those, in a way that's quite different from visual arts. . . . So here is a medium where you have this enormous potential. When it comes to film and music, it seems strange to me how little that relationship in

both of those forms—time, power—is really plumbed. You so often have music in movies where music is transitional and shorthand for the passage of time. What I'm talking about is something else: where you really can see it as a wide, open field, where you actually are going to be altering people's experience of time. It's always exciting to me, always a strange adventure to find out what you can do and how it happens. When we talk about music in that kind of context, I'm thinking as much about silence, or about sound.

A critical effect of *Instrument* is to shake an audience out of both Dorsky's narrative time and Dahlhaus's *temps espace*. There are many ways of producing this effect. Cohen uses as many as he can, lest we habituate to one. The effect is often one of disorientation, confusion, and the sense of having lost time. I've seen the film countless times and still get lost in it. Even though I have mapped out the structure, it still *feels* unpredictable. In the following pages, I offer a laundry list of techniques that contribute to a sense of nowness. I'll use Dorsky's term "absolute time" to generalize this temporal pole. Many techniques are required because of the tendency to seek refuge in a concept, in a narrative, in a summation of what the band is about. Like the element of surprise in warfare, once the techniques become predictable the element is lost. *Instrument* is a study in these techniques. In my analysis, I will consider both cinematic and musical techniques for three reasons: because of Cohen's interest in adapting musical time to cinema, because Cohen's films and Fugazi's music both display strategies of creating absolute time, and because analogous strategies run deep in both cinema and music. Throughout the film, temporal strategies help to push back on the tendency to look for relative time, to look forward or back in an attempt to make a whole of the film. Drawing from cultural critics such as Walter Benjamin, Cohen attempts to put into practice waking up the "sleepwalkers" (Cohen in Stein 2012: 27). And he achieves this respectfully. Rather than pointing out the tragedy of sleepwalking, he makes films that leverage the medium's potential to aid in "being present" and becoming aware of the undercurrents of daily life (30).

This approach came out of the conditions of film, not by design. The film is a product of this interest in absolute time and the fragmented nature of how it was filmed. Cohen explains how his limitations led to

shooting in certain ways: "Early on . . . I didn't have the gear or experience, and this was pre-video. . . . Eventually during the project, Hi8 appeared and we started to borrow that—but I didn't really know how to use it. Most of my work was about three or four years into the project that I started to shoot sync sound, but I continued to shoot Super 8 throughout. So it was a collage of dealing differently with time." In the edit, Cohen leveraged the discontinuity. As he explains, "You just have to take the ride, and there's nowhere to go but where I go and where the band goes."

The next sections are an account of that ride, perhaps a debriefing that identifies ways in which *Instrument* insists on absolute time. The editing and structure employ cinematic dub techniques: incompletion, punctualism, splicing, speed manipulation, and exposition. The first four techniques occupy the highly unsynced pole of Cohen's strategy and the last technique, exposition, is on the synced long-take pole. These techniques are not exclusive to dub, but thinking of them as analogous macrocompositional strategies reveals how the structure of the film both subverts and promotes a philosophy of art and production.

Incompletion

Many times, Cohen's cuts create macrocompositional fluidity. In a shot of the band performing "Waiting Room" in a packed room, the song cuts to a groove with a slower tempo and then to yet another groove with a slower tempo over which MacKaye staunchly denounces acts of violence toward minorities. The fluidity, as with dub, uses recorded musical material to create a macrocompositional assemblage. Other moments of song interruption are decidedly less graceful, challenging fans by abruptly interrupting a song. Cohen describes how the intent to thwart fan expectations led to a discovery of representing psychological time. "Some of the fans were just livid. They were like, 'How dare you! . . . You get us psyched and we want to hear it and see it and you completely deprive us of that.' But again, we felt that it was funny but also that it really reverberated with how the band sometimes felt, where that experience of being on the road has that effect of temporal distortion, where before the song starts it's already over, or the song goes on forever and they don't know how to get on." In a conventional rockumentary, songs taper off to make room for an authoritative voice, perhaps with a comment about the

song or a poignant story about the musicians. With incompletion, however, an overarching narrative doesn't overwhelm the significance of the cuts in *Instrument*. These cuts are hard felt discontinuities—both a truer representation of time for the band and a shock effect.

Cohen's interest in the hard cut runs throughout this and his other films. He traces his interest to listening to Neil Young's 1972 album *Harvest*. Cohen describes the startling transition between two songs: "It's not a live record, but you hear the audience applauding [after "The Needle and the Damage Done"] and you realize that it's a live solo acoustic performance. Then they just slam out of that clapping in a very impolite way and right into ["Words (Between the Lines of Age)"], with the full band. It's a totally fascinating move." The power of this transition is its forceful direction of listener's attention from the song itself to the recording setting. Cohen later found out how intentional Young's edit was: "I finally ran into Neil Young at an [art] opening and asked him about it. I was very relieved that he didn't look at me like I was crazy. He was like, 'Oh, yeah, that was a real interesting thing that we got into in the studio to make that work. We had to lift the levels of one thing to make it meet the levels of the other thing.' It's a *radical* gesture." It wakes the listener up to the liveness and the sculptedness of the music. Many of the hard cuts in *Instrument* are in service of incompletion. They provide a way of subverting *temps espace* so that the song *process* remains primary and Cohen and Fugazi's ethos of negotiating uncertainty emerges.

Punctualism

In *Instrument*, hard cuts often lead to unexpected sounds and images just as musical surprises occur in dub (Veal 2007: 74–75). The non sequiturs can interrupt but they can also redirect. As an athematic musical technique, Pierre Boulez coined the term "punctualism" to mean a prioritization of particulars in his own music: "we had achieved a certain 'punctuality' of sound—by which I mean, literally, the intersection of various functional possibilities in a given point" (Boulez 1991: 16). Forcing attention on particulars through surprise can yield a temporality of *temps durée* or absolute time. Suspending narrative time detaches an image or sound from its service to *temps espace* or narrative time.[6] Untethered, each musical event contains possibility. In *Instrument*, both

musical and cinematic fragments abound, often operating punctually rather than symbolically or narratively.

Cohen's shots have a strong sense of nowness to them—punctualist dwelling on details, graceful camera motion during long takes giving way to a sense of peering into the world. He had to fight to include these shots as he and the band tried to compress the film to a reasonable size. Collaboration was not as easy with the five of them editing. From MacKaye's perspective, collaboration was a matter of four plus one:

> Jem, as a filmmaker, just works by himself. And his creative battle is really internal. . . . I think he has a hard time editing because he can't get rid of things he loves. If you're in a band, especially in a band that works like Fugazi, your loved ones get killed all the time by other people. . . . You learn how to work together. So collaboration was something we were really well tuned to. I mean, we're four different people, but the four of us can create a single voice. Working with Jem was very difficult because he wasn't used to other people pushing back.

As a band, Fugazi had skills of collaborating in time—writing songs, making nonmusical decisions, and debating the implications of their actions. The collaboration with Cohen, however, involved a basic problem: what should be in the film? At first they had to determine the size of the container. "I tried to talk the band into doing a part one and part two and having them each be an hour and a half long, but," Cohen laughs, "I didn't get that past the committee." MacKaye insisted that it be no longer than two hours—the length of a videocassette tape as well as the upper limit of how long he thought someone could comfortably sit in a chair. They also had to figure out what to put in those two hours. That was the more challenging part.

The band saw a film as a place to put live performances that had been collecting not only through Jem's documentation but also through all the videos that audience members had sent them. Cohen saw the opportunity to document a wider experience of being in the world. MacKaye recalls arguing over material to cut as they began to assemble the film: "He wanted to take [out] stuff that was video that was shot by other people, and we wanted to take out filmic shit, like the roads." An argument developed over Cohen's insistence on using a shot of plastic ivy as they tried to cut down the length of the film. MacKaye continues:

So we talked to Jem and we were like, "Look this is what we're going to do. You sit down with the film, with a pad of paper, and you write down all the stuff in there you think could be cut. And the band will sit down with the film and a pad of paper and we'll make a list of all the things we want to cut. We sat right here in this room [at the Dischord Records house] watching it on the TV right there, and we just had a whole long list of things we thought could go as possible cuts. When I talked to Jem and we compared the two there was almost nothing in common. There was one particular thing: there was a shot. We were playing at [a] place called Tracks in Charlottesville, Virginia, and there's a shot where the camera pans up to a trellis. On the trellis is this fake plastic ivy. We sort of thought, "Well, that could probably go." . . . and so said to Jem, like, "Maybe we cut this out." And he's like, "Oh no, no, no, no, no. That's got to stay in." And we're like, "Why? It's just a shot of ten or fifteen seconds of dwelling on a trellis with plastic ivy." And he says, *"That's the movie.* If you take that shot out, you can take my name off the credits!" . . . I don't think he would have taken his off the credits, but it's worth saying that the shot stayed.

Upon inspection, however, the ivy is akin to Fugazi's musical strategies: a single stray hit on a bell by Canty and other unexpected sounds, a drift into a new, unexpected groove. The visual punctualism aligns with musical punctualism. A spider climbs on a piece of equipment, a plastic crown lies on a dashboard, an extreme close-up of an amplifier grill creates a pattern of twenty ordered circles. Punctualistically, dub techniques fragment images from their contexts. The varied grain of the film and video further separate these into an accumulating barrage of things, inducing a stream of direct observance.

Unlike Eisensteinian montage, this kind of juxtaposition over cuts does not force a new idea that bridges the cut; rather, the more radical disruption forces a new attention to the film. Punctualism contributes to an experience of absolute time. Images and sounds create a flow of time of their own. Without an editor giving time for reflection in narrative time, an audience cannot stop to reflect. As Jill Godmilow argues, film "runs in time, like performance does. If the audience misses something, there's no time for reflection because more information is coming at you. You can't go back and read chapter four after chapter five because

the film has already dragged you to chapter six. But there's another way in which that's not a tragedy at all" (in Miller 1997: 287). Being committed to the flow of time can produce a feeling of motion that is not necessarily linear. In the complex wake of time-based arts, possibility can develop, in league with Guy Picciotto's aesthetic-political statement in the film:

> For me, punk music was always about undercutting people's expectations and throwing a spin in the works. For me, I want this band to . . . If this is unsettling people, I want to really unsettle people. I want the sound always to be moving. Anything starts getting static, I start to get uncomfortable because I feel like what happened to hardcore is that things get so ritualized that they become . . . They're no longer powerful. They lose their power. They're not dangerous anymore. They don't excite people. They don't move people anymore. They just become some kind of traditional thing which people can just slip on the clothes and slip on an attitude. But for me, it's a life thing, man. And if it's going to be a life thing for me it has to always constantly be moving forward and have kind of a time thing, dimension to it.

Using Picciotto's statement, *Instrument* creates a link between aesthetics and a philosophy of art. To demonstrate the idea, his explanation precedes a shot of him climbing into a basketball hoop during a performance of "Glue Man." The sight is unsettling but also punctualist. Weakly tied to Picciotto's statement, it leads to a consideration of detail, an investigation of the hoop itself. "Will it hold his weight? How do his legs fit inside?" The performance offers unexpected corporeal attention to the surface of an ordinary thing.

Lingering over the entire film is the notion that our experience of music and film is a dynamic process, moving through states of rest and unrest—but mostly unrest. There is a general historical progression. But it's not a *compelling* one. It's not meant to be. Cohen denies us the position of evaluating the career of the band or developing a theme that organizes the group or the music. We can come up for air in moments of relative time. We peer below the surface at disparate images, sounds, and a general notion that a decade in the life of the band is passing. A sense of familiarity with the music and its production lingers.

The band's refusal to do interviews was by no means an insurmountable obstacle. The film draws from archival footage—the middle school

interview, an interview from German television, and a (reluctant) interview of MacKaye from a men's bathroom. But the lack of consistent syntax and hard cuts draw attention to the varied grain and the materiality of the footage. In moments of attentive reflection, we sense difference. Fragmenting shots and short sequences, the rough parts remain. Punctualist representation drags us through touring, recording, and interviewing. Each snapshot proves to move to another unpredictably. The potentiality of each musical moment, each fragment of documentary evidence, retains a weight of possibility.

Splicing

Identifying "tape splicing," Michael Veal shows that some dub engineers "splice together performances of completely different tempi, fundamentally subverting the music's typical function as dance music" (2007: 75). Brought to a film about musicians, splicing can juxtapose the temporality of waiting and performance—two dominant aspects of being on tour. MacKaye suggests that the felt rhythm of touring is different from the embodied rhythm of a song: "The live footage, a lot of times we would just excise it. You see the beginning and the end, cut out the middle. You don't need that. The shows were part of the rhythm of the situation but you don't need to see all of the shows." The clash of temporalities offers psychological representations of touring and also subverts rockumentary's typical function of edifying songs.

Throughout *Instrument*, splices of images and sounds occur across a spectrum of continuous and discontinuous transitions. One particular sequence at about forty-nine minutes employs a variety of splices that, put together, is jarring. The sequence begins with Canty rolling equipment into a loading bay, followed by a series of dull backstage shots. The silence of the backstage is represented through the murmur of bands playing on the other side of the walls and by incidental ambient sound. Cuts from people sitting in front of graffiti-covered walls explore the time and space of waiting. Audio cuts of room tone accompany the visual ones, offering shades of backstage silence. Then, a cut to the stage comes without much change in sound. Passing through the cut, the room tone of backstage and onstage is similar enough that it *sounds* like the same space. But onstage, the silence is one of musical pause. After what seems to be a long three seconds, the band bursts into "Smallpox Champion,"

only to be abruptly cut: The song goes for exactly two and a quarter measures before a deliberately ill-timed and ill-framed cut excises the bulk of the song—a dramatic eleven beats remaining. The song ends and the crowd cheers. A last cut returns to backstage, Canty and Picciotto signing announcement posters for people who helped with the show. The visual, room tone, and musical cuts remain complexly unsynchronized, resulting in a brisk confusion over time and space. The edit may not represent the song, but it might represent the psychological experience of the event.

The elisions and bewildering cuts of the "Smallpox Champion" mirror our lack of mastery over perception and memory. William Connolly argues that perception itself is "organized through complex mixtures of sensory encounter, virtual memory, and bodily affect" (2002: 27). Film can imitate this real complexity through devices such as flashbacks, mixing visual images, close-up shots, and jump cuts. Perception is subtractive in nature. Our affect-charged biocultural memory operates "below the threshold of perception; it mixes culture and nature into perception, thinking, and judgment" (34).

Many cuts in *Instrument* exploit visual discontinuities. Cohen describes how constructed his hard cuts are through two moments in the film.

> You see this airplane in the sky and there's something very troubling about it. I don't know. There's this sick feeling about seeing this plunge over the highways, some of the troubled parts of DC. How does it work? . . . It's both a visual and a sonic thing. . . . I had the camera go down and I didn't even have the whole version of the song in sync. But what I had was really smoking. . . . It just drops from an abstracted reality to a very concrete one. Ian just holds up his hand and it's very disorienting in a very interesting way. There's also a cut coming from the Washington Monument show and it drops down into "Forensic Scene." If you look at that transition, it doesn't make any sense. It comes out of left field but it feels very organic. I think most people wouldn't know there's a really weird cut there, but it is really weird. It has to do with motion in the frame and the hard cut.

On the one hand, the hard cuts are the tools of fragmentation and incompletion, roots of which are in dub techniques. The musical and the cinematic dub techniques offer a sense of surprise—a refreshingly vio-

lent pull from the time of song to the time of travel to the time of play and elsewhere. On the other hand, the fragmentation plays a role in representing the experience of time and memory.

Speed Manipulation

Speed variation also plays a role in representing the experience of time and memory. Much of the scraps of music that score the film are slowed in playback. Two sequences document speed manipulation: MacKaye plays with the reel-to-reel tape speed of his own vocals for "Me and Thumbelina" in one, and in another sequence of unhinged playfulness, Canty and Picciotto speak into a Casio keyboard and play back the pitch-altered samples. The film also demonstrates the technique through film speed manipulation, yielding a disorienting feeling familiar to those who have spent intensive time editing time-based media.

In the visual edit, the recording studio sequences particularly exaggerate time manipulation. Cohen knows this temporal experience through his experience editing. Picciotto suggests that the ungrounded feel of the film comes from their editing environments. They worked in fits and starts, never in the same editing space and usually after midnight in spaces that were cheap or free. To represent this general disorientation of creating and editing time-based media, images are sped up and slowed down. Repetition and hard cuts work less to show how the band works and more to resemble how it feels to craft an album. Cohen believes that film editing is particularly useful for recreating the elisions of time that happen in the recording studio. He explains:

> When people are in the studio, they might have gone for four hours and it feels like twenty or they might have gone for twenty hours and it feels like two. It's just conducive to echoing that in the filmmaking and cutting. . . . I think that basically the consensus from a lot of musicians about studio time is that it's a submarine. They're in this little capsule together and there's a degree to which it can be very creatively intense but also torturous. They have to accomplish these tasks and time is on their backs. . . . It's tough. It's a sort of gloriously miserable situation.

Though film editing, Cohen constructs the "submarine" feeling by playing with the rhythm of the cut and focusing on details. Fragmented shots of the recording process are intercut with ones of the band relaxing

or, in a few cases, acting crazy (ostensibly) from the pressure of recording. The time of the film can also wear on the audience. With no dramatic, musical, or task-wise narrative device structuring the sequence, the feeling of being lost in time and trapped in the space of the studio is strong.

Visual and Musical Exposition

The four techniques described above involve high degrees of editing. But on the other pole of Cohen's anti-MTV editing strategy, exposition lets a scene or a musical figure unfold on its own. The expository technique is akin to a dub engineer stepping away from the mixing desk with the record playing. I'll describe the *visual exposition* of the long take and then relate it to a form of *musical exposition* used throughout the film.

In narrative film, long takes are often used for story exposition. When discussing the long take at the beginning of *Instrument*, MacKaye brings up the tracking shot in Orson Wells's *Touch of Evil* (1958). A similarly constructed shot is in Martin Scorsese's *Goodfellas* (1990). A three-minute tracking shot introduces Ray Liotta's character by following him through the Copacabana club. In documentary, the direct cinema classic *Primary* (1960) follows John F. Kennedy from his car to the stage. In all these cases, a long take serves to show relationships as characters move through space.

In considering the effect of the long take, Susan Feagin distinguishes *time* from *timing*. "Timing can be indirectly significant when some aspect of a film continues longer than one might expect, enabling one to contemplate more subtle aspects of the story and the characters and to think about why the shot continues so long. In contrast, fast-paced montage and rapid cross-cutting often work directly to create feelings of excitement, so that an effect can be produced without requiring the audience to think" (1999: 174–75). If the fragmentation of quick cuts in *Instrument* creates feelings of disorientation and potential, the long takes offer moments to think. Feagin, in her analysis of Jim Jarmusch's *Stranger than Paradise* (1984), argues that the long take of nothing happening between characters allows us to think about how they spend their time (176). The unconventionality of such a shot prompts a cognitive moment ("Why is the shot so long?") and then a feeling of time experienced by those on film. Feagin adds one more consequence of the long take: an extended

duration of a shot can force us out of registering the meaning of the shot to examining the details of the shot. Like punctualism, a long take can produce a sense of absolute time. Her example is the interminable dragging of a chair along the floor in *Sling Blade* (1996). A quick cut would show the noisy dragging of the chair to be a breach of etiquette, but the longer-than-expected duration of the shot allows us to "experience the irritation ourselves" (178). Brought to music, this sense of time most closely resembles the feeling of being in a concert, stuck in a position, and following the music carefully.

The idea of refraining from cutting came from an Otis Redding television concert that Cohen and the band watched together. The concert editing was spare. Cohen describes their epiphany: "That was an example where you didn't care about the filmmaking or camera work. It was just like, 'Let this guy do his thing and be alone and capture it. There are times where you just need to get out of the way, document it, and let the document breathe and let the concrete documentation just exist. That was a real revelation in a way. Not a revelation, more of a confirmation.'"

The long take is as much an act of watching as it is listening. Cohen's longer shots of concerts sync to the sound from the soundboard. While there is a sense of stability of sound, there is less sound of the crowd. The effect is one of psychological realism. In narrative films, attenuation of the environmental sounds draws attention to the interiority of the character. Close miking the characters' voices privileges their actions and their experience by *aurally prioritizing* those sounds over others. Such an aural representation offers a psychological perspective. Consider a hypothetical scene where a character notices something in a crowded restaurant. Cinematically, presenting the character as having just experienced something significant can be done by attenuating the noise of the room or by changing the balance between noise and score. In the long takes of performance in *Instrument*, the crowd sound is present thanks to the bleed-through from other microphones (incidentally, also something used in dub mixes). As a result, we can hear the attenuation in the mix. The stage (music) is loud and the floor (audience) is soft. Sounds resemble the *experience* of being onstage. MacKaye claims that this representation in *Instrument*, though not realistic, resembles a psychological experience of being onstage:

> By and large, what you're hearing [in the film] is just what you're hearing through the PA. So you're not hearing the audience or the room. . . . It's a very weird sensation; I don't think many people pick up on it. But especially at that Olympia show . . . you barely hear the audience. So it's almost like you're in this very weird vacuum with the band. It's actually not an accurate portrayal of what that band was like, because the crowd was so vocal. . . . So it works, but it was unintended. Or it was, as we say, the art of necessity. 'Cause that's what we had.

The second sequence in the film serves as an extreme presentation of direct time—an eight-minute shot of mostly improvised performance. The music contains many radical shifts in dynamics. Instruments drop in and out in a somewhat expository manner. These openings of relative quietness offer moments to hear the bleed-through of the crowd, though for the most part the crowd seems unnaturally quiet for a rock audience. The production didn't allow for traditional multicamera shooting—Cohen was the only one filming. He followed the music and action with the limitations before him. In his words,

> It's a single camera. I'm onstage in Olympia, Washington, and the band is playing "Shut the Door." It's very interesting in that it's the opposite of a lot of the other approaches taken in the film because it's just the actuality. Even there, the fact that there're no cuts, that it's just me shooting, is very different. If you're shooting with an experienced crew and you do it by cutting between different angles, it's very, very different than when it's just one angle for that kind of duration because there's no escape and there's no distraction. There's no patching, no fixing. . . . Then we come out of that and we kind of hard crash into another very different temporal investigation.

The crash to the next sequence is hard because of the stability of the long take—a psychological stability of being onstage in a musical cocoon. The hard cut is accidental; Cohen ran out of film. He explains: "If the camera hadn't rolled out, it would have been a ten-and-a-half-minute take."

Cohen explains that though the long take was unconventional for music videos, it can reveal a performance in its own way:

Given that the average cut in a music video was under a second long—probably still is—that was really an extreme move. But what's interesting about it is that I don't think it's particularly difficult—most people don't think it's that difficult—to sit and watch the cut with no escape or distraction because the performance is extraordinary. And you are taking this mystery ride of where the band will go with this song. They are exploring it; the musicians are taking it places where I don't think they all know.

The long take has potential to rescue performance documents from *editing* that generates its own attention. Throughout the film, band members remind us that the music should speak for itself. To support their stance, uncut musical segments provide opportunities for listening. The long take offers a *visual expository* of musical listening.

What I call *musical expository* borrows ideas from both cinema studies and music theory to show a cinematic and musical technique that encourages Michel Chion's mode of reduced listening (see chapter 1; Chion 1994: 29–31). In documentary film, Bill Nichols identifies the expository mode, a direct-address style developed in the 1920s before sync sound offered other modal possibilities. "Expository texts take shape around commentary directed toward the viewer; images serve as illustration or counterpoint. Non-synchronous sound prevails" (1991: 34–35). Nichols considers films with a "voice of God" narration, which offer a sober unfolding of an argument or solution to a problem. Images and the flow of time are subordinate to the flow of spoken text. What he does not consider, however, is a direct address that is not text.

Exposition exists also in music analysis, the term referring to an initial thematic statement in a sonata or fugue. Often bare in the case of a fugue, the melody is first exposed for consideration. Complex variations, contrapuntal voices, or thematic development follows. The initial exposition offers a branch to hold onto throughout the flood of complex manipulation. In both Nichols's expository mode and this sense of musical exposition, the relationship with the audience is one that seems to say: "Listen to what I have prepared for you." The audio is forward—a direct address—and the images help direct listening.

In the beginning of *Instrument*, the structure of the music is exposi-

tory. The slowed, grainy images offer little in the sense of time or place. But each musical part exposes itself as a new element for the listener's consideration. The parts of "Slo Crostic" enter progressively, starting with the drums for a full eight measures. Then, an arpeggiated guitar part joins the drums. Eight measures later, bass and rhythm guitar enter. After yet another eight measures, the first guitar part changes to a fuller arpeggiation. The arpeggiation then drops out for eight measures. Such an expository arrangement imitates how a critical listener might alternate between focusing on a part of the whole and the whole itself.

The material used for the *musical expository* of "Slo Crostic" is conducive for listening. The music comes from a demo recording of what would become the much faster and more complex song "Caustic Acrostic" from *End Hits* (1998). In fact, much of the extended music in the film is not from the recorded versions, but rather they are demos, less polished and more extended grooves recorded as the band worked out their parts. Cohen used six demo recordings from *End Hits* (1998) as well as a demo of "Rend It" from *In On the Kill Taker* (1993) as musical material. Mixed with montages of live performance and music written to the images, these are the opportunities to "just listen" to the music. Because of their nature, the demo recordings have more space to unfold ideas than do their studio recordings. MacKaye explains what the band values in these recordings:

> The reason all four of us love those demos is that in the recordings we're relaxed. We're not doing something for posterity at that moment. We're just playing music together and recording it. We're not thinking about anybody else hearing it. . . . It's just us playing together. That's the essence of the band for me. The stuff that's in there was culled from like hours of stuff and I was like, "Yes. We can actually score these slow-motion things, we've *already written* the score and now we can use these same things but we have video." I remember being so happy about that development. . . . there's one thing from Saint Augustine's and there's the Washington Monument, the outdoor one, the black and white, there's three or four different black and white things that we took the song and we actually edited the slow-motion stuff—the Super 8 footage—we edited it to the song.

The expository sequences put both sound and image together in rhythmic play. Rather than music scoring to an image, the two operate in

common musical terms centered on rhythm. Cohen explains: "In the edit room, we started to think about rhythm and in particular think about radical juxtaposition of sound and image so that there wasn't really a distinction between the visual and the sonic, so that they were together in this soup that was the movie."

In the sequence of the 1993 Martin Luther King Jr. Concert for Justice, unsynced sound and image play in a counterpoint that is perhaps more effective than the actuality. We do not hear the actual music performed. There is no transition to the stage save for the word "home" at the end of a list of world tour dates from the previous sequence. The close-up shot of shoes moving onstage around a guitar cable is in sync with a bass riff in A minor. The lack of environmental sounds indicates that this is montage. The drums join and the image cuts to Canty on the drums. Staccato guitar notes lead up to a sustained double stop of a G and B just as the camera pans to reveal a brief shot where the back of MacKaye is framed by an endless audience that stretches back to the Washington Monument. MacKaye is relatively motionless, in keeping with the restrained musical figure and timbre of the guitars. Slow-motion moving heads in the audience bob to a dotted quarter as the guitar begins to strum the double stop more aggressively in dotted eighth notes. An intertitle frame then reveals that this performance is for the thirtieth anniversary of the March on Washington. The syntax aligns when, coming out of the black intertitle frame, Picciotto's head moves up in sync with a cymbal crash on the first beat. The camera zooms out and follows Picciotto and his guitar as he quickly disappears behind the drum set. The motion on the frame delivers the eye to a close-up of MacKaye's guitar. The cut matches the angle of the guitar to the angle of a cymbal stand and the camera swiftly moves to Canty from the side playing with an intensity matched to the rhythmic interplay of the nondiegetic music—though it is out of sync. But the sync is not completely out. The sticks move in dotted eighths to the score. The drums in the score use a figure of dotted eighths that align to some of the visual hits. The result is a loose attachment between image and sound. It is not akin to lip-syncing, but there is enough syntactical concision to let the sound and image reinforce each other. A strong cymbal hit coincides with camera movement in the opposite direction of the pan and then the camera moves quickly to the audience in a wipe, cutting in motion to a shot of Lally from the audience's perspective for a short mo-

ment. Just then, the bass part is at the end of the riff—the G in motion to A on beat four. Our visual and aural attention is on the bass for another few beats until a cut to the opposite perspective. Part of Lally and his bass are on the right and Picciotto faces us on the left, framing the audience and the first shot of the Washington Monument. In the cut, Lally's downward motion passes to Picciotto's downward motion, drawing our eye across the screen from right to left across the audience and the iconic monument. A drumroll takes us into a slightly different perspective on another beat four—still with audience, monument, Lally, and Picciotto, who is now in the middle of a dramatic motion. Picciotto walks across the stage and jumps, resulting in yet another visual emphasis to the fourth beat. As he finishes the move, he moves up as a straight 32nd-note guitar strum begins.

The microtiming of images to expository musical structure brings forward the parts of the music—the particular motion of the music. Sequences like this abound. An earlier sequence uses "Guilford Fall Demo" and images from a 1990 antiapartheid benefit at St. Augustine's School, band and crowd moving in concert to the edit, which, in turn, points to the musical interleaving. "Link Track" preserves the rhythmic edit over Picciotto apparently being dazed and a fan holding him up. In each of these expository sequences, Cohen offers a psychological realism of being intimate with the music, of being a close listener. Musical structure dominates both the measurement of time and the fragmented images.

The expository structure of these moments is not unusual for rock songs. Popular songs often begin with a single guitar playing part of the groove. The device is a well-worn technique brought to punk from dub reggae. Nearly half of the songs on Fugazi albums released before *Instrument* use this technique in the arrangement. When an instrumental part goes silent, memory fills it in.

Chronoscape for the Multitude: Portraiture and Perspective

Dub techniques subvert the narrative time of rockumentary and demonstrate Fugazi's musical process and aesthetic principles. But they also have another effect. The incompletion, punctualism, splicing, speed manipulation, and stable exposition all have a spatiotemporal effect because they are *cinematic* dub techniques. As an experience, watching the

film reveals perceptive capacity itself—our own ability to sense the world through the camera.

Cultural theorist Paul Virilio looks to children's games (peek-a-boo) as a developmental but crucial form of play with the seen and unseen, the creative acknowledgment that our humanness limits our perception. As Virilio says, "The basis of the game is the separation of the two extreme poles of the seen and the unseen, which is why its construction, the unanimity that pushes children to spontaneous acceptance of its rules, brings us back to the picnoleptic experience" (1991: 14). Picnolepsy, similar to epilepsy, is a condition in which consciousness lapses and we lose time without being aware of it. Virilio suggests that we are all picnoleptics. We have a human penchant to play with our limitations. Film then allows that play as an experiential prosthesis. Film can enable us "to look at what [we] wouldn't look at, to hear what [we] wouldn't listen to, to be attentive to the banal, to the ordinary, to the infra-ordinary" (36–37). As a result, the work of film is a work of "other-worlding," and the reflexive film acknowledges its limitation through play. Virilio continues: "The world is an illusion, and art is the presentation of the illusion of the world" (35–36). Through play, the prosthetic and the natural engage in creative play. Thus picnolepsy, the return to childhood, is part and parcel to human experience, complexly refiguring the "real" and the "imaginary."

Cinema, as an instrument, can allow heterosubjectivity, moving us beyond ourselves. This is a far cry from documentary's oft-claimed mission: organizing reliable evidence of the historical world. But it is close to John Grierson's definition of documentary film: "to teach." If teaching involves heterosubjectivity, the kind of cinema that Cohen practices is useful. Consider the similarity between dub and cinema audio that Michael Veal presents: "Virtual technologies such as sound recording and film were often misunderstood in their early years as serving purely documentary functions; their creations were often dismissed as inferior simulations of reality. A more expansive take is that creative manipulations of these technologies in fact create new forms of reality (that is, new ways of 'hearing' the world) within which they function as 'prosthetic' devices, ultimately extending human sensory perceptions into new areas" (2007: 218).[7] *Instrument* engages memory and the senses.

The effect of the temporal play in the film leads to what I call a wide

"chronoscape," a range of perspectives on temporality. *Instrument* unpredictably vacillates between Cohen's two extreme poles on either side of MTV video convention. Another way of thinking of these poles are as formalist and realist modes. We sometimes experience extreme temporal rearrangement of the image and/or the music (formalist) and sometimes experience the stable "live" performance of the band (realist). The two have their analogue in the record industry—the studio recording and the live recording. And within the domain of studio recordings, some sound like ungrounded studio collages and some simulate a real performance. Between the formalist and the realist modes exists a wide terrain of temporal experience. Most films create a narrower chronoscape so that an audience can attend to narrative or character development. With such a wide chronoscape, *Instrument* reveals the picnoleptic experience. The limitations and materiality of film stand for our own limitations, our own gaps in memory, and our own faulty senses. Reflexive films did this long before *Instrument*. But Cohen's film adds a crucial *social dimension* to its picnoleptic strategies with the addition of the audience portraits.

Throughout the film, a series of audience shots show changing time and place as well as examples of a nonfan audience, which I will relate to a post-Fordist social category. "'The crowd,' we called them." MacKaye is deliberate in his terminology. The distinction here is that a "fan" is someone committed to a particular band, an audience member thirsty for the backstage labor of the band or a target consumer. Throughout their career Fugazi took efforts to make sure that their shows were inclusive. Other successful bands might develop a group of fans who effectively narrow their tastes for that band. For example, $100 Eagles tickets effectively brought together a group of committed Eagles fans in the 1990s. Conversely, low ticket prices and all-ages venues brought unexpected people to Fugazi shows, which is demonstrated in the film through portraiture (see figure 5.2). The film is as much about them as it is the band. On one level, the recurring portraits of fans in the ticket lines are a gesture of inclusion, in sync with the punk ethos of community inclusion, a cinematic way of bringing the audience up onstage. On another level, the portraits confirm plurality itself. There is no typical crowd member.

The portraits taken in the ticket line form an important umbrella for the film. Like many devices used in *Instrument*, crowd portraiture came from a resistance to rockumentary convention. MacKaye insisted that the

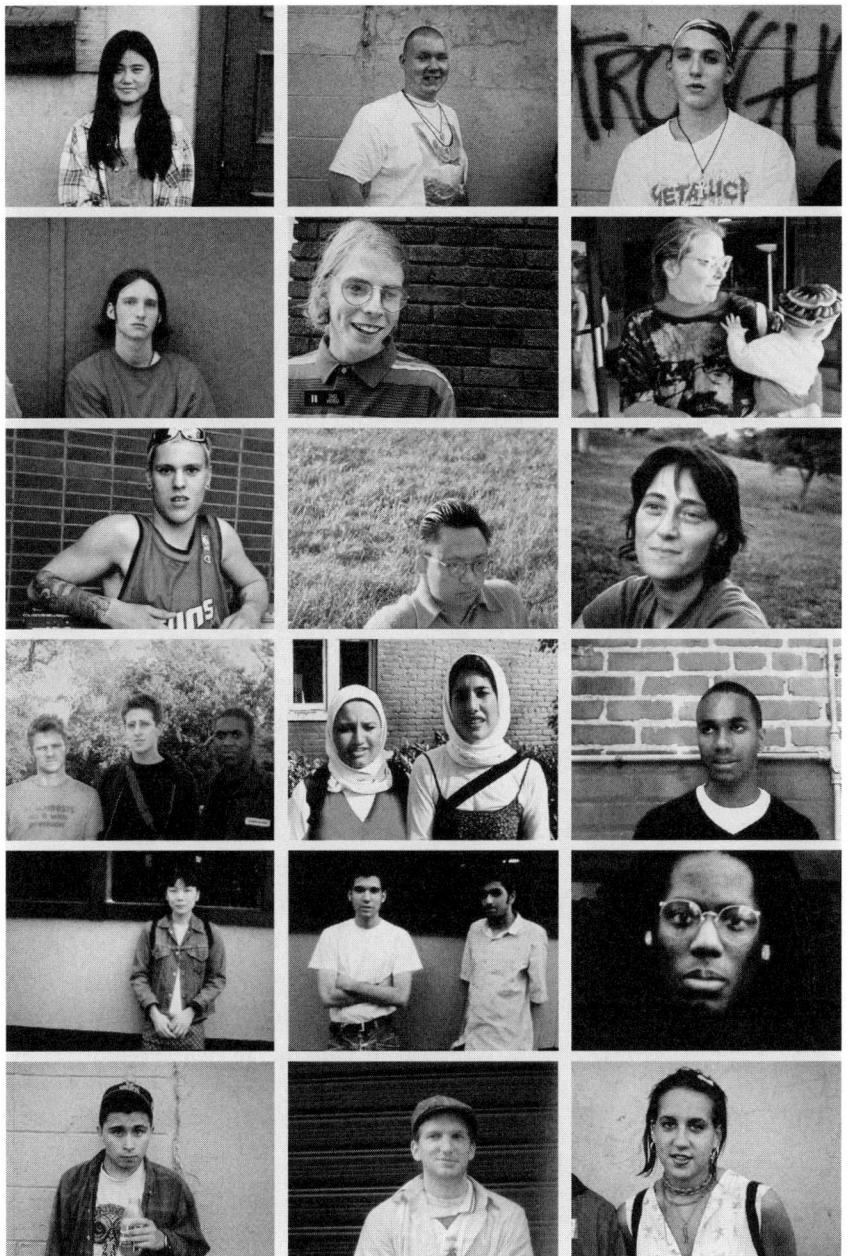

5.2. Crowd portraits.

crowd be in the film. Cohen, however, was wary. Audiences have become a stock device in rockumentary. MacKaye explains, "What [Jem] was worried about was people making the rock 'n' roll hand signal and going 'Whooo!' and playing to the camera, trying to show people going off to us and showing those kind of predictable, often kind of cheated shots where people are like rocking out. I was saying, 'No, like literally showing the audience.'" MacKaye thought that the crowd could show time and place in a way that the band couldn't. "It would become increasingly more interesting as time went by because you could see how [the crowd] presented at that time. . . . We're trying to convey a sense of atmosphere and space. A band doesn't do that. The band is just like the same four dudes sweating and sneering into a microphone."

When Cohen began interviewing the crowd, they became more than changing scenery. Their comments reveal them to be a crowd—a collection of people with many motivations for being there and many notions of what the music is. This plurality came about in the edit room as they began choosing crowd voices to include. MacKaye explains how they chose their first collection of quotes, only for Cohen to object: "Jem looked at the list and was like, 'No. You guys are only selecting the negative ones.' We just loved all the people saying, like, one guy was saying he wanted to kill me, he's gonna get me for something. [Jem] was like, 'At some point you have to deal with the fact that people like you. I understand you don't want to make it a stroke-fest, but you've got to acknowledge the fact that people like your band.'" Cohen also recalls the debate: "They wanted less of themselves and more critical stuff. [They didn't want] just people saying how much they loved them but also people saying they sucked and why. I thought that was fascinating." The combination brings out the diverse voice of the crowd through both look and testimony.

As the film progresses, the crowd begins to speak. (Cohen shot them with silent film in the beginning.) As they speak, people further differentiate themselves from each other. Transitioning from silence to speaking is similar to expository listening, discussed above. There is a progressive reveal of crowd differentiation. First they look back at the camera. Then they speak back to the camera.

Consider one more contribution of the crowd—the videos from Fugazi's archive not shot by Cohen. The basketball hoop shot, the benefit for Whitman-Walker Clinic, and the Gulf War protest show all have a home-

video feel. The long takes of what we might call "crowd cinematography" certainly respond to the slick MTV images through amateurism and the grain of the video. But because the crowd cinematography bears the look of home video, they offer a feeling of viewership as well.

Amateurism is as important in the punk rock DIY ethos as it is in Italian neorealist cinema. On DeSica's films, André Bazin writes that the value of amateur actors is a "guarantee against the expressionism of traditional acting" and that "the natural setting is to the artificial set what the amateur actor is to the professional. It has, however, the effect of at least partly limiting the opportunity for plastic compositions available with artificial studio lighting" (2004: 65). Including video from Fugazi's archive was a way of bringing amateur cinematography into the film. It confounds the rockumentary gaze because it limits the consistent construction of images in a similar way to that which Bazin identifies with amateur actors and natural settings. The amateur grain of the cinematography eschews style for heterosubjectivity of the crowd. The long takes of amateur video reveal a plural set of limited views on the event. They are moments of stability of "actual" time within the unstable dub editing that point to various momentary stabilities—each different in their subjectivity.

Together, the crowd portraiture and crowd cinematography make the picnolepsy social—a shared and differentiated set of limited views. The widened chronoscape represents a diverse experience of the music and, by extension, of the world. What the portraits reveal throughout is less the *people* of Fugazi than the *multitude* with whom Fugazi engages.

Paolo Virno argues for understanding the public as a multitude rather than as a people in a post-Fordist world. Resurrecting the distinction as made by Hobbes and Spinoza, the multitude is the many who see themselves as many (Virno 2004: 23). These Enlightenment-era political thinkers saw a distinction between citizens of a sovereign nation-state (a people) and a self-aware plural mass (a multitude). The modern conception of the people, according to Virno, is eroding in post-Fordism. Individual creativity and uniqueness has eroded solidarity. Virno suggests that there may be a universal socialization that celebrates difference and individuation in Enlightenment concepts of the multitude.

The crowd/fan distinction that *Instrument* reveals is homologous to the multitude/people distinction. The audience is not a shared commu-

nity of Fugazi devotees and that is its strength. The progressive diversity of fans captured in the portraits offers a multitude in look, attitude, testimony, and behavior. They are not a group constituted by a pull toward the band but rather a constellation of the many who understand themselves as many. *Instrument* attunes us to a mode of being—an instruction for living. As Virno argues, "The multitude is a *mode of being*, the prevalent mode of being today: but, like all modes of being, it is *ambivalent*" (2004: 26).

In summary, *Instrument* makes an aesthetic attempt to achieve neo-syndicalist goals of restricting and taking over musical labor. Cinematic dub techniques achieve three main functions: they thwart narrative time to guard against post-Fordist appropriation; they demonstrate the aesthetic practices of Fugazi without need for explanation; and, with the strategic inclusion of the crowd, they represent a manifestation of the multitude as experienced at their performances.

Reflecting on the film, MacKaye says, "I still think we could have cut out more stuff. I think it may not have made it a better film, but I think more people would have seen it." They could have made a fascinating narrative film. Imagine a rockumentary with a narrative of aspirational struggle. The film could show them doing everything themselves (concealing any sort of cultural capital they might have as children of professional and educated white parents). The film could have created a realist representation of a concert and selected devoted fans (there are plenty) singing along. Dave Grohl from Nirvana and Foo Fighters could have talked about how he looked up to them for keeping it real, and Ahmet Ertegun could have talked about how much he regrets not having them on Atlantic Records. More people would have seen *that* film. But Cohen would have presented less about Fugazi's music, discovered less about cinema, and supported an ideology that had now come knocking at their door.

EPILOGUE
Toward a Ciné-Ethnomusicology

In this book, I have shown that cinema can be scholarly in nature. Each of the films analyzed developed out of cinematic practices of understanding. They are also documents that offer critical perspectives to audiences. But it is not enough for me to stop at making a disciplinary claim that ethnomusicology works in another medium—especially in one with greater production costs. To conclude this book, therefore, I'll suggest that a ciné-ethnomusicology might add to ethnomusicology in both epistemological and practical ways. My main argument is that, as a practice, filmmaking inflects the nature of scholarly knowledge about music and culture by relating music to cinematic experiences—through the eye and the body—and presents that knowledge to audiences at screenings. This practice is familiar to most independent filmmakers. Thinking about a practice of ethnomusicological filmmaking and documentary filmmaking opens possibilities and reveals obstacles.

None of the films featured in this book were produced by ethnomusicologists, but in at least two ways they can be seen as ethnomusicological works. On one level, I argue that these *films themselves* do a type of visual and aural theorizing that is distinct yet congruent with (print) ethnomusicology. They have theses in the sense that they establish themes, make propositions, and then engage issues from a variety of perspectives. These cinematic theses link musical practice to social phenomena such as flows of capital, patriarchy, media spectacle, ritual, commodification, and labor. In addition, the coaesthetic understandings found throughout these films offer cinematic renditions of musical phenomena. For instance, Charlotte Zwerin's use of slow-motion body movement to direct reduced listening, Shirley Clarke's cineharmolodics, Jem Cohen's use of visual dub techniques, and D. A. Pennebaker and Chris Hegedus's creation of

Gesamtkunstwerk all reveal elements of music. In that sense, they are musicological.

On another level, *my analysis* of these films is ethnomusicological. These films all mean different things to different audiences. As Bruno Nettl partially defines it, "ethnomusicology is the study of all the musical manifestations of a society" (2015: 17). Of course, there are many definitions of the discipline. But suffice it to say that from Nettl's perspective, I have analyzed these films as cultural expressions themselves. My methods are also ethnomusicological in nature: interviewing people, observing musical phenomena, and listening critically with a multidisciplinary stance. I have tried to veer from a literary studies emphasis on the text itself to understanding these films as inherently linked to social process. (I hope that future scholars will conduct fieldwork by going to production and postproduction sites and be able to gather richer data about the connections between filmmakers and musicians.)

Centering a discussion around the three key questions I identify in the introduction to the book, I'll elaborate my call for developing a cinematic music scholarship that ties together the themes of the chapters, identifying disciplinary obstacles, and organizing the collection of practices that accrue through the five chapters on the films. Much of my thinking builds upon my own practice with making and presenting my own film, *Follow Me Down: Portraits of Louisiana Prison Musicians* (2013). I am not the only ethnomusicologist to have made a film and thought about it in relation to the discipline, but my hope is that this epilogue can help initiate a discussion of what ciné-ethnomusicology might be and how film can be useful for scholars and to general audiences.

What Does a Critical Cinema of Music Look Like?

A critical cinema of music uniquely contributes to ethnomusicological arguments. In my analysis of the five films I've selected, I hope to have shown that documentary can do more than just focus on a musical topic. Each of these films presents music as a form of social practice and identifies related critical issues. In production, filmmakers dove into unfamiliarity and made sense of it through shooting, interviewing, and recording sound. Repeated shoots adjusted for new understandings. Additionally, the editing room became a place to think through structuring, cutting, and creating relationships between sound and image. Major

advantages of cinematic theorizing are in producing reflexivity, conveying embodied knowledge, and sustaining ambiguity.

There are some models for the filmmaker-scholar. At the university, studies in film production and theory have traditionally been separate. Recent shifts in film studies, however, have been uniting the two practices. Many are willing to acknowledge that if a written text can examine writing, a film can examine cinema. Such disciplinary restructuring puts many filmmaker-scholars at the center of critical cinema. Jill Godmilow, Raúl Ruiz, Trinh Minh-ha, and Marlon Riggs all bring critical practices to filmmaking and also produce their share of print scholarship. Closer to ethnomusicology, visual anthropologists offer models for critical cinema—understanding how the visual image can do ethnographic theory. They have also looked at intersections between experimental film and anthropology (see Russell 1999; Schneider and Pasqualino 2014). Though not addressing musicology, the work of Robert Ascher, Robert Fenz, and Chantal Akerman is worth examining as films that make thorough use of the medium toward critical ethnographic ends.

A ciné-ethnomusicology might bring a sensitivity to sound and contribute more to aural theorizing. The films I have presented in this book do some of this critical work—revealing how soundtracks contribute to meaning, using visual elements to encourage critical listening, and providing aural subjectivities. The filmmakers' intent might not have intended to be scholarly, but their films offer good examples of cinematic attention to issues in musical practice. Through reflexive techniques (as discussed in relation to Jill Godmilow and Shirley Clarke), critical cinema can draw attention to issues of mediation, which is a preoccupation in ethnomusicology. Many ethnomusicological texts address issues of mediation (for example, Manuel 1993; Feld 1994; Slobin 2008; Bates 2016). In a film, however, Brechtian techniques can force experiences of reflexivity, making viewers critically aware of the nature of cinema and the terms of their own engagement. These reflexive experiences of cinema can transform audiences into personal sites of understanding.

For viewers, films can offer other ways of knowing. Bill Nichols suggests that a power of critical cinema lies in "situated knowledge and the subjectivities of corporeal experience" (Nichols 1993: 188). An example of how print and video might share arguments but have different epistemological effects is Bruce Jackson's work on Texas prison songs. His book

Wake Up Dead Man: Hard Labor and Southern Blues ([1972] 1999) and his short film *Afro-American Work Songs in a Texas Prison* (Jackson et al. 1966) offer markedly different experiences, though they present similar ideas about the function of prison work songs. Both show how song style is dependent on the materiality of labor. His book explains, for instance, how tempo relates to the ability to swing an ax or hoe and how short strophes are better for the exacting coordination of felling a tree with four axes. The film, however, locates the feeling of the singing in the viewer's body. The experience is visceral: the arching of the back in preparation for an ax cut, the thud of the hoe on the ground, the posture held for repeated low cuts, and the ducking out of the way of a falling tree when the song suddenly gives way to shouting. These felt experiences are also musical. Jackson allows long takes of the songs with limited narration. Watching and listening, the songs are at once part of labor and of dance. The theory that music can transform brutal labor emerges through vicarity: feeling the bodies on the screen (theorized in chapter 2).

Lastly, ambiguity developed in cinema can be productive and representative. I'll offer an anecdote of the power of cinema's incomplete representation of events. At the 2012 Society for Ethnomusicology conference in New Orleans, Michael Frishkopf presented a series of ten ten-minute films on the Arab Spring. Frishkopf organized a collaborative film by members of the Society for Arab Music Research and the Facebook group "Songs of the New Arab Revolutions." Now at over one hundred short films, the collaborative project offers raw views on music of the so-called Arab Spring. During Frishkopf's presentation, the ten short films screened in series without break, sequenced alphabetically by last name of the producer. The pragmatism of the moment spurred rough edits of a variety of material from cable television, cell phone video, and YouTube clips. There was little voiceover; the form of the videos arose from the subjects themselves. What emerged was a complex and admittedly partial view of music and the Arab revolutions. The films moved me. The long cell phone shots of soccer chants repurposed in Tahrir Square gave a sense of music's capacity to mitigate the confusion of diverse Egyptians imagining a new Egypt under the threat of government attack. In another, a grieving mother of a dead martyr sings with her neighbors while weeping in the street in a nationalist chorus. From all the accounts of people I know who have lived in Egypt through the struggles of revo-

lution, the events *were* inherently confusing, full of multiple viewpoints that often conflicted, and have their power in the raw direct experience of human contact. Streamlining meaning through narration and explanation would destroy that important truth. I left the screening with new questions and perspectives on relationships between music and the Arab revolutions.

What Are Some of the Constraints?

Each of the filmmakers discussed in this book worked with constraints of funding, access to musicians, agendas of other parties, and technologies. In each of the films, the constraints became productive. The Maysleses and Charlotte Zwerin found ways around their relative lack of access to the Rolling Stones, rendering the band's buffer zone into a site of dramatic conflict. The lack of access to personalities made room for focusing on the nature of music and its relation to film. Jill Godmilow hired an animator when she didn't have material for the timpani battle of the sexes, opening the idea of postrealist documentary cinema. Shirley Clarke didn't turn away from the producers' interest in Ornette Coleman as standing for triumphant individualism. Rather, she used those forces as oblique material to expose façades of racially uneven urban renewal. D. A. Pennebaker and Chris Hegedus transformed Depeche Mode's offstage lifelessness into a commentary on musical labor and a Wagnerian critique of the rock star. Jem Cohen's financial limitations forced him to use a variety of cameras with and without sync sound. The uneven grain of the film created a sense of the ten years of filming as the cameras improved. Additionally, the grain of the video created an opportunity for creating visual dub techniques out of the discontinuities. The limitations that filmmakers confront often become advantages because they reveal issues of music and culture, economies, and/or mediation. Documentary film is animated by these problems.

Ethnomusicologists, however, have their own sets of disciplinary and institutional challenges. As I mention in the introduction, film has been a promising medium for ethnomusicology for decades. The problem is that it is stalled in the category of "promising." Why are there so few ethnomusicological films? Here are five obstacles that stand in the way of a disciplinary adoption of filmmaking.

1. Film production is expensive. Most financial support for ethnomusi-

cologists is given under the assumption that funding is only needed to cover personal and travel expenses for one lone ethnographer. Film crews cost money. Equipment purchase and rental can be a preventative outlay. Production costs have declined since the days when the films in this book were made, but hiring the people and paying for editing, color, sound engineering, and titling can be expensive if professionally done.

2. Related to the first point, many music scholars don't have the type of media literacy needed to analyze, evaluate, and advise colleagues and students about video-based projects when they are not text-driven, expository films. This book is an effort toward remedying this issue. The more that scholars can have the confidence to understand how cinematic arguments are made, the more cinema can become a unique tool for the discipline.

3. Rank and tenure committees are not sure how to judge the scholarly value of films. Most tenure decisions rely on peer review, and as long as peer review is print based, it is unlikely that many junior scholars will take the risk of devoting major research time into a film. Collaboration is an important—and often necessary—part of producing films. When seen as coauthored works, films can weigh less in importance for print-centered evaluators. As of this writing, the *Journal of Video Ethnography* (JVE) has developed an independent peer-review system.

4. Academic conferences rarely make time or space to show films—scheduling them outside regular paper sessions in poorly equipped rooms. I have been to many late-night screenings at scholarly conferences that had only a handful of people in attendance. Once, I was the only one there. The filmmaker had not even bothered to show up.

5. Distribution is challenging if filmmakers hope to recoup costs. Digital self-distribution rarely nets much for niche films. Festival screenings charge submission fees until the film is well known enough to receive solicitations. People buy fewer films with the ease of streaming video. Educational distribution is one of the last viable markets for documentaries. Institutional rates and library budgets have been key for keeping many documentarians solvent.

Perhaps one of these obstacles can become an animating feature of a future film about the study of music.

Scholars can also work to overcome these impediments but must remain aware of various consequences of doing so. Technological, institu-

tional, and disciplinary obstacles are eroding. Digital technologies have reduced the cost of production, but as any filmmaker who began with film will attest, the cost of film and processing used to encourage cinematographers to make their shots count. The ease of digital filmmaking can result in having to sort through too many hours of unplanned and poorly shot video.

At the institutional level, tenure guidelines can be crafted to count artistic works (as is often done for composers and other practitioners). But given interdepartmental politics at the university level, aligning ethnomusicology's association with "artistic" works might threaten notions of scientific credibility, especially in the eyes of those from the hard sciences. Within ethnomusicology, Hugo Zemp and John Cohen have supplemented their documentaries with more familiar print scholarship (Zemp 1988; Cohen 1989). In addition, scholars can produce short films to fit into the time constraints of paper sessions at conferences rather than lobby for time for feature-length works. Perhaps an ethnomusicological film series could take the form of a symposium on disciplinary use of cinema. Knowing what obstacles to overcome and which to engage is important for any filmmaker-scholar.

What Are Some of the Useful Cinematic Techniques?

The in-depth film analysis in this book reveals a set of cinematic techniques that may be useful in creating a ciné-ethnomusicology. The devices I describe are by no means comprehensive but may contribute to other investigations into music. The diegetic slide discussed in chapter 1 can help to present different perspectives on music—as formal play, as a representation of something else, and as a material object. Music's relation to inner and outer vicarity discussed in chapter 2 can engage music through embodied understandings, passing experience from the subject on-screen to the audience. Amateur reenactment, mediated images, and attention to the presence of the camera can reflexively draw attention to mediation, most evidenced in chapters 3 and 5. The intermittent reharmonization discussed in chapter 3 can encourage thinking about connections between different places and geographically separated groups of people. Likewise, the parallel editing of the band and the fans in chapter 4 can set up ways of thinking about musical audiences and consumers. The dub techniques described in chapter 5 (incompletion, punctualism,

splicing, speed manipulation, and visual exposition) can simulate musical experiences of time. And crowd portraiture also discussed in chapter 5 can offer new perspectives on audiences.

Some of these techniques are coaesthetic and many of the filmmakers and musicians are co-conspiratorial to certain degrees. In other words, they share an interest in aesthetic form and an interest in critical sociopolitical perspectives. But they also invite the viewer in through positioning the interviewee as a witness-participant and offering degrees of vicarity (chapter 2).

Screening with Intent

When arriving at a final cut in producing a film, it can seem like the end goal. Far from it. For most, the next step is to show it to people—and this is more involved than it seems. Developing a practice of cinéethnomusicology requires filmmakers to strategize how to screen their films once they are complete. Finding an audience is central. Some of the other films in this book draw audiences already built by the fan base of the musicians they film—the films about popular groups such as The Rolling Stones, Depeche Mode, and Fugazi can tap into their audiences. In the case of *Antonia* (and, to a degree, *Ornette*), the featured musician is less of a draw. Despite that challenge, filmmakers can connect their *issues* to audiences by taking certain steps toward audiences and institutions.

Consider screening strategies that independent filmmakers have developed to make their films relevant. When I was in postproduction with *Follow Me Down: Portraits of Louisiana Musicians* (2013), I called Jill Godmilow and asked her advice on the film. I sent her a rough cut, and after viewing it she told me that my audience was going be made up of intellectuals and prison-rights groups. Her story about how she got *Antonia* into the world is instructive. It's not that she simply worked hard and got the film to audiences, she learned how *Antonia* operated with feminist audiences and began to coordinate her efforts with those groups. Her story is as follows.

Godmilow met Jerry Bruck Jr., who had just completed a film about I. F. Stone, a blacklisted investigative journalist who managed to self-publish an influential weekly newsletter. Bruck was figuring out how to self-distribute. He made contracts with theater owners and figured out how to make his own ads and where to put them. Godmilow joined Bruck

for a double billing of *I.F. Stone's Weekly* (1973) and *Antonia*. She said that while working with Bruck the most useful discovery was the importance of having the right film for the right audiences. The double billing offered feminist groups an event and the groups offered Godmilow the legwork necessary for producing the screening. In our interview, Godmilow explains:

> There were women's groups in Ann Arbor, Michigan, and everywhere that were trying to raise money. So you would get them to do all the initial publicity work—you know, put the posters up on the telephone poles. They had lists of people. They would take [out] a little ad and announce [the screening event], and you would give them the first night's proceeds as a benefit. But then, I couldn't be everywhere all the time, so they would arrange the interviews on television and radio. So I did that the first ten cities. That was a great trick. Both people got what they needed out of it, but they did a lot of legwork that you couldn't possibly do. So in every city, I did two TV interviews and three radio [interviews] and a local newspaper at the university (if there was one) and the other newspaper.

With that discovery of partnering, Godmilow found that pairing her film with another film about gender opened up feminist discussion and worked well for engaging these audiences. She moved from Bruck to double bill with *Beauty Knows No Pain* (1972), a short film by Elliott Erwitt. The short, though perhaps not intended to be a feminist instigation, also provided imagery about the female image. The contrast with *Antonia* opened up possibilities for discussing femininity. *Antonia* wasn't successful just because it was put together well or because it received awards and recognition; it was successful because it worked on audiences. The challenge of subject position that the film offered was useful to consciousness-raising groups.

I took Godmilow's story to heart and engaged my film with audiences nationally, travelling with the film, doing an introduction beforehand and a Q&A after. On a sabbatical I took university residencies, attended fundraisers for prison arts and advocacy groups, and traveled to a handful of film festivals. I continue to bring the film to prisons and enjoy the dialogue I have with prisoner and nonprisoner audiences. Film may be on the fringes of ethnomusicology, but the place of the fringe provides

a wide range of audiences. Ethnomusicologists already speak at other universities, at consulates, for political action events, and for cultural organizations, to name a few nodes within our networks. Likewise, ciné-ethnomusicology can help animate our relationships with sympathetic organizations.

Screenings as scholarly events also need an infrastructure and financing. While doing research on Shirley Clarke for this book, I ran across a comment that stresses the importance of touring with films. She says, "There are critics who call film a mass medium and criticize me for doing things in a medium that must be understood and accepted the first time round. In my own experience as a producer of shorts, my films have earned most when I have been willing to go with them and talk" (in Clarke et. al. 1960: 30). Clarke was advocating for a way of creating financial support for independent filmmakers but also for the organization of film societies, grant organizations, and distributors—an infrastructure for films that are not part of the established film industry. Beyond leveraging existing sympathetic institutions, academics can work to secure funding for filmmaker visits, have their libraries purchase films at institutional rates, and partner with local art house theaters. Ethnomusicologists might find larger and more diverse audiences. And as for engaging audiences from the perspective of a filmmaker, there is plenty to talk about.

APPENDIX A
EXTENDED MUSIC FILMOGRAPHY

The following filmography includes music films and other relevant films made by the directors featured in this book. Many of these works are referenced in the chapters and may supplement a more comprehensive study of each filmmaker. The films are listed chronologically.

Albert Maysles

Safari Ya Gari. 1961. Directed by Albert Maysles. New York: Maysles Films, Inc.

What's Happening! Beatles in the USA. 1964. Directed by David and Albert Maysles. New York: Maysles Films, Inc.

Gimme Shelter. 1970. Directed by Albert Maysles, David Maysles, and Charlotte Zwerin. New York: Janus Films.

Ozawa. 1985. Directed by Albert Maysles, David Maysles, Ellen Hovde, Susan Froemke, and Deborah Dickson. New York: Maysles Films, Inc.

Vladimir Horowitz: The Last Romantic. 1985. Directed by Albert Maysles, David Maysles, Susan Froemke, and Deborah Dickson. New York: Maysles Films, Inc.

Horowitz Plays Mozart. 1987. Directed by Albert Maysles, David Maysles, Susan Froemke, and Charlotte Zwerin. New York: Maysles Films, Inc.

Jessye Norman Sings Carmen. 1989. Directed by Susan Froemke and Albert Maysles. New York: Maysles Films, Inc.

The Met in Japan. 1989. Directed by Susan Froemke and Albert Maysles. New York: Maysles Films, Inc.

Soldiers of Music: Rostropovich Returns to Russia. 1991. Directed by Susan Froemke, Peter Gelb, Albert Maysles, and Bob Eisenhardt. New York: Maysles Films, Inc.

Baroque Duet. 1992. Directed by Susan Froemke, Peter Gelb, Albert Maysles, and Pat Jaffe. New York: Maysles Films, Inc.

Accent on the Offbeat. 1994. Directed by Susan Froemke, Deborah Dickson, and Albert Maysles. New York: Maysles Films, Inc.

Get Yer Ya-Ya's Out! 2009. Directed by Albert Maysles, Bradley Kaplan and Ian Markiewicz. New York: Maysles Films, Inc.

The Love We Make. 2011. Directed by Albert Maysles, Bradley Kaplan, and Ian Markiewicz. London: Eagle Rock Entertainment.

APPENDIX A

Jill Godmilow

Antonia: Portrait of a Woman. 1974. Directed by Jill Godmilow and Judy Collins. Santa Monica: Direct Cinema.

The Odyssey Tapes. 1980. Directed by Jill Godmilow and Susan Fanshel. New York: Museum of Modern Art.

The Popovich Brothers of South Chicago. 1997. Directed by Jill Godmilow, Ethel Raim, and Martin Koenig. Chicago: Facets Multimedia, 1997.

Shirley Clarke

Dance in the Sun. 1953. Directed by Shirley Clarke. Choreographed by Daniel Nagrin. New York: Milestone Films.

Bridges Go Round. 1958. Directed by Shirley Clarke. New York: Milestone Films, 1958.

Brussels Film Loops/Gestures. 1958. Directed by Shirley Clarke. New York: Milestone Films.

Skyscraper. 1959. Directed by Shirley Clarke, Willard Van Dyke, Irving Jacoby, Wheaton Galentine, and D. A. Pennebaker. New York: Milestone Films.

The Connection. 1962. Directed by Shirley Clarke. New York City: Milestone Films.

Portrait of Jason. 1967. Directed by Shirley Clarke. New York City: Milestone Films.

Ornette: Made in America. 1985. Directed by Shirley Clarke. New York City: Milestone Films.

D. A. Pennebaker and Chris Hegedus

A Stravinski Portrait. 1965. Directed by Richard Leacock and Rolf Liebermann. New York: Pennebaker Films.

Dont Look Back. 1967. Directed by D. A. Pennebaker. New York: Pennebaker Hegedus Films.

Monterey Pop. 1968. Directed by D. A. Pennebaker. New York: The Criterion Collection.

Alice Cooper. 1970. Directed by D. A. Pennebaker. New York: Pennebaker Hegedus Films.

Company: Original Cast Album. 1970. Directed by D. A. Pennebaker. New York: Pennebaker Hegedus Films.

Ziggy Stardust and the Spiders from Mars. 1973. Directed by D. A. Pennebaker. Burbank, CA: Warner Home Videos.

Elliot Carter at Buffalo. 1980. Directed by D. A. Pennebaker and Chris Hegedus. New York: Pennebaker Hegedus Films.

Shake—Otis at Monterey. 1986. Directed by D. A. Pennebaker, Chris Hegedus, and David Dawkins. New York: Pennebaker Hegedus Films.
Jimi Plays Monterey. 1987. Directed by D. A. Pennebaker, Chris Hegedus, and David Dawkins. New York: The Criterion Collection.
Sweet Toronto. 1988. Directed by D. A. Pennebaker. New York: Pennebaker Hegedus Films.
Depeche Mode 101. 1989. Directed by Chris Hegedus, D. A. Pennebaker, and David Dawkins. New York: Pennebaker Hegedus Films.
Jerry Lee Lewis. 1990. Directed by Chris Hegedus and D. A. Pennebaker. New York: Pennebaker Hegedus Films.
Comin' Home. 1991. Directed by Chris Hegedus and D. A. Pennebaker. New York: Pennebaker Hegedus Films.
Little Richard. 1991. Directed by D. A. Pennebaker and Chris Hegedus. New York: Pennebaker Hegedus Films.
Branford Marsalis. 1992. Directed by Chris Hegedus and D. A. Pennebaker. New York: Pennebaker Hegedus Films.
Keine Zeit. 1996. Directed by D. A. Pennebaker and Chris Hegedus. New York: Pennebaker Hegedus Films.
Down from the Mountain. 2001. Directed by Nick Doob, D. A. Pennebaker, and Chris Hegedus. New York: Cowboy Booking International.

Jem Cohen

Witness. 1986. Directed by Jem Cohen. Chicago: Video Data Bank.
Talk about the Passion. 1988. Directed by Jem Cohen. Chicago: Gravity Hill Films.
Flat Duo Jets Document. 1989. Directed by Jem Cohen. Chicago: Gravity Hill Films.
You're the Only One. 1989. Directed by Jem Cohen. Chicago: Gravity Hill Films.
Belong, REM. 1992. Directed by Jem Cohen. Chicago: Gravity Hill Films.
Country Feedback. 1992. Directed by Jem Cohen. Chicago: Video Data Bank.
Snacks and Candy. 1992. Directed by Jem Cohen. Chicago: Gravity Hill Films.
Nightswimming. 1993. Directed by Jem Cohen. Chicago: Video Data Bank.
The Four Seasons/Winter (Longform). 1994. Directed by Jem Cohen. Chicago: South Michigan Ave.
Brooklyn Museum. 1996. Directed by Jem Cohen with Steve Vitteleo. Chicago: Video Data Bank.
Concert à Quatre, Vocalise. 1996. Directed by Jem Cohen. Chicago: Video Data Bank.

APPENDIX A

E-Bow, the Letter. 1996. Directed by Jem Cohen and Patti Smith. Chicago: Video Data Bank.

I Was Dancing in the Lesbian Bar. 1996. Directed by Jem Cohen. Chicago: Video Data Bank.

Lucky Three: An Elliot Smith Portrait. 1997. Directed by Jem Cohen. Chicago: Video Data Bank.

Instrument. 1999. Directed by Jem Cohen. Chicago: Gravity Hill Films.

Benjamin Smoke. 2000. Directed by Jem Cohen and Peter Sillen. New York: Cowboy Booking International.

Cat Power Live: From Fur City. 2000. Directed by Jem Cohen and Peter Sillen. Chicago: Video Data Bank.

8-Ball Corner Pocket. 2001. Directed by Jem Cohen with T. Griffin. Chicago: Video Data Bank.

In Cape Breton. 2001. Directed by Jem Cohen with Boxhead Ensemble. Chicago: Video Data Bank.

Nice Evening, Transmission Down. 2001. Directed by Jem Cohen. Chicago: Video Data Bank.

Footage of the World Trade Center Ruins. 2002. Directed by Jem Cohen and Patti Smith. Chicago: Gravity Hill Films.

The Foxx and Little Vic. 2002. Directed by Jem Cohen, Vic Chesnutt, T. Griffin, Catherine McRae, and Peter Sillen. Chicago: Video Data Bank.

New York Waters (1 and 2). 2004. Directed by Jem Cohen with Boxhead Ensemble. Chicago: Video Data Bank.

Blessings, Omens, Spells and Mojos. 2005. Directed by Jem Cohen and Terry Riley. Chicago: Video Data Bank.

Building a Broken Mousetrap. 2006. Directed by Jem Cohen. Chicago: Video Data Bank.

Spirit. 2007. Directed by Jem Cohen. Chicago: Gravity Hill Films.

Equation Daumal. 2008. Directed by Jem Cohen and Patti Smith. Chicago: Video Data Bank.

Evening's Civil Twilight in Empires of Tin. 2008. Directed by Jem Cohen. Quebec: Constellation Records.

Long for the City. 2008. Directed by Jem Cohen. Chicago: Gravity Hill Films.

Notebooks. 2008. Directed by Jem Cohen and Patti Smith. Chicago: Gravity Hill Films.

The Passage Clock for Walter Benjamin. 2008. Directed by Jem Cohen and Patti Smith. Chicago: Video Data Bank.

Anecdotal Evidence. 2009. Directed by Jem Cohen. Chicago: Video Data Bank.

Manifesto D.F. 2009. Directed by Jem Cohen. Chicago: Video Data Bank.

APPENDIX B
CITED INTERVIEWS AND ARCHIVAL MATERIAL

Recorded Interviews
Jem Cohen, May 31, 2013.
Jill Godmilow, June 1, 2013, and June 2, 2014.
Albert Maysles, September 28, 2013, and February 15, 2015.
D. A. Pennebaker and Chris Hegedus, June 2, 2014, and February 16, 2016.
Ian MacKaye, February 19, 2016.

Telephone Interviews
Guy Picciotto, August 6, 2015.
Wendy Clark, October 26, 2015.
Kathelin Hoffman Gray, October 27, 2015.

Archival Material
Shirley Clarke Archive at the Wisconsin Center for Film and Theater Research.

APPENDIX C
GLOSSARY OF TERMS: SOUNDS, SHOTS, AND EDITING TECHNIQUES

Sounds

anempathetic sound: A sound, often diegetic (see below), that seems ill-fitting or even contradictory to the action on-screen, such as cheerful, upbeat music playing in the background during a tragic scene.

diegetic/nondiegetic sound: Referring to a distinction between the source of sound, including music, heard in a film. Diegetic sound is that which emanates from a source identifiable on-screen; for example, a radio playing in the background or a live music performance would both be diegetic. Nondiegetic sound is that which emanates from an off-screen source, for example, a musical score or a soundtrack.

Shots

close-up: A shot that tightly frames the subject. A close-up is the opposite of a wide shot.

dolly: Using a wheeled cart (or an equivalent) to allow for smooth camera movements; allows for moving the camera forward or backward in lieu of using a zoom.

long take: A continuous shot that goes on longer than a regular shot in a given film.

medium shot: A shot that more loosely frames the object so that the background is partially visible but the focus is still on the object. No clear definition exists to distinguish a medium shot from a close-up; for example, according to some analyses, a shot of a person from the waist up would be described as a medium shot, whereas others would describe it as a close-up.

pan: A shot in which a stationary camera turns left or right on its horizontal plane; the opposite of a tilt shot.

telephoto shot: A long shot with a telephoto lens that make distant objects appear closer than they actually are.

tilt: A shot in which a stationary camera moves up or down on its vertical plane; the opposite of a pan.

tracking shot: A shot that keeps the subject in the frame and follows it, often for an extended period of time. Such shots can be achieved using a number of means, including handheld Steadicams or dollies, and are commonly used to introduce a subject's interaction with its surroundings.

APPENDIX C

truck: Moving the camera side to side; a motion of the camera ninety degrees from the direction of the lens. Unlike a pan, which leaves the camera in place to pivot, a truck moves the camera.

wide shot: A shot that not only shows an entire object but allows the viewer to see the object's surroundings.

zoom: A shot in which the focal length of the lens is adjusted during the shot, giving a sense of movement and often resulting in a close-up.

Editing Techniques

continuity editing: An editing technique of arranging shots to suggest a certain progression of events, usually when cuts are not overly jarring and shots appear to transition logically—generally the desired goal of film editing.

crosscut (or cross edit): An editing technique of cutting between two or more different actions to suggest that they are happening at different times (parallel cut or parallel edit; see "parallel edit") or at the same time but in different locations.

cut-in: A shot that is edited into another shot or scene; can help elide time.

cutaway: A shot that interrupts a continuous action with a view of something else, usually related; can establish secondary action.

dissolve: An editing technique in which one image gradually gives way to another, in contrast to a hard cut.

elliptical edit: An editing technique in which an event on-screen occurs in a shorter time period than its actual duration, often achieved by cutting between shots showing different parts of the same event and cutting out unnecessary actions.

establishing shot: The initial shot of a new scene or sequence intended to introduce viewers to the scene or the sequence's context. Establishing shots are often wide-angle shots or long shots.

eye-line match: A continuity editing technique in which a shot of a subject's face looking at something is followed by a shot of the seen object in the direction of the subject's gaze. In continuity editing, the cut reveals what the subject sees by allowing the viewer's gaze to "match" that of the subject's.

eye-trace: An editing technique that aims to anticipate the focus of the viewer's eyes on the screen and plans cuts accordingly, putting movement/action in a new shot where the viewer's eyes will likely already be. A theory most commonly associated with American film editor Walter Murch.

graphic match: A continuity editing technique to transition between two successive shots in which some compositional element(s) between the two

shots match and give a sense of continuity, such as the famous "bone toss" scene in Stanley Kubrick's *2001*.

jump cut: A cut in which the same object is in two subsequent shots without much variation of the camera angle or position. Such a cut gives the sense that the object has jumped forward in time.

match on action: A continuity editing technique in which an action that starts in one shot continues or finishes in the next shot. For example, a subject could be opening a door in the first shot followed by a second shot from the interior angle showing the subject walking through the door.

mise-en-scène: All of the production elements visible in the frame that when combined create a desired image or effect.

montage: The edited result of arranging a series of short shots in sequence so as to manipulate time, space, and information in an abridged manner.

parallel edit (parallel cut): An editing technique to show actions in different places happening at the same time; can show more than one point of view or create dramatic anticipation of two storylines intersecting.

point-of-view (POV) shot/sequence: A POV shot is one that lets the viewer see from the perspective of a given character. In a POV sequence, a shot showing the character looking at something is followed by a POV shot showing what the character is seeing. A third shot can show the character's reaction to what he or she is seeing.

sequence: A series of related shots that are edited together to show something.

shot/reverse shot: A shot in which a subject looks at another subject followed by the other subject looking back at the first subject, giving the viewer the sense that the two are looking at one another.

umbrella structure: An editing technique in both narrative and documentary film in which the action repeatedly breaks and returns to a central setting or location that serves as a hub.

wipe/invisible wipe: A transition in which one frame gives way to another by having the new frame move across the old one, normally horizontally, in a "wipe" motion. An invisible wipe is a subtler and thus an often-preferred version in which an object, such as a wall, passes in front of the camera and a new shot begins out of the same object, offering a more seamless transition.

NOTES

INTRODUCTION

1 Thanks to Tim Rice for pointing to this etymology of the word "theory" during a conversation about film and about *looking* as a fundamental aspect of doing theory.

2 Anthropologist Sherry Ortner's ethnography *Not Hollywood: Independent Film at the Twilight of the American Dream* (2013) connects independent filmmaking since the late 1980s to cultural critique of neoliberal America. The book is part ethnography and part film critique, instructive in its framing of film as a cultural practice. Like histories, the ethnographic approach presents a landscape at the expense of deep analysis of a particular film. It does acknowledge, however, that film is a form of cultural critique—rendering complex social issues through a cinematic mode.

3 Albert Maysles, whom I interview for the chapter, began his filmmaking career as part of the Drew Associates, pioneers of the direct cinema movement of the 1960s. Direct cinema was a major movement in American documentary film—a method of filmmaking often discussed in relation to the French cinéma vérité. In 1959, Leacock cofounded Drew Associates, an independent production collective headed by journalist Robert Drew and including D. A. Pennebaker (discussed in chapter 4), Albert Maysles (discussed in chapter 1), and Terence Macartney-Filgate. Drew Associates took new, small lightweight cameras and synced audio recorders into the world with the goal of liberating truth from the manipulative conventions of cinema and journalism. Rather than asserting a narrative to explain a situation, Drew Associates let the crisis itself direct the cameras and structure the film. This method was a deliberate attempt to show rather than to tell. Telling often employs clear narrative, music, voiceover narration, and interviews. Drew's collaborator, Richard Leacock, justifies omitting interviews: "I want to discover something about people. When you interview someone they always tell you what they want you to know about them" (in Marcorelles 1973: 55). The small cameras had a power not in being invisible but, rather, in being portable.

4 I draw on Michel Chion's notion of "listening modes" (1994) and Matthew Rahaim's analysis of musicians' gestures (2012) to show in detail how the shots and the cuts of the film contribute to the music's changing state.

5 The chapter also includes a section based on a sustained conversation I had

NOTES TO CHAPTER 2

with Godmilow about postrealist cinema. A decade after making *Antonia*, Godmilow became a fierce critic of realist documentary. In her films and her writing, she advocated for making postrealist agitprop that could, in her view, produce more critical perspectives about complex issues.

1. WHERE IS THE MUSIC? WHAT IS THE MUSIC?

1 Examples of symbolic meaning in ethnomusicology include a traditional Norwegian song played on a Hardanger fiddle, which might signify nationalist feelings (Goertzen 1997: 25–58). The Suya in the Brazilian forest may sing to traverse the social barriers present between male and female siblings, using music to communicate in a culturally acceptable way (Seeger 1979). Afro-Cuban Santería performance has different meanings depending on the audience subject positions: tourists, older Cuban participants, black marketers, and young aficionados (Hagedorn 2001: 58).

2. REPRESENTING THE MARGINS AND UNDERREPRESENTING THE REAL

1 In a three-part history, Nichols places feminist and political cinema third. First was the Grierson-era documentary with direct address from an authoritative narrator. Second was postwar cinéma vérité with its reality effect. Or, consider a summary of Nichols's history: from expository to observational to interactive. Feminists favored direct address brought about by filmmakers *interacting* with their informants.

2 Most ethnomusicologists use "subject position" to identify the ethnographer's social position with respect to his or her work. Ethnomusicologist Deborah Wong is one of the few who remind us that feminist ethnography is a practice "in which subject position is constantly, deliberately questioned and resituated" and that analysis of performance from this perspective can be a useful window to the "politics of placement" (2004: 8–9). A major current in the critique of ethnography flows from this understanding that power is embedded in description. The scholarly influence is largely attributed to French poststructuralism (for example, Jacques Lacan, Michel Foucault, and Jacques Derrida) as well as to postcolonial critics (for example, Edward Said and Lila Abu-Lughod). Since subject position has entered through anthropology, it has mostly been a reflexive admission on the part of the ethnographer—a laying bare of the power relationships in which the author is embedded or perhaps a warning that author and reader may be complicit in a postcolonial gaze (Berliner 1978; Kisliuk 2006; see Rice 2003: 152–53). For an ethnomusicologist, subject position prompts an admission that, for example, she is writing as a thirty-something American Chicana about octogenarian Javanese street mu-

sicians. Subject position here acknowledges a perspective within discursive power relations of those who *have the power* to write versus those described. Reflexive anthropologists also use the linguistic metaphor of subject-verb-object (ethnographer-dominates-Other). There is a parallel in feminist cinema critique. Occupying subject position invites mastery over the objectified other. Transposing this critical understanding to the analysis of performance is a path that may bring more rigor to the study of how people identify with affiliations via musical means. But ethnomusicology has mostly relegated subject position to its use in thinking about author-informant relations. In short, "subject position" has more use with the "ethno-" of ethnomusicology than it does with the "music-" part. Or perhaps "-graphy" (a technique of producing images) carried the concept of photography to music ethnography.

3 Watching recapitulates the early childhood experience of looking in the mirror and discovering the self as separate. The "I" discovered in the mirror phase persists through a fantasy, self-discovered in external images, on the other. Mulvey picks up on Lacan's later writing about the gaze, in which an uncanny feeling is produced when the image in the mirror looks back at us. The gaze threatens the narcissistic view by exposing the lack of self in any image of the other.

4 Mulvey's provocative essay has since been revised and debated (see Mulvey 1990; Žižek 1992; Copjec 2000). Subsequent revision has looked at subject-position and object-position categories as gradients, as unstable, or as being read differently by active viewers. The questions surrounding gaze, however, remain in the general realm of Lacanian psychoanalysis: How does the reading of film operate? What are the power relationships created by such operations? What childhood experiences drive our scopophilia? Teresa de Lauretis argues that the idea of the male gaze does not accommodate how women engage film (de Lauretis 1987: 119). The array of differences within and among women goes unrecognized. Furthermore, the construction of wider cinematic subjectivities and their relation to sociality goes unexplored. There is a particular problem of understanding how a *female* gaze might operate.

5 For instance, one can account for change in Ethiopian jazz as Mulatu Astatke's music moves from a localized 1970s musical practice that has meaning in its cosmopolitan engagement to emotive film music that scores Bill Murray's lonely character in Jim Jarmusch's *Broken Flowers*—all the while, music as commodity fuels a world-music market. The metaphors (cosmopolitan engagement, Bill Murray's emotional state, and commodity) emerge from particular subject positions as musical practices move from place to place.

6 For example, our emotions might commit us to the idea that country singer

Lee Greenwood embodies a feeling of patriotism. Our feeling of that gives a sense of confirmation that country music is expressively American sentiment.

7 Barriers of gender equality center around visibility—moving into prestigious public institutions and the link between sexuality and the feminine body. When *Antonia* was in production, women had been able to move into positions like teaching and field sales, positions with a high degree of autonomy, but involvement in a professional orchestra requires a high degree of interaction with others. Many women conductors have hit a career ceiling in lower-tier orchestras. High-tier orchestras may have contained members who may react to the threat of women lowering the status and standards of the publicly visible elite organization. Blind auditions helped bring many women into instrumental positions in the orchestra. But seeing a conductor is an important way of evaluating her skill. Gender contradictions are felt once a woman steps onto the podium: "dominant social patriarchal discourses encourage them to pursue their femininity through their bodies, while dominant conducting conventions suggest that they need to renounce their femininity and adopt surrogate masculinity" (Bartleet 2008a: 39–40). In patriarchy, female sexuality is considered to be a primary attribute for women. As Ellen Koskoff surveys issues in women's music globally, she finds that "female sexuality itself may be negated or denied as a result of musical activity . . . render them asexual" (1989: 15).

3. THE USE AND ABUSE OF MUSICOLOGICAL CONCEPTS

1 The father-son story was also of personal interest. Clarke's daughter, Wendy, was in her twenties and developing into a collaborator and artist in her own right (see Cohen 2012: 100–1).

2 The people at the ranch were tightly controlled, organized with the assumption that strong people worked together in synergy. The synergists had a formal economic and labor structure. Everyone paid $45 a month for room and board and relationships were clarified by contracts and independently run minibusinesses (Reider 2009: 24). Ten percent of minibusiness profits went to the ranch. Individually led projects could take no more than four hours and the remainder of time would be in group activities like farming or upkeep. Allen's stated aim was "to grow as artists, scientists, and explorers; and by transforming themselves, to somehow transform the world" (Allen 2009: 53).

3 As a whole, the Theater of All Possibilities was not received well. A 1971 East Coast tour brought only small last-minute audiences. Many venues from previous tours would not honor another engagement (Veysey 1978: 402). In 1978, a San Francisco theater critic was as concerned with their quality as he was their

"cult-like" practices. He wrote, "Allegations have been made by one-time members of the Theater of All Possibilities which suggest that the theater group has cult characteristics using psychological humiliation and corporal punishment to keep members in line" (Brooks 1978).

4 Tarrant County saw a rise in two hundred thousand residents over the course of the decade thanks to shopping centers and improved transportation, but most moved to the more spacious suburbs (Hardwick and Gruen 2010: 205).

5 For a detailed analysis of arts venues' relationships to development, see chapter 1 of Marina Peterson's *Sound, Space, and the City: Civic Performance in Downtown Los Angeles* (2010).

6 For examples of documentary films using the first-person structure, see Ross McElwee's *Sherman's March* (1986), Michael Moore's *Fahrenheit 9/11* (2003), Fatih Akin's *Crossing the Bridge: The Sound of Istanbul* (2005), and Sam Dunn's *Metal: A Headbanger's Journey* (2005).

7 It is interesting that Clarke discovered the limits of the biographical mode at the same time that feminist filmmakers had begun to use the interview to amplify underrepresented voices (as detailed in the previous chapter).

8 Iris Cahn cut the sequence in film—odd, since Clarke's video experimentation would seem to be a more feasible process. Another source of inspiration was a Bette Midler video.

9 There is a long tradition of self-designed eccentricity in jazz, perhaps reaching a peak in bebop (see Baraka 2002: 181–91).

10 The reference is to Felix the Cat. The cartoon prankster from the silent film era is associated with both jazz in the Roaring Twenties and a sense of playful wonder. Clarke often uses Felix the Cat as a personal symbol of irreverence in her other work.

11 As part of an international diplomacy effort in the second half of the twentieth century, the State Department sent jazz musicians around the world as examples of American culture and independence (Davenport 2013; Tochka 2015; Fosler-Lussier 2015). The music stood for individualism, ingenuity, and prowess. The jazz ambassadors also distracted from racial inequities at home.

12 Clarke's films also extend experimental filmmaker Maya Deren's use of "spatio-temporal cut." Deren was an active female filmmaker who was a few years before Clarke in making films. Deren also worked with the relationship of cinema to dance.

13 In our phone interview, Kathelin Hoffman said that she was hoping to simulate daydreaming at the concert. The cutaways to the neighborhood, however, had a different effect through unexpectedly changing space, representations

of time, and connections to the music. Daydreaming implies distraction. Intermittent reharmonization is more likely to increase focus and reflexivity.

14 The symmetry of Ornette-Denardo Coleman and Shirley-Wendy Clarke is another aspect of this sequence. The two parent-sibling collaborations mirror each other and intertwine (see Cohen 2012: 100–2).

15 This was not an uncommon view for 1950s and '60s avant-garde artists. John Cage articulates a similar notion, imagining a world of utilities instead of governments (Piekut 2011: 60).

16 See appendix B for information on the Shirley Clarke archive consulted.

17 Though the term "harmolodic" did not get much mention until the early 1980s, its first mention in print is in the 1972 liner notes of the London Symphony recording of the piece.

4. THE THEATER OF MASS CULTURE

1 Despite his association with the dogmatic direct cinema cohort, Pennebaker had experience with engineering situations that would not have happened without the film project: *Maidstone* (1970) with Norman Mailer and the unfinished *One A.M.* with Jean-Luc Godard shot in 1968.

2 Pennebaker began drawing from other art forms in his film with Bob Dylan, *Dont Look Back* (1967). He recalls, "While I was knocked out by the songs, what I really wanted was the songs intermixed with the guy. That was the feeling I had. I wanted to write a novel, not a collection of songs" (in Kubernik 206: 7).

3 The later appearance of "real" instruments such as guitar and melodica are for effect rather than being part of the foundation of the song—accouterments to the swirling tapestry of synthesized sounds.

4 Typically, Western tonality is understood as deriving from combinations of notes drawn from a diatonic scale—for instance, the C, F, and G major triads are related tonally because they draw from the same pool of notes in the C major scale (C–E–G, F–A–C, and G–B–D all come from C–D–E–F–G–A–B). Wagner identified a radical approach in Beethoven's piano sonatas' abandonment of this principle (see Rehding 2011). Rather than associating triads that come from notes in a scale, triads can also be close or distant because of shared notes among them. For example, C major (C–E–G) and E minor (E–G–B) are closely related because they share two notes, C major (C–E–G) and E major (E–G-sharp–B) are somewhat close because they share one note. C major (C–E–G) and F-sharp minor (F-sharp–A–C-sharp) are distant because they share no notes.

5 Following Lewin, Guy Capuzzo adapts neo-Riemannian theory to pop music. Capuzzo shows nondiatonic chord progressions to be neo-Riemannian trans-

formational networks in the works of an eclectic mix of popular artists including Radiohead, Frank Zappa, Bob Dylan, King Crimson, and Depeche Mode. Other music theorists have applied neo-Reimannian theory to popular music (see Holm-Hudson 2002; Kochavi 2002; Santa 2003; Strunk 2003).

6 I made repeated attempts to contact the band about the Wagnerian influence on the music but could not get past their manager. Four theories might explain how so many Wagnerian elements made their way into Depeche Mode's music. It could be that progressive rock in the early 1970s expanded the harmonic palate of popular music. Martin Gore could have found interest in Wagner when in Berlin studying imagery for the *Music for the Masses* show. Classically trained Alan Wilder could have brought late-Romantic harmonic ideas when he joined the group. It also might be that common tones between chords make it easy to play keyboard changes because they involve changing one or two fingers on the triad (all but Wilder were amateur players when they began writing).

7 Depeche Mode's inward psychological turn is indebted to earlier British post-punk bands such as Joy Division and Echo & the Bunnymen. This dark introspection came into the United States via Depeche Mode and contemporaries by MTV during the "Second British Invasion" of 1982–86.

8 One of Pennebaker's classic shots is of Otis Redding at Monterey singing "I've Been Loving You Too Long." Redding is backlit and Pennebaker holds the shot to let the image vacillate from silhouette to blinding light. The lights at the Depeche Mode concert were far more elaborate. While lighting is generally minimal to absent in direct cinema, the stage offers challenges and possibilities.

9 The reference here is to the genre of backstage musicals that director Busby Berkeley developed in the 1930s such as *Footlight Parade* (1933) and that continued through Andrew Lloyd Webber's *The Phantom of the Opera* (1986) and Rob Marshall's *Chicago* (2002).

10 Ethnomusicologist Jaap Kunst coined the term "colotomic" in his description of gong punctuation in Javanese music (1949: 299–306). Judith Becker expanded "colotomic units" to describe "all hierarchical, binary, unsyncopated, cyclical, 8- or 16-beat phrase units marked by gongs, cymbals, hand cymbals, and clappers in Southeast Asian music" (1968: 177). Hierarchical layering offers several different points from which to feel a return of a figure from a smaller micro-isorhythm to larger macro-isorhythm. Nested colotomy is apparent in much of Depeche Mode's music in a way that, similar to Indonesian music and extended to electronic dance music, incorporates a spectrum of sounds that range from melodic to percussive.

5. CINEMATIC DUB AND THE MULTITUDE

1 It is worth considering the parallel in early rock 'n' roll when more commercial white acts had a national presence through television and product advertising and local black acts aligned with community activist and support organizations (Delmont 2012). What has often become informal economic necessity for many local black communities is often tied to local music groups. Hardcore musicians enjoyed a strategic mix of political locality and less visibility in national media while forging national and international networks. Their age (many were in junior high and high school) and the abandonment of Washington's downtown created restrictions that many other communities experience. Bands like Fugazi were able to make a choice to stay within an earlier black manifestation of rock practice.

2 Stella Bruzzi posits a BBC "docusoap" category between direct cinema and soap operas that uses some of the stylistic features from both. Shaky cameras and quotidian focus mix with fast-paced editing, guiding narration, and music. Unlike classic documentaries, docusoaps tend to lack any underpinning of social issues (see Bruzzi 2006: 120–22).

3 The Second World War spurred new and urgent use for cinema. Music also had a role in the effort. Humphrey Jennings's *Listen to Britain* (1942) is one of the first music documentaries. Jennings worked within John Grierson's GPO (General Post Office) Unit, the state-funded film division called into the war effort. In general, the films used more complex soundtracks (layers of sound) and realism to stir emotion and to represent the common person (two features that have lingered in documentary film). In 1934, a year after it was established, GPO developed mobile sound recording technology. These collected sounds became part of the aural palettes for these films. "John Grierson's work subsequently influenced the social and industrial documentaries of Paul Rotha, whose work represents an early attempt to demystify the structure of British industrial society" (Hassard 1998: 49). These were all propaganda films, sponsored by the state and aimed at bolstering audience morale. War made ordinary people important, justifying turning a camera on them. Propaganda films brought together interest in complex sociological systems and sound compositions that included both music and noise.

4 For instance, neither Nike nor Apple make their products; rather, they design them and coordinate related industries to create a product, leveraging flexible systems of production.

5 David Frankel also helped in translating many of the musical ideas of dub to the visual edit.

6 Similarly, Arnold Schoenberg developed an interest in the microscopic experi-

ence of music. His interest was similar to that of a particle physicist, interested not only in elements but in the potential forces that govern the smallest of sounds. He writes, "A motive is something that gives rise to motion. A *motion is that change in a state of rest which turns it into its opposite.* Thus, one can compare the motive with a driving force. . . . A *thing is* termed *a motive* if it is already *subject to the effect of a driving force, has already received its impulse, and is on the verge of reacting to it.* It is comparable to a sphere on an inclined plane at the moment before it rolls away; to a fertilized seed; to an arm raised to strike, etc. . . . *The smallest musical event* can become a motive if [it is] permitted to have an effect, even an individual tone can carry consequences" ([1917] 1994: 27, emphasis original).

7 Interestingly, Veal is drawing here on James Lastra's work on sound technology in early American cinema in which he argues that the unusual representations by early media threatened to render human sensory capacities obsolete (2000: 7).

WORKS CITED

Adorno, Theodor W. 2002. *Essays on Music*. Edited by Richard Leppert. Translated by Susan H. Gillespie. Berkeley: University of California Press.

Allen, John. 2009. *Me and the Biospheres: A Memoir by the Inventor of Biosphere 2*. Santa Fe: Synergetic Press.

Allen, Pamela. 1970. *Free Space: A Perspective on the Small Group in Women's Liberation*. New York: Times Change Press.

Allmendinger, Jutta, and J. Richard Hackman. 1995. "The More, the Better? A Four-Nation Study of the Inclusion of Women in Symphony Orchestras." *Social Forces* 74 (2): 423–60.

Altschuler, Glenn C. 2003. *All Shook Up: How Rock 'n' Roll Changed America*. Oxford, UK: Oxford University Press.

Appelbome, Peter. 1982. "Regional Reports: Silicon Prairie, Texas." *New York Times*, March 28.

———. 1984. "Caravan of Pipe Dreams." *Texas Monthly*, January: 124–28.

Azerrad, Michael. 2001. *Our Band Could Be Your Life: Scenes from the American Indie Underground 1981–1991*. Boston: Little, Brown.

Bachmann, Gideon, Richard Leacock, Robert Drew, and D. A. Pennebaker. 1961. "The Frontiers of Realist Cinema: The Work of Ricky Leacock." *Film Culture* 22–23: 12–23.

Baily, John. 1989. "Filmmaking as Musical Ethnography." *The World of Music* 31 (3): 3–20.

———. 2007. *Scenes of Afghan Music: London, Kabul, Hamburg, Dublin* (film). Alexandria, VA: Alexander Street. 97 min.

———. 2011. *Across the Border: Afghan Musicians Exiled in Peshawar* (film). Alexandria, VA: Alexander Street. 54 min.

Baraka, Amiri. 2002. *Blues People: Negro Music in White America*. New York: Harper Perennial.

Barbash, Ilisa, and Lucien Taylor. 1997. *Cross-Cultural Filmmaking: A Handbook for Making Documentary and Ethnographic Films and Videos*. Berkeley: University of California Press.

Barnouw, Erik. 1993. *Documentary: A History of the Non-Fiction Film*. 2nd rev. ed. New York: Oxford University Press.

Barsam, Richard. 1992. *Nonfiction Film: A Critical History*. Revised and expanded ed. Bloomington: Indiana University Press.

Bartleet, Brydie-Leigh. 2003. "Female Conductors: The Incarnation of Power?" *Hecate* 29 (2): 228–34.

———. 2008a. "Women Conductors on the Orchestral Podium: Pedagogical and Professional Implications." *College Music Symposium* 48: 31–51.

———. 2008b. "'You're a Woman and Our Orchestra Just Won't Have You': The Politics of Otherness in the Conducting Profession." *Hecate* 34 (1): 6–23.

Bates, Eliot. 2016. *Digital Tradition: Arrangement and Labor in Istanbul's Recording Studio Culture*. Oxford, UK: Oxford University Press.

Bazin, André. 2004. *What Is Cinema?* Vol. 2. Berkeley: University of California Press.

Bebb, Bruce. 1982. "The Many Media of Shirley Clarke." *Journal of the University Film and Video Association* 34 (2): 3–8.

Beck, Jay, and Tony Grajeda. 2008. *Lowering the Boom: Critical Studies in Film Sound*. Urbana: University of Illinois Press.

Becker, Judith. 1968. "Percussive Patterns in the Music of Mainland Southeast Asia." *Ethnomusicology* 12 (2): 173–91.

Benjamin, Walter. 2007. *Illuminations: Essays and Reflections*. Edited by Hannah Arendt. New York: Schocken.

Berg, Gretchen. 1967. "Interview with Shirley Clarke." *Film Culture* 44: 52–56.

Berger, Harris M. 1999. *Metal, Rock, and Jazz: Perception and the Phenomenology of Musical Experience*. Middletown, CT: Wesleyan University Press.

———. 2009. *Stance: Ideas about Emotion, Style, and Meaning for the Study of Expressive Culture*. Middletown, CT: Wesleyan University Press.

Berliner, Paul. 1978. *The Soul of Mbira: Music and Traditions of the Shona People of Zimbabwe, Perspectives on Southern Africa*. Berkeley: University of California Press.

Bianchini, Franco. 1990. "Urban Renaissance? The Arts and the Urban Regeneration Process." In *Tackling the Inner Cities: The 1980s Reviewed, Prospects for the 1990s*. Edited by Susanne MacGregor and Ben Pimlott, 215–50. New York: Clarendon Press.

Blacking, John. 1973. *How Musical Is Man? (Jesse and John Danz Lectures)*. Seattle: University of Washington Press.

Booth, Stanley. 2012. *The True Adventures of the Rolling Stones*. Chicago: Chicago Review Press.

Bordwell, David, and Kristin Thompson. 1997. *Film Art: An Introduction*. 5th ed. New York: McGraw-Hill.

Boulez, Pierre, and Paule Thévenin. 1991. *Stocktakings from an Apprenticeship*. Translated by Stephen Walsh. New York: Clarendon.

Braverman, Harry. 1998. *Labor and Monopoly Capital: The Degradation of Work in the Twentieth Century*. 25th anniversary ed. New York: Monthly Review Press.

Broad, William J. 1991. "As Biosphere Is Sealed, Its Patron Reflects on Life." *New York Times*, September 24.

Brooks, Jack. 1978. "Theater Group: Cult or Stage?" *San Francisco Progress*, December 22.

Brown, Laura S. 2004. *Subversive Dialogues: Theory in Feminist Theory*. New York: Basic.

Bruzzi, Stella. 2006. *New Documentary*. 2nd ed. London: Routledge.

Buckley, David. 2002. *R.E.M.: Fiction: An Alternative Biography*. London: Virgin.

Burke, Patrick. 2010. "Tear Down the Walls: Jefferson Airplane, Race, and Revolutionary Rhetoric in 1960s Rock." *Popular Music* 29 (1): 61–79.

Capuzzo, Guy. 2004. "Neo-Riemannian Theory and the Analysis of Pop-Rock Music." *Music Theory Spectrum* 26 (2): 177–200.

Cecchi, Alessandro. 2010. "Diegetic versus Nondiegetic: A Reconsideration of the Conceptual Opposition as a Contribution to the Theory of Audiovision." In *Worlds of Audio Vision*, 1–10. Accessed January 2017. www-5.unipv.it/wav.

Cheng, M. N. H. 1998. "Women Conductors: Has the Train Left the Station?" *Harmony: Forum of the Symphony Orchestra Institute* 6: 81–90.

Chesler, Phyllis. 2005. *Women and Madness*. First ed., revised and updated. New York: Palgrave Macmillan.

Chion, Michel. 1994. *Audio-Vision: Sound on Screen*. Translated by Claudia Gorbman. New York: Columbia University Press.

Christensen, Lance Eugene. 2000. "I Will Not be Deflected from My Course: The Life of Dr. Antonia Brico." Master's thesis, University of Colorado at Denver. Accessed June 2017. http://digital.auraria.edu/content/AA/00/00/17/43/00001/AA00001743_00001.pdf.

Christgau, Robert. 1992. "The Rolling Stones." In *The Rolling Stone Illustrated History of Rock & Roll: The Definitive History of the Most Important Artists and Their Music*, edited by Anthony DeCurtis, James Henke, and Holly George-Warren, 238–51. New York: Random House.

Clarke, Shirley, Edward Harrison, Bill Kenly, Elodie Osborn, Amos Vogel, and John Adams. 1960. "The Expensive Art: A Discussion of Film Distribution and Exhibition in the U.S." *Film Quarterly* 13 (4): 19–34.

Cogswell, Michael. 1996. "Melodic Organization in Two Solos by Ornette Coleman." In *Annual Review of Jazz Studies 7: 1994–1995*, edited by Edward Berger, David Cayer, Henry Martin, Dan Morgenstern, and Lewis Porter, 101–44. Lanham, MD: Scarecrow Press.

Cohen, John. 1989. "Sets of Expectations." *Society for Visual Anthropology Newsletter* 5 (2): 12–16.

Cohen, Thomas F. 2012. *Playing to the Camera: Musicians and Musical Performance in Documentary Cinema*. New York: Wallflower Press.

Cohn, Richard. 1996. "Maximally Smooth Cycles, Hexatonic Systems, and the Analysis of Late-Romantic Triadic Progressions." *Music Analysis* 15 (1): 9–40.

Coleman, Ornette. 1972. *Skies of America* album liner notes. Columbia KC 31562, vinyl LP.

———. 1985. "Ornette Coleman on WNYC's Meet the Composer in 1985." Interview with Tim Page. *WNYC*, May 22. www.wnyc.org/story/ornette-coleman-obituary/.

Connolly, William E. 2002. *Neuropolitics: Thinking, Culture, Speed*. Minneapolis: University of Minnesota Press.

Cooper, Marc. 1991. "Take This Terrarium and Shove It." *Village Voice*, April 2.

Copjec, Joan. 2000. "The Orthopsychic Subject: Film Theory and the Reception of Lacan." In *Film and Theory: An Anthology*, edited by Robert Stam and Toby Miller, 437–55. Oxford, UK: Blackwell.

Corry, John. 1985. "TV Weekend; 'Tongues' Shows Off Video Devices." *New York Times*, August 2.

Crawford, Peter Ian. 1992. "Film as Discourse: The Invention of Anthropological Realities." In *Film as Ethnography*, edited by P. I. Crawford and David Turton, 66–82. Manchester, UK: Manchester University Press.

Dahlhaus, Carl. 1982. *Esthetics of Music*. Cambridge: Cambridge University Press.

———. 1985. *Realism in Nineteenth-Century Music*. Cambridge: Cambridge University Press.

Daly, Steven. 1993. "The Rock & Roll Rebirth of Everybody's Favorite Euroweenies." *Rolling Stone*, November 25.

Dargis, Manohla. 2015. "Review: 'Counting,' a Meditation in Story Shards." *New York Times*, July 30.

Dauer, A. M. 1969. "Research Films in Ethnomusicology: Aims and Achievements." *Yearbook of the International Folk Music Council* 1: 226–33.

Davenport, Lisa E. 2013. *Jazz Diplomacy: Promoting America in the Cold War Era*. Jackson: University Press of Mississippi.

Davies, Bronwyn, and Rom Harré. 1990. "Positioning: The Discursive Production of Selves." *Journal for the Theory of Social Behaviour* 20 (1): 43–63.

de Lauretis, Tera. 1987. *Technologies of Gender: Essays on Theory, Film, and Fiction*. Bloomington: Indiana University Press.

Delmont, Matt. 2012. "'They'll Be Rockin' on Bandstand, in Philadelphia, PA':

Dick Clark, Georgie Woods, and the Value of Rock 'n' Roll." *Journal of Popular Music Studies* 24 (4): 457–85.

Dixon, Wheeler W. 2007. *Film Talk: Directors at Work*. New Brunswick, NJ: Rutgers University Press.

Dorsky, Nathaniel. 2005. *Devotional Cinema*. 2nd ed. Berkeley, CA: Tuumba Press.

Edwards, Michelle. 2003. "Women on the Podium." In *The Cambridge Companion to Conducting, Cambridge Companions to Music*, edited by José Antonio Bowen, 220–36. Cambridge: Cambridge University Press.

Elder, Bruce. 2001. "The American Vanguard: Flux and Experience." In *Unseen Cinema: Early American Avant-Garde Film 1893–1941*, edited by Bruce Posner, 144–52. Chatsworth, CA: Anthology Film Archives.

Ellis, Jack C., and Betsy A. McLane. 2005. *A New History of Documentary Film*. New York: Continuum.

Evans, Gareth. 2009. "Jem Cohen." In *Common Ground*, edited by Adam Pugh, 15–27. Norwich, UK: Aurora Press.

Faulk, Barry J. 2010. *British Rock Modernism, 1967–1977: The Story of Music Hall in Rock*. Farnham, UK: Ashgate.

Feagin, Susan L. 1999. "Time and Timing." In *Passionate Views: Film, Cognition, and Emotion*, edited by Carl R. Plantinga and Greg M. Smith, 239–55. Baltimore: Johns Hopkins University Press.

Feld, Steven. 1976. "Ethnomusicology and Visual Communication." *Ethnomusicology* 20 (2): 293–325.

———. 1994. "From Schizophonia to Schismogenesis: On the Discourses and Commodification Practices of 'World Music' and 'World Beat.'" In *Music Grooves: Essays and Dialogues*, edited by C. Keil and S. Feld, 257–89. Chicago: University of Chicago Press.

———. 2012. *Sound and Sentiment: Birds, Weeping, Poetics, and Song in Kaluli Expression*. 3rd ed. Durham, NC: Duke University Press.

Feld, Steven, and Carroll Williams. 1975. "Toward a Researchable Film Language." *Studies in the Anthropology of Visual Communication* 2 (1): 25–32.

Finn, Robin. 2003. "Public Lives; A Vérité Veteran Reflects on Life Behind the Camera." *New York Times*, May 30.

Florida, Richard. 2002. *The Rise of the Creative Class: And How It's Transforming Work, Leisure, and Everyday Life*. New York: Basic.

———. 2004. *Cities and the Creative Class*. London: Routledge.

Fosler-Lussier, Danielle. 2015. *Music in America's Cold War Diplomacy*. Berkeley: University of California Press.

Frank, Thomas. 1997. *The Conquest of Cool: Business Culture, Counterculture, and the Rise of Hip Consumerism*. Chicago: University of Chicago Press.

Frith, Simon. 2001. "The Popular Music Industry." In *The Cambridge Companion to Pop and Rock*, edited by Simon Frith, Will Straw, and John Street, 26–52. New York: Cambridge University Press.

Fuller, Buckminster. 1966. "The Music of the New Life: Thoughts on Creativity, Sensorial Reality, and Comprehensiveness." *Music Educators Journal* 52 (5): 46–146.

Galbraith, Gary. 2014. "The 'Rocks Off' Rolling Stones Setlists Page: 1969 US Tour." Last modified 2014. http://rocksoff.org/1969.htm.

Godmilow, Jill. 1999. "What's Wrong with the Liberal Documentary." *Peace Review: A Journal of Social Justice* 11 (1): 91–98.

———. 2002. "Kill the Documentary as We Know It." *Journal of Film and Video* 54 (2/3): 3–10.

Goertzen, Chris. 1997. *Fiddling for Norway: Revival and Identity*. Chicago: University of Chicago Press.

Goldberg, Michael. 1990. "MTV's Sharper Pictures." *Rolling Stone*, February 8.

Goodman, John. 2012. "Ornette Coleman Film Back in Circulation Thanks to Shirley Clarke Project—Q&A With 'Ornette: Made in America' Producer Kathelin Gray." *North Shore News,* October 26. Accessed January 2017. www.nsnews.com/entertainment/dossier/ornette-coleman-film-back-in-circulation-thanks-to-shirley-clarke-project-1.364060.

Hagedorn, Katherine J. 2001. *Divine Utterances: The Performance of Afro-Cuban Santería*. Washington: Smithsonian Institution Press.

Hall, Jeanne. 1991. "Realism as a Style in Cinema Verite: A Critical Analysis of 'Primary.'" *Cinema Journal* 30 (4): 24–50.

Halleck, DeeDee. n.d. "Interview with Shirley Clarke." Unpublished interview, Chelsea Hotel, New York, 1985. Accessed May 2013. www.davidsonsiles.org/shirleyclarkeinterview.html.

Harbert, Benjamin. 2013a. *Follow Me Down: Portraits of Louisiana Prison Musicians* (film). New York: Films for the Humanities & Sciences. 96 min.

———. 2013b. "Noise and Its Formless Shadows: Egypt's Extreme Metal as Avant-Garde *Nafas Dowsha*." In *The Arab Avant Garde: Music, Politics, Modernity*, edited by Thomas Burkhalter, Kay Dickinson, and Benjamin J. Harbert, 229–72. Middletown, CT: Wesleyan University Press.

Hardwick, M. Jeffrey, and Victor Gruen. 2010. *Mall Maker: Victor Gruen, Architect of an American Dream*. Philadelphia: University of Pennsylvania Press.

Hare-Mustin, Rachel T. 1978. "A Feminist Approach to Family Therapy." *Family Process* 17 (2): 181–94.

Hassard, John. 1998. "Representing Reality: *Cinema Vérité*." In *Organization-Representation: Work and Organization in Popular Culture*, edited by John Hassard and Ruth Holliday, 41–66. London: Sage.

Hatten, Robert. 1985. "The Place of Intertextuality in Music Studies." *American Journal of Semiotics* 3 (4): 69–82.

Haug, Frigga. 1987. *Female Sexualization: A Collective Work of Memory*. London: Verso.

Hearn, Alison. 2008. "Variations on the Branded Self: Theme, Invention, Improvisation and Inventory." In *The Media and Social Theory*, edited by David Hesmondhalgh and Jason Toynbee, 194–210. London: Routledge.

Hebdige, Dick. 1979. *Subculture: The Meaning of Style*. London: Routledge.

Heidegger, Martin. 2008. *Being and Time*. Reprint ed. Translated by John MacQuarrie and Edward Robinson. New York: Harper Perennial Modern Classics.

Hinley, Mary Brown. 1984a. "The Uphill Climb of Women in American Music: Performers and Teachers." *Music Educators Journal* 70 (8): 31–35.

———. 1984b. "The Uphill Climb of Women in American Music: Conductors and Composers." *Music Educators Journal* 70 (9): 42–45.

Holm-Hudson, Kevin. 2002. "A Study of Maximally Smooth Voice-Leading in the Mid-1970s Music of Genesis." Paper presented to the Society for Music Theory, Columbus, Ohio, October 31–November 3.

Honneth, Axel. 2004. "Organized Self-Realization: Some Paradoxes of Individualization." *European Journal of Social Theory* 7 (4): 463–78.

Hrebeniak, Michael. 2006. *Action Writing: Jack Kerouac's Wild Form*. Carbondale: Southern Illinois University.

Jackson, Bruce. (1972) 1999. *Wake Up Dead Man: Hard Labor and Southern Blues*. Reprint, Athens: University of Georgia Press.

Jackson, Bruce, Toshi Seeger, Daniel Seeger, and Peter Seeger. 1966. *Afro-American Work Songs in a Texas Prison* (film). Beacon, NY: Folklore Research Films. 29 min.

Jagow, Shelley M. 1998. "Women Orchestral Conductors in America: The Struggle for Acceptance—An Historical View from the Nineteenth Century to the Present." *College Music Symposium* 38: 126–45.

Jalon, Allan M. 2012. "D.A. Pennebaker Gets an Oscar, Talks about Vermeer." *Huffington Post*, December 4.

Johnston, Sheila. 1985. "Film Narrative and the Structuralist Controversy." In *The Cinema Book*, edited by P. Cook, 222–50. London: British Film Institute.

Jørgensen, Kristine. 2007. "On Trans-diegetic Sounds in Computer Games." *Northern Lights* 5 (1): 105–17.

Keightley, Keir. "Reconsidering Rock." 2001. In *The Cambridge Companion to Pop and Rock*, edited by Simon Frith, Will Straw, and John Street, 109–42. New York: Cambridge University Press.

Kisliuk, Michelle Robin. 2006. *Seize the Dance!: BaAka Musical Life and the Ethnography of Performance*. Oxford, UK: Oxford University Press.

Klosterman, Chuck. 2006. *Chuck Klosterman IV: A Decade of Curious People and Dangerous Ideas*. New York: Scribner.

Kochavi, Jonathan. 2002. "Contextually Defined Musical Transformations." Ph.D. dissertation, State University of New York at Buffalo.

Koskoff, Ellen. 1989. "An Introduction to Women, Music, and Culture." In *Women and Music in Cross-Cultural Perspective*, edited by Ellen Koskoff, 1–23. Urbana: University of Illinois Press.

Kubernik, Harvey. 2006. *Hollywood Shack Job: Rock Music in Film and On Your Screen*. Albuquerque: University of New Mexico Press.

Kunst, Jaap. 1949. *Music in Java*. The Hague: Martinus Nijhoff.

Lastra, James. 2000. *Sound Technology and the American Cinema*. New York: Columbia University Press.

Lesage, Julia. 1978. "Political Aesthetics of Feminist Documentary Film." *Quarterly Review of Film Studies* 3 (4): 507–23.

Lev, Peter. 2006. *The Fifties: Transforming the Screen, 1950–1959*. Oakland: University of California Press.

Lewin, David. 1984. "Amfortas's Prayer to Titurel and the Role of D in 'Parsifal': The Tonal Spaces of the Drama and the Enharmonic C-flat/B." *19th-Century Music* 7 (3): 336–49.

Litweiler, John. 1992. *Ornette Coleman: A Harmolodic Life*. New York: William Morrow.

Lowenthal-Swift, Lauren. 1988. "Pennebaker: D.A Makes 'em Dance." *Film Comment* 24 (6): 44–48.

MacDonald, Scott. 2005. "Jill Godmilow (and Harun Farocki)." In *A Critical Cinema 4: Interviews with Independent Filmmakers*, 123–57. Berkeley: University of California Press.

MacDougall, David. 1998. *Transcultural Cinema*. Princeton, NJ: Princeton University Press.

Macleod, Beth Abelson. 2001. *Women Performing Music: the Emergence of American Women as Classical Instrumentalists and Conductors*. Jefferson, NC: McFarland.

Manuel, Peter. 1993. *Cassette Culture: Popular Music and Technology in North India*. Chicago: University of Chicago Press.

Marcorelles, Louis. 1973. *Living Cinema: New Directions in Contemporary Film-Making*. New York: Praeger.

Marcus, George. 1990. "The Modernist Sensibility in Recent Ethnographic Writing and the Cinematic Metaphor of Montage." *Visual Anthropology Review* 6 (1): 2–12.

Marx, Karl, and Fredrick Engels. 1988. *The Economic and Philosophic Manuscripts of 1844 and the Communist Manifesto*. 1st ed. Translated by Martin Milligan. Amherst, NY: Prometheus.

McElhaney, Joe. 2009. *Albert Maysles*. Urbana: University of Illinois Press.

McNeill, David. 1992. *Hand and Mind: What Gestures Reveal about Thought*. Chicago: University of Chicago Press.

Merriam, Alan P. 1964. *The Anthropology of Music*. Evanston, IL: Northwestern University Press.

Miller, Lynn C. 1997. "[Un]documenting History." *Text & Performance Quarterly* 17 (3): 273–87.

Mimnagh, Tara. 2003. "Catching Up With *Depeche Mode 101*: Verite Very." In *Practising Popular Music: 12th Biennial IASPM-International Conference, Montreal 2003 Proceedings*, edited by Alex Gyde and Geoff Stahl, 618–24. Accessed January 2017. www.iaspm.net/publications/.

Mulvey, Laura. 1975. "Visual Pleasure and Narrative Cinema." *Screen* 16 (3): 6–18.

———. 1990. "Afterthoughts on 'Visual Pleasure and Narrative Cinema' inspired by Duel in the Sun." In *Psychoanalysis and Cinema*, edited by E. Ann Kaplan, 24–36. New York: Routledge.

Nettl, Bruno. 2015. *The Study of Ethnomusicology: Thirty-Three Discussions*. 3rd ed. Chicago: University of Illinois Press.

Nichols, Bill. 1983. "The Voice of Documentary." *Film Quarterly* 36 (3): 17–30.

———. 1991. *Representing Reality: Issues and Concepts in Documentary*. Bloomington: Indiana University Press.

———. 1993. "'Getting to Know You . . .': Knowledge, Power, and the Body." In *Theorising Documentary*, edited by Michel Renov, 174–91. London: Routledge.

———. 2001. "Documentary Film and the Modernist Avant-Garde." *Critical Inquiry* 27 (4): 580–610.

Nilsen, Sarah. 2011. *Projecting America, 1958: Film and Cultural Diplomacy at the Brussels World's Fair*. Jefferson, NC: McFarland.

Norton, Barley. 2015. "Ethnomusicological Filmmaking and Theorizing." Paper presented at the International Council for Traditional Music 43rd World Conference, Astana, Kazakhstan, July 16–22.

O'Connor, Alan. 2008. *Punk Record Labels and the Struggle for Autonomy: The Emergence of DIY*. Lanham, MD: Lexington.

Ortner, Sherry B. 2013. *Not Hollywood: Independent Film at the Twilight of the American Dream*. Durham, NC: Duke University Press.

Patoski, Joe Nick, and Bill Crawford. 1989. "The Long Strange Trip of Ed Bass." *Texas Monthly*, June.

Peary, Gerald. 2003. "Straight Shooter: Charlotte Zwerin at the HFA." *Boston Phoenix*, October 31. www.bostonphoenix.com/boston/movies/film/documents/03284622.asp.

Peterson, Marina. 2010. *Sound, Space, and the City: Civic Performance in Downtown Los Angeles*. Philadelphia: University of Pennsylvania Press.

———. 2013. "Sound Work: Music as Labor and the 1940s Recording Bans of the American Federation of Musicians." *Anthropological Quarterly* 86 (3): 791–823.

Piekut, Benjamin. 2011. *Experimentalism Otherwise: The New York Avant-Garde and Its Limits*. Oakland: University of California Press.

Powers, John. 2013. "Peeling Away the Layers in a 'Portrait of Jason.'" *National Public Radio*, May 2. www.npr.org/2013/05/02/179876018/peeling-away-the-layers-in-a-portrait-of-jason.

Pribram, E. Deidre. 1993. "Seduction, Control, and the Search for Authenticity: Madonna's Truth or Dare." In *The Madonna Connection: Representational Politics, Subcultural Identities, and Cultural Theory*, edited by Cathy Schwichtenberg, 189–212. Boulder: Westview.

Rabinovitz, Lauren. 1983. "Choreography of Cinema: An Interview with Shirley Clarke." *Afterimage* 11 (5): 8–11.

———. 2003. *Points of Resistance: Women, Power, and Politics in the New York Avant-garde Cinema, 1943–71*. 2nd ed. Urbana: University of Illinois Press.

Rahaim, Matthew. 2012. *Musicking Bodies: Gesture and Voice in Hindustani Music*, Music/Culture. Middletown, CT: Wesleyan University Press.

Rehding, Alexander. 2011. "Tonality between Rule and Repertory; Or, Riemann's Functions—Beethoven's Function." *Music Theory Spectrum* 33 (2): 109–23.

Reider, Rebecca. 2009. *Dreaming the Biosphere: The Theater of All Possibilities*. Albuquerque: University of New Mexico Press.

Reynolds, Simon. 2006. *Rip It Up and Start Again: Postpunk 1978–1984*. New York: Penguin.

Rice, Timothy. 1994. *May It Fill Your Soul: Experiencing Bulgarian Music*. Chicago: University of Chicago Press.

———. 2003. "Time, Place, and Metaphor in Musical Experience and Ethnography." *Ethnomusicology* 47 (2): 151–79.

Rockwell, John. 1983. "Jazz: Ornette Coleman Home Again." *New York Times*, October 23.

The Rolling Stones. n.d. "Band." Accessed February 2017. www.rollingstones.com/band/.

Romney, Jonathan. 1995. "Access All Areas: The Real Space of Rock Documentaries." In *Celluloid Jukebox: Popular Music and the Movies since the 1950s*, edited by Jonathan Romney and Adrian Wootton, 82–93. London: British Film Institute.

Rosenthal, Alan. 1980. *The Documentary Conscience: A Casebook in Film Making*. Berkeley: University of California Press.

Rothman, William. 1997. "Cinéma Vérité in America (II): *Don't Look Back*." In *Documentary Film Classics*, 144–210. New York: Cambridge University Press.

Rouch, Jean. 1995. "The Camera and Man." In *Principles of Visual Anthropology*, edited by Paul Hockings, 79–98. The Hague: Mouton.

———. 2003. *Ciné-Ethnography*. Translated and edited by Steven Feld. Minneapolis: University of Minnesota Press.

Ruoff, Jeffery. 1993. "Conventions of Sound in Documentary." *Cinema Journal* 32 (3): 24–40.

Russell, Catherine. 1999. *Experimental Ethnography*. Durham, NC: Duke University Press.

Sandhu, Sukhdev. 2015. "Jem Cohen: The Former Ice-Cream Seller Chronicling an Overlooked America." *Guardian*, March 30.

Santa, Matthew. 2003. "Nonatonic Progressions in the Music of John Coltrane." *Annual Review of Jazz Studies* 14: 13–25.

Schepartz, Fred. 2009. "Neo-Syndicalism: A Path Toward Reimagining Socialism." *Mobius: The Journal of Social Change* 20 (2). http://mobiusmagazine.com/editorials/editor20.2.html.

Schneider, Arnd, and Caterina Pasqualino. 2014. *Experimental Film and Anthropology*. London: Bloomsbury Academic.

Schoenberg, Arnold. 1994. *Coherence, Counterpoint, Instrumentation, Instruction in Form*. Edited by Severine Neff. Translated by Severine Neff and Charlotte Cross. Lincoln: University of Nebraska Press.

Schwarz, David. 2006. *Listening Awry: Music and Alterity in German Culture*. Minneapolis: University of Minnesota Press.

Seeger, Anthony. 1979. "What Can We Learn When They Sing? Vocal Genres of the Suya Indians of Central Brazil." *Ethnomusicology* 23 (3): 373–94.

———. 2004. *Why Suyá Sing: A Musical Anthropology of an Amazonian People*. Urbana: University of Illinois Press.

Seeger, Charles. 1961. "Semantic, Logical and Political Considerations Bearing upon Research in Ethnomusicology." *Ethnomusicology* 5: 77–80.

Sesonske, Alexander. 1980. "Time and Tense in Cinema." *Journal of Aesthetics and Art Criticism* 38 (4): 419–26.

Shank, Barry. 2001. "From Rice to Ice: The Face of Race in Rock and Pop." In *The Cambridge Companion to Pop and Rock*, edited by Simon Frith, Will Straw, and John Street, 256–71. New York: Cambridge University Press.

Sherrod, Katie. 1995. "Power: Who Runs Fort Worth?" *D Magazine*, November. www.dmagazine.com/publications/d-magazine/1995/november/power-who-runs-fort-worth.

Shipley, Jesse Weaver. 2013. *Living the Hiplife: Celebrity and Entrepreneurship in Ghanaian Popular Music*. Durham, NC: Duke University Press.

Shipton, Alyn. 2001. *A New History of Jazz*. New York: Bloomsbury Academic.

Shuker, Roy. 2005. "Documentaries." In *Popular Music: The Key Concepts*, 2nd ed., 85–87. New York: Routledge.

Simon, Artur. 1989. "The Eye of the Camera: On the Documentation and Interpretation of Music Cultures by Audiovisual Media." *The World of Music* 31 (3): 38–55.

Slobin, Mark. 2008. *Global Soundtracks: Worlds of Film Music*. 1st ed. Middletown, CT: Wesleyan University Press.

Smith, Jeff. 1999. "Movie Music as Moving Music: Emotion, Cognition, and the Film Score." In *Passionate Views: Film, Cognition, and Emotion*, edited by Carl R. Plantinga and Greg M. Smith, 146–67. Baltimore: Johns Hopkins University Press.

Smith, Paul. 1988. *Discerning the Subject*. Vol. 55. Minneapolis: University of Minnesota Press.

Snowden, Don. 1986. "Jazz Portrait 'Ornette' 20 Years in the Making." *Los Angeles Times*, January 22.

Sontag, Susan. 1966. *Against Interpretation, and Other Essays*. New York: Farrar.

Spellman, A. B. 2004. *Four Jazz Lives*. Ann Arbor: University of Michigan Press.

Spivak, Gayatri Chakravorty. 1993. *Outside in the Teaching Machine*. New York: Routledge.

Stahl, Matt. 2013. *Unfree Masters: Popular Music and the Politics of Work*. Durham, NC: Duke University Press.

Stein, Amelia. 2012. *The American Spring: What We Talk about When We Talk about Revolution*. New York: Skyhorse.

Sterritt, David. 1998. *Mad to Be Saved: The Beats, the '50s, and Film*. Carbondale: Southern Illinois University Press.

Stilwell, Robynn J. 2007. "The Fantastical Gap between Diegetic and

Nondiegetic." In *Beyond the Soundtrack: Representing Music in Cinema*, edited by Daniel Goldmark, Lawrence Kramer, and Richard Leppert, 184–202. Berkeley: University of California Press.

Strunk, Steven. 2003. "*Tonnetz* Chains and Clusters in Post-Bebop Jazz." Paper presented to the West Coast Conference of Music Theory and Analysis, Albuquerque, New Mexico, March 21–23.

Sullivan, John Jeremiah. 2006. "The Final Comeback of Axl Rose." *GQ*, September.

Tatro, Kelley. 2014. "The Hard Work of Screaming: Physical Exertion and Affective Labor among Mexico City's Punk Vocalists." *Ethnomusicology* 58 (3): 431–53.

Taylor, Henry M. 2007. "Discourses on Diegesis: The Success Story of a Misnomer." *Offscreen* 11 (8–9). www.offscreen.com/pdf/taylor_diegesis.pdf.

Taylor, Timothy Dean. 2016. *Music and Capitalism: A History of the Present*. Chicago: University of Chicago Press.

"300,000 Jam Musical Bash." 1969. *Chicago Tribune*, December 7.

Tochka, Nicholas. 2015. "Sound, Sovereignty, and 'The Battle for the Mind' in the Early Cold War, c. 1945–1960." Paper presented at the Society for Ethnomusicology 2015 Annual Meeting, Austin, Texas, December 3–6.

Turner, Victor. 1979. "Betwixt and Between: The Liminal Period in Rites de Passage." In *Reader in Comparative Religion: An Anthropological Approach*, edited by W. A. Lessa and E. Z. Vogt, 234–43. New York: Harper & Row.

Turner, Victor W. 1982. *From Ritual to Theatre: The Human Seriousness of Play*. New York: Performing Arts Journal Publications.

Veal, Michael E. 2007. *Dub: Soundscapes and Shattered Songs in Jamaican Reggae*. Middletown, CT: Wesleyan University Press.

Veysey, Lawrence R. 1978. *The Communal Experience: Anarchist and Mystical Communities in Twentieth Century America*. Chicago: University of Chicago Press.

Virilio, Paul. 1991. *The Aesthetics of Disappearance*. Translated by Phil Beitchman. New York: Semiotext(e).

Virno, Paolo. 2004. *A Grammar of the Multitude: For an Analysis of Contemporary Forms of Life*. Cambridge, MA: Semiotext(e).

Vogels, Jonathan B. 2005. *The Direct Cinema of David and Albert Maysles*. Carbondale: Southern Illinois University Press.

Wagner, Richard. 1998. "The Artwork of the Future." In *Strunk's Source Readings in Music History*. Rev. ed. Vol. 6, *The Nineteenth Century*, edited by Leo Treitler and W. Oliver Strunk, 52–70. New York: Norton.

Walser, Robert. 1993. *Running with the Devil: Power, Gender, and Madness in Heavy Metal Music*. Middletown, CT: Wesleyan University Press.

Wells, John D. 1989. "Me and the Devil Blues: A Study of Robert Johnson and the Music of the Rolling Stones." In *American Popular Music: Readings from the Popular Press*, edited by Timothy E. Scheurer, 160–67. Bowling Green, OH: Bowling Green State University Popular Press.

Werbner, Pnina. 1996. "Stamping the Earth with the Name of Allah: *Zikr* and the Sacralizing of Space among British Muslims." *Cultural Anthropology* 11 (3): 309–38.

Whitt. Allen J. 1987. "Mozart in the Metropolis: The Arts Coalition and the Urban Growth Machine." *Urban Affairs Quarterly* 23 (1): 15–36.

Williams, Martin. 1993. *The Jazz Tradition*. 2nd rev. ed. New York: Oxford University Press.

Williams, Richard. 1976. "Dub and the Sound of Surprise." *Melody Maker*, August 21: 21.

Winston, Brian. 1993. "The Documentary Film as Scientific Inscription." In *Theorizing Documentary*, edited by Michael Renov, 37–58. New York: Routledge.

Wong, Deborah. 2004. *Speak It Louder: Asian Americans Making Music*. New York: Routledge.

Zahos, Zachary. 2012. *Ornette: Made in America: A Musical Jazz Journey Press Kit*. Harrington Park, NJ: Milestone Film.

Zemp, Hugo. 1979. *'Are'are Music* (film). Watertown, MA: Documentary Educational Resources. 141 min.

———. 1986. *The Wedding of Susanna and Josef* (film). Watertown, MA: Documentary Educational Resources. 126 min.

———. 1988. "Filming Music and Looking at Music Films." *Ethnomusicology* 32 (3): 393–427.

———. 1990a. "Ethical Issues in Ethnomusicological Filmmaking." *Visual Anthropology* 3 (1): 49–64.

———. 1990b. "Visualizing Music Structure through Animation: The Making of the Film Head Voice, Chest Voice." *Visual Anthropology* 3 (1): 65–79.

———. 1990c. *The Song of Harmonics* (film). Watertown, MA: Documentary Educational Resources. 38 min.

Zimmerman, Jeffrey. 2008. "From Brew Town to Cool Town: Neoliberalism and the Creative City Development Strategy in Milwaukee." *Cities* (25): 230–42.

Žižek, Slavoj. 1992. *Everything You Always Wanted to Know about Lacan (but Were Afraid to Ask Hitchcock)*. London: Verso.

INDEX

Note: Page references in *italics* refer to figures and photos.

absolute time, 222–24
Adorno, Theodor, 164
Allen, John P., 110–16, 118–20, 128, 131–33, 138, 141, 154–55
Allen, Marie, 113, 154
Allen, Pamela, 70
Altamont Speedway concert: *Berkeley Tribe* on, 54, 56; in *Gimme Shelter* film, 16, 25, 53–64, *55*, *61*, *63*; Hunter's death and, 16, 25, 33, 55, 63
amateur reenactment, reflexivity and, 129–30
American Express, 206
American Federation of Musicians, 215
anempathetic music, in "Love in Vain" (*Gimme Shelter*), 42–53, *47*
animation, Godmilow on, 100–101
Another Worldy (Thornton), 104
Anthropology of Music, The (Merriam), 5–6
Antonia: A Portrait of the Woman (Godmilow), 67–107; audience of, 252–54; and Brico's concerto (1973), 71–72; compassionate liberal audience of documentary cinema, 97–99; distribution and accolades, 73–74; and feminism and feminist cinema of 1970s, 68–73, 252; framing interiority in, 91–93; gender issues and continuity between private and public, 88–91; gender issues of conducting, 84–88; Godmilow's *Far from Poland* and pedigree of the real compared to, 94–95; Godmilow's *What Farocki Taught* and pornography of the real compared to, 96–97; "kitchen sequence" as vicarity of, 79–84, *81*, *83*; methodology of, 93–94; music subject positions in, 74–79; overview, 15–16, *17*, 67–68; and postrealist cinema, 68, 94–97, 99–106
Appadurai, Arjun, 169
"Artwork of the Future" (Wagner), 162
Atlantic Records, 201, 244
audience: audience-performer relationship, 173–75; characterization of fans, 165–66, 169–71, 174, 175; compassionate liberal audience of documentary cinema, 97–99; depiction of, 181–83, *182*, 187–90; exposition and bleed-through of, 233, 234; fans hired for filming, 158–60; festival atmosphere and, 192–97; as multitude, 203, 238–44, *241*; plural nature of audience, *55*, 56–64, *61*, *63*; screening films for, 252–54
Augustine, Margaret, 154–55

backstage, in rockumentaries, 211
Baily, John, 4, 10
Ballade in F major (Chopin), 82–83, *83*
Barger, Sonny, 62
Bartleet, Brydie-Leigh, 85
Bass, Ed, 108, 110–12, 115–20, 131, 138, 154–55
Bass, Sid, 117–19, 155

289

Batteries Dogon (Rouch), 4
"Battle of the Sexes" (tennis match), 68–69
Baudrillard, Jean, 22, 122–23
Bazin, André, 243
Beatles, The, 30, 56, 158
Beauty Knows No Pain (Erwitt), 253
"Behind the Wheel" (Depeche Mode), 192, *193*
"being there," as direct cinema strategy, 29, 31, 41, 65, 144
Benjamin, Walter, 11–12, 164
Berger, Harry, 49–50
Berkeley Tribe, on Altamont Speedway concert, 54, 56
Berlin Philharmonic, Brico and, 74–75, 82
biographical individualism, 212
"Black Celebration" (Depeche Mode), 185–88
Blacking, John, 36
Blank, Les, 2, 5
"Blasphemous Rumours" (Depeche Mode), 181–83, *182*
Bolen, Bob, 135–36
Boulez, Pierre, 225
Braverman, Harry, 167
Brico, Antonia: on *Antonia* film, 98–99; biographical information, 69–70, 74–75, 82; and Collins, 67, 71, 72, 79–84, 98; and Denver Businessman's Orchestra concerto (1973), 71–72, 82, 83; "pioneer" feminist status of, 79–84; Schweitzer's friendship with, 92–93. See also *Antonia: A Portrait of the Woman* (Godmilow)
Bridges Go Round (Clarke), 142, 144
Bruck, Jerry, Jr., 89, 252–53
Brussels World's Fair (1958), 142
Burke, Patrick, 57
Burns, Ken, 103–4

California Department of Corrections, 1
Canty, Brendan, 203, 227, 229–31, 237
capitalism: festival atmosphere of Depeche Mode's Rose Bowl show, 192–97; *Gesamtkunstwerk* of estrangement, 160–64, 190; musical labor, 166–67, 211–15, 249; neosyndicalism resisting post-Fordism in *Instrument*, 210–15; of post-Fordist music industry, 164–71; rise of grunge and reality TV, 207–8; self-promotion rejected by *Instrument*, 19, 204–7; syndicalist movement, defined, 210; theatrical view of post-Fordist America, 158–60
Capote, Truman, 32
Capuzzo, Guy, 177
Caravan of Dreams: Coleman's connection with, 110; and Fort Worth revitalization, 109, 131–35, 139; and Fuller's geodesic dome, 113–14, *114*, 128, 147, 149; funding and inception of, 116–19; legacy of, 154–55; and *Ornette* film funding, 145; and *Skies of America* (Coleman), 119–20, 148, 150. See also *Ornette: Made in America* (Clarke)
causal listening, 62–63
"Caustic Acrostic" (Fugazi), 236
CBS, Maysles and, 27
Cherry, Don, 147
Chesler, Phyllis, 70
Chester, Oliver, 165, 193–94
Chicago, Judy, 69
Chion, Michel, 35–36, 40, 41, 45, 46, 189, 235
Chopin, Frédéric, 82–83, *83*
choreography of film, 143–46
chronoscape: chronoscape for the multitude, 238–44; defined, 20
ciné-ethnomusicology: consider-

INDEX

ations for making ethnomusicological films, 20–22; methodology, 11–15; overview, 1–4, 245–46; print-focused theorizing and, 10–11; watching films for, 22. See also *Antonia: A Portrait of the Woman* (Godmilow); *Depeche Mode: 101* (Pennebaker, Hegedus); documentary film; *Gimme Shelter* (Maysles, Maysles); *Instrument* (Cohen); *Ornette: Made in America* (Clarke)

cineharmolodics: choreography of film shooting and video editing, 143–46; Coleman's harmolodic theory, 146–54; overview, 6, 142

city symphony genre, 18, 119

Clarke, Shirley: *Bridges Go Round*, 142, 144; cineharmolodics used by, 6, 142–54; cinematic intervention techniques of, overview, 120–23; *The Connection*, 124–26, 138; *The Cool World*, 138; *Dance in the Sun*, 138; Godmilow on, 106–7; intermittent reharmonization used by, 137–41, *139*, *140*; *The Link*, 141; original filming of *Ornette* by (1967–1969), 112–13; *Portrait of Jason*, 125, 126; reflexivity used by, 123–30; representation of Fort Worth by, 130–37; resumption of filming of *Ornette* by (1983–1985), 108–10; *Skyscraper*, 18, 111, 132; on touring with films, 254. See also *Ornette: Made in America* (Clarke)

Clarke, Wendy, 109, 141

Cohen, Jem: biographical information, 200, 201–2; chronoscape used by, 238–40, 242, 244; constraints on, 249, 251; dub techniques used by, 6–7, 215–17, 219–28, 230–34, 236–38, 245; Fugazi roles of, 209–10. See also *Instrument* (Cohen)

Cohen, John, 5, 102

Cohn, Richard, 176–77

Coleman, Denardo, 112, 116, 124, 127, 141, 152

Coleman, Ornette: biographical elements in film, 120–30, *122*, *127*; cineharmolodics and story of, 6, 142–54; early jazz career of, 111–12; and Fort Worth's establishment, 130–37; *Free Jazz*, 146; intermittent reharmonization and story of, *137–41*, *139*, *141*; original filming of *Ornette* (1967–1969), 112–13; resumption of filming of *Ornette* (1983–1985), 115–20; *Shape of Jazz to Come*, 146; *Skies of America*, 109, 112, 120, 124, *140*, 147–54; Synergia Ranch and Caravan of Dreams connection with, 110, 119–20, 148, 150 (*see also* Caravan of Dreams; Synergia Ranch). See also *Ornette: Made in America* (Clarke)

Collins, Judy, 67, 71, 72, 79–84, 98

Columbia Records, 148, 153

communitas, 191–92

Connection, The (Clarke), 124–25, 126, 138

Cool World, The (Clarke), 138

Cortez, Jayne, 127

"Country Honk" (Rolling Stones), 51

Crawford, Peter Ian, 8, 12, 126

Dahlhaus, Carl, 50, 221–24

Dance in the Sun (Clarke), 138

Dandy Warhols, The, 22

Dauer, A. M., 10

Davies, Bronwyn, 78

Decaro, Mia, 193

Demott, Joel, 159

Denver Businessman's Orchestra, 71–72, 82, 83

Depeche Mode: 101 (Pennebaker,

291

Hegedus), 156–99; "Blasphemous Rumours," 181–83, *182*; *communitas* concept, 191–92; estrangement within post-Fordist music industry, 164–71, *168*; festival of Rose Bowl show in, 192–97, *193*, *195*; film editing as visual analysis, overview, 171–73; *Gesamtkunstwerk* of estrangement, 160–64, 190–91; "Just Can't Get Enough," 197–99; "Master and Servant," 173–75; musical style of band, 6–7, 156–58; "Nothing" and "Shake the Disease," 188–90; "People Are People," 183–85, *185*; "Stripped" and "Black Celebration," 185–88, *187*, *188*; theatrical view of post-Fordist America, 158–60; "The Things You Said," 175–81, *178*, *179*, *180*, *181*. See also *individual songs*

de Rochemont, Richard, 129

De Sica, Vittorio, 202, 243

diegetic sound: diegetic sliding, 50–53, 251; as ecology of sound, 26, 60, 62–63, 82; for mood, 28, 35, 38–39; transdiegetic sound, 48–49; used by Burns, 103–4

Dig! (Timoner), 22

Dinner Party (Chicago), 69

direct cinema: in *Depeche Mode: 101*, 160; long takes as hallmark of, 172–73; by Maysles, 25–29, 31, 32, 41, 42, 65, 144

Dischord Records, 208, 220

documentary film: compassionate liberal audience of documentary cinema, 97–99; defined, 239; dub techniques as documentation, 219–20 (*see also* dub techniques [*Instrument*]); as historical document, 33; "rockumentary" style, 215–17, *218*

Dont Look Back (Pennebaker), 13, 14, 21–22, 30, 156, 163, 191

Dorsky, Nathaniel, 12, 172–73, 221–24

Dow Chemical, 95–96

Drew, Robert "Bob," 27–28, 42

Drew Associates, 27–28, 30, 42, 163

"Dub and the Sound of Surprise" (Williams), 219

dub techniques (*Instrument*), 215–38; avoiding "rockumentary" style with, 215–17, *218*; and chronoscape for the multitude, 238–44; documentation and demonstration levels of, 219–20; fragmentation, 217–19; incompletion, 217–19, 224–25; overview, 6–7; punctualism, 225–29; speed manipulation, 231–32; splicing, 229–31; and temporality, 220–24; visual and musical exposition, 232–38

Dylan, Bob, 21–22, 30

ecology of sound: in *Gimme Shelter* film, 26, 60, 62–63; as sound of present, 82. *See also* diegetic sound

editing: anempathetic music, 42–53, *47*; listening encouraged by, 34–42, *37*, 64; responsiveness for, 14–15; video editing of film, 143–46. See also *Gimme Shelter* (Maysles, Maysles); Hegedus, Chris; Zwerin, Charlotte

Elder, Bruce, 50

Ellerbe, Charles, 136

emotional commitment, 78

End Hits (Fugazi), 236

epistephilia, 212

Epstein, Jean, 36

Ertegun, Ahmet, 201, 244

Erwitt, Elliott, 253

"Everything Counts" (Depeche Mode), 194, *195*

exposition, visual and musical, 232–38

Far from Poland (Godmilow), 94–95
Farocki, Harun, 95
Faulk, Barry, 56
Feagin, Susan, 39–40, 232–33
Feld, Steve, 4, 6, 7, 10
feminism: "consciousness-raising" by, 68, 73; feminist audience of *Antonia*, 252; gender issues with "male gaze," 76–77, 104; gender issues with orchestral conducting, 84–88; music continuity between private and public spaces, 88–91; patriarchy and liberal documentary audiences, 97–99; and "pioneer" status, 79–84; poststructuralists on gender issues, 75–76; second wave of 1970s, 68–70
Fergus, Sandra, 165, 193–94
Film as Ethnography (Crawford, Turton), 8
filmmaking: as ciné-ethnomusicology, 1–4, 245–46; cinematic techniques, overview, 251–52 (*see also* audience; diegetic sound; dub techniques (*Instrument*); reflexivity; subject positions); constraints of, overview, 21, 249 (see also *individual names of films*); critical cinema of music, characterized, 246–49; as research tool, 1–4, 8–11, 249–51; screening films and, 252–54; for understanding music, 7; writing about filmmaking about music, 11–15. See also ciné-ethnomusicology; diegetic sound; documentary film; editing; sound; visual techniques
Five Spot, 112, 146
Flaherty, Robert, 32–33, 54
Fletcher, Andrew, 166, 175, 183
Flying Burrito Brothers, 61
Follow Me Down (Harbert), 1, 252, 254
"Forensic Scene" (Fugazi), 230

Fort Worth (Texas): Coleman's recognition by establishment of, 130–37; Fort Worth Symphony Orchestra, 150; revitalization of arts in, 109, 131–35, 139 (*see also* Caravan of Dreams). See also *Ornette: Made in America* (Clarke)
fragmentation dub techniques, 217–19
Frank, Thomas, 204
Franks, Andy, 167, 168
Free Jazz (Coleman), 146
Free Space (Allen), 70
Fugazi, post-hardcore style of, 200–203. See also *Instrument* (Cohen); *individual songs*
Fuller, Buckminster, 109–14, *114*, 128, 146–49

Gahan, Dave: on labor of music, 166–67; and leitmotif of film, 168; performance by, 173–75, 181–87, *182*, 189–93, *195*, 195–98
gender issues: feminist poststructuralists on, 75–76; with "male gaze," 76–77, 104; music continuity between private and public spaces, 88–91; orchestral conducting as male profession, 84–88. See also feminism
geodesic dome, harmolodic structure and, 113–14, *114*, 128, 147, 149
Gesamtkunstwerk: defined, 160; of estrangement, 160–64, 190–91
gesture: metagestures, 177–79; reductive listening through, 44–48, *47*, 245
Gimme Shelter (Maysles, Maysles), 24–66; Altamont Speedway concert and events, 53–64, *55*, *61*, *63*; alternative structuring of film, 32–34; "Love in Vain" sequence in, 42–53,

293

47; Maysleses' film background, 24–32 (*see also* Maysles, Albert; Maysles, David); overview, 15–17; "Wild Horses" sequence in, 34–42, *37*
Giordano, John, 127, 150
"Glue Man" (Fugazi), 228
Godmilow, Jill: on animation, 100–101; *Far from Poland*, 94–95; on feminism, 69, 71–73; "Kill the Documentary as We Know It," 102; *Lear '87 Archive (Condensed)*, 103; *The Popovich Brothers of South Chicago*, 94, 101–2; on time constraints of film, 227–28; *What Farocki Taught*, 96–97. See also *Antonia: A Portrait of the Woman* (Godmilow)
Goldovskaya, Marina, 2, 3
Gore, Martin, 166, 177, 179–81, 183, 193, 198
Grateful Dead, 62
Grierson, John, 239
Grohl, Dave, 244
grunge music, rise of, 207–8
"Guilford Fall Demo" (Fugazi), 238
Gurdjieff, G. I., 113–14

Hard Day's Night (Lester), 30
Hardwick, Christopher, 165–66, 180, 188, 193
harmolodics: defined, 112, 149, 150; and Fuller's geodesic dome, 113–14, *114*, 128, 147, 149
harmonic circularity, 176–77, 187
Harré, Rom, 78
Harvest (Young), 225
Hauptmann, Moritz, 86
Hebdige, Dick, 205
Hegedus, Chris: on commercialism and music, 169, 170–71; on crowd images, 196–97; decision to film Depeche Mode, 156–58; dramatic tension by, 189–90; editing of, and lighting, 183–86; editing role of, 163–64, 198; on editing style of MTV, 172; and harmonic circularity, 175–76, 187–88; and non-Riemannian tonality, 181, 182; theatrical view of post-Fordist America by, 158–60. See also *Depeche Mode: 101* (Pennebaker, Hegedus)
Heidegger, Martin, 164
Hells Angels, 61, 62
Hoffman, Kathlein, 108–11, 116, 122, 128–29, 138, 145, 148, 151–52
Holliday, Jason, 125
Holm, Hanya, 143
"Honky Tonk Women" (Rolling Stones), 55
Honneth, Axel, 212
Hrebeniak, Michael, 148
Humphrey, Doris, 143
Hunter, Meredith, 16, 25, 33, 55, 63

I. F. Stone's Weekly (Bruck), 253
"I'm So Tired" (Fugazi), 219
In Cold Blood (Capote), 32
incompletion dub techniques, 217–19, 224–25
Inextinguishable Fire (Farocki), 95
In On the Kill Taker (Fugazi), 236
Instrument (Cohen), 200–244; and chronoscope for the multitude, 238–44; documentary style of, 202–3, 208–10; documentation and demonstration levels of, 219–20; dub techniques, overview, 215–17, *218*; fragmentation, 217–19; incompletion, 217–19, 224–25; musical style of Fugazi, 200–203; neosyndicalism resisting post-Fordism in, 210–15; punctualism, 225–29; rise of grunge and reality tv, 207–8; self-promotion rejected by, 204–7; speed manipu-

lation, 231–32; splicing, 229–31; and temporality, 220–24; visual and musical exposition, 232–38
interiority, framing, 91–93
interviews, reflexivity and, 126–28

Jagger, Mick: and *Gimme Shelter* film, 31, 34–35, 39, 43–48, *47*, 50–56, *55*, 62–64 (see also *Gimme Shelter* (Maysles, Maysles); on 1960s music, 30
James, William, 32, 49, 58
Jarmusch, Jim, 39
Jaruzelski, Wojciech, 95
Jazz Tradition, The (Williams), 146
Jefferson Airplane, 57, 61–62
Johnston, Sheila, 77–78
"Just Can't Get Enough" (Depeche Mode), 197–99

K-62, 95
Keightley, Keir, 194
Keshishian, Alek, 22
Kessler, Baron Jonathan, 194
"Kill the Documentary as We Know It" (Godmilow), 102
King, Billie Jean, 68–69
Kreines, Jeff, 159
Kubik, Gerhard, 4

Labor and Monopoly Capital (Braverman), 167
Lacan, Jacques, 76–77
Lally, Joe, 208, 237–38
Lang, Michael, 62
language: gesture and reductive listening, 44–45; linguo-centrism, 11; and semantic listening, 35–36, 39
Lazlo, Elizabeth, 193
Leach, Truvenza, 127
Leacock, Richard, 27–28, 31, 41, 137, 154, 196

Lear '87 Archive (Condensed) (Godmilow), 103
leitmotif: defined, 168; "Pimpf" as leitmotif of *Depeche Mode: 101*, *168*, 168–69, 186, 191, 192
Lesage, Julia, 70–71
Lester, Richard, 30
Let It Bleed (Rolling Stones), 51
Lewin, David, 176
Link, The (Clarke), 141
"Link Track" (Fugazi), 238
"Love in Vain" sequence (Gimme Shelter film), 42–53, 47

MacDougall, David, 9
MacKaye, Ian: on audience, 240–42; Dischord Records, 208; on Fugazi's image, 214; image of, 204, *205*; on *Instrument*'s rejection of promotion, 209–11, 212–13; performances and interviews in *Instrument*, 224, 229, 237; on production techniques used in *Instrument*, 216, 217, 219–20, 226, 232, 233, 236, 244
Madonna: Truth or Dare (Keshishian), 22, 122–23
"male gaze," 76–77, 104
March of Time (de Rochemont), 129
Marcus, George, 8–9
Marshall, Demon, 121, *122*, 139
Martin Luther King Jr. Concert for Justice, 237
Marx, Karl, 164
"Master and Servant" (Depeche Mode), 173–75
May It Fill Your Soul (Rice), 5, 7
Maysles, Albert: audience as character of, 54, 56, 57–59, 64; biographical information, 26–27; cinematography of, 34–35; direct cinema method of, 25–28, 31, 32, 41, 42, 65; and Drew Associates, 27–28; faces

shown in films of, 24–25, 59; film structuring by, 32; legacy of, 64–66; Maysles Films formed with brother, 28–30; music choices of, 38, 42–43, 49; *Opening in Moscow*, 137; *Psychiatry in Russia*, 27, 30; reduced listening used by, 41; Rolling Stones' relationship with, 30–32, 34; sequence shots and framing used by, 39–41; sound recording innovation of, 29. See also *Gimme Shelter* (Maysles, Maysles)

Maysles, David: appearances in *Gimme Shelter*, 33, 64; direct cinema method of, 25; Maysles Films formed with brother, 28–30; and sequence shots, 41; sound recording innovation by, 29; and Zwerin, 37. See also *Gimme Shelter* (Maysles, Maysles)

McNeil, David, 44

"Me and Thumbelina" (Fugazi), 231

mediated historical footage, reflexivity and, 129

Melody Maker (magazine), 219

Merriam, Alan, 5–6, 7

Mimnagh, Tara, 183

Minh-ha, Trinh, 104–5

"Modernist Sensibility in Recent Ethnographic Writing and the Cinematic Metaphor of Montage, The" (Marcus), 8–9

Monterey Pop (Pennebaker), 58

Ms. (magazine), 67, 71

MTV: commercialism of, 206–8, 212; editing strategy of, 172, 232

Muck, Karl, 87

multitude: audience as, 203; chronoscape for the, 238–44, *241*; defined, 20, 243–44

Mulvey, Laura, 76–77

Museum of Modern Art, 144

musical exposition dub techniques, 232–38

Music for the Masses (Depeche Mode), 157, 169, 177. See also *Depeche Mode: 101* (Pennebaker, Hegedus)

musique concrète, 36

Nanook of the North (Flaherty), 32–33, 54

napalm development, 95–96

narration techniques: direct address narration ("voice of God"), 39, 73, 235; first-person, 124

neo-Riemannian tonality, 176–77, 181, 190, 192, 196, 197

Nevermind (Nirvana), 208

Nichols, Bill, 33, 73, 212, 235

1960s idealism, "Stones Concert Ends It" (*Berkeley Tribe*) on, 54, 56

Nirvana, 208

Nix, Bern, 153

Norton, Barley, 10–11

"Nothing" (Depeche Mode), 188–90

Opening in Moscow (Maysles), 137

Operating Manual for Spaceship Earth (Fuller), 113

Oppenheim, David, 113

Ornette: Made in America (Clarke), 108–55; background on story elements, 154–55; cineharmolodics of, 6, 142–54; cinematic intervention techniques, 120–23; Coleman's recognition by Fort Worth establishment, 130–37; Godmilow on, 106–7; intermittent reharmonization in, 137–41, *139*, *140*; original filming of (1967–1969), 112–13; overview, 15–16, 17–18, 108–10; reflexive biography techniques in, 123–30, *127*, *128*; resumption of filming of *Ornette* (1983–1985), 115–20

INDEX

"Other Side of This Life, The" (Jefferson Airplane), 61–62

Palacas, Helen, 71, 81–83, 89–91
Palmer, Robert, 147
Parziale, Chris, 166, 193
patriarchy. *See* feminism; gender issues
Payson, John, 206–7
pedigree of the real, 94–95
Pennebaker, D. A.: biographical information, 160–61; Clarke's work with, 137, 142, 154; on commercialism and music, 164, 166, 167, 170; on decision to film Depeche Mode, 156–58; *Dont Look Back*, 13, 14, 21, 30, 156, 163, 191; Drew Associates and, 27–28; and festival of Rose Bowl show, 193–97; *Gesamtkunstwerk* in work of, 160–64, 190–91; *Monterey Pop*, 58; ritual process in film structure of, 191; theatrical view of post-Fordist America by, 158–60; visual analysis by, 171–72, 174, 175, 185. See also *Depeche Mode: 101* (Pennebaker, Hegedus)
"People Are People" (Depeche Mode), 183–85, *185*
Pericles in America (Cohen), 102
Peterson, Marina, 215
Piano Concerto in A minor, Op. 54 (Schumann), 88–91
Picciotto, Guy: comments in *Instrument* by, 203, 211, 228; cultural comment by, 230, 231, 237–38; performance in *Instrument* by, 216, 217, 219, 230, 231, 237–38
"Pimpf" (Depeche Mode), *168*, 168–69, 186, 191, 192
pluralism: cinema as plural experience, 30; plural nature of audience, in *Gimme Shelter*, 55, 56–64, *61*, 63

Pointer, Jane, 154
Poland, Solidarity Movement in, 94–95
polarization, 60
Popovich Brothers of South Chicago, The (Godmilow), 94, 101–2
pornography of the real, 96–97
Por Por Funeral for Ashirifie, A (Feld), 4
Portrait of Jason (Clarke), 125, 126
post-Fordism: neosyndicalism and resistance to, 210–15; theatrical view of post-Fordist America, 158–60
postmodern cinema, Crawford on, 126
postrealist cinema: Godmilow on, 68, 94–97, 99–106; *Instrument* example, 213
Powers, John, 125
Pribram, E. Deidre, 22, 122–23
Prime Time, 140, 149, 151
Psychiatry in Russia (Maysles), 27, 30
psychological portraiture, reflexivity and, 128–29
punctualism dub techniques, 225–29

racial issues: *The Connection* and *The Cool World* on, 138; in Fort Worth, 116, 120, 125; in New York, 138
Rahaim, Matthew, 45, 177–78
reality television, rise of, 207–8
Reassemblage (Minh-ha), 104–5
Redding, Otis, 233
reduced listening, 36, 39, 41–43, 46, 61, 235
Rees, Helen, 2–3
reflexivity: in *Antonia*, 81, 92–93, 101; in *Far from Poland*, 95; in *Instrument*, 239–40, 246–47, 251; in *Ornette*, 116, 121, 123–30; overview, 5, 12, 18
relative time, 222–24
R.E.M., 207
"Rend It" (Fugazi), 236

297

Rice, Tim, 2–3, 5, 7, 78
Richards, Keith, 38, 40, 41, 48, 49, 52
Richardson, Sid W., 111, 116, 117
Ricker, Bruce, 36–37
Riemann, Hugo, 176
Riggs, Bobby, 68–69
"rockumentary" style, avoiding, 215–17, *218*
Rockwell, John, 127, *128*
Rolling Stones: *Berkeley Tribe* on, 54, 56; Maysleses' relationship with, 30–32, 34. See also *Gimme Shelter* (Maysles, Maysles); *individual band members*; *individual songs*
Rossellini, Roberto, 202
Rothman, William, 21–22, 191
Rouch, Jean, 4, 10, 33
rubble films, 202–3
Rubinstein, Arthur, 87
Russell, George, 127, *127*

Salesman (Maysles, Maysles), 30, 32, 38, 72
Schaeffer, Pierre, 36
Schepartz, Fred, 210
Schuller, Gunther, 149
Schumann, Robert, 82, 88–91
Schwarz, David, 85–86
Schweitzer, Albert, 92–93
screening, 252–54
Seeger, Charles, 11
Serken, Jay, 166
Seventeen (Kreines, Demott), 159
"Shake the Disease" (Depeche Mode), 177, 188–90
Shape of Jazz to Come (Coleman), 146
Shipley, Jesse Weaver, 121
Shipton, Alyn, 146
"Shut the Door" (Fugazi), 234
Simon, Artur, 10
simultaneity, intermittent reharmonization and, 137–41

Skies of America (Coleman), 109, 112, 120, 124, *140*, 147–54
Skyscraper (Clarke), 18, 111, 132
Sling Blade (film), 233
"Slo Crostic" (Fugazi), 236
"Smallpox Champion" (Fugazi), 229–30
Smith, Jeff, 60
Smith, Paul, 78
Solidarity Movement (Poland), 94–95
sound: electronic arrangement in *Depeche Mode: 101*, 173–75; harmonic circularity, 176–77, 187; neo-Riemannian tonality, 176–77, 181, 190, 192, 196, 197; orchestra experience in *Antonia*, 87–88; recording techniques innovated by Maysleses, 29; tense of, 82. See also narration techniques
Sound and Sentiment (Feld), 6
Spears, Jane, 183–85
speed manipulation dub techniques, 231–32
splicing dub techniques, 229–31
Stahl, Matt, 22
Stilwell, Robynn, 48–49
Stone, I. F., 252–54
"Stones Concert Ends It" (*Berkeley Tribe*), 54, 56
"Stripped" (Depeche Mode), 185–88, *187*, *188*
Stuart, Mel, 58
subject positions: interiority of, 92–93; overview, 74–76; vicarity, defined, 76–79; vicarity in *Antonia*, 79–84, *81*, *83*
sympathetic proprioception, 46, 179
"Sympathy for the Devil" (Rolling Stones), 62, 64
synchresis, 45, 48, 52, 189
syndicalist movement, defined, 210
Synergia Ranch: and Caravan of

Dreams, 116–19 (*see also* Caravan of Dreams); Coleman's connection with, 110; ecotechnical projects of, 115, 145; and Fuller's concept of synergy, 109, 113, 147; modern-day work of, 155; overview, 110, 112; Synergians, 110, 146; Theater of All Possibilities, 114–15, 119. See also *Ornette: Made in America* (Clarke)
synergy, Fuller on, 109, 113, 147

Tacuma, Jamaaladeen, 136
"Talk about the Passion" (R.E.M.), 207
tape splicing, 229–31
Tatum, Eugene, 121, 130
Taylor, Mick, 39–40
Taylor, Timothy, 169
temporality: in *Antonia*, 90–91; overview, 21; sound and tense, 82; *temps durée* and *temps espace*, 220–24
temps durée and *temps espace*, 220–24
Theater of All Possibilities, 114–15, 119
Their Satanic Majesties Request (Rolling Stones), 51
"Things You Said, The" (Depeche Mode), 175–81, *178*, *179*, *180*, *181*
Thornton, Leslie, 104
Timoner, Ondi, 22
Tonnetz matrix (for Depeche Mode songs), 177, *178*, *179*, *188*, *193*
transformational loop (for Depeche Mode songs), 177, *179*, 192, *193*
Treavis, Irene, 100
Tristan and Isolde (Wagner), 168
Turner, Victor, 191–92
Turton, David, 8

underrepresentation: and *Antonia*, 68, 74, 100, 105; defined, 5, 20; and *Instrument*, 215; and *What Farocki Taught*, 96–97

Veal, Michael, 217–18, 229, 239
Vertov, Dziga, 12
Veysey, Laurence, 114
vicarity: in *Antonia*, 79–84, *81*, *83*; defined, 76–79
Vietnam War, napalm development and, 95–96
Virilio, Paul, 239
Virno, Paolo, 20, 203, 213–14, 243–44
visual techniques: gesture and reductive listening, 44–48, *47*; Godmilow on watching music, 102–5; orchestra experience in *Antonia*, 85–88, *88*; polarization, 60; representing element of music with images, 6–7; scopophilia and "male gaze," 76–77, 104; sequence shots and framing used by Maysles, 39–41; slow motion, 43–44; synchresis, 45, 48, 52, 189; visual exposition dub techniques, 232–38. See also editing
Vogels, Jonathan, 34–35, 49

Wadleigh, Michael, 58
Wagner, Richard, 160–64, 176
"Waiting Room" (Fugazi), 224
Walentynowicz, Anna, 95
Warner Brothers, 170, 206, 207
Watt, Coulter, 80
Watts, Charlie, 33, 34, 39, 41
Wattstax (Stuart), 58
Wells, John D., 50
Wexler, Haskell, 30
What Farocki Taught (Godmilow), 96–97
What's Happening! (Maysles, Maysles), 158
Whitt, J. Allen, 131
Wilder, Alan, 175–76, 198
"Wild Horses" sequence (*Gimme Shelter* film), 34–42, *37*

Williams, Carroll, 10
Williams, Martin, 127, 146
Williams, Richard, 219
With Love from Truman (Maysles, Maysles, Zwerin), 32
Women and Madness (Chesler), 70
Woodstock (Wadleigh), 58

"You Gotta Move" (Rolling Stones), 37–38
Young, Neil, 225

Zemp, Hugo, 10
Zwerin, Charlotte: audience scenes by, 58, 59–60, 62, 64; collaboration with Maysleses, 25–26, 32; dialogic editing by, 32–33; and diegetic sliding, 50–53, 251; listening encouraged by editing of, 34–42, *37*, 64; and reductive listening through gesture, 44–48, *47*, 245; transitions by, 53. See also *Gimme Shelter* (Maysles, Maysles)

Music:Interview

A SERIES FROM WESLEYAN UNIVERSITY PRESS
Edited by Daniel Cavicchi

The Music/Interview series features conversations with musicians, producers, and other significant figures in the world of music, past and present. The focus is on people who have not only made good music but have had insightful and profound things to say about creativity, politics, and culture. Each Music/Interview book presents an original approach to music-making, showing music as a vehicle for inspiration, identity, comment, and engagement.

The interview format provides conversations between knowledgeable insiders. By foregrounding individual voices, the series gives readers the opportunity to better appreciate the sounds and music around us, through the voices of those who have experienced music most directly.

Yip Harburg
Legendary Lyricist and Human Rights Activist
Harriet Hyman Alonso

Words of Our Mouth, Meditations of Our Heart
Originators of Jamaican Popular Music
Kenneth Bilby

Fela
Kalakuta Notes
John Collins

Reel History
The Lost Archive of Juma Sultan and the Aboriginal Music Society
Stephen Farina

American Music Documentary
Five Case Studies of Ciné-Ethnomusicology
Benjamin J. Harbert

I Got a Song
A History of the Newport Folk Festival
Rick Massimo

Magic City Nights
Birmingham's Rock 'n' Roll Years
Andre Millard

Producing Country
The Inside Story of the Great Recordings
Michael Jarrett

Always in Trouble
An Oral History of ESP-Disk', the Most Outrageous Record Label in America
Jason Weiss

ABOUT THE AUTHOR

Benjamin J. Harbert is an associate professor in the Music and the Film and Media Studies Departments at Georgetown University. He is the producer and director of *Follow Me Down: Portraits of Louisiana Prison Musicians* (2013) and coeditor of *The Arab Avant Garde: Music, Politics, Modernity* (2013).